The Art of the Comic Book
An Aesthetic History

Studies in Popular Culture
M. Thomas Inge, General Editor

The Art of the Comic Book

An Aesthetic History

ROBERT C. HARVEY

UNIVERSITY PRESS OF MISSISSIPPI
Jackson

Library of Congress Cataloging-in-Publication Data

Harvey, Robert C.
 The art of the comic book : an aesthetic history / Robert C. Harvey.
 p. cm. — (Studies in popular culture)
 Includes index.
 ISBN 0-87805-757-9 (cloth : alk. paper). —
ISBN 0-87805-758-7 (paper : alk. paper)
 1. Comic books, strips, etc.—History and criticism.
2. Popular culture—United States. I. Title.
II. Series: Studies in popular culture (Jackson, Miss.)
PN6725.H37 1996
741.5'09—dc20 95-377
 CIP

British Library Cataloging-in-Publication data available

Dedicated to all those
whose names are mentioned herein,
those whose passion and performance
turned the medium into an art form—
and especially to
JACK KIRBY,
HARVEY KURTZMAN,
and
WILL EISNER

CONTENTS

A WORD TO THE FORE BEATS A PAIR OF ANYTHING

If you've come in here hoping to find a way to understand your preteen offspring by breaking the code embodied in the principal documents of their culture, be advised that you took a wrong turn back there at the bookshelf. This book isn't about children's literature. Yes, it is about comic books, but comic books aren't exclusively children's literature anymore. Some comic books are, but many are not, and this opus is mostly about the ones that aren't. The ones that aren't are not necessarily "adult comics" either, if by "adult comics" you mean "X-rated comics." So what *is* this book about then? Well, you'll soon find out if you keep turning pages. But I thought it might be important for you to know, right at the outset, that I won't be talking about comic books as if they were the province of children. Instead, I'll be talking about the medium of comics—the art of the medium, as well as the history of it.

For the incurably bibliomaniacal, I might add that this book could have been aptly titled *Son of the Art of the Funnies*. *The Art of the Funnies* is the name of a book I wrote about the aesthetic history of the newspaper comic strip, and if you glance again at the title of the book you have in your hands, you might think that this is a sequel to the first volume. Well, it is and it isn't. It's a sequel only temporally, in that it was published second. Actually, the first book originally contained most of this one. It could have been called *The Big Book of the Whole Aesthetic History of Comics*, and it would have traced the evolution of the medium from newspaper strips through comic books, stitching all the shreds and tatters together into a wonderfully coherent tapestry. But, like all big ideas, it was a little too big, so it seemed best to let it end after it finished talking about newspaper comic strips. I then took what remained and made this book out of it. So that first book sort of gave birth to this book, and that's why *Son of the Art of the Funnies* seemed like such a good title for it. But that title wouldn't have told you much about the content of the book. Better, I figured, to save it for the motion picture.

From that bibliographic history, you might conclude that this book is mostly a pastiche of leftovers. Not true. Granted, some of the chapters herein have appeared earlier in slightly different form, embedded in reviews I wrote for the *Comics Journal* over the years—chapters 1, 3, 5, 7, and 8, to be exact. And chapter 10 was published by Bill Black in a comic book called something like *More Fun*, if memory serves. (And memory will have to serve because I have lost my copy of the magazine in my files. That's where I lose everything—in my files.) The part of chapter 2 that concerns Jack Kirby was published in the *Comics Journal* no. 167 in April 1994 as part of a special section of eulogies

and remembrances honoring Kirby shortly after he died. But that article was untimely ripp'd from the unpublished part of the first book, so the magazine incarnation is really the "reprint" and the material here is the first edition. Otherwise, the content of this volume—nearly two-thirds of it—was composed expressly for the present occasion. Most of it, in fact, was written to trace as carefully as I could the aesthetic history of comic books, using previously composed material only to illuminate landmarks along the way.

Although I have dedicated this book to the chief actors in the drama I have attempted to outline, I remain grateful to the same persons whose support enabled me to produce the first book—Gary Groth, editor of the *Comics Journal*, whose steadfast pursuit of the elusive phantoms of excellence in the medium of the comics has fostered intelligent and demanding criticism for the art form; M. Thomas Inge, general editor for Studies in Popular Culture for the University Press of Mississippi, who got me into this; and my wife Linda, whose patience and understanding defy description (but not appreciation).

I am also grateful to Frank Stack and Jay Lynch, who read the parts of chapter 9 that apply to them and told me what to change in order to make it truthful; and to Clay Geerdes, who read much of chapters 6 and 9, checking facts and suggesting more accurate sources of information (and telling me not to generalize—advice I'm afraid I never follow); and to Will Eisner, who generously permitted me extensive use of pages from *The Spirit*, and Pete Eisner, who produced excellent copies of the artwork in question for the press to use for purposes of reproduction; and to George Dardess, who read the essay on *Maus* and pointed out a couple of rents in the fabric of my argument; and to Pamela MacFarland Holway, a copy editor of discernment, sensitivity, and wit with a passion for language and logic, all of which she brought to bear on this book as well as its progenitor.

It's been fun. I've found more pleasure in reading comics and writing about them over the years than I ever did actually drawing cartoons—during those brief intervals when I did it seriously (that is, for money, the telltale augury of all seriousness). Not that I've finished writing about the medium. My next book will be called *My Favorite Cartoonists, and Why I Think They're the Best*. (It'll be nice to have a title I don't have to explain.) In it, I'll talk about the cartoonists whose work I copied studiously as a youth, as well as those whose excellence I didn't have room to catalogue in either *The Art of the Funnies* or its scion. Gus Arriola, Carl Barks, Jack Cole, Cliff Sterrett, Crockett Johnson, Al Capp, Jack Bradbury, Percy Crosby, R. B. Fuller, Ham Fisher, Chic Young, George Carlson, Wally Wood, Virgil Partch, George Price, Chad, Ding, T. S. Sullivant, Russell Patterson, Pat Oliphant, Willard Mullin, Al Hirschfeld, Leslie Turner, Fred Harman, Frederick Burr Opper, C. C. Beck, Wayne Boring, Jerry Robinson, and—well, you get the idea. I had to leave a lot of worthies out. But I managed to include a lot, too. And now, you should go on in and meet them.

—R.C.H.
January 1995
Champaign, Illinois

The Art of the Comic Book
An Aesthetic History

CHAPTER I
Slouching toward an Aesthetic
The Beginning of a Critical Vocabulary

O body swayed to music, O brightening glance,
How can we know the dancer from the dance?

No disco beat sounded in the ear of William Butler Yeats when he penned the lines above. But that doesn't put his distinguished doggerel beyond our ken. Whether it's the fox-trot or the hustle, you can't identify a dancer unless he's dancing. A dancer is one who dances. By definition.

A cartoonist's drawing board is not the place around which to stage any kind of ballroom frolic: the risk of upsetting the ink bottle is great enough to discourage even the most discreet toe-tapping. Years of practice at keeping both feet on the floor at all times have made cartoonists no more commonsensical and practical than anyone else, although the habit has resulted in fewer tears being wept over spilt ink than in other professions.

Even if cartoonists don't waltz through their work, the metaphor in Yeats's lines is not without significance for the art of the comics. Just as we cannot know the dancer without the dance, we cannot know the story in comics without the pictures. By definition. In common critical parlance, comics are understood as narratives told by a sequence of pictures, with the dialogue of the characters incorporated into the pictures in the form of speech balloons. Comics are a hybrid form: words and pictures. And their dual nature can dupe the unwary into thinking about them in ways not entirely appropriate to the medium.

Because comics are narratives, many critics and students of the medium treat comics as they do another storytelling medium, literary fiction. The emerging critical canon is consequently laced with discussions of plot, character development, theme, and all the rest of the apparatus of literary criticism. But this approach ignores the narrative function of the pictures in comics. In the best examples of the art of the comics, the pictures do not merely depict characters and events in a story: the pictures also add meaning—significance—to a story. The pictures are thus as much a part of a story as the plot line. No serious consideration of the art of the comics can overlook the narrative function of pictures. At the same time, other critics are tempted to treat the comics as they would film. Recognizing the narrative role of the pictures, they discuss achievements of the medium by using the language of film criticism.

Both approaches can be helpful to the student of comics. Each approach provides insights, not to mention a clutch of terms, that are useful in discussing the form. But neither can wholly embrace the unique aspect of comics' static blending of word and picture for narrative purposes. For that, we need a vocabulary and a critical perspective forged expressly in the image of the form. Before we can properly understand the aesthetic history of the medium—how it emerged and developed— we must be able to perceive comics in their own

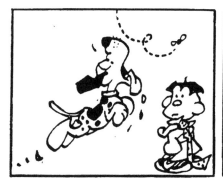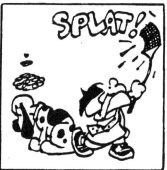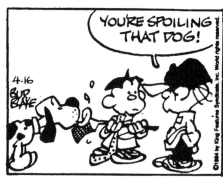

Figure 1. *In Bud Blake's* Tiger, *we don't get the joke unless we understand both the words and the pictures together. And neither words nor pictures are humorous without the other. (April 16, 1994)*

terms. In the next few pages, I'm going to suggest a way of doing that, a way that furnishes us with the means of evaluating the art of the comics as well as describing the medium.

As I've said before (in *The Art of the Funnies*) one litmus test of good comics art is to ascertain to what extent the sense of the words depends upon the pictures and vice versa. It's only one sort of test; there are doubtless others. But when words and pictures blend in mutual dependence to tell a story and thereby convey a meaning that neither the verbal nor the visual can achieve alone without the other, then the storyteller is using to the fullest the resources the medium offers him. Although possibly not the ultimate test of comic art effectiveness, an analysis of the verbal-visual blending does give us a way of approaching comics, of getting into the art form and of seeing how it does what it does.

We'll be looking at pages of comic book art for most of this volume, but by way of illustrating the verbal-visual blending principle I've just proclaimed, let's look at a few less space-consuming

examples taken from the pages of the daily newspaper. The interdependency of word and picture is most dramatically demonstrated in humorous comic strips because we don't understand the joke unless we grasp the narrative significance of both the verbal and the visual. This melding of meaning is perfectly illustrated in the sample from Bud Blake's *Tiger* strip reprinted here (figure 1). Without the pictures, we wouldn't know how little Punkinhead, Tiger's younger brother, is "spoiling" the dog; without Tiger's words in the last panel, we can't know how we are to view or interpret the actions we see depicted. And the instant we understand how Blake wants us to construe the action, the joke surfaces. Suddenly, the humor explodes in our consciousness as we grasp the "meaning" of both word and picture. Johnny Hart takes verbal-visual blending one step further—into the realm of metaphysical humor—in the *B.C.* strip at hand (figure 2).

In contrast, the humor in our examples from Jeff MacNelly's *Shoe* and Bob Thaves's *Frank and Ernest* (figure 3) is entirely verbal: we don't need the

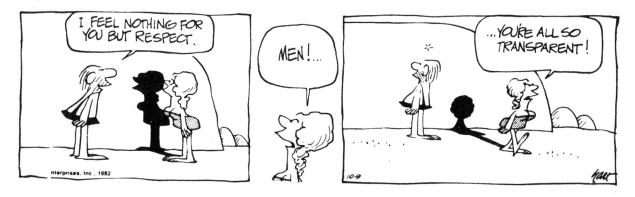

Figure 2. *Johnny Hart blends the visual and the verbal for his punch line in this installment of* B.C. *(October 9, 1982)*

4 THE ART OF THE COMIC BOOK

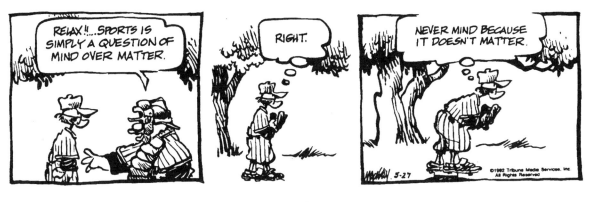

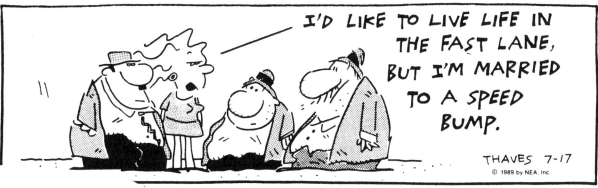

Figure 3. *The humor in Jeff MacNelly's* Shoe, *at the top, is entirely verbal: the pictures contribute nothing to the joke. (March 27, 1992) Ditto for Bob Thaves's* Frank and Ernest, *above. (July 17, 1989)*

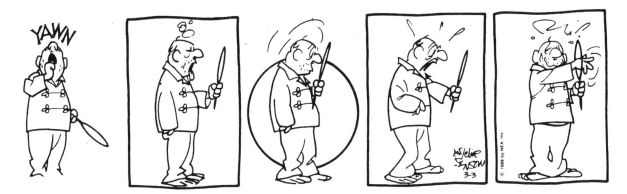

Figure 4. *In this* Born Loser *strip by Art Sansom and his son Chip, the comedy is wholly visual; no words are necessary. (March 3, 1989)*

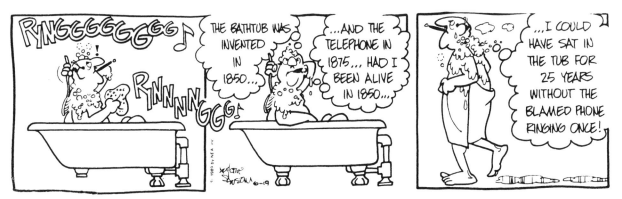

Figure 5. *Although the humor in this* Born Loser *strip is almost entirely verbal, the comedy is enhanced by the timing of the speech. (June 19, 1989)*

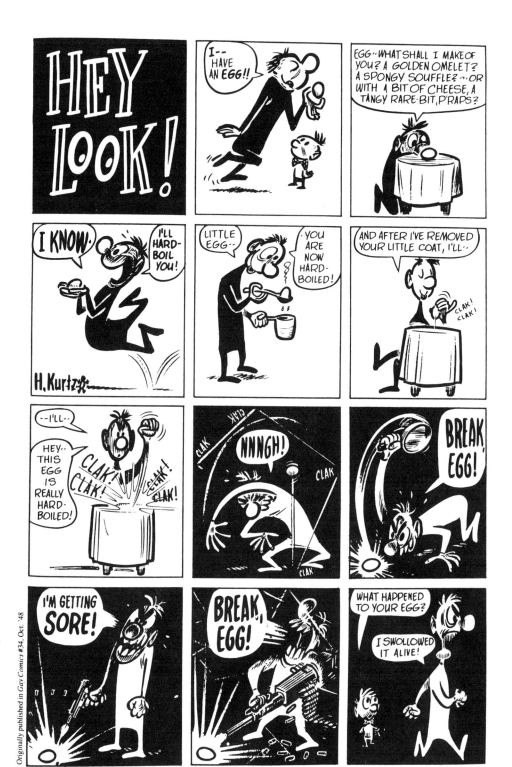

Figure 6. *The spaciousness of a full page permits Harvey Kurtzman to build to his comic punch line by timing the action (and simultaneously elucidating the personality of his character) in this* Hey Look! *page (October 1948).*

Originally published in *Gay Comics* #34, Oct. '48

pictures in order to understand the joke. And in the example from Chip Sansom's *Born Loser* (figure 4), the humor is entirely visual. While all three strips are funny, none of them exploits the nature of the medium as fully as strips that blend word and picture. Both the *Shoe* and *Born Loser* strips

do, however, deploy another of the medium's resources to good effect: they both "time" the action. In controlling narrative information, issuing it panel by successive panel, they withhold punch line information until the last panel. When it is divulged, it acts in concert with the reader's previ-

ously accumulated information to create the comedy. In another *Born Loser* strip (figure 5), much of the humorous success of the episode arises from the timing of the speech, from its being dribbled out, a phrase or two at a time, over a somewhat extended period through a succession of speech balloons. While the humor is not created by a thorough blending of word and picture here (in fact, the joke can be understood through the words alone), the visuals add to the humor by revealing that the phone call forces its victim to get out of the bathtub, thereby giving greater dramatic weight (and hence humorous import) to his concluding remarks.

Time also figures in a page of Harvey Kurtzman's classic comic book feature, *Hey Look!* (figure 6). In the roomier format of a full page, Kurtzman has time (that is, space) to develop his joke. Kurtzman achieves much of his comedy by showing his character progressing gradually from sweet reasonableness to murderous hysteria, a progression possible to depict only with the greater resources of the full-page layout. Again, verbal-visual blending contributes to the humor: the extent of the character's dementia is revealed in the way Kurtzman draws his face as well as in the words the character screams. And although the punch line can be understood in verbal terms alone, the last panel's picture enhances the humor: the egg, we are assured by the testimony of our eyesight, is still unbroken.

Verbal-visual blending is vividly revealed in humor strips, but we can find it in storytelling strips, too. Here are three successive 1929 daily strips from Roy Crane's celebrated *Wash Tubbs*, the strip that set the pace in the late 1920s and through the 1930s for an entire generation of cartoonists who told adventure stories in their strips. (The influence of this signal strip is described in profuse detail in our previous sally into the aesthetics of comics, *The Art of the Funnies*; having now delivered two commercials for this tome in as many pages, I promise not to mention it again for at least several chapters.) The trio of strips yonder (figure 7) are from the adventure in which the redoubtable Captain Easy is introduced (on May 6, to be exact). The partnership that was established in this story coupled Easy's rugged soldier-of-fortune resourcefulness with Wash's ebullient high spirits, giving to the ensuing tales of adventure their characteristic spirit of fun-loving boisterousness in the face of life-threatening danger. Panel 3 in the top strip blends word and picture to achieve its effect: without the picture, we can scarcely make sense of Easy's words; and the words add intensity of feeling to his actions. The last panel carries the story forward, showing Easy escaping.

In the next strip, Crane gives dimension to his new character's personality. Easy was introduced only three weeks before this incident, and up to this time he has appeared simply as a rough-and-ready vagabond adventurer. Out for himself chiefly, he has only scorn for the diminutive Wash, whose ability to handle himself in a fistfight is at best dubious. But here we begin to see a nobler side of Easy. Verbally, he berates himself for being at all concerned with Wash's fate, but his actions are clearly those of a man who is determined to come to the little guy's aid. Easy's plan is hinted at in the visual-verbal blending of the last panel of the second strip: if he intended merely to hide from the soldiers, he wouldn't be climbing up into the tree in hopes that Wash's captors would come by there with their prisoner. In the bottom strip, the pictures carry much of the storytelling freight, but the verbal content of the sequence adds to the narrative movement. Pictures and words do not so much blend here as run parallel, each advancing the story, adding information and implication to the unfolding action. Easy's command to Wash in panel 3 may be unnecessary, but his use of the term *podner* tells us that he sees Wash now as something more than a helpless nuisance. And in the last panel the words divulge elements of plot while the picture shows us two adventurers, dashing through life together, laughing and having a great time—the classic Crane depiction of his heroes.

The capacity of the medium to employ words and pictures in tandem to achieve complementary narrative purposes without precisely blending in mutual dependence is illustrated in another *Wash Tubbs* strip, this one from 1932 when the partnership between Easy and Wash had matured into a well-established tradition (figure 8). This strip has all the vintage Crane touches—a toothsome lass, comic operetta soldiers, and headlong action. In it, we also see Crane's archetypal villain, the brutish pirate Bull Dawson (in checkered vest and trousers). In panel 3, the picture gives meaning to the caption's words: Easy appears to be settling a score indeed. But the picture in the last panel almost re-

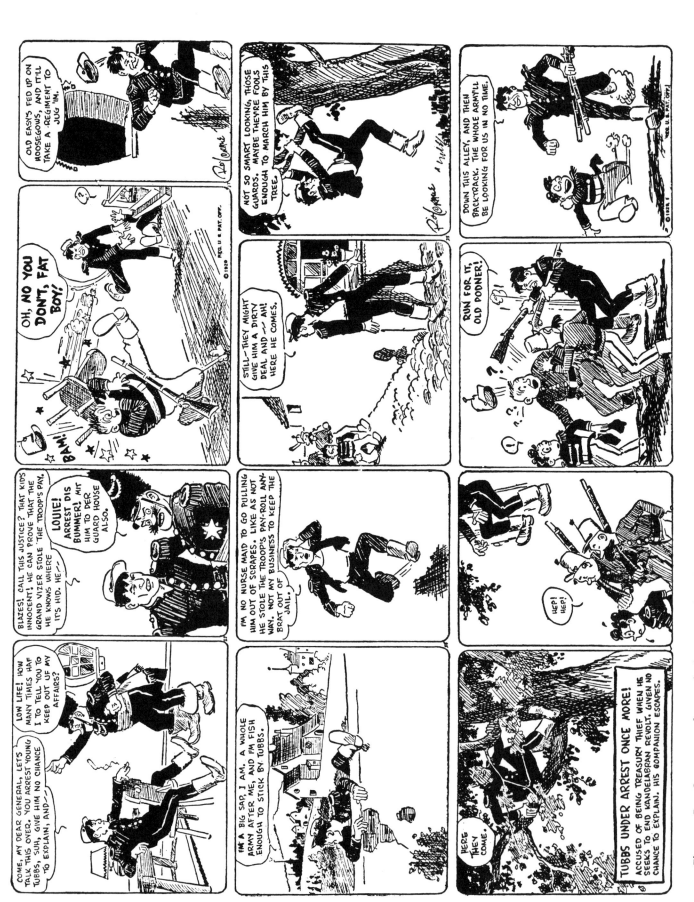

Figure 7. *Roy Crane was adept at deploying words and pictures in tandem to create meaning in his classic Wash Tubbs strip. (May 27–29, 1929)*

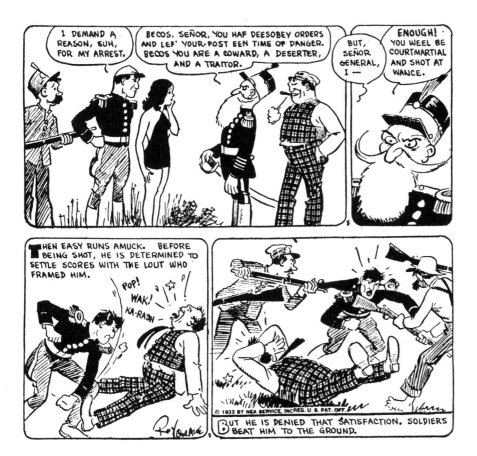

Figure 8. *Sometimes, as in this* Wash Tubbs *strip, the verbal and the visual complement each other without, exactly, blending. (October 8, 1932)*

futes the caption's contention. Judging from the obvious fury of Easy's assault and the cringing Bull Dawson on the ground, we could well suppose that Easy is pretty far from being "denied that satisfaction." This verbal-visual interplay leaves us feeling that Easy has accomplished his purpose—or very nearly so.

Not all comics exploit the nature of the medium as fully as the examples I've summoned just now. In fact, we could probably find more examples of highly verbal comics, ones that are little more than "illustrated narratives," than we could of comics that blend word and picture for the greatest dramatic economy in narration. These are still comics even if they aren't exemplary verbal-visual blends—just as the statue in the city park is a piece of sculpture even if it isn't exactly a Michelangelo. But looking for verbal-visual blending is nonetheless a useful exercise: it provides us with a mode of entrée into the art of the comics. It is a way of tuning up our sensibilities for tuning in to the way the medium works. If nothing else, it makes us aware of the narrative role of the pictures. But there's more to the visual nature of the medium than the purely narrative information we find in the pictorial aspects.

The graphic elements of comics art are woven together to create the warp and woof of the medium's visual nature. For the sake of discussion, we can unravel at least four distinct graphic threads: *narrative breakdown*—the division of a story into panel units; *composition*—the arrangement of pictorial elements within a panel; *layout*—the arrangement of panels on a page and their relative size and shape; and *style*—the highly individual way an artist handles pen or brush (or draws a face or composes a panel or lays out a page or breaks down a story). Although pulling at separate threads like this might threaten to unravel the fabric, discussion of one aspect of graphics almost invariably leads to another, with the result that the visual tapestry always emerges whole.

To understand the role of pictures in the art of the comics, it's not enough to simply identify these visual elements as if they were so many idlers loitering across the page. We must see how each functions to tell the story. Generally speaking, narrative breakdown is the device by which

timing is achieved; by manipulating time, the cartoonist produces dramatic effects. Page layout and panel composition can enhance the dramatic effects of timing by giving varying visual emphasis to different elements of a story or event. The lingo of the cinematographer proves useful here—close-up, medium shot, establishing shot, up-shot, down-shot, tracking, panning, and so forth. But style is another matter. The mark of the maker, its storytelling role is marginal and subtle—too subtle for much elaboration here.

To see how these elements work in storytelling, let's take a look at a sample of Marshall Rogers's work, a couple of pages from *Detective 475*, for instance. On the two pages reproduced here, Batman pays Bruce Wayne's girlfriend a late-night visit. He suspects she knows that Wayne and Batman are one, and he hopes that by confronting her he can get her suspicions out into the open where they may be dealt with.

Batman's approach to Silver St. Cloud's apartment is suitably silent: no narrative captions drone noisily as he throws a line to her building and swings over to it, hovering for a few moments outside her window (figure 9). Composition (that is, camera angle and the direction of the "shot") in the next two panels underscores the unfolding of events. In panel 3, we begin by seeing what Batman sees; then the camera shifts 180 degrees in the next panel to show us what meets Silver's eyes just at the moment she turns in surprise to find Batman at her window. Narrative breakdown heightens the drama of the moment by slowing down the action. Batman's entrance is drawn out over two panels, and as time slows the action, tension builds.

Panel 5's composition further heightens the tension by dramatizing the mysterious and threatening character of the Batman. He steps into the room, its largest and therefore dominating figure, shrouded in his cape, which billows into the room ahead of him as the window lets in the draft along with the Dark Knight Detective. Layout assists composition in creating the scene's vaguely threatening atmosphere. The position of Batman's speech balloon in the preceding panel—its proximity to the predominant figure of Batman in panel 5—encourages the eye to reverse its customary route. Instead of going first to the figure of Silver at the far left, we drop from panel 4 to Batman in panel 5, and then his wind-blown cape sweeps us

across the panel to Silver, crouched on the bed. From there, we drop immediately to panel 6, where her startled, widened eyes add the final touch to the effect of the sequence.

The sequence evokes not fear so much as it does expectancy—the expectancy of a pregnant pause. Emphasizing Batman in panel 5 has the effect of deemphasizing Silver, who appears small and thus somewhat defenseless in comparison to the caped and cowled intruder. Were she the larger of the figures in the panel, her emotional state (whether fear, surprise, or curiosity) would dominate the scene. As it is, though, Batman and empty space—silence—command the panel, creating an expectant void over which Batman appears to loom supreme. But there is irony in that apparent circumstance. Batman, whose identity as Wayne Silver has guessed, is actually at the mercy of this diminutive figure. But owing to the panel's composition, the mystery and aura of the Batman legend still envelop him, and, as we shall see, they ultimately defend his secret.

The virtual silence, verbally, of panel 5 has forced us to let the picture do most of the storytelling, the speaking—and its tale has not yet been completely told. The composition of the panel sets the motif for the ensuing scene: across as wide a space as a panel will allow, the two actors are poised in confrontation. Nor will the scene to follow narrow the gap between them. There will be no true meeting of the minds here: the two will hold each other off, remaining as far apart at the end of the scene as they were at its beginning. The issue of whether Silver really knows Batman's identity will remain unresolved as far as Batman himself is concerned.

After panel 6's recapitulation of the problem at hand, Batman proceeds to the business of his call. He gives Silver an opening: the "something" she might have to tell him could be that she knows he's Bruce Wayne. But she refuses to step through that opening. In panel 8, she moves away from Batman, and on the next page (figure 10), she averts her eyes. He can't pin her down. And the composition of the panels shifts point of view and distance both swiftly and violently, mimicking with its movement Silver's own elusiveness. She dodges the chance Batman offers. Batman considers taking off his mask to reveal what he suspects they both know, but by panel 4 on the second page, he has elected to keep himself wrapped in mystery—

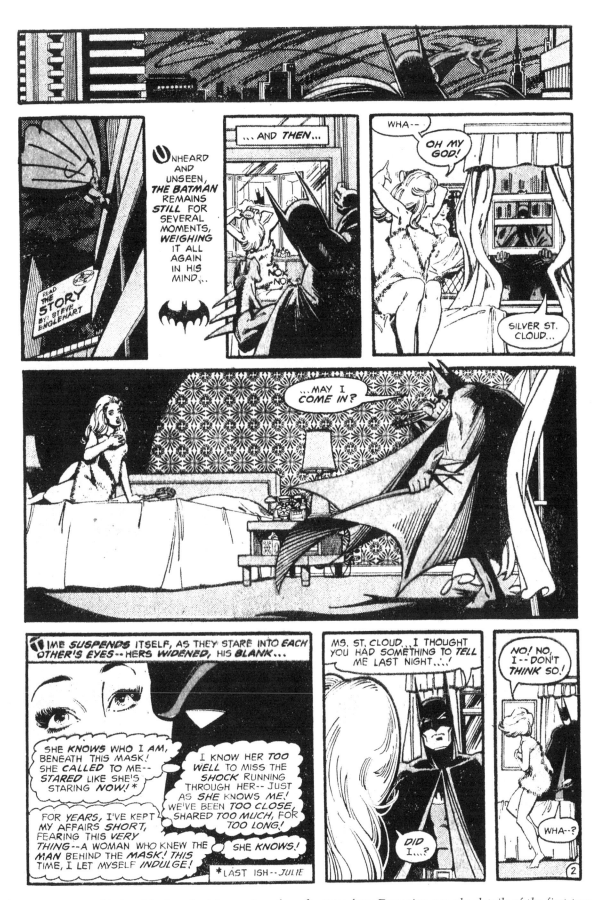

Figure 9. *Because this is a black-and-white version of a color page from* Detective 475, *the details of the first two panels are not as clear as they could be. In the narrow horizontal panel at the top of the page, we see the back of Batman's head as he throws a line to the building across a street. In the next panel, he swings on the rope across the chasm to the window of Silver St. Cloud's apartment.*

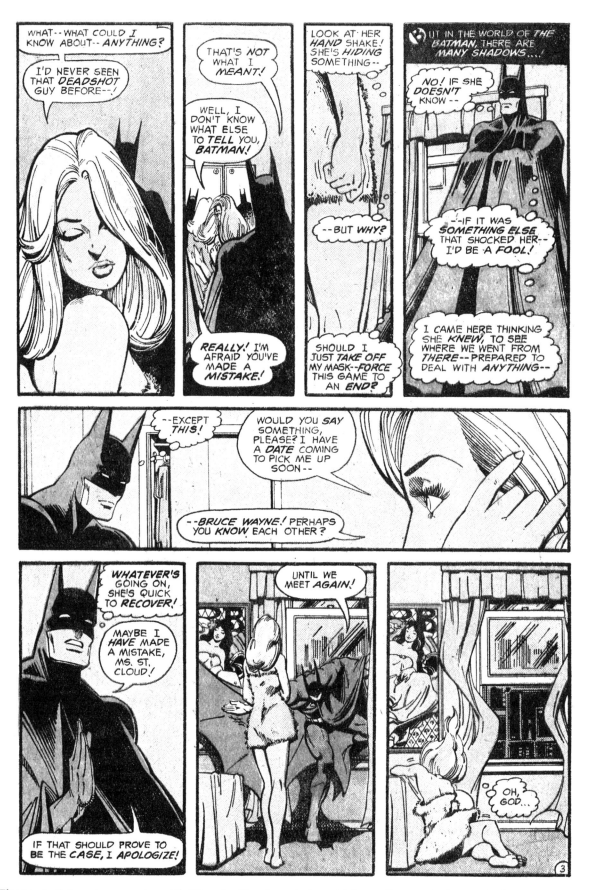

Figure 10. *Batman's encounter with Silver St. Cloud concludes with her collapse, which reveals the emotional strain she was under. But the picture in the last panel is nearly meaningless without the verbiage that has preceded it.*

shrouded, arms folded in resolute imperturbability. As it turns out, that is his best defense.

Panel 5 on this page is a replay of the previous page's facing panel: at the interview's end, the two are still as far apart as the page will permit. But now their positions are curiously reversed. For the first time, Batman is on the left. This visual reversal breaks the pattern so far established, and thus the panel echoes with its unexpected composition the unexpected outcome about which Batman muses from panel 4 to panel 5. Now, moreover, Silver is the larger of the two figures. The initiative has shifted from Batman to her, and she takes it: her remarks put an end to the interview, but her seeming control is an act of sheer will. As soon as Batman wafts out the window, she collapses, no longer able to retain her composure.

On the next page (not reproduced here), Silver reveals why she didn't confess her knowledge. She was, first of all, awed by the figure of the Batman. But just as important, she feels she would lose the man she loves if she were to confront him with the fact that he has for so long kept secret. Her fright, her tension, are brought on by the realization that, whatever she might say, Batman knows she knows. But to preserve her relationship with Wayne, she must deny it.

A complex bit of characterization and motivation. But without the concluding panels of the interview, we could scarcely be aware of the intensity of the emotion underlying the scene. In panel 8, Silver's inner drama is given outward and visible substance. Panels 7 and 8 carefully build to make this revelation, their narrative breakdown and composition giving us in close proximity two scenes that take place in identical settings—same angle, same dimensions. The effect is to place the scenes but an instant apart (the still-flapping curtains, a deft touch). Batman disappears in an instant, and Silver immediately collapses—revealing that the reason for her self-control was simply and solely the presence of the Batman. For his sake—and for the sake of the relationship she wishes to preserve with his alter ego—she had to appear ignorant of his secret.

The power of this two-page scene arises chiefly from the emotions that run beneath its surface, emotions that are dramatically revealed by the skillful timing of the last two panels. And the last panel—which to some may seem a throwaway bit of superfluous elaboration—is the most telling panel in the sequence. Much of its power, though, derives from the strategies of composition and narrative breakdown that lead up to it. The sequence also derives power from the narrative economy of allowing words and pictures to blend to tell the tale. Neither Batman's parting remark nor Silver's sobbing prayer would have as much significance alone as they do in conjunction with the pictures they accompany. And the last panel without Silver's silent invocation would be quite ambiguous. While the pictures would have some narrative meaning without the speech balloons, the full significance of the two-panel series depends upon words as well as pictures. This mutual dependence reveals, in effect, that neither words nor pictures are superfluous—neither therefore impedes or diverts the story's momentum. Were the sequence to be laden with verbal narrative, the dramatic moment would be encumbered and overshadowed with explanatory persiflage.

The same kind of economic blending of the visual and the verbal gives dramatic power to another Rogers sequence, this one from *Detective 472* (figure 11). Rupert Thorne is trying to beat out of Hugo Strange the latter's knowledge of Batman's secret identity. The page printed here ends a 2½-page sequence. Twice before we have watched Thorne puff his cigar with icy nonchalance as we hear the sounds of Strange being beaten off-camera. The blending of words (the sounds) and pictures (of Thorne's calm visage) portray his personality more vividly than either words or pictures could do alone. And each repetition of the scene makes Thorne seem even more ruthless.

The four parallel panels in mid-page draw out Strange's death-rattle defiance of Thorne, making his demise seem all the more painful by lengthening his final moments. Strange's words alone do not tell us he is dying: the words need the pictures to suggest that, at the least, he has lost consciousness. Thorne's henchman pronounces the final verdict, but the pictures of Strange's fist slowly unclenching have prepared us for it. And the repetitive pictures of Thorne watching Strange's death agony—motionless, his face lost in shadow (and therefore incapable of showing us any emotion)—complete his portrait as an unfeeling monster. The design of the page also supports the mood of the pictures. Rogers's grid of panels, with its balance and near symmetry, reinforces the imperturbability of Thorne. And the vertical thrust of the four pan-

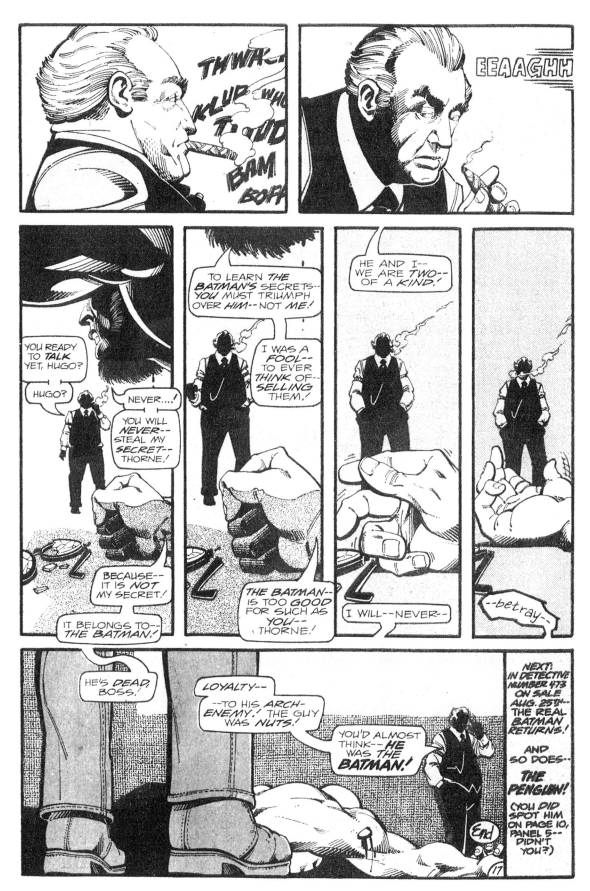

Figure 11. *In this Marshall Rogers page from* Detective 472, *layout adds to the emotional impact of the events: the vertical thrust of the four panels in mid-page seem to be crushing the life out of the expiring Hugo Strange.*

els in mid-page seems to bear down on Strange, crushing the life out of him. In all, a remarkably successful page.

The Silver St. Cloud/Batman interview is not without faults. Perhaps the most glaring of them is the mood-disrupting voyeurism that pervades the scene. It begins almost at once, with Batman playing the Peeping Tom at Silver's window. And Silver's garb, a simple fuzzy towel that threatens to rumple to the floor every other panel, continues the theme, teasing us and distracting us from the otherwise serious business of the sequence. The verbal clutter of panel 6's recapitulation on the first page is also excessive, but the recap is clearly essential. And squeezing it all into one panel leaves enough room for the dramatic development of the remainder of the sequence. What space is left for the image in this panel is dramatically used—thanks to a perceptive caption.

The two-panel pan at the end of the top tier on the next page is not markedly successful. Neither panel is large enough to suggest movement across the same scene, so the only effect remaining is that we focus first on Silver's trembling hand and then on Batman—as if we were looking at two separate panels rather than different aspects of the same scene. But these slips are not costly fumbles: the scene still succeeds in achieving dramatic emotional power by exploiting the visual-verbal storytelling capacities of the medium.

Comic books, however, did not always harness so effectively their words and pictures. It took cartoonists decades to learn how to plumb so thoroughly the potential of the form. In the chapters ahead, we'll survey the history of those decades of development, stopping to examine the work of the masters of the medium, whose efforts inspired their colleagues and thereby shaped the art of the comics. We'll be looking at some milestones and high points, rather than at every comic book title, character, or creator. In short, I do not attempt here a comprehensive history of comic books; I intend only to chart the aesthetic development of the medium. We already have several serviceable histories of comic books, Ron Goulart's *Over 50 Years of American Comic Books* being one of the best. I turned to it most often as I traced the growing maturity of the form in the pages to the right.

CHAPTER 2
Legions in Long Underwear
The Advent of the Comic Book and the Reign
of the Superhero

While newspaper comic strips were being prodded into maturity in the mid-1930s by the inspired performances of artisans like Milton Caniff and Hal Foster and Alex Raymond, another form of visual-verbal graphic storytelling was entering its infancy. At the end of the decade, the comic book was a fact of adolescent American life. And it had arrived on the scene just in time to go to war. When young soldiers went overseas, they took comic books with them—by the hundreds of thousands. Although aimed at younger readers, these four-color magazines proved to be effective morale boosters for the older brothers of their intended audience. Soldiers could read a comic book quickly without concentrating much, and that was just the sort of mildly engaging diversion young men needed to survive military routine. Comic books helped them while away the idle periods of unpredictable duration that customarily intervened between short spurts of feverish activity. Hurry up and wait—and read a comic book while you waited.

Comic books were produced for civilian consumption too, but it was the military appetite that generated the enormous demand that propelled the infant industry to robust maturity within a very few years. By the end of World War II, the comic book was an established literary form. And before the end of the century, it would be aiming for

adult readership with production values and storytelling standards far more sophisticated than those that had governed its birth. By then, not many would remember that comic books were established as a distinct medium because of a rejected newspaper comic strip.

Few saw the unique storytelling potential of the comic book format at first. Initially, comic books merely reprinted newspaper strips, cutting them up and rearranging them in page format. Comic books of this sort appeared on the newsstands shortly after newspapers began publishing comic strips in the last decade of the nineteenth century. In reprinting strips, these publications imitated the practice of such weekly humor magazines as *Judge* and *Life*, the latter having issued several volumes that recycled its cartoons under the titles *The Good Things of Life* (starting in 1883) and *The Spice of Life* (1888). Although some of the cartoons from *Life* were narrative sequences of pictures, most were single-panel cartoons. The first book to focus on sequential narrative cartoons was probably F. M. Howarth's *Funny Folks*, which, in 1899, reprinted comic strips from the pages of *Puck* magazine, almost half in full color.[1]

The recycling practice thus inaugurated was continued for the next three-and-a-half decades, but most of these efforts were in black and white. Then, in 1933, at the urging of two of its sales-

men, Harry Wildenburg and Max C. Gaines, the Eastern Color Printing Company in New York published a thirty-two-page magazine that reprinted Sunday funnies in color. *Funnies on Parade* was produced as a giveaway for Proctor and Gamble, and its success prompted repetition. Gaines produced two more collections of color Sunday comics for companies to distribute as premiums in connection with radio programs. And then, early in 1934, he took the next step: he produced a comic book that was intended to be sold. When it sold out at ten cents a copy, he engineered a successful sequel in May, *Famous Funnies* No. 1; and when the second issue of *Famous Funnies* hit the stands in July 1934, it signaled the arrival of the monthly comic book. But it was still a magazine of comic strip reprints.

Perhaps the first to see greater potential in the comic book format was a former cavalry officer turned adventure-story writer, Major Malcolm Wheeler-Nicholson. Beginning with *New Fun* (cover-dated February 1935), he produced several comic book titles, all of which printed stories that had been created expressly for his publications.[2] None of Nicholson's magazines sold very well, however—perhaps because their interiors were in staid black-and-white instead of lively color. Despite the lack of financial success, though, the Major soldiered on, generating more new titles for more new stories.

Meanwhile, Max Gaines had moved to McClure Syndicate, where he had secured a position on the strength of his promise to generate work for two big two-color presses that McClure had acquired from the recently defunct *New York Graphic* newspaper. Gaines arranged for the two presses to run in tandem to produce four-color reprint comic books, which he began packaging for Dell Publishing in late 1935. With a teenage cartoonist named Sheldon Mayer as his editor, Gaines cranked out *Popular Comics* and *The Funnies* in 1936 and then *The Comics* in 1937. About the same time, newspaper feature syndicates started producing their own reprint comic books: King Features published *King Comics*, and United Features, *Tip Top Comics*. More would follow in the next few months and years.

By late 1936 Nicholson had two poorly selling titles on the stands—*More Fun* (a reformatted *New Fun*) and *New Comics*. His only competitor publishing comic books with new material was a company formed by two of his former employees, William Cook and John Mahon, whose Comics Magazine Company produced several issues of three titles in 1936. Cook-Mahon fared no better than Nicolson, but the two companies did create a market for more new comics stories. Much of this material was created by the first comic art "shop," which had been set up in the summer of 1936 by a farsighted entrepreneur named Harry "A" Chesler.

Chesler had been in advertising in Chicago, and when he saw comic books on the horizon, he realized that he could package material for an assortment of comic book publishers in the same manner that brochures were manufactured for different clients by advertising agencies. He recruited several writers and artists and set up his "shop," a comic book factory that could produce stories for Nicholson and Cook-Mahon quickly and cheaply by using assembly-line methods. The Chesler Shop was a large room on the third or fourth floor of an old tenement building at 276 Fifth Avenue. Some eight or ten artists sat at drafting tables arranged in rows, the better artists nearest the windows along one wall. Cartoonist Joe Kubert, who worked in the shop after school while a teenager, recalled the scene: "The elevator was so rickety that none of the guys would take a chance riding the thing, and instead, they walked up three or four flights of stairs. The wooden floors creaked. There was dust everywhere from the cracks in the wood as you walked. The windows were wide open in the summer. As for air conditioning, forget it. It was hot as hell in the place." Writers brought their scripts into Chesler, who had an office on a lower floor of the building, and he brought them up to the shop and assigned them to artists. There was a certain amount of horsing around among the artists, but they bent over their drawing boards diligently when they heard the elevator coming up. "That was a warning that Harry was coming," Kubert said.

"Let me describe Harry," Kubert continued. "He was about fifty or fifty-five at that time, a short, heavy-set guy with a perpetual cigar in his mouth. Always wore a hat. Always wore a suit with a tie and vest. He would chew a cigar back and forth as he was talking to you, and he would have one hand in his vest pocket with the jacket pulled back. He looked like a promoter, a hustler, but without the negative connotations. He was honest, but he looked like the kind of guy you wouldn't

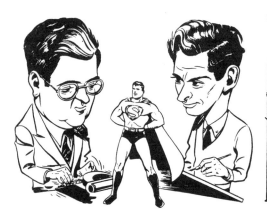

Figure 12. *Caricatures of Siegel (on the left) and Shuster (who may have drawn this picture) bracket a portrait of their seminal creation, Superman. At the right, we see one of the team's earliest characters, the rugged and energetic Slam Bradley, who, with his diminutive pal Shorty, did an imitation of Roy Crane's adventuring pair, Captain Easy and Wash Tubbs.*

trust beyond a ten-foot pole's reach. He had an exterior that was rough as nails but he was one of the kindest, nicest guys you could ever know. When he doled out the weekly salaries, his gag was, Well, how much do you *need* this week?"[3]

The Chesler Shop was not the only source of fresh material for Nicholson. Some came in over the transom. Among these unsolicited stories were several continuing features created by a couple of young men in Cleveland. Jerry Siegel and Joe Shuster had met while in high school, and, after discovering a common interest in comics and science fiction, they decided to collaborate, Siegel writing stories and Shuster drawing them. After graduating from high school in 1932, together they produced several comic strips that they peddled to syndicates without success. Many of the features in the earliest issues of Nicholson's comic books looked like rejected Sunday comic strips, and the first Siegel and Shuster effort the Major published may have been one of the team's attempts at newspaper syndication. This was *Doctor Occult*, and it appeared in *New Fun* No. 6 (October 1935). Both Siegel and Shuster were twenty-one years old at the time. Over the next couple of years, Nicholson bought several more features from the Cleveland youths—*Henri Duval* (a swashbuckler), *Radio Squad*, *Federal Men*, *Spy* (a husband-and-wife sleuthing team), and *Slam Bradley*, a two-fisted detective who betrayed the influence of Roy Crane's Captain Easy. But Nicholson would be out of the business before Siegel and Shuster's most famous creation saw publication.

Plagued with financial shortfalls, Nicholson nonetheless persisted in his desire to launch one more new magazine. To do so, he was obliged to take on his printer, to whom he owed money, as a partner. The company he formed with Harry Donenfeld was called Detective Comics, Inc., and it published the comic book of that name starting in early 1937 (cover-dated March). This production, the first single-theme comic book, was not markedly any more successful than Nicholson's other ventures, but it was financially viable enough by the end of the year to encourage him to think of starting yet another comic book. But before *Action Comics* got off the ground, Donenfeld had forced Nicholson out of the company.

In the spring of 1938, *Action*'s editor, Vincent Sullivan, was looking for fresh material with which to inaugurate the new publication when Sheldon Mayer brought him a comic strip that had been rejected by McClure Syndicate. Mayer's enthusiasm for the strip had convinced Max Gaines that it might be worth publishing. By this time, Gaines was printing Donenfeld's comic books on those McClure presses, and he knew a new comic book title was waiting in the wings. If the syndicate didn't want the strip, he did: if he could persuade Donenfeld to use it in the new comic book, printing that book would keep the presses rolling. So Gaines sent Mayer to show Sullivan the strip. Recalling the moment years later, Sullivan said, "It looked good. It was different and there was a lot of action. This is what the kids wanted."[4] It ran in *Action Comics* No. 1, cover-dated June 1938. And it transformed the infant comic book industry.

The feature was *Superman*, another Siegel and

Shuster product. They had initially created it early in 1933 as a comic book, but when the proposed publisher backed out, the team shelved it until late 1934 when they revamped it in newspaper comic strip format and tried to sell it to syndicates. By early 1938 they were knocking at McClure Syndicate's door. Mayer knew immediately that Siegel and Shuster had a winner: "I went nuts over the thing," he said in later years. "It was the thing we were all looking for. It struck me as having the elements that were popular in the movies, all the elements that were popular in novels, and all the elements that I loved. I thought it was great."[5]

Superman had superhuman strength, he could fly, and he was virtually invulnerable—traits that were explained by his alien origin on a planet with greater gravity than Earth. And he was intelligent and was motivated by a noble sentiment that prompted him to deploy his extraordinary talents to "benefit mankind." To this, Siegel added the appeal of a dual identity. Although a super-powered being, Superman went through daily life as a mild-mannered newspaper reporter named Clark Kent. It was, Siegel said, right out of his own life:

> As a high school student, I thought that someday I might become a reporter, and I had crushes on several attractive girls who either didn't know I existed or didn't care. . . . It occurred to me—what if I was real terrific? What if I had something special going for me, like jumping over buildings or throwing cars around or something like that? Then maybe they would notice me. That night when all the thoughts were coming to me, the concept came to me that Superman could have a dual identity, and that in one of his identities he would be meek and mild, as I was, and wear glasses, as I do. The heroine, who I figured would be a girl reporter, would think he was some sort of a worm; yet she would be crazy about this Superman character. . . . In fact, she was real wild about him, and the big inside joke was that the fellow she was crazy about was also the fellow who she loathed. By coincidence, Joe was a carbon copy of me [mild-mannered, spectacled, desirous of acceptance by women].[6]

Here was a fantasy that would captivate American youth. It was the adolescent male dream made real.

The first few issues of *Action Comics* did not sell spectacularly, but by the fourth issue it was doing very well. And when Donenfeld ran a newsstand survey to discover the cause, he found kids clamoring for the magazine with Superman in it. Donenfeld decided to conduct a marketing test: he put Superman on the cover of the next available issue (No. 7) to see how that issue would sell. When it did well, Superman's fate was sealed. Thereafter, he was on the cover of every issue (albeit sometimes just his name in headline type—until No. 19, when the magazine began showcasing him exclusively every issue). Circulation of the comic book rose rapidly to 500,000 a month. In the summer of 1939 Donenfeld started another title, *Superman*, featuring only the Man of Steel. By 1940 it was selling 1,250,000 copies a month. And on January 16, 1939, Siegel and Shuster finally realized their first dream: on that date, the *Superman* newspaper comic strip made its debut, syndicated by McClure. In two years three hundred papers had picked up the strip.[7]

In the world of pulp magazine literature, there had been other supermen before Siegel and Shuster's creation—Doc Savage, for instance, and the hero of Philip Wylie's 1930 novel, *Gladiator* (which inspired Siegel). And there had been other dual-identity heroes: Zorro, the Shadow, the Scarlet Pimpernel. And there had been costumed do-gooders in the comics. Lee Falk had started his long-running *Phantom* feature in February 1936, and Mel Graff had introduced the Phantom Magician in his AP strip, *The Adventures of Patsy*, in the spring of 1935. But Siegel and Shuster's Superman combined these ingredients to create a new formula for adventure stories—the superhero formula.

Apart from the novelty of their recipe, though, Siegel and Shuster offered little that was wholly unprecedented. The stories were fairly routine action-adventure yarns. Shuster's art, often called "primitive," was nonetheless entirely adequate to its task. He did not plumb the potential of the medium, but he recognized that the comic book format was not quite the same as the comic strip format, and he sometimes varied the standard "Sunday page" treatment, occasionally using a page-wide panel, for instance, to give greater emphasis to the action.

In a notoriously copycat industry like comic book publishing, it is perhaps puzzling to realize how slow other publishers were to ape Donenfeld's

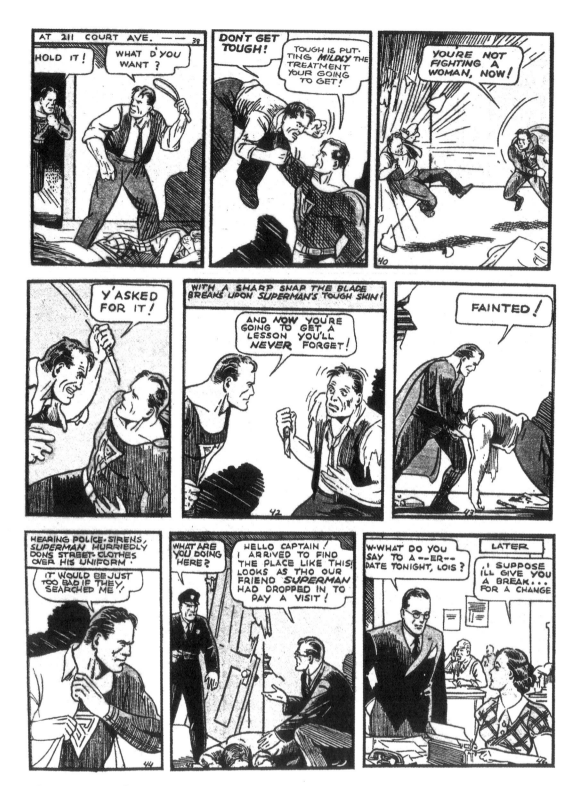

Figure 13. *Here's action and romance from the inaugural Superman story in* Action Comics No. 1, *as Superman bursts in upon a wife beater. Shuster understood the rhetoric of the medium (he even uses a pagewide panel in this first adventure), but he missed his opportunity to heighten the drama of this encounter when he failed to picture the knife blade breaking against the chest of the Man of Steel. And the transition from panel 8 to panel 9 is awkwardly accomplished: the key caption, to the right in the last panel, is misplaced; better to put it in the upper left-hand corner, where it would be read first.*

success. But the conundrum disappears when we remember that there weren't many comic book publishers in the summer of 1938. And not even Donenfeld was fully aware of his success until several months after the first issues hit the stands. Maybe the first to perceive a publishing phenomenon in the making was Donenfeld's accountant, a fugitive from Wall Street named Victor Fox. Fox presumably saw the sales figures coming in on *Action Comics*, recognized the cause, and decided to jump on the bandwagon. He left Donenfeld, formed his own company, and commissioned the comic art shop run by Jerry Iger and Will Eisner to produce a clone of Superman. Called Wonder Man, this superhero was so patently an imitation of Superman that when he made his debut in *Wonder Comics* No. 1 in May 1939, Donenfeld brought suit immediately for copyright infringement. Caught, Fox stopped producing the character at once.

In the same month Wonder Man appeared, Donenfeld began imitating his own product with the introduction of Batman in *Detective Comics* No. 27. Drawn by Bob Kane and written by Bill Finger, Batman represented the other half of what would become the traditional superhero profile. Like Superman, Batman wore a costume and had a secret civilian identity, but Batman had no superpowers; his considerable physical and mental prowess he acquired through constant training. With the arrival of Batman, the floodgates opened, and a host of long-underwear characters began cavorting across the four-color pages of comic book after comic book as other publishers sought to cash in on the new formula. Roughly in order of their appearance came Fantom of the Fair, Masked Marvel, the Flame, Green Mask, Blue Beetle, Amazing Man, Cat Man, the Sandman, Hourman, the Human Torch, Submariner, Dollman, Captain Marvel, Flash, Hawkman, the Spectre, Ultra Man, Plastic Man, Green Lantern, and on and on. Of the lot, perhaps the only distinctive creations were Quality's Plastic Man and Fawcett's Captain Marvel.

Created by twenty-seven-year-old cartoonist Jack Cole, Plastic Man wore red leotards and a black-and-yellow striped belt with a diamond-shaped yellow buckle. His superpower was elasticity. He could stretch himself at will to any desired size; he could mold himself into any shape. In hot pursuit of the bad guys, he lengthened his stride by stretching his legs. He frequently caught up with evildoers by disguising himself; the fun was in discovering which piece of red furniture in the hoodlum's hideout had black-and-yellow stripes with a yellow diamond. Understandably, Cole didn't take any of this very seriously. He drew in a realistic if simple style, but his pictures were often populated with characters rendered in a cartoony, "big-foot" comedy manner. His villains were usually obsessive, their personalities wholly defined by their lawbreaking objectives. So single-minded were they that they seemed quite insane. The combination of nutty crooks and cartoony drawings gave Plastic Man's adventures a zany surrealism. But Plas and the rest of the cast were entirely serious in their various pursuits, thereby grounding the seeming wackiness in realistic intention. The stories were engrossing as well as amusing, with strong overtones of parody. But it was not so much superheroics or crime fighting that was parodied as it was the criminal mind itself. The parody's moral point was that only madmen seem to seek a life of crime.

Unlike most of his fellow superheroes, Captain Marvel made no pretense at science fiction. He was pure science fantasy. Magic, not science, guided his fate. He had super strength, he was invulnerable, and he could fly. Like Superman. But Captain Marvel acquired his gifts by incantation: when teenage newsboy Billy Batson shouted the name of an old magician, Shazam, a bolt of lightning transformed him into the adult superhero. Captain Marvel's adventures, written after the first year by Otto Binder or under his supervision, were enlivened by a whimsical wit, and the resulting tongue-in-cheek tenor of the feature was reinforced by the simple graphic technique of C. C. Beck, who styled Captain Marvel for a staff of artists. Captain Marvel was immensely popular and starred in a proliferation of comic book titles (which also featured other superpowered members of "the Marvel Family"), eventually outselling even Superman. But Captain Marvel fell victim to the protective passions of Superman's publishers. Ignoring the obvious differences in the conception and functioning of the two characters, Superman's lawyers sued for copyright infringement. After battling in court for over a dozen years, Fawcett eventually stopped publishing the line in the mid-1950s.

In the flood tide of superheroics on the newsstands, comic books that simply reprinted news-

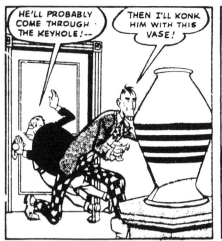

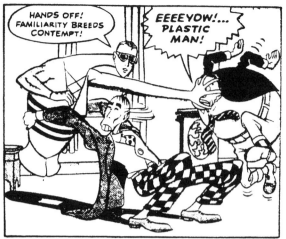

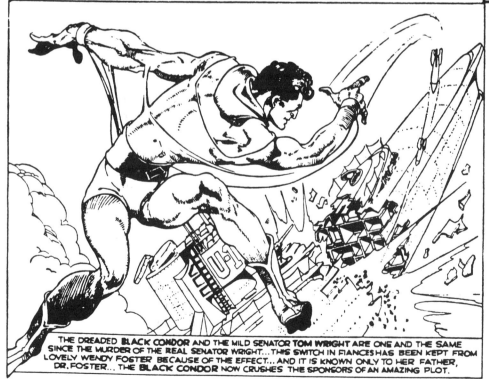

Figure 14. *Part of the fun in Jack Cole's stories about Plastic Man lay in finding the disguised Plas whenever he assumed another shape in order to infiltrate the bad guy's lair. In this selected four-panel sequence (top of the page), the yellow and black stripes on the vase are a dead giveaway. Immediately above are two random panels from C. C. Beck's Captain Marvel oeuvre in which the Big Red Cheese displays his prowess; and, at the left, a panel showcasing Lou Fine's spectacular mastery of anatomy in rendering the Black Condor.*

paper comic strips were soon reduced to a minority. All at once, there was a voracious demand for stories and characters created expressly for comic books, a demand that stimulated the growth of comic art shops. Shortly after Harry Chesler set up his shop in the summer of 1936, Jerry Iger and Will Eisner formed a shop in support of their newspaper syndicate, Universal Phoenix Features, which sold comic strips to weekly newspapers and foreign markets. Several of the features first distributed overseas eventually saw print in the United States in comic books published by Quality (beginning in late 1937) and Fiction House (starting in the fall of 1938). Eisner and his staff of artists and writers also produced entirely original comic book stories for both publishers. As the thirties drew to a close, Lloyd Jacquet (Nicholson's first editor) and Jack Binder established the other two of what comics historian Jerry Bails has identified as the four major comic art shops (in volume 4 of his invaluable *Who's Who of American Comic Books*).[8] As the forties wore on, about sixteen other shops formed. These were smaller operations, involving fewer artists and writers than the big four, and most of them specialized in particular titles. The shop of C. C. Beck and Pete Costanza, for instance, produced most of the Captain Marvel features for Fawcett.

Methods of production varied according to the personalities of the shop directors. At the Jacquet Shop, the same artists were routinely assigned to specific features, so its productions were stylistically distinguishable one from another. Jack Binder, however, set up a regular factory, which resulted in every feature looking the same. As Bails tells it: "Binder operated a true assembly line in producing comics. Five or six artists might work on a single story. The shop records reveal that the work was broken into: layout, pencils on main figures, pencils on secondary figures, inks on main figures, inks on secondary figures, etc. No wonder every Binder strip bore a common stamp."[9]

Quality control was exercised by the shop art director, and quality varied according to his personality and talent. At the Eisner-Iger Shop, Eisner was in charge of the creative end, while Iger handled the business side (and lettered pages sometimes). Eisner presided from a drawing board at one end of a large room; other artists sat at drawing boards that lined the walls of the room. At his

drawing board Eisner roughed out stories in non-photo blue pencil on sheets of illustration board—breaking down the action, designing page layouts, sketching in figures, indicating dialogue. These rough pages he passed on to a staff writer, who wrote captions and dialogue. Then the page went to the other artists. The first of these would finish Eisner's pencils and then ink the figures; a second artist would draw in the backgrounds and ink them. Finally, the lettering would be inked and the page erased and cleaned up.

At various stages in the production, each page passed under Eisner's eye for approval. When he saw something that didn't meet his standards, he suggested changes. Sometimes he made the changes himself. And in addition to supervising the work of the shop, Eisner also created new characters for features to be sold to publishers. Among his creations were Sheena (Queen of the Jungle) for Fiction House, and Mr. Mystic, Lady Luck, Dollman, Manhunter, Uncle Sam, Black Condor, Blackhawk, and Black X for Quality. When introducing a new character, Eisner typically wrote and drew the first couple of stories to set the mold and then turned the feature over to shop production.

The quality of the work produced by shops was remarkably high, considering the circumstances. Generally speaking, the shops were staffed by artists who fell at one of two extremes: either they were raw beginners, youths barely out of high school doing their first work for publication, or they were painters and easel artists and illustrators who had ample experience but whose work was not good enough to secure them a livelihood in those Depression years, when competition for jobs was keener than ever. The younger artists saw comic books as a training ground, a sort of stepping-stone to more dignified careers in illustration or more lucrative work as syndicated comic strip cartoonists. Siegel and Shuster virtually typified this situation: unable to sell comic strips to syndicates, they'd contented themselves with selling their creations to comic book publishers. For some of the older, more experienced artists, comic books provided a way of marking time on their way down. Their career prospects had dimmed; they no longer hoped to hit it big as illustrators. They sought only to make a living for themselves and their families. For most of the staff artists—young and old—comic books thus represented a

secondary career choice. For a few, though, comic books were a challenging new art form, full of promise.

Comic art shops epitomized the early decades of comic book production, which, for the first thirty years or so, lived off mostly anonymous pools of talent that stamped out stories to order. By the early sixties, the independent comic art shop had virtually disappeared. The Wertham purge of the comic book industry in the mid-fifties had swept away dozens of comic book publishers, leaving only a few of the larger concerns still functioning. The major publishers soon established what amounted to their own in-house shops to crank out their books, leaving little work for the smaller shops. But the comic art shops of the thirties and the forties had left their mark on the art form.

The shops' factory production methods were both the cause and the effect of the economy of the comic book industry. And that economy has profoundly shaped the artistic quality of the medium.

THE ART OF THE COMICS is practiced regularly in but two formats: newspaper strips and comic books. Of the two, the book format easily has the greater potential. Comic strips operate under severely restricted conditions that not only limit panel size and number but regulate the unfurling of narrative developments in those strips that tell stories from day to day. While the daily installment format inherently builds the suspense necessary to any story, it also requires a certain amount of repetition each day in order to recapitulate the events of preceding days. Only on Sundays can the newspaper strip approach running the full gamut of its capacities. But in the comic book, with its equivalent of a couple of dozen Sunday pages all between a single set of covers, the medium finds its best chance to realize a greater range of possibilities. Comic books can tell their stories all at once with no repetition (and therefore with greater dramatic impact), can exploit varying panel sizes and shapes to embellish stories with special narrative-enhancing effects, can manipulate time over longer periods to create mood, and can do it all in color. But despite these advantages, the economics of the field militated against comic books' achieving much of their potential until the 1980s.

For one thing, the original market for comic books was the young reader. It was for kids that

Max Gaines manufactured the first comic books as giveaway premiums. And kids, in our society (like it or not), are to be sheltered from a vast range of ideas and subjects. The consequent effort to produce comic book stories suitable for young readers resulted too often in simple-minded stories reflecting the ultimately misguided belief that youth is equivalent to immaturity (as it is) and immaturity to mindlessness (which it isn't). This wasn't universally true of the comic book industry, but it was true enough for long enough in this country to inhibit the medium's growth to its full potential. Oddly, in the 1980s a compensatory effort to make comic books more appealing to older readers erred in another direction by supposing that "mature themes" would enable comics to grow up. Although that's probably valid to some extent, the notion too frequently took flight by mistakenly equating "social issues" or "personality portrayal" with "mature themes." There's more to mature storytelling than that: there is also the way a social issue is treated and how the story is told.

While comic books have historically been addressed to the young, newspaper strips have unabashedly aimed at adult readers as part of the circulation-building mechanism of the paper. They seek shamelessly to make habitual newspaper buyers out of the adult population, since adults usually have more money to spend on the things advertisers blandish on newspaper pages not otherwise devoted to comics. In order to attract and hold such readers, comic strips have traditionally been more realistic in their stories, more cerebral (but not necessarily intellectual) than action-oriented—and even, in a remarkable degree, more mature—than comic books.

But, through the first fifty years of their history, an even more insidious economic circumstance worked against comic books' developing to the fullest their inherent capacities as a visual-verbal narrative art. Until the late 1980s a successful comic book artist could not expect to earn as good a living as a successful comic strip cartoonist (many of whom made small fortunes at their craft). The income of a strip cartoonist, whose work is syndicated for distribution to hundreds of newspaper clients, grows as the number of papers carrying his feature increases. In contrast, the book cartoonist was paid a page rate that seemed to have little relationship to the circulation of his product. An accident of comic book history, the

page-rate formula was established in the very beginning, ironically (and unwittingly) by the newspaper syndicates.

Syndicates charged the publishers of the first comic books five to seven dollars a page for reprint rights to their comic strips. And when publishers started demanding original material for comic books instead of reprinting newspaper strips, that new material had to be produced at a rate competitive with the reprint fees. Thus, the comic art shops with their teams of writers, pencilers, and inkers had to produce enough pages a week to make the paltry page rate yield a living wage for all concerned. The solution, as Will Eisner described it, was to streamline production in order to increase the quantity produced. "I hired artists on salary," he explained, "rather than paying them by the page. If I hired an artist at ten or fifteen dollars a week and if I did the writing and Iger did the lettering, we could produce a fair amount of material, sell each page for five dollars and still make a profit."[10]

Shop practices thus established the per-page rate as the unit of pay for comic book artists and writers. Although this rate was often higher than the per-newspaper rate in newspaper syndication, the book cartoonist could hope to increase his income only by increasing the number of pages he did (and there are practical physical limits here)—while the strip cartoonist's income goes up quite independently of the quantity of his output. On the basis of these economic facts alone—without considering, in other words, such things as the personal preferences of cartoonists for one comics format over the other—we would expect to find more cartoonists doing strips than books as their life's work. In fact, of course, that is precisely the situation. It's no wonder that Siegel and Shuster first sought syndication for their work: they knew a syndicated comic strip could bring them both fortunes.

Given the modest income that comic book cartooning has traditionally afforded, we cannot be surprised to discover that the comic book industry has been more of a young cartoonist's field than has the comic strip industry. Many cartoonists plying their pens in comic books were doing their first commercial work, comic books being historically the proving ground for virtual beginners. The more skilled these artists became, the more qualified they were for more lucrative positions in the wider field of commercial art. And as they became qualified—often after relatively short stints—many comic book artists left comics to move into advertising art or other, richer, related fields. (And much the same can doubtless be said for those who write comic books, many of whom left—or hope to leave—for careers in motion pictures or television.)

The consequences of this circumstance for the state of the art of the comics were not cheering. Comic strips were likely to be drawn by seasoned and experienced cartoonists—who, in this, the most confined format of the art, could not exploit their experience to any great extent. Comic books, whose greater flexibility in format would permit fuller development of the art, were likely to be drawn by cartoonists still in apprenticeship, whose penchant for experimentation was comparatively untempered (and unguided) by experience. The economics of the comic book industry were such that the four-color format was assured of a reasonably steady influx of new, young talent. Youthful enthusiasm is usually accompanied by the kind of inventiveness unfettered by tradition that is good for the art. That's a plus. But this advantage is offset considerably by the likelihood that many young and inventive cartoonists would leave the field just as they were beginning to master its nuances. And when they did, they undermined the art form's potential by depriving the medium of the possible benefits to be derived from the skill of experienced cartoonists, cartoonists who have mastered the rudiments and discovered which new techniques work and which don't. Experience isn't everything. But it is something—something that, compared to the comic strip field, the comic book field was often woefully lacking.

I don't mean by any of this to belittle the considerable accomplishments in comic book art of cartoonists who have happened to be relatively inexperienced. Nor would I opt for making it any more difficult for young talent to enter the field. Such a course would surely have robbed the art of such innovations as those inaugurated by Neal Adams, Barry Windsor-Smith, Jim Steranko, and the like. Nor am I forgetting the achievements of cartoonists like Jack Kirby and Gil Kane and Joe Kubert and Carl Barks and others who have steadily worked a lifetime in the field: by such exceptions, the rule is proven. But we are contemplating the potential of the unique visual-verbal art of the

comics. And since the greatest potential—because the greatest flexibility—lies in the comic book format, it is worth pausing for an instant to reflect on what the state of the art would be if Adams and Steranko and others like them were still drawing comic books, or if Will Eisner did it full-time for a living instead of part-time as a hobby. Where would they have taken the art form next? What would they do for an encore?

The field has attracted more Adamses and Sterankos. And that's good. But it's too bad that the Adamses and Sterankos did not stay longer—long enough to build on the experiences of their too brief periods of innovation and brilliance, long enough to profit from the mistakes and the successes of their experiments—long enough, that is, to help elevate the art of the comics to whatever heights it can achieve in the more flexible of its formats. It is ironic that the economics of the industry have for so much of its history worked against the art—not always with success, mind you, and not universally, with every single cartoonist, but often enough to establish a tendency that prevailed until the 1980s, when developments that we'll consider in chapter 6 changed the opportunities for the art dramatically.

While I'm astride this horse, let me rub a grain of salt on one more saddle sore that the beast must suffer with. A minor irritation, doubtless—but one that increasingly inhibited the development and full realization in comic books of a visual-verbal art form. I'm speaking of the assembly-line or committee-work method of production. The division of labor is not in itself an insurmountable obstacle to the creation of good visual-verbal art, but the emergence of the writer in the 1970s as the dominant creative force threatened the integrity of the art. Before I drape this naked assertion with explanatory fustian, let me assert the definition of a term.

I've used *cartoonist* rather loosely to describe anyone who draws comics. But the fact is that not everyone who draws comics is a cartoonist. A cartoonist is one who creates in the visual-verbal mode of the comics—someone who is a writer-artist. And in the creative processes of the cartoonist, neither words nor pictures take precedence over the other: they blend. Unhappily, in the comic book industry there have been too few cartoonists.

As a historical matter, the medium chewed up story material so rapidly that it soon became necessary to assign to some persons the invention of stories and to others the task of illustrating those stories. At first, both functions were often performed by cartoonists, some of whom were probably better at inventing stories than others, who were probably better at drawing pictures than at concocting tales. But eventually, this division of labor permitted comic books to utilize the considerable storytelling talents of persons who might not be able to draw a stitch as well as the illustrating talents of artists who probably could not type word one of a story. That's the extreme situation; some writers could draw a bit, and some artists could invent stories. But the industry could accommodate the extremes, too.

By and large, this compromise of the art to meet the demands of volume production has worked adequately. But the compromise did not always enable all parties to be represented equally. As the creative team became increasingly specialized, writers tended to be more and more creatures of words exclusively and less often "cartoonists" with a flair for story invention. Regardless of how visually oriented a writer's imagination may be, his natural bent is to rely on words to do the storytelling job.

Those who love words and what words can do cannot help but yield (with the best possible intentions) to the temptation to use words to "improve" their stories. The simplest plot can be given depth and complexity in much less space with words than with pictures. Thus, motive is complicated, personality polished to reveal another facet, and subplot recapitulated by adding a clause to a narrative caption here, a phrase to a bit of dialogue there, a paragraph in a thought balloon somewhere else. Bit by bit, a story acquires excess verbal baggage, the relationship between word and picture becomes increasingly tenuous (their mutual dependence being undermined), and at last the visual-verbal blend itself is sacrificed to verbal elaboration of plot, subplot, and characterization. While the story may be wondrously complex as a result, it is also too complex to make the best use of the medium in the pages available. The peculiar narrative economy of comic art's visual-verbal blend is forfeit—and with that, much of the dramatic power of the medium is dissipated.

We can scarcely fault writers for their admirable desire to make better stories. Nor can we blame

Figure 15. *This cartoon of mine could be entitled "The Tyranny of Writers." With or without a title, however, it might turn tyranny on its head if it successfully demonstrates that pictures are worth thousands of words.*

them when they try to protect the stories they invent. We have the testimony of such writers as Len Wein and Chris Claremont to the effect that sometimes the pictures they eventually saw illustrating their stories did not seem to do the job in precisely the way that the writers had initially imagined they would.[11] Given this situation, it is not inconceivable that a writer might choose to write enough words to tell the story *his* way—and in a way that cannot be substantially altered by the illustrating artist. In short, with the words carrying the bulk of the narrative load. Over the years, then, writers' legitimate attempts to control their stories have yielded comic book stories that too often traded more in the coin of the writer's realm and less in the stock of the illustrator's—and words did more of the storytelling than pictures. When that happened, the nature of the medium changed. Instead of having stories whose meanings were achieved by blending pictures and

words, we sometimes had stories whose pictures simply illustrated (or "decorated") verbal narratives.

The purpose of this long detour (appearances to the contrary notwithstanding) is not to denigrate the collaborative productions of creative comic book teams in favor of the paper-and-ink offspring of a single cartoonist, laboring in splendid isolation to produce his comic strip. After all, most successful newspaper strips are group enterprises, too. The group is smaller—typically, the originating cartoonist plus one or two assistants, who ink and/or letter the strip. And since the efforts of this group are focused on a single product and since the originator usually retains tight control over both story and art, the result is more the product of a single creative consciousness than are the productions of comic book shops. Still, I didn't call this quorum to sing the praises of the single-minded production methods of comic strips over the usual

group-grope methods of comic book production. There are too many variables in each situation for that kind of simplistic comparison. After all, a strong editor-cartoonist like Harvey Kurtzman (as we will soon see) can direct the efforts of a gang of artists toward shaping their products to directly reflect his personal vision as surely as a comic strip originator like Al Capp can herd his stable of assistants into maintaining the tone and flavor of his brainchild, *Li'l Abner*.

No, I'm not here to call names and sling disparagement. Rather, I've attempted to outline a tendency inherent in the traditional method of comic book production, although this tendency is by no means a universally accomplished fact. Not all comic books have devolved simply into illustrated stories; many are still visual-verbal stories— comics. And even most of the illustrated tales of, say, a Roy Thomas in the late 1970s contained occasional pages of visual-verbal narrative. At the same time, the tendency in the direction of the illustrated story has received additional impetus from the promotion of writers to editorial positions. When the final control over a story as well as its initial conception rests with those whose primary mode of creation (and of evaluation) is verbal rather than visual, we can hardly expect the visual aspects of the medium to maintain equal status with the verbal. Fortunately, as we'll see a little later, developments in the late 1980s have asserted the visual aspects of the medium once again. But the impulse toward illustrated verbal narratives remains a temptation in the medium, an urge best resisted.

Despite the gloomy cast of some of this dire diatribe, the state of the art is scarcely grim. I admit to having deliberately overstated the case by oversimplifying it. But the wild hyperbole serves a purpose. In the first place, by exaggerating the circumstances, the problems are brought into sharper focus. Secondly, by emphasizing the obstacles to the creation of good comic art, I intend to give the rhetorical advantage to the negative side in answering the most basic of the questions facing any critical analysis. If I've exaggerated the limitations and constraints inherent in the customary method of producing comic art in book format, then I've painted as bleak a picture as the facts will support. And if, in such a setting, it is still possible to imagine (and to find) examples of visual-verbal narrative art that exploit to the full-

est the medium's unique capacities, then the procedure we have been following for "tuning in" to comics remains valid. But first, that basic question.

I'm following the lead here of Daniel Mishkin, whose perceptive remarks in the *Comics Journal* I'll paraphrase, reconstructing them into a single question. Given the "structural, commercial, technological, and accidental constraints" of the medium, he asks, is it possible to produce comics that fully exploit "the medium's unique (and uniquely successful) narrative strategies, testing the limits of what the medium can do and avoiding what it cannot do in the service of its artistic ends"? More specifically, "Can a 17-page magazine featuring stories . . . comprising words and pictures produced on deadline by a loosely banded group of creative personnel, tell worthwhile and well executed" visual-verbal narratives?[12] In short, can comic book narratives be art? And can that art appeal to mature readers?

The answer, I submit, is still "yes." Such stories can be written for the enjoyment of both young and older readers—if the temptation to "write down" to one's audience is successfully resisted. The newspaper comic strip proves that it can be done. Such stories can be produced by relatively inexperienced writers and artists—and they have been, as we'll see before we finish this safari. And such stories can be produced by creative teams in which the wordsmiths are the controlling forces— if those writers make a conscious effort (as many do) to let the visuals bear an equal portion of the narrative burden and if they do not indulge the temptation to complicate a story (thereby siphoning off its dramatic momentum) with verbal embroidery.

While it's the writer's role that has, through much of the medium's history, most threatened to rock the boat, tipping everything in the direction of verbal narrative, when Image Comics surfaced noisily in 1992 by asserting the primacy of picture over word, the publisher exemplified its credo with such uncompromising effrontery that narrative content, or story, was altogether missing from many of the books produced by this aggregation of artists. But just as the impulse to verbalize an entire story can be restricted and controlled, so too can the urge to draw pretty pictures without narrative purpose. And that is why my answer to Mishkin's question is affirmative. But before we reach

examples to support this assertion, let us continue to explore how comic book storytelling works, and there can be no better place to resume this examination than with Jack Kirby. Kirby was there at the beginning. And he remained an active and powerful creative force until he retired in the late 1970s. At the beginning, he shaped the art of comic book narrative more dramatically than most of his contemporaries; and midway in his course, he almost single-handedly revitalized a withering medium.

MUCH OF THE EARLIEST ORIGINAL MATERIAL for comic books ignored the special character of the medium. Narrative breakdown was governed by verbal content rather than story direction. In many of the stories, there was only sporadic narrative continuity from panel to panel; instead, each panel illustrated some aspect of the story, and captions carried the narrative along. In visual terms, a story might be a series of illustrations often so independent of one another as to be virtually isolated incidents—in narrative sequence, admittedly, but without connective continuity. Page layout was wholly undistinguished and, indeed, virtually purposeless. Comic book artists imitated what they saw in the funnies of their newspapers and designed pages with uniform grids of equal-sized panels, ignoring the spacious page format that would have allowed them to vary the size—both height and width—of panels for emphasis.

Among the first to recognize a greater potential for the medium were Will Eisner and Jack Kirby. Preoccupied with the short-story form, Eisner saw that visual images could be manipulated to create mood and should be carefully timed for narrative impact. Although he was working in comic books before Kirby started and was as much a force in shaping the medium as Kirby, I'm saving a close look at his work until later (in chapter 4, to be punctilious to a fault) in order to focus here on the growth and development of superhero comics, the genre responsible for the initial success of the medium as well as its mainstay through so much of its history. And Kirby had a profound impact upon the medium with his superhero comics. He saw, perhaps as a result of having worked briefly in animation as an in-betweener, that the potential for portraying action in comic books was not being much exploited at first.

"Nothing around really moved," Kirby once said, recalling his early days. "I created the follow-up action which none of the strips had. In other words, another strip might have one action in one panel and an unrelated action in another panel, whereas I would have a continuous slug fight. If a guy parried, he would follow it up with a thrust. . . . So it would give the strip a little motion."[13]

A little motion. With typical understatement, Kirby modestly avoids the spotlight.

His modesty was ingrained. It had its origins in the ethnic and economic insecurities of New York's Lower East Side ghetto, where Kirby had been born Jacob Kurtzberg. Moreover, short in stature, Kirby always felt people overlooked him. When he teamed up with Joe Simon in 1940, Simon emerged at once as the front man, the business manager. "Joe's function was to associate with the publishers," Kirby told Eisner in an interview in 1982. "He was 6' 3" and I was 5' 4"," he laughed. "The publishers would not look at me, and I took that in stride. . . . [But] Joe was highly visible."

Although he influenced the art of the comic book enormously, Kirby, in contrast to Eisner, did not ponder much the artistic import of what he did. He saw himself as an entertainer. "I'm in show business," he told Eisner. "I'm a performer, and I'm going to be the best performer I can."[14]

Trying to be the best got him out of the ghetto. While a teenager, he drew cartoons for a mimeograph newspaper produced by the Boy's Brotherhood Republic, a youth organization founded in 1932 by Harry Slonaker to give boys the kind of responsibility that would bring them hope in those Depression years. His drawing talent surfaced early, and he soon used it to generate income for his family: he quit school in 1935, at the beginning of his senior year, to take work with Max Fleischer's animation studio.

As an in-betweener, Kirby drew the sequences of pictures between "key" drawings. His drawings showed a character's movement from one position to the next, thus conveying the impression of continuous motion by depicting each position between the defining extremes. It was like factory work, and he didn't much like it. But it brought in a paycheck for almost two years, until he found a position with Lincoln Features Syndicate, a small operation for which he drew the entire array of newspaper cartoons—editorial cartoons, comic

Figure 16. *Starring the Green Lantern of yore, this page from* All Star Comics No. 3 *(winter issue; date unspecified but assumed to be December 1940–January 1941) is fairly typical of much of the early comic book superhero material. Captions carry a large share of the narrative. Note, too, the tepid visualization in panel 4; the page's only real action, the Green Lantern's blow to the villain's jaw could have been much more vigorously depicted, which would have made the panel the exciting high point of the page.*

Figure 17. *Jack Kirby's animation test for Fleischer Studio shows the task of the in-betweener: between the three key drawings, the in-betweener did the drawings that take movement from one key drawing to another.*

strips, single panel information features—each in a different style. Kirby also freelanced with other small syndicates, including Eisner and Iger's Universal Phoenix Syndicate. For U.P.S., starting in the spring of 1938, he drew several strips. Three of them were subsequently published in *Jumbo Comics*, a Fiction House title for which the Eisner-Iger Shop began producing material that summer. At the end of 1939 Kirby started working for Victor Fox, and there he met Joe Simon.

A couple years older than Kirby, Simon had attended college and had worked on the art staffs of a couple of newspapers, where he also did some sports and editorial cartoons. About 1938 he got involved with comic books, doing some freelance work for the Jacquet Shop and then for Martin Goodman's Timely Comics. A few months after Kirby started working for Fox, Simon joined the company as editor-in-chief of the comic book line, continuing to freelance on the side. He recognized Kirby's talent immediately, and when Kirby, knowing of Simon's extramural endeavors, asked if he had any work he could help with in the evenings, Simon leaped at the opportunity. They worked together on the second issue of *Blue Bolt*; it was the first collaboration of what became the most celebrated creative team in comics.

Initially, the two worked together quite closely in producing pages of story. "Jack had a great flair for comics," Simon recalled in his autobiography. "He could take an ordinary script and make it come alive with his dramatic interpretation. I would write the script on the [illustration] boards as we went along, sketch in rough layouts and notations, and Jack would follow up by doing more

exact penciling."[15] Simon then lettered the balloons and inked the drawings, using a brush to make the task go faster. ("Brush work dried faster than pen," he explained.) Sometimes Kirby inked, too, depending upon the demands of their production schedules. And sometimes he even reinked pages that Simon had done, fussing with this effect or that. But he didn't like inking his own drawings: "If I ink it," he once said, "I would be drawing that picture all over again for no reason at all."[16]

Eventually, Kirby, having absorbed Simon's distinctive layout skills, took over most of the actual story production, plotting the story and penciling both script and pictures on the pages. Simon concentrated on the business aspects of their partnership; he was the business manager and the salesman, knocking on publishers' doors to get work. Simon inked when he could, but often they hired other artists to finish Kirby's work. Then, late in 1940, the team created the first of dozens of characters for which they are renowned: Captain America. The character was more than simply famous. In his history of the medium, Jim Steranko put it this way: "If Superman and Batman were the foundations of the business, Captain America formed the cornerstone of the industry."[17]

Captain America was a superpowered patriot, and the times were right for such a figure. Most informed Americans knew the country was headed for a showdown with Hitler's Nazi Germany sooner or later. "We weren't at war yet, but everybody knew it was coming," Kirby remembered. "That's why Captain America was born. America needed a superpatriot." The costume he and Si-

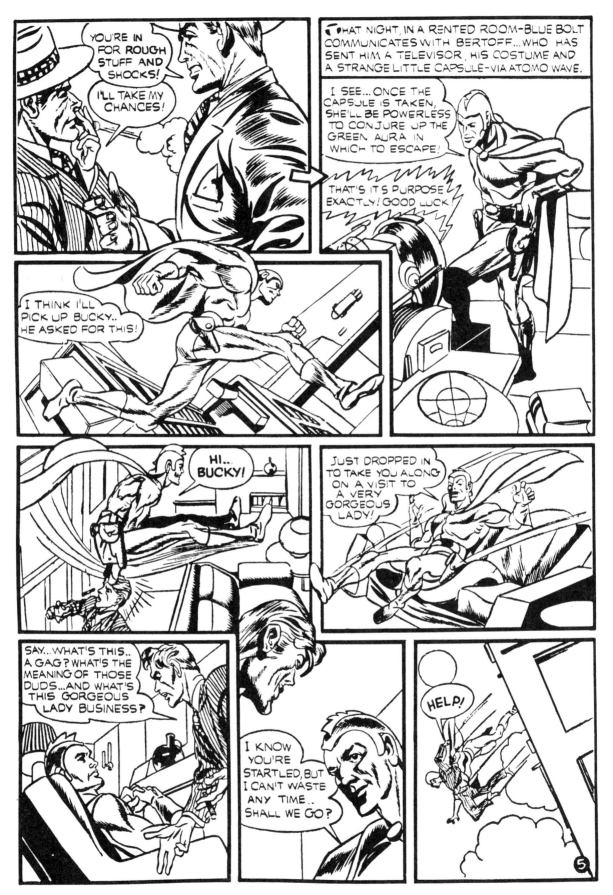

Figure 18. *The first comic book for which Simon and Kirby teamed up was* Blue Bolt. *Here, a page from* Blue Bolt *No. 9 (cover-dated February 1941) displays the graphic excitement that their layouts and energetic action sequences created. Notice the virtually continuous action from panel 4 to panel 5; and again through the bottom three panels. Compare the vitality of this page to the page in figure 16.*

mon devised stressed their purpose: "Drape the flag on anything, and it looks good," Kirby said. "We gave him a chain mail shirt and a shield, like a modern-day crusader. . . . He symbolized America."[18] Germany was widely suspected of having infiltrated the United States to sabotage manufacturing and transportation and communications. Captain America's first assignments thus involved battling saboteurs and fifth columnists; later, he would take on virtually the entire German army. Or so it seemed.

The impact of this new comic book upon other comic book artists was immediate and lasting. *Captain America* No. 1, cover-dated March 1941, burst on the scene like a skyrocket, illuminating possibilities until then scarcely dreamed of. Although it was the energy of his compositions that distinguished his work from most other comic book productions, Kirby was also a better artist than many of the worn-out hacks or aspiring young amateurs then scratching out stories. His command of human anatomy, for instance, was thorough and sure; as a result, he could draw the long underwear characters with real conviction from any angle the action demanded. And there was plenty of action.

In arranging for action to be much more continuous from panel to panel during fight sequences, Kirby said he "choreographed" those sequences as if they were ballets, creating what Gil Kane has called "lyric violence." To emphasize the energetic movement of his characters, Kirby said, "I tore my characters out of the panels. I made them jump all over the page."[19] His characters seem to ignore the panels, their limbs extending beyond the border lines. His figure drawings reek body English: they are contorted to emphasize movement, power, action. Even when simply poised for action, they seem tensely coiled in readiness.

In contrast to most comic book superhero action sequences of the day, Kirby's drawings reverberate with exaggerated movement. When Captain America strikes a foe on the jaw, Kirby drew the victim bent over backward, his feet lifted off the ground by the force of the blow. The point of the blow's impact is indicated by a star-burst of lines; the course of Captain America's fist, by an arc of parallel speed lines, the sweep of the arc emphasizing, again, the power of his clout. Kirby deployed the visual resources of the medium for effect; others tried for photographic fidelity to nature. To persuade us of the reality of their superheroes, they drew realistically, but in so doing, they failed to convey any sense of energetic action. In a real fistfight, a person who has been struck a blow to the jaw does not leap backward as Kirby's characters do; instead, his head jerks back and his body crumples to the ground. Artists aiming for realism would show the punched-out party mildly disarranged by the blow—his head turned to one side, say, or tilted backward. But in depicting the crucial instant, the instant immediately after the blow is struck, they drew the body still erect—beginning to sag into unconsciousness, perhaps, but scarcely flipping heels over head. And there's not much visual excitement in a picture of a crumpling body. But when Kirby showed Captain America striking a blow for freedom, the foul fellow he strikes is flung rearward across a page-wide panel, the narrow dimension of the panel underscoring with its shape the force of the blow.

Kirby multiplied the effect of his technique by putting Captain America and his young sidekick Bucky into combat with dozens of opponents at once. These scenes are mobbed with tumbling bodies, careening off furniture or into panel borders, and Cap and Bucky seem to be wading in disabled foes, up to their knees—even waists—in collapsed bodies. And the fights go on for a page at a time; in other comic books the fights last only a panel or two. Often, Kirby depicted his characters coming directly at the reader, bursting out of the page. Suddenly, you are face-to-face with the action. You are in it.

Kirby systematically sought ways to avoid monotonous drawings: "I would tip the perspective of a room to make it less static," he said.[20] He also shifted camera angles rapidly, selecting the most dramatic perspective for his pictures: a racing automobile, seen from under the front bumper, becomes a rocket, blasting ahead at full throttle, the thrust of the distorted perspective emphasizing the direction and speed of its movement. Simon's page layouts add to the impression of vigorous movement. The panels are irregularly shaped, the shapes often echoing the actions depicted in them. The panels of most other superhero comic books march across the pages in hypnotically regular cadence—every panel the same size, all arranged in uniform tiers. And within the panels, the action is usually seen from the same staid, straight-on angle, panel after panel—and often from the same

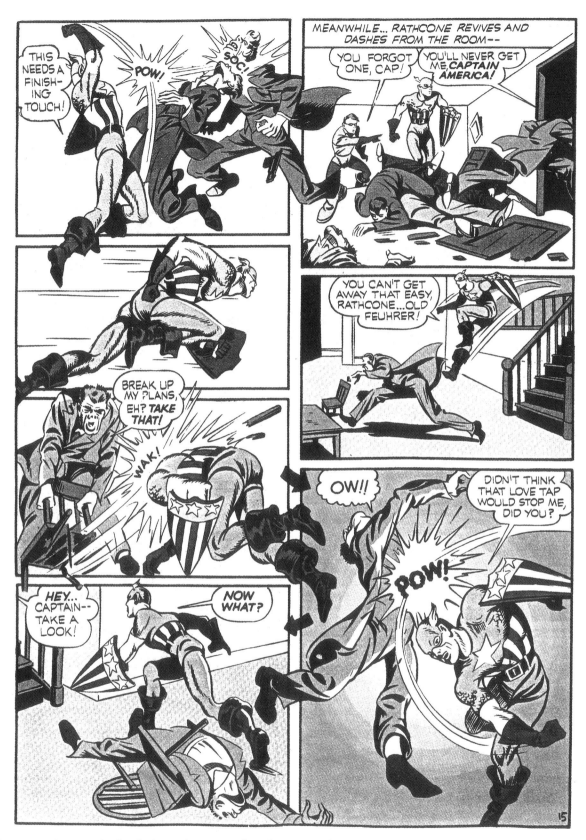

Figure 19. *This was the kind of visual energy Jack Kirby imparted to comic books when he and Joe Simon launched Captain America. (*Captain America *No. 1, March 1941)*

distance. The monotony is stunning. And the contrast to the Simon and Kirby pages is vivid.

As strikingly different as Kirby's visual techniques must have appeared to his contemporaries in the spring of 1940, his impact upon the way superheroes would henceforth be depicted resulted probably as much from the popularity of Captain America as it did from the vigor of the artist's style. Although there were few other artists in comics who could match Kirby's skill, there were some—Jack Burnley on Starman, for instance, and Crieg Flessel on the Sandman, and Lou Fine on the Black Condor. But none of these artists were doing a hero in red, white, and blue, pitted against the looming Axis from across the Atlantic. Kirby's character was pitched to the needs of the hour. In that time of national crisis and overheated passions, the superpatriot captured an audience immediately. Simon and Kirby did the first ten issues of *Captain America*, and because of the immense popularity of the title, their work was highly visible. That visibility over the course of almost a year guaranteed that Kirby's pacesetting work would be seen by his peers. And once they saw it, they could not help but imitate it: the excitement of Kirby's art is simply too persuasive. "Suddenly, after Captain America," Steranko wrote, "came a platoon of red, white, and blue spangled superheroes: American Avenger, American Crusader, American Eagle, Commando Yank, Fighting Yank; in stars and stripes, Yank and Doodle, Yankee Boy, Yankee Eagle, Yankee Doodle Jones, the Liberator, the Sentinel, the Scarlet Sentry, Flagman; in the same military moniker—Captain Flag, Captain Freedom, Captain Courageous, Captain Glory, Captain Red Cross, Captain Valiant, Captain Victory."[21]

Captain America set a new standard for the way comic book stories should be told, too. Superhero comic books that were produced after *Captain America* appeared were drawn differently. Some of the less skilled artists imitated Kirby so clumsily that they seemed unaffected by his work. But the competent artists enlivened considerably the action of their pages in the Kirby manner. At about this time, another cartoonist had begun to exert influence upon the artists who rendered superheroic adventure. Burne Hogarth, who had inherited the Sunday *Tarzan* strip after Hal Foster left in 1937, was drawing the human figure with such minute attention to musculature that his characters seemed flayed of the first couple of layers of skin. This treatment gave dramatic emphasis to the actions being depicted: Hogarth's characters, their muscles shown in bold relief, appeared to strain with the effort of their endeavors. The effect was to add a visual intensity to the drama of the narrative.

Thanks to Superman and to artists following Kirby's lead, comic books in the late thirties and through the forties became the province of superheroes. Under the spell of artists like Hogarth and Lou Fine (from the Eisner-Iger Shop and perhaps the finest figure artist to work in comic books in the early years), superhero comic books became showcases for figure drawing. And as these artists strove to depict as vigorously and continuously as possible the physical action associated with superheroes, the medium began to achieve something of its unique potential.

Superheroes and comic books were made for each other. In symbiotic reciprocity, they contributed to each other's success. Superheroes in comics sparked a demand for comics—and that demand created the need for original superhero material, written and drawn expressly for the medium. Comic books were the ideal medium for portraying the exploits of super beings. They were nearly the only medium at the time. You could write about superheroes in novels, or you could film their adventures. But neither books nor movies were quite up to the task of depicting superheroes' impossible feats. Books lacked the conviction, the authority and impact, of visuals. And in the movies, the incredible deeds of superheroes looked phony: the film technology of the day had not yet developed the sophisticated special effects necessary to give the celluloid images an authentic feel. But comic books made superheroics both palpable and probable. At the time, the adventures of Superman, Captain America, Captain Marvel, and their ilk could be recounted only in comics because only in comics could such antics be imbued with a sufficient illusion of reality to make the stories convincing.

To demonstrate the point, let me turn to a page from the Kirby oeuvre. Simon and Kirby created a number of memorable characters before they both entered military service in World War II—the Newsboy Legion and the Boy Commandos, for in-

Tarzan
by Edgar Rice Burroughs

DESPERATE COMBAT

BARRING TARZAN'S PATH TO THE WATERS OF THE OASIS STOOD A HUGE AND POWERFUL HYENA. THE APE-MAN HESITATED. SUDDENLY THE BEAST LEAPED FOR HIS THROAT!

THE APE-MAN DODGED--BUT NOT QUICKLY ENOUGH. THE SLASHING FANGS RIPPED A DEEP GASH IN HIS ARM.

BLEEDING PROFUSELY TARZAN BACKED AWAY. NOW THE APE-MAN WAS FACED WITH A DUAL DILEMMA.

TO SPEND HIS ENERGIES IN DIRECT COMBAT WITH THE BEAST MIGHT KEEP HIM FROM REACHING THE OASIS. YET, IF THE BEAST WERE NOT KILLED QUICKLY, THE FLOWING WOUND WOULD SAP HIS STRENGTH.

WITHOUT WARNING, THE BEAST SPRANG AGAIN!

THE JUNGLE LORD MET THE CHARGE HEAD-ON. HIS FINGERS CLOSED ON THE ANIMAL'S THROAT.

THE SNARLING HYENA STRUGGLED TO WRENCH ITSELF FREE.

IN HIS EFFORT TO RETAIN HIS GRIP, THE WEAKENED APE-MAN FELL HEAVILY.

Copr. 1945 Edgar Rice Burroughs Inc. - T.M. Reg U S Pat Off.
Distr. by United Feature Syndicate, Inc.

IN A FLASH THE BEAST WAS UPON HIM--SLASHING, TEARING HIS FLESH. TARZAN REACHED FOR HIS KNIFE.

WITH A SUPREME EFFORT, HE STRUCK ONCE, TWICE--AND THE HYENA LAY STILL.

THE APE-MAN ROSE UNSTEADILY. ON THE HORIZON, THE OASIS DANCED BEFORE HIS EYES. NOW HIS GOAL SEEMED HOPELESSLY DISTANT.

-CG-11-11-45

HOGARTH.

WEAKENED FROM LOSS OF BLOOD, UNUTTERABLY WEARY, HIS IRON WILL FORCED HIM TO GO ON--OR PERISH IN HIS TRACKS!
NEXT WEEK: THE OASIS

Figure 20. *Burne Hogarth's treatment of the human figure in* Tarzan *helped set the fashion for how musculature should be depicted in order to enhance the drama of physical activity. (November 11, 1945)*

Figure 21. *The action seems to burst out of the splash page for the first story in the first issue of Simon and Kirby's* Fighting American.

stance (both evoking memories of the Boy's Brotherhood Republic). And while perhaps the most historically illustrative sample of the Kirby corpus might be a page from *Captain America* or one of the other prewar titles, I've chosen instead a page from the first issue of *Fighting American* (cover-dated April–May 1954) as being equally pertinent to our present purpose. Not as highly regarded as some of his other creations or as exuberant visually, *Fighting American* nonetheless represents to me Kirby during one of his best periods, the fifties. *Fighting American* was among the last of the clas-sic Simon and Kirby collaborations—and, published in 1954, it represented a last gasp for Golden Age superhero comics, which entered about then the post-Wertham doldrums until the Marvel Age dawned in the early sixties.

In later years, Simon and Kirby both referred to *Fighting American* as a satire, but the satirical elements did not enter into it until after the first is-sue.[22] The first issue was straight superheroics. The origin tale introduces us to the brothers Flagg: Johnny, crippled war hero and crusading super-patriot newscaster, and Nelson, who does Johnny's

legwork and writing. Johnny's crusading has won him many enemies, some of whom finally do him in. But modern science revitalizes and strengthens Johnny's once powerful body and transfers Nelson's identity into it, thereby creating "the agent of the future"—Fighting American.

The page we'll look at comes from Fighting American's second adventure, in which he gains a young ally, Speedboy (otherwise a page boy at Flagg's radio studio and, curiously, altogether nameless save for his sobriquet when costumed). As the episode begins, Johnny Flagg (Nelson in Johnny's body) is about to dismiss as harmless a telephone threat against his life when he is attacked by a tiny guided missile, a "baby buzz bomb." The page boy, thinking the bomb a fly, swats it down—and it explodes. Alerted to the danger, Flagg takes a second phone threat more seriously. And well he should, as the page before us shows: he's soon assaulted by a swarm of baby buzz bombs (figure 22).

At first blush, there seems nothing particularly spectacular about this page. The layout is thoroughly competent but conventional. Verbiage, except for the tautology of panel 6's caption (oddly misplaced: it would be more appropriate in the preceding panel), is kept to a minimum. Word and picture blend in panels 1 and 3; the visuals enhance the significance of Fighting American's remarks in panels 5 and 7; and the exchange in panel 4 keeps the plot moving forward even as Fighting American sheds the last of his mufti. For the most part, the story unfolds chiefly in the pictures—appropriately enough for an action sequence.

But narrative breakdown, while not striking in the effects produced, is nevertheless artfully constructed to impart to the sequence a powerful sense of movement. Every key moment in the action is depicted: Flagg hangs up the phone, leaps out of the bomb's way, begins to strip to his Fighting American costume, poises himself for the next move, grabs Speedboy and lunges toward the window, plunges out, and lands on a desk below. (How, exactly, he gets into an office in panel 7 after having apparently left the building in panel 6 is another matter. But happily we're discussing movement, not logical consistency.) The action is nearly as continuous as possible, short of full animation.

Panel composition also enhances the impression of headlong action. Camera angle shifts rapidly

through the first three panels; distance, in the first two. The camera angle of panel three is maintained through the next two panels, and the consistent viewpoint we are forced to assume makes rapid comprehension of the action easy. Because we spend no time orienting ourselves to each successive scene, the scene itself becomes a constant—an unchanging "stage" across which the actors move—and our attention is thus focused on the moving figures, portrayed throughout in an easily recognizable, full-length manner. The direction of Fighting American's leap in panel 5 is continued through panels 6 and 7, adding a sense of continuous momentum to the act. Camera angles in the last two panels place us almost in the path of Fighting American's trajectory, dramatically increasing our sense of involvement. And because language is used sparingly (except, perhaps, for panel 4), nothing we see diverts our attention long from the colorful images before us.

Although this page is probably not a perfect example of why superheroes and comics belong together, it nevertheless goes a long way toward supporting that contention. The visual excitement of the art (energetic figures, dramatically shifting camera angles, bright colors) underscores the hurtling action. And the absence of wholly continuous action (the province of film)—the gaps, as it were, between the panels—actually works to create the impression of vigorous activity: the key moments of action that are depicted come at us in explosive bursts. Much that happens here is, if not entirely impossible, highly improbable. Bombs go off so cleanly that the stage is left with little clutter to interfere with our perception of the main action. Flagg strips off his clothes effortlessly; we don't worry about a recalcitrant button or zipper. Fighting American explodes out of the window—a flying missile, not a falling body. And when he lands, he is so impervious to hurt that he can wisecrack amid the wreckage.

Fighting American's flip remark in the last panel is an interesting study in impossibilities. When does he speak? The conventions of the medium allow three possibilities—each an instant apart: just before he lands, as he lands, or just after. In any of those circumstances, the sound of falling glass and timber would, in film and in real life, drown out his words. But not in the comics. In the comics, word and picture can be coupled to reveal the hero's cheery bravado even in the very midst of

Figure 22. *An analysis of the action on this page from* Fighting American *demonstrates (among other things) how perfectly suited to comic books are stories relating the adventures of superheroes.*

thundering action, collapsing buildings, or stampeding elephants.

Realistic rendering helps make it all seem possible, and Kirby's skillful deployment of the medium's resources makes the action so exciting that we overlook the impossibilities. We can't help concluding that superheroics are possible—but, we must add, only in the comics.

SUPERHEROES FELL OUT OF FAVOR somewhat in the years immediately after World War II. Many of the wartime superheroes had been superpatriots in the Captain America mold; without the war to fight—without the super villainies of the Nazis and the Japanese—readers doubtless no longer felt much psychological craving for that kind of champion. Whatever the cause, the number of superhero titles declined sharply in the postwar years. During the war, 90 percent of the DC titles had been superheroes; after the war, that percentage declined to two-thirds; then, by the end of the decade, to about 50 percent.[23] In the same postwar period, publishers were clamoring for comic book material. Wartime rationing of paper had stemmed expansion during the hostilities; now that paper was again available, the publishers wanted to cash in. Although superhero titles continued to be produced, comic book makers began concentrating their efforts on other subjects that promised to generate greater sales.

The search for new best-sellers resulted for a time in a great variety of comic book titles. Publishers lofted trial balloons all over the horizon, concentrating first on one subject, then on another. And as soon as one type of comic book looked to be successful, everyone jumped into its gondola and produced a flotilla of similar titles. Humorous comic books featured the antics of teenagers and animals; Westerns and stories of cops and robbers received serious treatment. As the decade drew to a close, romance and crime comics began to dominate the newsstands. Simon and Kirby launched the romance comic book genre with their *Young Romance* in the summer of 1947 (cover-dated September–October). The idea had its seeds in the humorous comics about teenagers, who were always contending with members of the opposite sex. The Simon-Kirby innovation was to treat romance seriously; their stories were told in the first person by one of the principals in the manner of a "true confession" (to invoke the name of one of the popular magazines of the day).

The pacesetter for the crime titles was undeniably Lev Gleason's *Crime Does Not Pay*. Observing the newsstands loaded with magazines like *True Detective*, *Official Detective*, and *Master Detective*, Gleason had decided to start a comic book focusing on "true stories" of criminals about a year after he became partners with Arthur Bernhard. Bernhard had published his first comic book, a superhero title called *Silver Streak*, in December 1939. In the summer of 1941 (at about the time Gleason joined the firm) Bernhard started a second comic book; it starred a character who had become popular in *Silver Streak*, Daredevil. (This Daredevil is a boomerang expert in a blue-and-red costume with a spiked belt—not to be confused with the blind lawyer with a miraculous radar sense introduced a quarter of a century later by Marvel Comics.) A year later, *Silver Streak* was discontinued altogether, and Gleason launched *Crime Does Not Pay* in its place (even beginning with No. 22, *Silver Streak*'s next number).

Cartoonist Charles Biro had joined the Gleason-Bernhard enterprise in 1941 to produce and edit *Daredevil*. And he took over the crime comic book, too, as soon as Gleason described the concept to him. It was a propitious assignment. Biro, whose drawing talent was adequate but not remarkable, turned out to be a writer and editor of acumen and a promoter with a distinctive flair for selling four-color fantasy. The Gleason line of books was one of the smallest on the newsstand, but in many respects it was the most distinctive. In addition to *Daredevil* and *Crime Does Not Pay*, the company produced *Boy Comics*, starring the young athlete Chuck Chandler, who became better known as Crimebuster. Biro designed covers that were tantalizing and provocative. Action-packed and gory, they were successful in seducing people to part with their dimes, Ron Goulart says, "because they dealt in giddy *anticipation* of a violent act rather than in a depiction of the act itself."[24] To see what happens, you had to buy the comic book. By the end of the war, the three titles together were selling so well that they established Gleason as a major comic book publisher.

Under Biro's guiding hand (initially, he drew the stories as well as writing them), the books emphasized characterization, and the stories had a strong

Figure 23. *Typically, Lev Gleason's crime comics retailed the life stories of criminals, tracing their paths to power. This narrative maneuver made the criminals the protagonists of their stories, in effect transforming them into "heroes." (*Crime Does Not Pay *No. 127, October 1953)*

moral thread stitched into their fabric. Called "illustories" rather than comic books (an interesting portmanteau coinage that is as descriptive of the hybrid medium in its binomial construction as it is in its connotation), the Gleason titles derived their drama as well as their morals from character development. It was a storytelling technique that would pave the way to the downfall of the crime comic book. In fashioning his "true stories," Biro focused on individual criminals, and in tracing their lives of crime, he showed not only how they became crooks in the first place but what undesirable human beings they became in consequence. The moral lesson was implicit in the career of the criminal—in his increasing depravity—as well as in his fate, his ultimate defeat at the hands of the law.

And Biro made sure his readers wouldn't miss the point. Every story began with a long prose introduction that sermonized on the lesson it would teach: "This is the story of the violent and bloody career of Les Everhurd. He died as he had lived—a

mad, ambitious enemy of society." And so on for another forty words. And at the end of the Everhurd saga, we read: "Who can tell what the driving force behind Everhurd was? Was it greed for money or power or bitter hate for society and its authority? Whatever it was, it still stands as a lesson to those who might contemplate a career of crime."[25]

This strenuous moralizing was just barely enough to temper the dramatic power of the stories themselves—the pages of brightly colored action drawings. The pages that concentrated on the crook. But in the hands of many of Biro's imitators, the moralizing became muted, and the lessons were lost amid the turgid excitement of headlong lawless action. The apparent newsstand success of *Crime Does Not Pay* encouraged imitation in the postwar scramble for something that would sell as well as superhero titles had during the war. And imitation bred excess, as each copycat tried to outsensationalize the others.

Simon and Kirby were among the first to take Biro's book as inspiration. In the winter of 1947 they revamped *Headline Comics*, converting it, as of the March issue, from a collection of stories about boy heroes to an anthology about the deeds of gangsters and murderers. In their restraint on matters of violence and sex, Simon and Kirby were the exceptions rather than the rule. Everyone else, it seemed, tried to outdo the Gleason title. In the increasingly frenzied search for new and more sensational spectacles, the moral content of the crime comics was soon eclipsed by blood and bosoms. The undermining flaw in the crime comic book design—namely, the genre's narrative technique—emerged more and more clearly. As the protagonist of the tale, the outlaw stood in the narrative spotlight traditionally occupied by the hero of a story. Hence, by this storytelling maneuver, the crook became the ostensible hero. And by implication, the crook's career became "heroic," and the life of crime was held up—however unintentionally—as worthy of admiration. This unintended by-product of the narrative method fueled the argument against comics that was being advanced in the postwar years by a psychiatrist named Fredric Wertham and others.

Comic books had been under attack almost from the beginning. Printed on cheap paper in garish colors and often not drawn very well, comics appeared to be crude and vulgar and therefore not fit for consumption by their intended audience, chil-dren. But the earliest of these anti-comic book fulminations fell, for the most part, on deaf ears. After the war, though, the country experienced a startling rise in crimes committed by young people. The term *juvenile delinquent* came into the language. The public, disoriented by fear of communism and by alarm at the tattered state of the postwar American family, was looking for a scapegoat. And comic books fit the bill. Wertham was not the only one crusading against comic books, but he was perhaps the most persistent—and as a psychiatrist, he had the best credentials. His 1954 book, *Seduction of the Innocent*, claimed to be based upon scientific research. Its science is extremely suspect, but its message is clear: crime comic books glorified a life of crime, and publishers should not be permitted to produce such publications. And when Wertham said crime comic books were "primers" for crooks, teaching how to rob and kill, he had only to point for substantiation to stories that detailed how their criminal protagonists has risen to the top of their profession.

And the comic book industry was guilty of other sins, too, according to Wertham. The way women were drawn, for instance, was salacious and unwholesome. Given prominent physical sex characteristics, comic book women fueled adolescent sexual fantasies, inflaming appetites to a probably uncontrollable degree. Wertham's catalogue of threats to the mental stability of the young is much longer. It includes the famous insinuation that the relationship between Batman and Robin is homosexual, for instance, as well as allegations of racism and sexism. There was enough truth—that is, enough half-truth—in his diatribe to make a case that was convincing to adults not familiar with comics. But he made his strongest arguments by using crime and horror comic books as examples of unsavory entertainment for the young.

The earliest comic book of horror stories was probably *Adventures into the Unknown*, first published by the American Comics Group in the fall of 1948. These were tales of eerie events and ghosts and goblins and other creatures of the supernatural night. At first, nothing much came of this single title's foray into the terror-fraught world of the paranormal. But by the time Bill Gaines and Al Feldstein began telling horror stories in EC Comics in the spring of 1950, the season was ripe for the genre. In horror and crime comic books,

the industry had at last found a winning substitute for the superpatriot titles of the war years. We'll take a longer look at EC Comics and the birth of horror comics in chapter 6. Here, suffice it to say that EC and its legions of imitators gave Wertham and his adherents all they could have hoped for. Virtually every publisher produced a horror title sooner or later in the early fifties. Even Simon and Kirby joined the crowd—with *Black Magic*, starting in October 1950. The newsstands seemed glutted with crime and horror comic books. Parents became increasingly alarmed. The cry to ban comics grew louder.

To forestall government censorship, comic book publishers banded together and created the Comics Code Authority to establish and enforce stringent regulations about what could not be printed in comic books. These new commandments forbade showing any authority figure (police, politicians) as corrupt, any female generously endowed, any methods by which criminals operated, and so on. Blood and gore and violence were prohibited in virtually any form. So were stories about the walking dead or brutal torture or "unnecessary knife and gun play" or physical agony or gruesome crime. Specific words were proscribed as titles of comic books—"weird," "crime," "horror," or "terror."[26] Funded by assessments against the member publishers, the CCA set up shop with a small staff of readers. Every page of every comic book submitted for the CCA seal of approval was read and approved by these readers while in the final art stage, just before going to the printer.

Distributors were reluctant to carry any comic books not bearing the CCA seal. Without distributors to get titles to the newsstands, publishers faced certain extinction. Many stopped publishing comic books altogether. In 1952, according to Goulart, about five hundred comic book titles "fought for attention on America's newsstands." By 1955 that number stood at about three hundred. "The monthly sales of Lev Gleason's titles fell from 2,700,000 in 1952 to around 800,000 in 1956."[27] DC and Marvel were similarly affected. EC Comics, most of which used forbidden words in their titles, simply disappeared from existence. Companies that continued to publish comics produced pablum, since only the most innocuous kinds of stories could pass muster with the CCA censors. As an art form, the medium languished: the strictures of a censored medium are not con-

ducive to creative experimentation. The boom years were clearly over. Television, which became a nationwide medium in the mid-fifties, was partly responsible for the decline of the comic book industry. But the anti-comic book crusade had played a large role in the demise of the business, too.

For a few years, a spate of comic books based upon television shows flooded the newsstands with undistinguished work. Then, in the spring of 1960 at DC Comics (then called National Periodical Publications, the publishing oak that had grown out of Nicholson's acorns), editor Julius Schwartz made a fateful decision. Schwartz had engineered a revival of interest in superhero comics by refurbishing two of DC's oldest characters, the Flash and the Green Lantern (in 1956 and 1959, respectively). Seeking to extend his winning streak, Schwartz decided to launch a new title in which several superheroes would act as a team. From a marketing point of view, the plan seemed relatively risk-free. First, in teaming several superheroes, it repeated a popular device from the forties; what sold well then might just sell well again. Secondly, by putting several superheroes on the cover of the magazine, Schwartz avoided gambling on the popularity of a single character to sell the comic book. *The Justice League of America* (cover-dated October–November 1960) confirmed Schwartz's instincts: it sold well.

Over at Atlas Comics (once Timely Comics, soon to be Marvel Comics), publisher Martin Goodman directed his editor, Stan Lee, to come up with something akin to the Justice League in order to cash in on the apparent resurgent interest in superheroes. And Stan Lee turned to Jack Kirby.

Kirby had been working with Lee since late in 1958, when the company had been near death's door. Kirby had come to the office looking for work. "I came in, and they were moving out the furniture," Kirby recalled. "They were taking the desks out. I had a family and a house and I needed work, and Atlas was coming apart! Stan Lee is sitting on a chair crying. He didn't know what to do. I told him to stop crying. I said, Go in to Martin and tell him to stop moving the furniture out, and I'll see that the books make money. And I came up with a raft of new books, and all these books began to make money."[28] These were what Kirby called "the monster books"—*Strange Worlds*, *Tales to Astonish*, *Tales of Suspense*, all stories of

the supernatural featuring creatures from outer space. He also contributed to the company's string of westerns, *Kid Colt Outlaw*, *Gunsmoke*, *Rawhide Kid*, and *Two-Gun Kid*. It was a busy time for Kirby.

In the winter of 1960, charged with creating a new team of superheroes, Lee says he conjured up "the kind of characters I could personally relate to; they'd be flesh and blood, they'd have their faults and foibles, they'd be fallible and feisty, and—most important of all—inside their colorful, costumed booties, they'd still have feet of clay."[29] Then, he says, he wrote "a detailed first synopsis for Jack to follow" and gave it to Kirby, who went off to draw the inaugural adventures of the Fantastic Four. The result was a team of superheroes like the Justice League but with a crucial difference: they had individual personalities, flawed like everyone's, and they bickered and squabbled amongst themselves.

Kirby's version of the act of creation is somewhat different. In fact, he maintained that Lee had very little to do with concocting this distinctive new breed of superhero. The two men had developed a unique way of working together, a method that had the dubious benefit of permitting each to claim creator's credit. Lee would give Kirby a plot outline—often little more than an oral précis. Then Kirby, according to Lee, would "draw the entire strip [the comic book story], breaking down the outline into exactly the right number of panels, replete with action and drama. Then it remained for me to take Jack's artwork and add the captions and dialogue."[30] Who, then, created the story? Lee could claim he did: he invented the plot and added the necessary explanatory verbiage at the end of the process. Kirby could claim he did: not only did he give the plot and the characters a graphic reality, he (in Lee's words) provided the action and drama. Neither man is lying, or even stretching the truth. Both men are entirely correct.

Their manner of producing comic books was quickly institutionalized. Lee adopted the same procedure when working with other artists who succeeded Kirby on some of the new titles that soon came pouring out of Marvel. The method had perhaps been the invention of necessity: only in this way could Lee and his stable of artists crank out enough product to keep the sales of the new comic books soaring.[31] Assuming that Lee did, in fact, supply his artists with rough plots, he effectively delegated to them the task of fleshing out

story ideas, which saved him hours of work over a typewriter. He could then use the time he saved to script dialogue and captions for the pages of narrative artwork that his artists turned in. The result was a high rate of production. And there was another benefit.

The so-called Marvel Method, whether by design or accident, had the virtue of putting the control of storytelling into the hands of the artists, who tended to tell stories pictorially rather than verbally. For comic book artists like Gil Kane, this approach was the only approach that made any sense. "I've worked from scripts," Kane said, "but the most freeing experience I've had, other than working from my own scripts, is to write according to the technique that Stan Lee and Jack Kirby worked out, which was talking over a plot line with the writer and then laying out the entire story dramatically, and afterwards the writer comes in and puts in the copy. I find that for me that is the most satisfying thing. I'm rarely in agreement with a writer. In fact, it's ridiculous that the first one to approach a white, unmarked page is the writer and not the artist, or that the writer makes all determinations on how the page is cut up and everything else."[32]

"[The Marvel Method] is the best thing in terms of writing and drawing and effecting a balance," Kane elaborated on another occasion. "Just like a writer and a director get together when they are going to do a [movie] and discuss it, the point of view and the approaches and then begin a basic story line. It's best now, to do it that way, to turn out an outline, give that outline to the artist after it's already been discussed. And the artist then dramatizes it. That's what the artist is: he's a dramatizer. If the writer is in effect a structurer, the artist is a dramatizer, a storyteller. And after he's then interpreted this structure that they have both agreed on, then the writer comes on and he's able now to second guess. That means he's able to take advantage of dramatic situations that are fully developed [by the artist/dramatizer]. And I think without question that the [resulting] writing is infinitely more spontaneous, more varied, more effective than it ever could be if the writer just sits down and just types out 'panel one, scene one' and dictates the thing right from the start. And the artist is merely an instrument—and not an instrument that has any choices or alternatives. [Under that circumstance] he has this straitjacket that he

has to work with, this script, which doesn't anticipate transitions, quick cuts. It doesn't anticipate a visual interpretation because if it did, then they would do storyboards, they wouldn't do script."[33]

Working in the Marvel Method, artists did more than give the characters facial expressions and body language: they created the narrative breakdowns and layout, thereby determining the pace of the story and the visual emphases—and with that, the essential action and drama of the stories. In theory. In practice, it didn't always work that way. As other writers joined (and then succeeded) Lee in plotting and scripting stories, they found themselves less content with his makeshift method: sometimes the artists did not produce the visual effects the writers had imagined they would. And what they did produce "ruined" the writers' concepts for stories. To correct these "errors," as I observed earlier, writers heaped expository prose onto the pages, weighing the action down with verbiage. Still, the Marvel Method, for a time (Kirby's time at any rate), restored some of the visual-verbal balance that the enthronement of writers elsewhere in the industry had threatened for years.

Although Kirby once denied outright that Lee did any writing at all on the features they created jointly—saying, instead, that he, Kirby, devised the stories himself and wrote the dialogue and captions on the backs of the illustration boards—he may have been exaggerating.[34] At the time, he was involved in an arduous effort to retrieve his original artwork from Marvel—a complicated, painful, and acrimonious endeavor. And when he was pressed about Lee's role in creating what eventually became known as the Marvel Universe of superheroes, Kirby claimed the credit. Lee, according to Kirby, did nothing but supervise production and schedules and the like.

Since each of the principals directly contradicts the other, we will probably never be able to resolve the matter by relying exclusively on their testimony. The truth, as is the case in most disputes of this kind, doubtless resides a little in each camp. My guess is that Kirby did more plotting and character creation than Lee cares to admit; Kirby probably did some writing, too—scripting speeches and captions—particularly when the new line of comics began to sell and the team had to produce more and more books faster and faster to meet the demand. But Lee's colorful command of language is his own, not at all like Kirby's way with words:

the distinctive Marvel lingo was undoubtedly furnished by Lee. His role, however, was essentially that of verbal embellisher (lyricist, as Gil Kane put it). In my view, Kirby was the creative force of the team.

On his own behalf, Kirby once pointed out that Lee didn't create very much of anything after he, Kirby, left Marvel in late 1970. And that's true. Lee's highly touted creative period occurred entirely while Kirby was in the Marvel bullpen. Kirby, on the other hand, went on to create singlehandedly the highly imaginative Fourth World series of titles for DC Comics in 1971—a heroic science fiction mythology about gods fighting gods that he then plotted, drew, and scripted for two years. Kirby's lifetime record fairly teems with characters and concepts he created. And when it comes to the Fantastic Four, the astonishing first of the new generation of superheroes—the characters that would change the nature of superhero comics—they are more likely Kirby's creations than Lee's. Everything in Kirby's career suggests that the invention of this aggregation of idiosyncratic albeit heroic personalities was but the latest step on a path he had followed most of his professional life.

With the Fantastic Four, Kirby was revisiting familiar ground. He and Simon could almost be said to have specialized in fabricating teams of heroes for comic books. Their first such venture had been *Young Allies* for Timely Comics in the summer of 1941; the book featured a gang of kids who tagged along with Captain America's sidekick, Bucky, providing a juvenile chorus for his deeds. Then came the Newsboy Legion, which debuted in DC's *Star Spangled Comics* No. 7 (cover-dated April 1942). Spotlighting a gang of so-called bad kids from the mean streets of New York who make good when the adult world is apparently stacked against them, the Newsboy Legion was reminiscent of the Boy's Brotherhood Republic of Kirby's youth, as I said before. But the series was part of an even more visible boy gang phenomenon. Beginning in 1937, Hollywood had produced a series of movies based upon Sidney Kingsley's Broadway play, *Dead End*, in which Leo Gorcey, Huntz Hall, and others played canny slum kids. The Dead End Kids movies emphasized a youthful display of camaraderie, street-smart wisecracking youths, and, in the best American tradition, the eventual triumph of the underdog. (The movie series went by several

Figure 24. *Throughout his career, Kirby had worked with teams of characters—like the Boy Commandos pictured here, a World War II creation.*

names over the years, finishing with a twelve-year run as the Bowery Boys in 1958.) When Simon and Kirby asked themselves what would happen if the Newsboy Legion went to war, the Boy Commandos resulted.

Appearing first in *Detective Comics* No. 64 in June 1942, the Boy Commandos eventually graduated to their own title. The significant thing about the group, however, was that each of the boys came from a different Allied country: Alfy was from England; André, from France; Jan, Holland; and Brooklyn, from the United States. And each boy's personality reflected something of the national character associated with his place of origin. With his derby hat and accent, Brooklyn—not surprisingly (given Kirby's background)—was the most picturesque of the troupe. The boys would be reincarnated again in *Boys' Ranch*, a Simon and

Kirby offering we'll look at more carefully in chapter 10. And in that, it is Wabash, a Southern kid with the physiognomy of Brooklyn, who is the most distinctive of the youths.

In late 1956 Kirby was again working for DC Comics. He was now a solo act. Simon still worked with him on *Young Romance*, but comics, for all intents and purposes, were no longer his principal livelihood. At DC, Kirby worked on "monster and superstition" titles, *House of Mystery* and *Tales of the Unexpected*, and then created a concept for a continuing series. This was *Challengers of the Unknown*, another team adventure title. Beginning in *Showcase* No. 6 (cover-dated February 1957), the team consisted of four adults: Professor Haley, a scientist and skin diver; Ace Morgan, a fearless jet pilot; Rocky Davis, an Olympic wrestling champion; and Red Ryan, a cir-

cus daredevil, the youngest of the quartet and something of a hothead. They had all survived a plane crash, and, feeling that they were living on borrowed time, they agreed to take on any assignment, particularly those involving unknown dangers. As before, Kirby enlivened the tales he told by making his protagonists as interesting—and as human—as possible. And that meant they weren't perfect. "Perfect heroes are boring to the reader," Kirby said; "they've got to have human frailties to keep the story interesting."[35]

In the Fantastic Four, then, Kirby can be seen continuing an endeavor that he had been improving upon since before the war. He gave his heroes distinctly different personalities, and he gave his stories an extra dimension by having those personalities rub up against each other, sometimes creating friction of a sort superhero comics wholly lacked.

Published in 1961 (cover-dated November), *The Fantastic Four* comic book revitalized Goodman's business, becoming the foundation for the Marvel Comics Group. When the title sold, Kirby created other new characters, including the X-Men, whose popularity was destined to outstrip that of all the others and to set a new fashion for superhero teams. But all of Kirby's new characters were based upon the now-proven premise that superheroes were people too, and they should have distinct personalties as realistic and quirky as those of their readers. After the Fantastic Four came the inarticulate Hulk, brute strength incarnate; then the Norse thunder god Thor, an early manifestation of Kirby's fascination with gods. (And in the meantime, Steve Ditko was collaborating with Lee on Spider-Man, a teenage superhero riddled with adolescent angst, and Doctor Strange, a magician who strays into the supernatural.)

While Kirby was plotting and drawing (sometimes working from Lee's ideas; sometimes, we suppose, not), Lee secured a place for himself in the history of comics by scripting Kirby's creations, lacing the editorial pages as well as the captions with outrageous alliterations and unabashed hyperbole. Lee's was no small accomplishment: his extravagant verbal gyrations gave the books a tongue-in-cheek tone, and this attracted a new readership. Kirby created the visual excitement— the characters and the adventures; Lee created the marching minions of Marvel fandom.

Their combined effort bordered on mocking the very genre Kirby had helped to create before World War II. As it turned out, it was an approach that appealed to an audience older than the traditional comic book readership—namely, college students. This broader, more mature as well as more articulate readership eventually formed itself into a network of fans that became a viable market that fostered economic growth that, in turn, nurtured creativity in the medium. It began with readers of Marvel and DC Comics writing letters to the publishers about their favorite characters—and about errors in science or fact or continuity that they had spotted in the latest issues of their favorites. When the letter writers began writing to one another, the network began to form. Some fans started publishing newsletters, and some of the newsletters metamorphosed into saddle-stitched magazines. In the spring of 1961 Don and Maggie Thompson produced the mimeographed *Comic Art*, arguably the first "fanzine" to be devoted to all areas of cartooning—strips, books, animated cartoons, political cartoons. About the same time, Jerry Bails and Roy Thomas published *Alter Ego*, which concentrated on the superhero in comic books.

The natural impulse to meet and talk with a pen pal resulted eventually in the first comic book conventions. In April 1964 Robert Brosch convened a gathering of fans of comics, science fiction, and movies in a downtown Detroit hotel. His effort was continued the next year by Jerry Bails and Shel Dorf, who christened the event the "Detroit Triple Fan Fair." (Later, in 1970, Dorf took what he had learned about media fan conventions and founded the San Diego Comic Convention, destined to become the nation's largest such event.) In the summer of 1964 another convention for comics fans was conducted in New York by a fellow named Bernie Bubnis, who also coined the term "comicon." A network such as now existed commanded some modicum of respect among publishers: it sometimes seemed that there were almost enough such fans to constitute a buying public whose purchases alone could assure the success of various comic book titles. Then in the mid-1970s a Brooklyn school teacher set out to prove the validity of that supposition. Phil Seuling, one of the pioneers of comic book conventions, now proposed a daring marketing departure to Marvel and DC. What he proposed became known as the direct sale market, and it revolutionized comic book publishing.

Figure 25. *In this self-portrait, Kirby surrounds himself with characters he did while at Marvel Comics.*

Until the direct sale shops came into existence, comic book publishers had sold their wares through national distributors of magazines and periodicals. Stores bought their publications from the distributors at a discount—say, 60 percent of the cover price. But if a store didn't sell all of the copies of a particular title it had purchased, it could return the unsold items for credit against their next order. Because the sale of periodicals is time-bound—that is, this month's issue is theoretically outdated by next month's issue—there were always a number of unsold copies at the end of the month. The market was wholly unpredictable: in order to realize a sale of 130,000 copies of a comic book, a publisher might print 250,000 copies. Perhaps half of the print run would never be sold, and the unsold copies were, by agreement, destroyed as an act of good faith to assure the publisher that he had received all the revenue that a given issue could produce. (No copies, in other words, were

being sold under the counter after the retailer had been credited with the returns.) But with the growth of a fan market, a demand for back issues had developed. Seuling's idea depended upon the vitality of that demand.

The idea was this. If the publisher would agree to sell directly to stores at a greater discount off the cover price than they would receive through a distributor, then the stores would forfeit returns for credit. If they didn't sell all of a month's title, they'd store them for eventual sale to buyers of back issues. The deep discount and the interest in back issues made the plan economically feasible for retailers. The advantage to a publisher was that it would no longer be necessary to print 250,000 copies of a title in order to sell 130,000 of them. Moreover, once the network of direct sale shops was in place, publishers were able to solicit the shops in advance of the publication of all titles and then set print runs based upon quantities ordered.

The direct sale shops made comic book publishing a money-making venture again. Since publishers no longer had to risk investment in gigantic print runs half of which routinely never sold, they had more financial resources to devote to developing titles that would appeal to the fan market—which, by the mid-1970s, was extensive enough to support the industry almost without general newsstand sales. Before long, many titles were available only through the direct sale network. And many of those, as we'll see anon, were extremely individualistic artistic statements. The prospect of realizing a reasonable financial return on a relatively small investment stimulated the formation of several small publishing houses, often called "alternative publishers." And the more publishers, the more outlets for creative expression. With a ready market for relatively personal works and a growing number of publishers willing to publish such products, the comic book industry became receptive to artistic enterprise as never before.

It is perhaps not too wild a speculation to say that all of this can be traced to Jack Kirby's inspiration. It was he who laid the groundwork for superheroes with human rather than archetypal personalities. And superheroes with human failings attracted—and held—an older audience, and that continuing interest led to direct sale comics shops as well as adult readership.

The success of the revitalized superhero comic books at DC and at Marvel assured the supremacy of superheroes in the four-color format. Before too many years had passed, the two major companies were producing no other kinds of comic book. No more monster tales or TV-based books. Not even, after a while, any westerns (the last of the vintage genres to fold). At the dawn of the 1980s, everything was superheroic, and nothing was anything else. By the end of the decade, that would change. But before we glimpse that development, let us prolong our examination of how storytelling works in the comic book format. To do so, let me turn to a selection of efforts in the nonsuperheroic mode, a selection that incidentally reveals something of the evolution of storytelling techniques from the late forties to the early eighties.

CHAPTER 3
The Search for Art and Meaning
Westerns and the American Spirit

Superheroes flourished in comic books because they were the only medium in which the fantastic spandex exploits of these characters could be convincingly depicted. But, as we have observed, the four-color world of the forties and fifties was not exclusively the province of superheroes clad in brightly colored tights. At the corner drugstore, the magazine racks overflowed with a wild profusion of different types of comic books. There were jungle books, romance books, funny animal books, funny kid and funny movie star books, cops and robbers books, books of comic strip reprints and books of horror stories, space adventure books, and war story books. It was the Golden Age of the comic book, and it was probably called the Golden Age because it glittered with the rich variety of its material. Conspicuous in those days among the hordes of titles were the ones about cowboys and Indians. Westerns. That Westerns bulked so large in the medium should not be surprising: the Western embodies the mythic archetype of the American spirit. It is therefore meet and right that a medium as popular and as distinctly American as the comic book should include a healthy helping of Western titles. What is surprising about the Western genre of the comic book is that it so completely disappeared in the 1980s. Or did it? Let's take a look.

Before we examine a page or two from a few comic books belonging to this vastly neglected genre (pausing along the way to admire the accomplishments of some vastly overlooked artists of the Golden Age while also observing something about the evolution of storytelling styles), let me hesitate on the brink of inquisition to explain why I persist in drooling analytically over rude charades of bruising action instead of contemplating, say, a quiet sequence of panels depicting a heated philosophical discussion between two well-dressed fashion models. Clearly, we are more likely to be spiritually and intellectually uplifted by philosophical fashion models than by brawling cowboys. But spiritual levitation is the province of the other departments of scholarly endeavor. Let others better suited to the task scrawl volumes in appreciation (or deprecation) of comic books as literature, comic books as film, comic books as great philosophical drama. Here, we'll just look at the pictures. We'll stare and we'll meditate. And we'll do so in the passionate conviction that comics are a visual medium—a conviction that leads us to the conclusion that whatever stories are told must be told by the pictures in tandem with the words. Huddled together here for shelter against the acid reign of literary criticism in evaluating comic books, we gaze fixedly at the pictures to see how a sequence of images can be manipulated to enhance visually the dramatic values in a story.

If we ignore the absence of great uplifting themes in the tales told in most comic books, it's not because there can't be such themes: it's because there aren't many. Faced with this yawning void where there could be philosophical purpose and other assorted haute couture, we may as well explore the potential of the medium for telling stories, thereby snatching some significance from the maw of vacuousness. And if I focus with unseemly fascination on scenes of throbbing action, it's because a visual medium is well-suited to depicting action. Fact is, action sequences are best depicted visually. Comic books can, of course, do more than tell stories that are merely fistfights, but scenes of action show more vividly than other kinds of scenes the sequential nature of the medium. In such scenes we can often discern the medium's capacity for giving dramatic emphasis to its stories through skillful deployment of the visual content. And that is not all we can find. In discovering such endowments, we may also find art where we thought we'd see only craft. And where we find art, we might also find meaning, perhaps even philosophy.

And now, if I haven't wearied you with this perversely circular rhetoric, let us admire a nugget or two from the Golden Age of comics, beginning with a page from *Tomahawk* No. 33 (cover-dated July 1955). (I know: I promised Westerns—cowboys, not colonial woodsmen. But if *Tomahawk* doesn't strike you as a Western, you should skip ahead to read the startling conclusion of this chapter—a full-bore essay of literary criticism, complete with rhetorical ruffles and philosophical flourishes, which I've included here just to prove it can be done with comic books.) The page at hand (figure 26), like most of the pages that record the doings of Tomahawk and his sidekick Dan Hunter, was drawn by Frederic Ray, Jr. You can't say that Ray wallpapered the Golden Age with samples of his work. He worked only at DC, and from 1940 until 1971 he drew very little other than *Tomahawk*: only such backup features as "Congo Bill" and "Radio Squad," for instance. But his work appears steadily through the twenty-two-year run of *Tomahawk*.

In Ray, Tomahawk found his ideal delineator. Through careful research, Ray brought authenticity to his rendering of colonial America. (His series of drawings of colonial military uniforms has been exhibited at the Smithsonian.) In style as well as in his dedication to authenticity, Ray reveals his debt to Milton Caniff and Noel Sickles. In Tomahawk's woodsy environs, the shadowy chiaroscuro technique of the Caniff-Sickles school of impressionistic illustration adds atmosphere as well as realism. Ray chiseled a certain cragginess into the visages of his characters, chipping out their features with boldly black splashes of defining shadow. And because Ray worked almost exclusively on *Tomahawk*, the artwork of the books is stylistically unified, which in turn imparts to the series and the character a distinctive flavor.

In the story from which our sample page is taken, Tomahawk and Dan Hunter guide a group of traveling actors to safety through hostile Indian country. Since they are outnumbered by the Indians, direct combat is inadvisable, so Tomahawk seeks to confuse and delay the pursuing war party by using the skills of various of the performers. A ventriloquist and then a magician baffle the Indians with their arts—while the rest of the party makes for a raft that Otter Mike Shannon holds ready for their escape. As a final ploy, Tomahawk takes some marionettes from the company's puppeteer and hangs them from a tree limb. The breeze makes the puppets dance, and the Indians pause in their pursuit to marvel at the antics of the "little people." The page before us picks up the tale here and concludes it.

This page is a wholly competent piece of comic book storytelling and is therefore typical of the best that the period has to offer. In form, it is somewhat reminiscent of the earliest comic books in which the pictures often merely illustrated the captions. Here, however, the captions don't have the verbal continuity of straight prose narrative that marked primitive comic book storytelling. In fact, here, words and pictures combine to tell the story in the modern medium's customary mode. In panel 2, for instance, the picture locates Tomahawk for us and tells us what he is doing. And as he flees the scene, he explains how he vacated his barky perch. In panels 3, 4, and 5, the pictures shoulder the burden of the storytelling by showing Tomahawk making good his escape, while the words collect the loose ends of the plot.

Adequate comics storytelling though this is, there is little blending of word and picture to the degree that neither makes sense without the other—a circumstance that would make the most economical (and hence dramatic) use of the medi-

Figure 26. *On this rather conventional (and therefore typical of its time) page of comic book art the action is episodic rather than continuous. (Tomahawk No. 33, July 1955)*

um's capabilities. Panel 5 comes closest: the picture, showing the raft easing into the river away from the Indians on the shore, lends significance to the remark about the escape being "too close for comfort." And the remark itself spices up the otherwise undramatic visual. Elsewhere, some of the verbiage is superfluous. Panel 3, for example, shows Tomahawk as he "speeds toward 'Otter Mike' Shannon's raft"—a piece of caption that is scarcely essential. And the captions for panels 2 and 5 seem similarly excessive.

Despite such lapses, the storytelling generally makes effective if modest use of the medium. Even though words and pictures do not, strictly speaking, blend for mutual meaning, each of these storytelling elements carries significant narrative freight. The pictures bear a share of the narrative without simply illustrating the captions, and the words explain aspects of the story or plot that cannot be easily visualized.

But even such competence as this is not enough to elevate the craft of comics storytelling to an art. There is little evidence here that the sequential nature of the medium is being exploited to its fullest for dramatic effect. The narrative breakdown, for instance, does not time the action so much as it simply divides up the story into panel-sized units. The breakdown is episodic: panels give us sequential episodes in the unfurling story line. In other words, each panel advances some aspect of the story with its ration of expository caption and dialogue, and the accompanying picture does the same for a parallel aspect of the story. While this is undeniably effective use of the medium, it falls short of dramatic use, which requires that breakdowns enhance the story by, say, deliberately timing developments to build suspense. The only evidence of timing on this page is in panels 3 and 4, which do time the action but build too swiftly to panel 4's climatic picture (the most dramatic composition on the page) of Tomahawk's successful leap to safety on the raft. Visually, not only is this the high point of the page, but it is also the story's most exciting picture (fittingly enough: it is, for all practical purposes, the conclusion of the tale).

Dramatic timing, however, requires that more panels be devoted to creating suspense than are deployed to this purpose here. Episodic breakdowns make effective and economical use of the medium, but there's not much continuity of action except

that which is achieved incidentally through the sequential nature of the medium. And sequence is not, in and of itself, all that dramatic. For emotional impact, stories require timing, and dramatic timing requires more than episodic breakdowns: it requires breakdowns that depict continuity of action in order to build to a conclusion. For an example of comics that portray continuity of action, let's pick up one of Fawcett's *Tom Mix Western* books. Appropriately, the books feature the cowboy movie star whose influence shaped movie Westerns for thirty years. Mix flicks were fast-action adventures with a hero who reeked of integrity.

One of the megastars of silent movies (from about 1917 to 1928), Mix developed an on-screen character that set the fashion for horse-opera heroes until the early fifties. He didn't drink, smoke, treat women disrespectfully, or indulge in unnecessary violence. He rarely killed his foes, dispatching them instead with knockout punches. Mix described his formula: "I ride into a place owning my own horse, saddle, and bridle. It isn't my quarrel, but I get into trouble doing the right thing for somebody else. When it's all ironed out, I never get any money reward. I may be made foreman of the ranch, and I get the girl, but there is never a fervid love scene."[1]

Mix's contribution to the fledgling Western movie was superb showmanship, according to Michael Parkinson and Clyde Jeavons in *A Pictorial History of Westerns*. His sixty-plus films for Fox "were fast, cheerful, high-spirited, and streamlined," full of fist fights, chases, and stunts, with Mix doing most of his own stunt work throughout.[2] And the *Tom Mix* comic books of the late forties were just as action-packed as the movies of the twenties. The books I remember most fondly were tightly drawn: every detail precisely placed and rendered, no loose-end sketchy lines, no purely decorative filigree. The depiction of action particularly gripped me then—and it does now, as I reread some of the old books. Mix and his cohorts (but most often just Mix) seem to move more quickly and directly than any other characters in comics. Mix moves without a single wasted motion or false start—an impression probably derived from the artist's habit of using speed lines lavishly, albeit precisely: their sweeping arcs trace exactly the course of motion. A fight scene in a *Tom Mix* book is always a flash of excitement.

This distinctive rendering results from the com-

Figure 27. *For staging dynamic, continuous action, Carl Pfeufer cannot be surpassed. The action continues in figure 28. (*Tom Mix Western *No. 10, October 1948)*

bined efforts of Carl Pfeufer (who penciled the book) and John Jordan (who inked it), according to Hames Ware, co-editor with Jerry Bails of *Who's Who in American Comic Books*, the source of much of the professional biography being retailed here. Pfeufer came to comic books from newspaper strips: *Don Dixon*, a science fiction strip inspired by *Flash Gordon*; *Tad of the Tanbark*, a jungle story (both starting in 1935); and *Gordon, Soldier of Fortune* (1936). All three features folded in 1941. Apart from his Fawcett collaboration with Pfeufer, Jordan's comic book career took place in the Jacquet Shop, roughly between 1940 and 1943. In the mid-fifties, he drew the *Don Winslow* newspaper

strip. Ware, who has studied the work of both men, opines that "neither achieved solo what they managed to do in tandem" on such Fawcett characters as Tom Mix, Mr. Scarlet, and others.[3] The Pfeufer-Jordan team produced 90 percent of the Tom Mix stories at Fawcett (from 1948 to 1953), according to William Harper in his *Tom Mix Original Art Catalogue*.[4]

For dynamic, continuous action sequences, Pfeufer simply cannot be surpassed. Equaled maybe, but not surpassed. Detailed analysis shows that the excitement in a sustained Pfeufer fight scene is generated by more than sweeping speed lines. Here are nine panels from *Tom Mix Western* No. 10

Figure 28. *The action, vigorous as it is, is the only source of drama in this sequence.*

(October 1948): five panels from the bottom of one page and the first four panels of the facing page (figures 27 and 28). We find Tom perched on a roof one night, looking over to a neighboring building (a hotel) in which he sees the heroine of the piece, Carol, being threatened by the hotel owner, Belson, and his thugs. Tom swings into action, rescues the girl, and brings Belson to justice (in the conclusion of the story, not shown here).

One of the first impressions we are likely to have of this sequence derives from its essential difference from the fight scenes in superhero books thirty years later, when fight scenes dominated the medium. In the Mix fight, there are no close-ups, and most of the action depicts the characters in full figure, or nearly so. Another likely impression is that the action progresses with remarkable swiftness, Tom bobbing and whirling in a maelstrom of flailing fists and flying objects. The brevity of the speech balloons doubtless contributes to this effect: timed to the speed of the actions, the speeches convey no complicated bits of information that would impede quick reading. But the pictures themselves, which tell virtually all of the story of this encounter, also work to create a sense of fast action: careful examination reveals panels artfully composed and arranged to enhance that impression as well as to tell the story.

Comic book pages, like the pages of all reading matter, are read from left to right, top to bottom.

The reading eye, as it moves in its course, can be hastened or slowed in its progress by the compositional elements of the page and of the panels. For merely competent comic book art, it is necessary only that the composition not interfere with reading. But in the finest examples of the art, composition underscores action and story. Scenes of fast action, for instance, are designed to be read swiftly; scenes in which action slows or hesitates, to be read slowly. The composition of the panels at hand (see figures 27 and 28) hastens the reading in keeping with the action by repeating pronounced patterns. In the first few panels, the pattern is a diagonal. The direction of the "falling" diagonal in panel 2 (upper left to lower right) is maintained through the next two panels speeding the eye on its journey as it follows Tom's entry and landing. And as Tom ducks in panel 5, his action is a continuation of the same essentially downward movement. Similarly, in panels 6 through 8 the repetition of circular forms—the clearly delineated arcs of all blows and the circular lamp shade—hastens eye movement so that it matches the swift tempo of the action.

Other subtle touches within the overall patterns further enhance the reading experience. The direction of the diagonal changes between panels 1 and 2: in the first panel, the diagonal runs from lower left to upper right; in the second, it reverses itself to run from upper left to lower right. The shift forces the eye to move *up* to the right in panel 1, then down to the left in panel 2—duplicating Tom's presumed movement as he jumps up off the roof and then falls down toward the next building. The shadow on the hotel in panel 2 gives added downward impetus to Tom's plunging entry into the room in panel 3.

The composition of individual panels directs our attention in the service of the narrative. For example, the second point of focus in panel 3 (the first being Tom) is the huddled group, which immediately introduces us to the entire cast of the following scene—emphasizing, by his predominance in the picture, the hotel owner Belson, who then becomes (in panel 4) the first victim of Tom's onslaught. The eye is next likely to pick up the swinging fist that breaks the border of panel 5, moving then to Tom and finally to the rest of the scene. In that movement, the eye again duplicates the order of Tom's actions: he presumably sees

first the assaulting fist (out of the corner of his eye) and then ducks.

The camera angle shifts dramatically in the next panel (the first on the facing page in the printed book) and then again in the next, producing some telling effects. In panel 6, reversing the camera angle puts into the more noticeable foreground the thug picking up the lamp that he will toss in the next panel. It's a subtle touch, admittedly: it doesn't distract at all from the main action of panel 6, but it does prepare the way for the action of panel 7. Notice that the visuals tell the story: the thug doesn't say, "Maybe this lamp will stop Mix," or some such. And it's the shift in camera angle that permits this wholly visual storytelling.

Notwithstanding the preparation supplied in panel 6, the thrown lamp is likely to come as something of a surprise in panel 7. The lamp detail in panel 6 is overshadowed by the more spectacular action of Tom's roundhouse punch, so we are only vaguely aware of the lamp. In contrast, the lamp is the first thing likely to be focused on in panel 7—and it's coming out of the panel, directly towards us! This kind of surprise is made possible by completely reversing the camera angle once again. And it's effective storytelling. Just as Tom was probably only marginally conscious of the lamp in the room, so are we; just as the lamp comes suddenly into his consciousness, so it does for us. Moreover, as the eye moves from panel 6 to panel 7, we become sensible of events in parallel to Tom's consciousness of them: first we see the lamp, then Tom ducking—exactly the order of his perception and action. Finally, underscoring our identification with Tom, the lamp seems to be coming at us.

In panel 8, Tom's arcing blow takes him from the crouching position of panel 7 to the striking position of panel 8. Still telling the story visually, panels 6 and 7 show looming shadows, dramatically falling away from the light source—the lamp. Then in panel 8, when the lamp has presumably shattered and gone out, we're plunged into sudden darkness, and Tom's upper body and the crook's are shadowed into near silhouette. With Tom's final remark, words and pictures blend, each enhancing the meaning of the other as the fight concludes. Meanwhile, Belson, the leader of the baddies, has recovered enough to begin to creep away—his foreground position attracting our at-

tention second in panel 8 as we read down the page (noting first Tom's final blow).

The last panel is the sequence's only serious failure, an awkward composition that needs Carol's short speech for clarification. Tom and Carol are crowded into the left half of the panel, creating a void at the right—toward which they both are looking. The composition effectively nudges our glance in the correct direction, but Belson's head is not sufficiently evident for clear identification without Carol's shout. Still, this lapse is not enough to undermine the effectiveness of the sequence as a whole.

The entire sequence (including, even, the faulty last panel) is carefully staged, choreographed even. The bad guys move in on Tom from probable locations, given their initial position as established in panels 3 and 4. The shifting camera keeps us always informed as to where most of them are at all times—and where they are coming from. One minor error: the scene is so consistently staged that we know that the window in back of the clobbered crook in panel 8 is a physical impossibility. That guy came at Tom from the interior of the room, and Tom was between this fellow and the window throughout the action except in this panel. The partly silhouetted broken window, which frames the brighter night outside (brighter now that the lamp is shattered within; a nicely authentic detail), is a dramatic way of closing the sequence. But it upsets the otherwise plausible consistency of movement that has thus far prevailed throughout—a continuity of action that gives us a different kind of fight scene from those we find in superhero books three decades later.

The sequence looks different, and its objectives are doubtless different. The major concerns in these panels seem to be, first, to make eye movement exciting and swift, in time with the action itself, and, second, to achieve a panel-to-panel continuity of action in exclusively visual terms. The impression of swiftness is encouraged by the repetition of patterns (first diagonals, then circles), and continuity of action is accomplished through careful staging. The resulting visuals seem as continuous as the key drawings in animation—an impression underscored here by the sweeping, arcing speed lines that suggest not only the sure and direct course of blows but the points of origin for each movement.

Latter-day superheroic fisticuffs feature psychic trauma as well as physical drama. After Jack Kirby introduced superheroes replete with personality problems, no fight sequence could be completed without airing the angst of the protagonist. The purpose of such scenes is not simple physical conquest alone, and the pictures reflect the difference. Pictures of colorfully clad combatants swinging fists at each other alternate with intense close-ups that focus on furrowed brows or clenched teeth or flexed neck muscles and other signs of anger, anguish, or pain. In the Tom Mix sequence, in contrast, we have only the action itself as the source for excitement and drama. Insofar as that defines the objective of this sequence, the artistry by which that objective is accomplished is considerable—even exemplary of its kind.

Although I've belabored mostly individual panel composition in this discussion, inasmuch as one panel's composition is determined by its relationship to panels coming before and after it, I've also been talking about layout. But it's narrative breakdown that figures most significantly in a final assessment. The selection of narrative units here results not just in a depiction of each of Tom's most dramatic moves in the fight (his entry, connecting punches, ducking and dodging): it also shows those moves in virtually continuous motion. The episodic breakdown of the *Tomahawk* page is more typical of comics storytelling during the Golden Age—hence the distinction of Pfeufer's *Tom Mix* work of the same period. But sustained continuity of action alone does not create dramatic emphasis. Artfully staged and timed as the action is here, there is no dramatic high point. The action is staged and timed for continuity only. The fight does not *build* toward a conclusion: it simply reaches its conclusion because all such things must end. And so, while Pfeufer's effort is nonetheless a commendable example of the kind of thing of which comics are capable, his signal craftsmanship does not elevate comics storytelling to the higher reaches of art.

But don't give up hope. For an example of timing for effect in comics, let us turn to a page by S. Robert Powell.

Bob Powell was one of the great unacknowledged workhorses of the Golden Age of comics. He was there near the beginning, working for Fox, Fiction House, and others in 1939 out of the Eisner-Iger

Shop. When he got out of the Army Air Corps in 1945, he set up his own shop, doing work for Harvey, Street and Smith, Fawcett, and Magazine Enterprises. His last comic book credits were at Marvel in 1965, but he worked for Topps Gum Cards until his death in 1967. (He called in one day, saying he didn't think he could finish his latest assignment. "Why not?" asked the secretary on the phone. "I'm dying," said Powell.)[5] Many of the characters of the early days bore the Powell imprint: Dr. Fung and D-13 at Fox; Gale Allen, Camillia, Inspector Dayton, and others at Fiction House; Abdul the Arab, Lee Preston, Betty Bates, and Spin Shaw at Quality. He worked on early issues of *Jumbo Comics* and the first issues of *Sheena*. (Ed Lane, whose Powell index compiled for publisher Al Dellinges is my source for some of this, says the first issue of *Sheena* appears to be all Powell.)

Powell's distinctive style emerged in the late forties after he set up his own shop. At one point he had five assistants, according to Howard Nostrand, Powell's chief assistant from 1948 to 1952. Writing in *Graphic Story Magazine*, Nostrand said Powell's best work was done when he was using his first three assistants. "They were George Siefringer, who did backgrounds; Martin Epp, who inked, lettered and helped George on backgrounds, and me," Nostrand wrote. "I started out (in 1948) inking and then got into doing backgrounds (when George was too hung over or just AWOL) and then pencilling." Nostrand goes on to describe their operation:

> The way the drill went was as follows: Powell would pencil the story; it would then be sent to the publisher to be lettered, have the borders inked in, and have any changes the art director deemed necessary. When we got it back, Bob would ink in the faces, I would ink in the figures, and George and Marty would do the backgrounds. . . . Powell would then give it a final once-over, and it would then be mailed to the client. When I first started with Powell, his work was more linear than light and shade. When I started inking for him, I tried to get more of a light-and-shadow effect in what we were doing. The change in Powell's work was so gradual that nobody ever realized it. The only way you could tell would be to compare one of the *Shadows* or *Doc Savages* done in 1948 to some of the stuff turned out in early 1952.[6]

In its maturity, Powell's work was notable for the faces of his characters. He could render a face rec-

ognizable in an astonishingly wide variety of comically exaggerated as well as serious expressions. The advantages for visual comedy were fully exploited in a number of humorous backup features he produced in the late forties and early fifties—notably "The Flying Fool," "Chickie Ricks," and "Slewfoot Jones." Working for Magazine Enterprises, he also produced some of the most toothsome of the funnybook heroines in the 1950s for *Thun'da*, *Cave Girl*, and *Africa*.

Both Powell's sense of humor and his penchant for hourglass figures are illustrated in a Slewfoot Jones story printed in *True Sport Picture Stories* No. 2. As Ed Lane tells it: "Slewfoot gets off a train and while ambling through the terminal, he trips over a suitcase. In a neat 3-panel pan we follow his gaze slowly upward from the floor . . . up the legs . . . then a body and breast profile . . . then the breasts and face profile . . . of a beautiful 44-28-36 movie star. But, in what must easily be the classic put-on in comics, emblazoned boldly on the breast are the woman's initials—VD. Over the next two pages, she and Slewfoot get friendly at a local soda fountain, always with the VD initials prominent on her bosom." Her name, it is eventually revealed, is Vyvian Doheavee. "How this got past the editor is beyond me," Lane marvels; "perhaps Slewfoot didn't have a monopoly on naivete."[7]

In *Bobby Benson's B-Bar-B Riders*, a book produced by Powell's shop for Magazine Enterprises in the early fifties, the mature Powell style is amply showcased. Typical of the period, the comic book was a spin-off from a popular radio program for kids. As Bhob Stewart observed in *Graphic Story Magazine*, comic book and radio program tie-ins were more important in the 1940s than comic book and TV tie-ins are today. In those days, he says, "the comic was the only visual reference for a radio comedy or drama. But that same comic might never have existed were it not for the popularization of the character on radio."[8] Bobby Benson was a young kid (some twelve to fifteen years old) who ran a modern day ranch with the substantial assistance of his foreman, Tex Mason, who was aided in turn by the ranch's resourceful Indian cowhand, Harka. And all hands were impeded, occasionally, by a red-haired galoot named Windy Wales, who provided the comic relief.

A short story in each of the first thirteen issues featured "The Lemonade Kid," who was actually

Tex Mason duded up in a Hollywood cowboy outfit of yellow and green. A memorable (not to say, er, colorful) character, the Kid solved mysteries with mental prowess first, then got his physical exercise in bringing the culprits to account. Our sample of Powell's work comes from the Lemonade Kid story in *B-Bar-B Riders* No. 6 (February 1951). This is the last page in the story, which concludes the Kid's attempt to round up a batch of escaped bank robbers (figure 29). Aided by Harka, the Kid overcomes the bad guys in a flurry of gun smoke and fisticuffs.

Powell often did sequences of the kind of sustained continuity of action that we found in *Tom Mix*, but this page is not an example of that. The first two panels here, in fact, are composed simply to present two of the most vivid and exciting views of a fight in mid-brouhaha. Beginning with panel 3, however, the breakdown is geared for something besides reaching the end of the story. Concluding the story requires merely that the Kid win his fight. But the breakdown here aims for an additional effect—the comic conclusion of panel 5. Panel 3 shifts our attention to outside the outlaws' cabin, where two guards are intrigued by the sounds of battle emanating from the building. When they enter the cabin in panel 4, a strategic close-up artfully withholds from our view any hint of the surprise awaiting them. Then, in panel 5, Powell springs his surprise.

In this sequence, Powell has skillfully manipulated the resources of the medium for a particular effect: the fight ends, but on a comic note appropriate to the rollicking spirit in which the entire affair has been conducted. Powell times the action for three panels, building suspense over the first two and deliberately withholding information in the second in order to spring his conclusion as a comic shocker in the last. Here, the craft of comics storytelling approaches art.

The sequence is vintage Powell. Typically, he injects visual humor into such lighthearted encounters, and here we have ample evidence of his proclivity for comic touches. The power of the Kid's blow in panel 2 drives his adversary into the panel border with such force that the border is bent in outline of the bad guy's body; in panel 3, the dust-up in the cabin huffs and puffs through cracks and windows; and in panel 5 (although it may not be very clear in this reproduction), the heads of the two outlaws are slightly squashed,

like ripe melons, by the impact of their collision.

High-spirited stuff, this. But for a finale, perhaps we need something that manages the resources of the medium to a more serious and hence dramatic purpose. For comics storytelling in a more sober (even grim) vein, then, let us take up one of the last of the Western comic book titles, *Jonah Hex*, which chronicles the adventures of a bounty hunter. Published thirty years after the titles we've been peering at, *Jonah Hex* vividly demonstrates how storytelling techniques have changed by the 1980s. In an early issue (No. 32, January 1980) written by Michael Fleischer and drawn by Jose Luis Garcia Lopez, we find both continuity of action and timing for effect in combination with yet another facet of comics storytelling, layout—all working together to create dramatic impact. In contrast to the conventional grids of regularly shaped panels we've inspected in Golden Age titles, Lopez's layouts are often exotic, and sometimes so extravagant that they entangle the story line. But on the page reproduced here (figure 30), the layout overcomes its eccentricity in achieving its dramatic effects.

The page comes in the middle of a spectacular gunfight, the centerpiece of the story. Hex has come to Murphysburg to confront and somehow take revenge upon another, older, bounty hunter, Arbee Stoneham. Eight years ago, Stoneham stole Hex's bounty from him by appropriating his catch at gunpoint—justifying his high-handed heist by saying that he'd been tracking the same outlaws. Now, on the way to Stoneham's house and vengeance, Hex walks through the stockyards, where he's ambushed by a dozen owlhoots whom he has been pursuing. Warned of the ambush, Hex turns the tables on his would-be drygulchers, and, before the end of the encounter, he kills all twelve of them. As we pick up the action here, Hex has just shot four of his opponents—and he's keeping score while three more dash toward him.

Unhappily, the opening panel of the page is flawed by clumsy perspective. The wall of the shed behind which Hex is loading his gun is not angled sharply enough: Hex, who should appear to be hidden by that wall from the view of his onrushing attackers, seems instead to be visible to them. We need the speech of one of the bad guys to clarify the situation. But the horizontal panel serves admirably otherwise to set the scene, locating the

Figure 29. *Here, Bob Powell gives us drama as well as action (albeit somewhat episodic action): the narrative breakdown of the first four panels aims toward the comic conclusion in panel 5. (Bobby Benson's B-Bar-B Riders No. 6, February 1951)*

Figure 30. *In this sequence, Jose Luis Garcia Lopez gives us continuity of action that builds to a dramatic conclusion. (Jonah Hex No. 32, January 1980)*

principal players in the drama to follow. Panel 2, focusing on Hex's grim visage as he clicks shut the just-loaded chamber of his six shooter, builds suspense momentarily by giving us an ominous pause before the quiet of the stockyard is shattered by gunfire. Then the action is virtually continuous through the next four panels as Hex throws himself in front of his assailants and keeps his countdown going in three parallel panels that seem to tick off the seconds in cadence with Hex's blazing guns.

The breakdown of the page times the action, building suspensefully toward the three-panel conclusion across the bottom tier, and panel composition enhances the timing. Camera distance changes across the three opening panels: first, a long shot to set the scene; then a close-up, intensifying the pregnant pause before the coming storm; then, to depict Hex's move that initiates the action and to reestablish the relative location of the actors, a medium-range shot. This variation in the distance makes the action seem less continuous and, hence, slower, in keeping with the objective of the breakdown, which is to delay action and build suspense until the crescendo of the concluding trio of panels.

The repetitive composition of the last three panels emphasizes the swiftness of Hex's assault, and layout adds to their impact. We read through the action of these panels quickly because we don't have to orient ourselves to different successive scenes: having identified the elements of the first panel, we find similar elements in the same positions in the next two. Layout heightens the effect by the parallel positioning of the panels, all of which are the same size and shape. Each successive panel is a nearly perfect echo of its predecessor, and thus the scene drums its grisly conclusion into our consciousness with the visual equivalent of the monotonous cacophony of the blasts from Hex's guns. And the shock effect of the scene is accentuated by focusing on Hex's victims, contorted in their death throes.

Within the limited objective of this sequence, the page achieves a highly dramatic effect by manipulating the visual dimension of the comics: breakdown for timing, composition and layout for additional emphasis. Here, comics storytelling is art.

But to what purpose? Is the story worth telling?

Hex does not emerge from the slaughterhouse of the stockyard unscathed. Against seemingly impossible odds, he triumphantly escapes the ambush by killing all of his assailants, but he's wounded twice. Taking time out to get patched up, he finally goes on about his errand and, burning for revenge, finds Stoneham. But what he finds is the proverbial hollow shell. Stoneham is now an old man, white hair stringing down his back. Vision blurred and memory hazy, Stoneham doesn't recognize Hex. And Hex barely recognizes his former nemesis. The once commanding Stoneham presence is now confined to a wheelchair. Victim of an ambush, the old bounty hunter was crippled by a bullet that fractured his spine. His livelihood gone, he quickly declined into senility, his life quietly draining away even as he tried to recall exciting scenes from his past. Thus, by an accident of his profession, the erstwhile self-reliant bounty hunter is rendered helpless.

Hex stands there equally helpless. Fate has deprived him of the chance for revenge. But can he fail to see himself in Stoneham? Hex has just survived an attempt on his life, his arm in a sling as a reminder. Highly charged scenes of a dramatic gunfight, like the one we've just loitered over, are fresh in our minds. And they're certainly fresh in Hex's. Given the similarity of his recent experience to the ambush that did Stoneham in, Hex cannot help but see in the crippled old man a presentiment of his own possible destiny. Those who live by the gun, goes the old saw, die by the gun. And sometimes, they just wither uselessly away. Hex is victorious this time—over both his old foe and the bushwackers in the stockyard. But for how long will luck and his skill preserve him from a fate like Stoneham's?

Within the framework of this larger story, the gunfight with the drygulchers does more than dazzle us with Hex's prowess: it emphasizes the ever-present threat of death in the life of the bounty hunter. Such an emphasis is common enough in the exploits of Jonah Hex, but in this story, it dramatizes the premonition that we—and Hex—must see in Stoneham's fate. The more impact the gunfight scenes have, the more dramatic Hex's encounter with the old cripple. Hence, what might seem gratuitous violence serves a dramatic purpose within the story.

In achieving this kind of resonance, Fleischer's Jonah Hex story is a cut above the stories we found in the Golden Age comics. Those are simple ac-

tion adventures: Tomahawk's, a tale of evasion and escape; Tom Mix's and the Lemonade Kid's, stories about capturing crooks. In such stories, the simplest virtues prevail and are thereby championed. The genre of the Western, for all its action and adventure, seldom does more. And yet there are inherent in the genre larger questions.

The American West and the literature and cultural traditions it inspired constitute a uniquely American mythology. Historically and culturally, the West was a promise wrapped in hope, and it fostered a national optimism peculiar to the American Dream. For nearly three hundred years, the principal business of Americans was opening the West—and conquering it. As long as the West remained a raw and undeveloped resource, pregnant with economic possibilities, any American could envision a better future for himself. Backed by a political heritage that trumpeted personal freedom and initiative, a man could always see himself moving to the West, where, by dint of hard labor and individual enterprise, he could wrest a living—perhaps even a fortune—from the potent wilderness. Self-reliance and independence were nurtured by such traditions, and they became national habits of thought that endured beyond the closing of the frontier.

As a literary genre, the Western embodies these facets of the national character. The hero of the Western is typically a strong and independent personality. Frequently a loner and always imaginatively resourceful and completely self-reliant, the Western hero is precisely the type who can easily be seen journeying alone into the wilderness to make his living by conquering every obstacle in his path. But the Western mythology represents more than the puissance of the individual. Despite his solitary character, the Western hero is portrayed as a social creature. He almost always stands for social justice—for good over evil, for right over wrong, for law not disorder, and, finally, for civilization instead of anarchy. And in the horse-opera hero's social conscience, we encounter the great unexplored conflict inherent in the mythology of the Western. It is a conflict that was born with the genre.

The Western very nearly took definitive shape in the form of dime novels that were produced in vast quantities during the last half of the nineteenth century. The heroes of dime novels were men of action, adept at the skills of violence and the arts of survival that were essential in the untamed West. They were expert hunters and gunfighters, and they seemed to devote themselves entirely to rescuing damsels from savage Indians and to shooting it out with robbers and assorted other riffraff and ne'er-do-wells. Most of the dime novel heroes, like Deadwood Dick, were fictional; but others, like Buffalo Bill Cody and Kit Carson, were ostensibly real persons, whose authentic adventures, colorful enough in themselves, were glamorized, then exaggerated, and finally wholly fabricated.

In popularizing the lives of real persons, the dime novel reached back to its roots. The earliest books in the Western genre were those inspired by the life and adventures of Daniel Boone. In some of the accounts of Boone's life, he is represented as a standard-bearer of civilization, building settlements and towns in the raw wilderness. In other accounts, Boone is seen as a fugitive from civilization, a child of nature who, unable to bear the encroachment of settlements upon his beloved forest, flees into the Western wilderness before the advance of civilization. In the contradictory ethos of these tales, the conflict within the character of the Western hero was foreshadowed. Later, James Fenimore Cooper immortalized the skilled woodsman as child of nature in his Leatherstocking tales. Natty Bumppo, the titular hero of the five-novel series, prefers the perfect freedom of the forest to the social restraints of the city, and his wisdom and humanity are inspired by his love of nature. The Leatherstocking persona endured beyond Cooper's novels. He appears in many of the dime novels, albeit usually in a minor, supporting role: it would not do to have a national mythology with an antisocial hero.

Implicit in the child-of-nature mythos is a criticism of civilization, which can be seen as drawing a veil of artificiality between the individual and a spontaneous expression of the natural (always "good") self. By the same token, Natty Bumppo's impulse to flee civilization can be understood as a desire to escape the civilizing control of law and societal restraint in favor of the possibility of unrestricted personal gratification that the wild freedom of the forest promises. But the national mood could not long tolerate such images in its mythic literature. The manifest destiny to bring the entire continent under the sway of a unifying government and social order required another kind of hero: the economic potential of the West could not

be fully realized unless the comfort and security of civilization were imposed upon it. And the national mythology therefore required a hero who was a harbinger of civilization, a champion of social order and progress, not a social critic or a social misfit.

When the Leatherstocking persona moved further west, he became a mountain man, and the literature recording his adventures was, for a time, a debunking literature. In his rejection of civilized life, the mountain man was seen as wholly self-indulgent, preferring to follow the baser impulses of his unrestrained nature in pursuit of danger and adventure, where survival of the fittest required that he kill or be killed without regard for ethical proprieties. But this development again left the national mythology without a proper hero.

Into the temporary vacuum stepped Kit Carson.

Just as the promise of the far West began to glow hot in the nation's consciousness during the 1840s, accounts of John C. Fremont's explorations of the Rocky Mountains and points west started to captivate readers. Skillfully edited by Fremont's wife, these reports presented a slightly refurbished image of the mountain man—but one that was eagerly seized upon by those who dreamed of empire in the West. The dream required a civilizing hero, and Fremont's tempered portrait of Carson as his guide supplied a version of the mountain man suitable for much subsequent enthusiastic embroidery to that purpose. And so Kit Carson, trapper, scout, and Indian fighter, assumed the mantle that Daniel Boone had once worn—the one discarded by Cooper in favor of the child-of-nature persona, that of pioneer for civilization.

Popular literature soon took up the banner that Fremont had raised with his tales of Kit Carson. The first of Beadle and Adams's dime novels appeared in 1860, and in the flood of books about Carson and Buffalo Bill Cody and Davy Crockett and Wild Bill Hickok and others, the Western hero was transformed from a man in tune with nature to a man who conquered it—it and all other obstacles to civilized life. And when the long cattle drives that have become so much a part of the myth of the West began in 1866, the Western hero began to assume yet another shape.

Although the authentic cowboy was little more than a common laborer in the West, he became a hero because he was marketed as one. Buffalo Bill started touring the country with his Wild West Show in 1883, and in 1884 he introduced a new featured performer—Buck Taylor, "The King of the Cowboys," who entertained the crowd with gunplay and rope tricks and riding skills. Taylor and his imitators demonstrated that the cowboy had the capacity for the kind of violent action that provided amusement for the multitudes. The cowboy could be romanticized. And so he was: he was made into a man of action, a rugged individualist, championing justice and fair play. Teddy Roosevelt completed the transformation of the cowboy from common drudge to romantic hero. Recounting his 1884 ranching adventures in North Dakota in his *Ranch Life and Hunting Trail* (1888), he lionized the cowboy, setting him up as a model of masculinity and idealistic pragmatism; and he did it again in *The Rough Riders* (1899).

The Western hero was a conqueror of nature, but a conqueror with a difference. For all his mastery of the arts of survival in a pitiless wilderness (often among lawless marauders), the hero of the Western was not a ruthless wild man. Nor was he the noble savage of Rousseau's invention. Noble, yes; but not savage. The cowboy became a gentleman in chaps, despite his untutored lingo; the gunfighter, a knight in buckskin vest. In short, the Western hero was a proper Victorian hero in perfect step with his age. Cool, taciturn, courageous, and just, the latter-day heroes of the horse operas were skilled with guns but slow to use them, rugged but gentlemanly, respectful of women but shy among them. They were models of two-fisted integrity.

The dime novel all but completed the Western hero's evolution. But neither the dime novel nor the Western mythology that subsequently emerged were entirely successful in confronting or reconciling the self-contradictory character of the Western's heroic persona. In the final analysis, the self-reliant independence so typical of the Western hero is fundamentally in conflict with his social conscience. The kind of hero who single-handedly conquers the wilderness and overcomes all other obstacles to the achievement of his desires is not, in ordinary life, the sort who willingly submits to the restraints of social custom and law if they are seen as inhibiting his own righteous impulses. The conflict is between freedom and law, license and order. And the alternative to a law-abiding society has always seemed to be a lawless one. Are freedom and lawlessness then synonymous?

The question echoes across the American experience, but the genre of the Western ignores such distinctions in order to perpetrate its mythology. Only in myth does a nearly almighty individual bow willingly, routinely, to the dictates of societal restraint. The mythology nonetheless serves its purpose: like religion, it inspires by precept and example.

In the character of Fleisher's Jonah Hex, we find a more pronounced intimation of the conflict inherent in the Western's heroic persona than we find in Tomahawk, Tom Mix, or the Lemonade Kid. Hex, a bounty hunter, seems to serve the law. But he rides the outlaw trail, and as a self-sufficient gunfighter, he acts alone, and so positions himself outside society. Moreover, he acts not so much on society's behalf as on his own: it's chiefly the money that motivates him—not, as with Tomahawk, Mix, and the Lemonade Kid, a socially inspired desire for justice. In his motivation, then, Hex is virtually asocial, a free agent. He serves the cause of civilization only incidentally.

But such inklings only hint at the heart of the matter. Perhaps a hint is all we can hope for in our mythology: direct confrontation might destroy the myth. Still, it would be refreshing to see the contradictory themes of the Western mythology explored in comics, to see there something besides the simple triumph of good over evil, justice over injustice, law over lawlessness. Meanwhile, just as we might look to Westerns for action and adventure in a four-color world suddenly bereft superheroes, we could look to superhero comics for more than a mere echo of our mythology's themes. The superhero, after all, is but the Western heroic persona elevated to near omnipotence. And in the superhero's vigilante adventuring outside the law (however ostensibly on the law's behalf), the internal conflict in the national mythology once again finds expression.

CHAPTER 4
But Is It Art?
The Spirit of Will Eisner

Will Eisner knew from very early in his career that the medium of comics was an art form. And as soon as he knew, he treated it with loving, nurturing care. Not since Winsor McCay launched his Sunday comic strip *Little Nemo in Slumberland* in 1905 had anyone explored the form's potential as deliberately as Eisner did. And no one of Eisner's generation pushed against the envelope of possibilities harder or experimented as thoughtfully or as skillfully over as long a period. And very few of his generation—or of any other—have had as much impact upon the medium as he.

We have seen Eisner in the comic art shop that he and Jerry Iger founded, creating characters and visually drafting original stories for the infant medium. As the creative straw boss of the shop, Eisner molded and shaped its product. Harvey Kurtzman, who was to the postwar generation of comic book creators what Eisner was to the prewar generation, believed Eisner to be "the greatest" of the early artists who worked in the form. Writing his impressions of the history of comic books, Kurtzman said of Eisner: "It was Eisner, more than anyone else, who developed the multipage booklet story form that became the grammar of the medium."[1] Gil Kane agreed: "Eisner actually created the first original context for the comics field and gave it a dramatic structure and a way of handling pictures that was different from simply redoing Sunday page strips."[2] Great as Eisner's influence doubtless was through the productions of the Eisner-Iger Shop, he would leave an even greater mark upon the art form after he left the shop to create one of the great characters in comics, the Spirit.

Born in Brooklyn in 1917, the oldest son of Jewish immigrants, Eisner, like most of the kids in his neighborhood, began looking for a way out of the ghetto almost as soon as he realized he was in one. While looking, he sold newspapers on Wall Street. The job supplemented the family income, and it also exposed young Eisner to the funnies. Between sales and at the end of the day, he read the comics—*The Gumps*, *Little Orphan Annie*, *Krazy Kat*, and, later, *Tim Tyler's Luck* and *Thimble Theatre* with Segar's astonishing Popeye. "The adventure strips especially were very, very exciting for me," Eisner said, "and around the time I started reading them, they were entering their heyday."[3]

He also read books. The stories of Horatio Alger appealed powerfully, Eisner recalled: the possibility that he could rise above his circumstances through dint of hard work and diligence spoke directly to him as a kid in the ghetto. And he devoured pulp magazines. "At that time, the pulps formed the basis of popular storytelling. They were everywhere, and I read as many as I could. [They] gave me a sense of storytelling."[4] And like most of his

Figure 31. *When Will Eisner interviewed Harvey Kurtzman for one of his "Shop Talk" features in* Will Eisner's The Spirit, *Eisner drew Kurtzman (above, left)—but Kurtzman's drawing of Eisner came out looking like the Spirit, so Eisner drew himself (right), too. At the left, another Eisner self-portrait, this one full-face. (Eisner was persuaded that he looked like his character Dolan; and to some degree, he does.)*

friends, he went to the movies often; he spent every Saturday afternoon in the comforting cavern of a movie theater, spellbound by double features and the week's serial chapter.

When his family moved to the Bronx, Eisner entered DeWitt Clinton High School, where the curriculum fortunately encouraged students with artistic and literary talent. Eisner followed his natural bent. He drew pictures. And by the time he was ready to graduate, many of the pictures he drew were panels in comic strips. He had realized by then that he wanted to be a cartoonist. Syndicated cartoonists, he knew, earned steady incomes, and a steady income would enable him to get out of the ghetto. But getting himself syndicated proved harder than he'd thought.

The summer after he graduated from Clinton, Eisner attended the Art Students League, where he took painting under Robert Brachman and drawing from the renowned George Bridgman. At the end of the summer, he found a job working the graveyard shift in the advertising department of the *New York American*. He also worked in a printing

shop and freelanced cartoons to magazines (without selling any). Then in early 1936 he heard about a magazine that was buying original comic strip stories, and he went to show his portfolio. At the offices of *Wow! What a Magazine* he met the editor, Jerry Iger. Iger published some of the comic strips Eisner had developed in high school. But *Wow!* didn't last long. By the summer, it had folded. Eisner, however, had seen the future. A few months later, he approached Iger about forming a partnership to produce original material for the infant comic book industry. Eisner would create the material; Iger would find buyers. Iger was a cartoonist of the big-foot comedy school, so he could draw and letter. His chief assignment, though, would be to sell the products of the shop.

Among the first deals Iger engineered was to supply material to Editors Press Service for distribution to foreign markets, which were reprinting American newspaper comic strips at a furious rate. Iger and Eisner also set up their own feature service, Universal Phoenix Syndicate, to distribute their products to weekly papers in the United

States. Eisner created the seafaring adventure strip *Hawks of the Seas* for both markets, drawing it in the Sunday page format appropriate to a weekly feature. They created other features, too, many of which first saw publication in such outlets as *Wags*, a British weekly tabloid published in England and Australia. In less than a year, the Eisner-Iger Shop was also supplying American comic books with original stories. At first, much of this material consisted chiefly of recycled strips from the inventory the shop had produced for Editors Press Service and Universal Phoenix. *Hawks of the Sea*, for instance, was published by Quality in *Feature Funnies*, beginning with the November 1937 issue. Since comic book pages were of different dimensions than a Sunday newspaper page, the strip had to be revamped for comic book publication. To this purpose, Eisner cut up the artwork, panel by panel, and created the new pages by pasting up the old panels in modified configurations, often rewriting dialogue and captions to suit the new arrangement and expanding the original pictures to make them fit by adding more artwork to some of the panels. Although it was ostensibly a purely mechanical operation, this task stimulated Eisner's thinking about page layout, leading him to adopt novel storytelling devices—like the "jump cut," in which the subject seems to move rapidly, almost discontinuously, from one activity to another. This innovative technique was born of the need to leave out a connecting panel because the page wouldn't accommodate as many panels as the strip originally had. Later, Eisner would put this experience to use in a much more creative manner, deliberately deploying his resources to produce the specific effects he desired.

In a relatively short time, the Eisner-Iger Shop had more work than Eisner and Iger could produce themselves. For a while, Eisner, drawing in five different styles and signing as many different signatures, was able to handle the load—and convince clients that the shop was staffed with enough people to shoulder whatever jobs they took on. Eventually, however, they hired additional artists and writers—especially after they started supplying Fiction House with material in mid-1938. Within a couple of years, they had a staff of twenty or so. The names constitute a roll call of the medium's pacesetters: Jack Kirby, Lou Fine, Bob Kane (a classmate of Eisner's at Clinton High), Dick Briefer, Chuck Mazoujian, Mort Meskin, Bob Powell,

George Tuska, Klaus Nordling, Nick Viscardi, and staff writer Audrey "Toni" Blum.

In supervising their work, as we've seen, the twenty-year-old Eisner imposed his own artistic sensibilities. And much of the work produced by the shop bears his imprint. He was enamored of Milton Caniff's use of camera angles in *Terry and the Pirates*, for example, and as he experimented with increasingly extreme viewpoints, the shop's material was riddled with bizarre bird's-eye and worm's-eye shots. He was impressed, too, with the picture novels of Lynd Ward. (Told entirely with pictures—absolutely no words—Ward's stories vividly demonstrated the potential narrative function of body posture and facial expression.) As the creative director of the enterprise, Eisner had more artistic license, with more opportunity to exercise it, than he would ever enjoy again. He was a young man working in a medium not yet fully formed. The demands of his assembly line and the challenges of shaping the medium to fit both those demands and his own aesthetic sense absorbed him and satisfied him. But part of the satisfaction came from contemplating future developments and helping bring those into being. So when Everett M. "Busy" Arnold called in the fall of 1939 and proposed they have lunch, Eisner accepted with eager anticipation.

Arnold was a printing press salesman who had become vice president of the Greater Buffalo Press, where most of the nation's Sunday funnies were printed. Seeing the success that a competitor, Eastern Color Printing, had been having with *Famous Funnies*, he decided to enter the nascent comic book field himself, but unlike Major Wheeler-Nicholson, he had secured financial backing before he launched his reprint title, *Feature Funnies*, in the fall of 1937. Arnold's backers were the Cowles brothers, who owned the *Des Moines Tribune and Register*, which operated a feature syndicate under that name. As comic books began to proliferate, the syndicate's top salesman, Henry Martin, conceived the notion of a comic book supplement for newspapers. Patterned after its newsstand brethren, the supplement would be produced weekly and would be marketed like other newspaper comic strip features by the syndicate as an insert for newspapers' Sunday editions. Martin approached Arnold with the idea, and Arnold liked it. They needed someone to produce the material—someone who could write and draw and make

deadlines—and the person they knew who could do all that was Will Eisner, who had been reformatting *Hawks of the Seas* for Arnold's *Feature Funnies* since the third issue. Over lunch with Eisner, Arnold proposed that the young man take on the weekly comic book assignment. Eisner seized the opportunity with both hands. He had been aiming for a syndicated feature ever since he decided to become a cartoonist.

"I could now break out of the ghetto of comic books and move into the world of mainstream comic strips, the Mecca of all cartoonists," Eisner recalled years later in an interview with Tom Heintjes. He had already recognized that the creative challenges in comic books were limited by the interests of their intended audience— adolescents—"and yet I realized I would be spending the rest of my life in comics," he added; "I really believed in the validity of this medium." He compared his attitude then to that of Lou Fine, who, he said, dreamed of illustrating books but wound up in comics because the opportunities for fledgling illustrators during the Depression were virtually nonexistent. For Fine, comic books represented a way to make money. "That aspect was important to me, too," Eisner acknowledged, "but it was the attraction to the medium that made me want to stay. And then along came this remarkable opportunity . . . the chance to work for newspapers with a mature audience."[5]

The catch was that he'd have to leave the Eisner-Iger Shop. In order to produce a sixteen-page comic book every week, he would have to devote himself full-time to the project. Eager as Eisner was to expand his creative horizons, leaving a successful business with a good income during those hard times was a daunting prospect. But he wouldn't be putting all his eggs in one basket. Perhaps hedging the bet on the new venture, Arnold sweetened the deal: he offered Eisner joint ownership of three newsstand comic book titles, new titles that Eisner would produce in addition to the syndicated Sunday newspaper insert. Arnold wanted to expand his line of comic books, and he saw Eisner as the means to this end. And the proposition suited Eisner, too: if the weekly comic book project fell through, Eisner would still have work (and an income) from the other comic books. Eisner couldn't do all the work himself; the venture would require a shoplike operation. But he knew where he could find the talent. He sold his interest in the Eisner-

Iger Shop to Iger (an option offered in their partnership arrangement), agreeing at the same time to take only four of the staff with him—Fine, Mazoujian, Powell, and Nordling.

In the spring of 1940 Eisner and Arnold and Martin formed a three-way partnership, with Eisner as head of Will Eisner Productions, the entity that would produce material for their jointly owned comic books, *Smash Comics*, *Hit Comics*, and *National Comics*, as well as the weekly comic book supplement. Knowing that he was absolutely essential to the success of this undertaking, Eisner had driven a virtually unprecedented bargain in the last stages of the negotiations: he had insisted on owning the copyright on the lead feature he would create for the weekly. Martin and Arnold balked, but Eisner held his ground. "A creative control factor is implicit [in ownership]," he said, "—more important than financial considerations."[6] Eventually, they compromised. The feature was copyrighted by Arnold, but Eisner's ownership was stipulated in their contract so that whenever their partnership was dissolved, all rights reverted to Eisner. Satisfied, Eisner returned to his studio and created the Spirit.

He had been toying with ideas during the previous weeks. What he wanted was a framework that would allow him to tell any kind of story he could dream up. "I was interested in the short story form," he told Heintjes, "and I thought here at last was an opportunity to work on short stories in comics. I could do the stories I wanted because I was going to have a more adult audience." For such a framework, he decided upon the detective story, the protagonist of which would be "an adventurer who would enable me to put him in almost any situation."[7]

In conceiving the Spirit, Eisner discarded at once the notion of a costumed crime fighter, a superheroic long-underwear character. He wanted something more realistic. "When I decided upon the Spirit," he said, "I worked from the inside out, you might say. That is, I thought first of his personality—the kind of man he was to be, how he would look at problems, how he would feel about life, the sort of mind he would have."[8] The Spirit would not be deadly serious; he would have a lighthearted side that would enable him to have fun while he was getting the job done. And he would have feelings, too, emotions that sometimes showed.

Working late in his studio one night, Eisner sketched and jotted notes about his creation. "He had to be on the side of the law," he said, "but I believed it would be better if he worked a little outside of the law. In that way, he acquires some of the sympathy most of us feel for adventurers who are absolutely on their own. For the necessary connection with the regular police, I gave him Commissioner [Eustace P.] Dolan."[9] Dolan was right out of central casting: a gruff, pipe-chomping, jut-jawed Irish cop, given to muttering in his moustache about the countless abuses the world and its bureaucracies cruelly inflicted upon him but nonetheless good-hearted under all the bluster and grumping. In order to provide for an eventual love interest, Eisner gave Dolan a beautiful daughter, Ellen, who would, in the natural course of things, fall in love with the Spirit.

That night, Eisner roughed out the first story. In it, we meet criminologist Denny Colt, a friend of Dolan's who sometimes helps on difficult cases. While trying to apprehend an evil scientist named Dr. Cobra, Colt is drenched with chemicals from one of Cobra's experiments and loses consciousness. He appears dead and is promptly buried. But that night, we see him rise from the grave. He isn't dead at all. The chemicals by which he had been overcome had only placed him in suspended animation, and when he regained consciousness and found himself in a coffin, he broke out. He decides, however, to remain "dead." As "the spirit" of Denny Colt—a legal nonentity—he can fight crime in a different way. "There are criminals beyond the reach of the police," he tells Dolan, "but the Spirit can reach them." He excavates a subterranean dwelling beneath his tombstone and takes up residence in Wildwood Cemetery.

Arnold and Martin were not altogether happy with Eisner's creation. They had expected a costumed character. After all, it was the popularity of Superman and Batman and their ilk that had created the market in newspapers for a weekly comic book. Ergo, the lead character of that comic book ought to be in costume. But Eisner was adamant: "Any kind of costume would have limited the kinds of stories I could do. It would have been an inhibiting factor." Still, he recognized that his partners had a point. Reluctantly, he put a mask on the Spirit. And, later, he put gloves on his hero. And the Spirit would never remove either mask or

gloves. "Those were the only two concessions I made," Eisner said.[10] One of these concessions he turned to advantage. In his treatment of the Spirit's mask, Eisner would establish the uniqueness of his character with trademark precision. The bit of blue cloth always looked as if it had been pasted on: it was virtually a skin graft, and the Spirit's features—his eyebrows, the fold of skin under the eye—were as visible through the mask as they would have been without it.

The first *Weekly Comic Book* appeared on June 2, 1940. Two other regular features completed the sixteen-page contents: *Mr. Mystic* and *Lady Luck*. Both created by Eisner, they were produced on the weekly schedule by Powell and Viscardi, respectively.

In the inaugural Spirit story, several of the devices Eisner would employ so distinctively as to make them earmarks of his storytelling style are on display. The pictures are often heavily shadowed and the perspectives unusual. The panels are oddly shaped, sliced into narrow slivers and wedges. The unusual layout was Eisner's reaction to the severe constraint he felt under the seven-page limitation imposed upon his storytelling. "It was clear to me that the seven pages allotted was too confining," he once wrote. "I began to experiment with techniques I'd been using in comic books." In refitting *Hawks of the Seas* to a comic book format, he had used circular panels, diamond-shaped ones, and diagonals—"whatever would accommodate what I was trying to fit in." At the time, he had seen storytelling potential in the expedient. Now he began to explore the possibilities, using "a flurry of panels to speed up action, long odd-shaped panels to show dimension that a standard panel destroyed, characters popping out of panels to add depth. So much to say and so little room to say it in."[11]

By the fifth outing of the insert, Eisner's distinctive deployment of the opening page, the "splash page," had begun to surface. "When I began, I saw the splash merely as something that should grab the attention of someone flipping through the newspaper," he said. "I soon became theoretical about it and saw it as something more than a design element. It could set a scene, set a mood, define a situation."[12] As Eisner became more adept at deploying this aspect of his feature, he made an indelible mark on the art form. Some of his splash

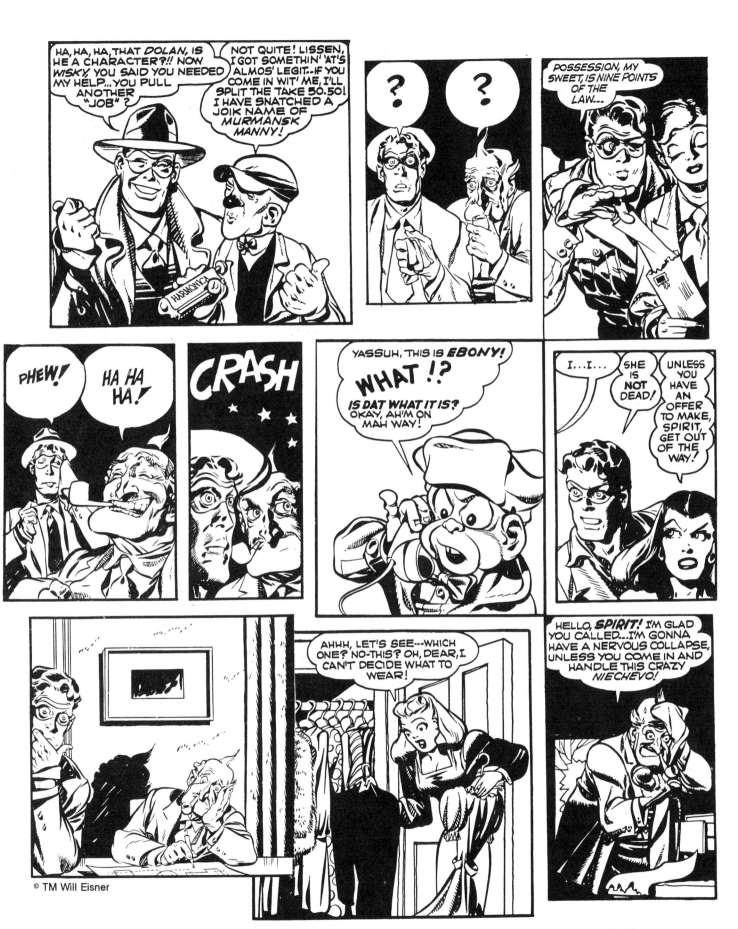

Figure 32. *A montage of portraits of the principals in* The Spirit: *Dolan, Ebony, and Ellen (at the closet)—but chiefly the Spirit, whose mask adheres so closely to his visage that we can see his eyebrows through the cloth.*

pages in later years, as we shall see shortly, were such powerful statements of mood and theme that they could stand alone as works of graphic art.

In the Spirit's second adventure on June 9, Eisner introduced a character he hadn't anticipated the need for when he'd been formulating the frame for his storytelling. Ebony White first appeared as a cab driver. A young black man, his eyes roll in that stereotypical expression of wide-eyed fright as he drives by Wildwood Cemetery. Everything about Ebony is a stereotype of his race: his large eyeballs, pink big-lipped "mushmouf," his linguistic mutilation of pronunciation and diction, his comic costume (a funny hat, a red jacket with big yellow buttons), his low-comedy behavior. Years later, Eisner would feel no little embarrassment at having perpetuated such a racial caricature. But in the summer of 1940 he discovered he had a need for Ebony: the Spirit needed someone to talk to, someone to "think aloud" with. His motivation as a detective depended upon his interpretation of evidence and events, and we had to know what he was thinking. Eisner could have depicted him wandering around all the time with his head perpetually clouded by thought balloons, but this maneuver is visually and dramatically uninteresting. It is much better theater for the Spirit to talk over his options with someone—preferably someone not as bright as the Spirit, someone to whom he would naturally offer explanations. Ebony was perfect for the role. He became a regular member of the cast with his next appearance, in the third issue of the insert. And it wasn't long before he had captivated his creator.

On September 15, only two months after being introduced, Ebony took over the entire Spirit story for a solo adventure. It was Eisner's first venture into undiluted comedy, and it had lasting repercussions. Until the introduction of Ebony, Eisner's work had been pretty much straight-faced realistic illustration and serious storytelling. After Ebony's arrival—after the September 15 story in particular—we can find more humor in the Spirit stories. Sometimes the humor takes the form of outright comedy, as in the Ebony story. But most of the time, the characteristic Eisner risibility is found in facial expressions, unexpected exaggerations of anatomy, the way a person holds something or walks. Hereafter, humor is a hallmark of *The Spirit.*

About Ebony, Eisner was never apologetic (and

rightly so). The character grew on him, as many comic strip characters do with their creators. Eisner came to regard the character with great affection, and he concocted many occasions for the black youth to prove that he was more than a stereotype—that he had a personality of his own, that he had dignity and intelligence and resourcefulness. Eisner's latter-day discomfort with the character arose from his realization that he had employed a racial stereotype, often in stereotypical fashion. But this portrayal was more the result of blindness than bigotry, a consequence of an unwitting insensitivity to the feelings of other races rather than a desire to persecute. In this, Eisner—despite having endured the slings and arrows of anti-Semitic prejudice himself—was doubtless much like many good-intentioned whites of his generation. Taught that racial differences ought not to matter, he overlooked them. He was blind to them. And yet he recognized comedy where everyone else found it in those days: he recognized it in Amos and Andy, in Stepin Fetchit, in Butterfly McQueen, in little Buckwheat. In discussing the issue with interviewers years later, Eisner reminded them that the United States was a country of immigrants "with funny hats and funny ways," eccentricities that created a foundation for much American humor. "It was perfectly acceptable for a long time to make fun [of such minorities] or to employ humor that was built around the differences in color, differences in ways of talking," he explained. "I was a creature of the times—as all writers are. Very few writers can claim to be that far ahead that they don't reflect the humor of their times. To me, Ebony was a very human character, and he was very believable—at that time."[13]

The first Ebony solo story had served to establish aspects of the character's personality. Eisner had invented story lines before to serve this purpose for other characters; and he would do it again, many times. He often selected a case for the Spirit solely because it afforded him the chance to display a facet of his protagonist's personality that had heretofore escaped notice (as in the story we'll examine in chapter 8). "The main thrust of my effort," he said once, "was to create a human character."[14] His passion for developing his hero's personality grew into a fascination with the human condition generally. After the diversionary Ebony story proved edifying as well as entertaining, Eisner frequently treated the Spirit's case in a giv-

Above, originally published January 12, 1941.

Right, originally published December 8, 1940.

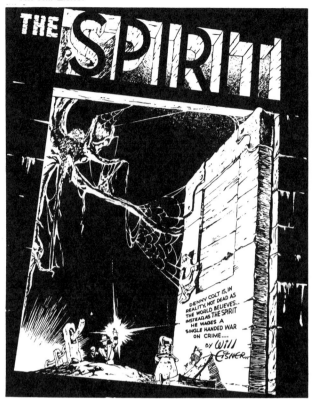

Originally published January 5, 1941.

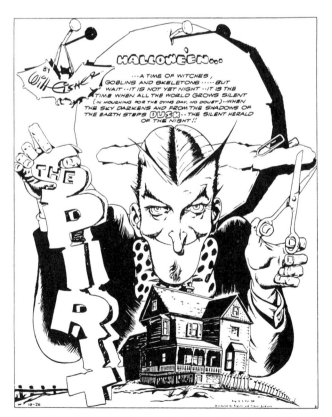

Originally published October 26, 1941.

Figure 33. *Splash pages from the first two years of* The Spirit.

en week as an excuse to develop an element of general human interest, shifting the spotlight off his hero, sometimes for most of the story. Time after time, he focused on some ordinary soul, a perfect specimen of common humanity, whom he would confront with some extraordinary event— and then watch to see how the character reacted, how he survived. "I have something of an obsession with this," he admitted, "—with time, with meanings in life, with what motivates people to go on when they're faced with terrible problems, with the idea of a single life being affected by larger events."[15]

By December 1940 all the characteristic Eisner storytelling ingredients were in the mix, and the distinctive Spirit story began appearing regularly. With virtually every appearance of the feature, Eisner advanced the art of cartooning, introducing some new attitude or treatment or plot twist that demonstrated what the medium was capable of. As Cat Yronwode, Eisner's biographer, observed: "The strip proved to be exactly the vehicle Eisner needed to take his already daring ideas one step further. From a modest beginning, the series rapidly evolved into a one-man virtuoso exploration of the comic medium's potential."[16] Eisner and his creation were poised on the brink of a great continuing experiment. But the expectant air that everyone was breathing in that season was not of an artistic sort: the U.S. Congress had passed the Selective Service Act in September, and everyone expected war with Germany sooner or later. Eisner, a bachelor, knew he would be among the first to be called if war broke out.

The *Weekly Comic Book* proved financially successful. Although it was not picked up by an impressive number of newspapers, the papers that did subscribe were large metropolitan dailies, and they paid fees based upon circulation that were substantial enough to generate a good profit for Eisner's operation. At some of the larger newspapers, editors began asking about the possibility of a daily strip version of *The Spirit*. In the fall of 1941 Eisner complied. The daily strip began October 13.

Producing a daily syndicated comic strip had been the pinnacle of Eisner's youthful dreams, but after doing one for a while he was no longer a hostage of that ambition. Having worked in the more spacious format of the comic book page, he found the strip format confining in the extreme: "It's like trying to conduct an orchestra in a phone booth,"

he said.[17] Still, his creative energies heated to a roiling simmer, he played with the new format in much the same manner as he had tinkered with the pages of comic books. One memorable installment, for instance, consisted of a single narrow panel that did no more than depict the Spirit's footprints in the snow (figure 34). It was a suspenseful maneuver: the footprints led from left to right, step by step; then at the extreme right of the panel, the Spirit lay prostrate—wounded and exhausted by his effort to find help.

But Eisner would not have time to explore the medium much more. Early in 1942 he was notified that he would be inducted into the army in May. He and Arnold scrambled to organize the shop to continue producing *The Spirit* during his absence. The daily strip would be drawn by Lou Fine and then Jack Cole until it ceased in 1944; the weekly supplement was written by Toni Blum and others and drawn by various hands throughout the war years. Meanwhile, in the army, Eisner soon attracted attention with his cartoon contributions to *The Flaming Bomb*, the base newspaper at the Aberdeen Proving Ground in Maryland. Transferred to the Pentagon, he was assigned a pioneering project—to create cartoons that would instruct soldiers in safety and preventive maintenance in such publications as *Firepower* and *Army Motors*. He was art director of the latter when he was discharged in 1945 after the war.

Producing educational cartoons had piqued his creative imagination, however, and in 1950 he would apply successfully for a government contract to produce for the military a monthly magazine called *P*S*, which continued the effort he'd begun while on active duty. He formed his own company, American Visuals, to produce the magazine and other related products that used cartooning to heighten soldiers' awareness of safety, personal hygiene, political responsibilities, equipment repair and maintenance, and the like. By the end of 1952 the challenges in this new field of endeavor became so absorbing that Eisner left the world of commercial cartooning altogether to concentrate his energies on producing cartoons for educational purposes, thereby expanding the horizons of the art form even further than he had done already in comic book format. But when he first returned to civilian life after World War II, Eisner took up pen and brush to revitalize his creation.

Figure 34. *Three consecutive daily strips, from January 1 through 3, 1942, the last one demonstrating Eisner's impressive use of the strip format to create dramatic emphasis.*

The Spirit had fallen into disrepair at the hands of others: they did not understand the character, nor did they have Eisner's artistic ambitions for the medium. But when the master returned, he quickly recaptured "the spirit" of the prewar crime fighter. It was, however, more than a rehabilitation: his ambitions intact, Eisner improved upon past performances. Both his vision and his graphic style had matured; his sheer technical skill was greater by reason of additional years of practice. And after more than three years away from the feature, Eisner was full of ideas and eager—impatient—to continue his work. Consequently, *The Spirit*, the end product of vision, style, technical skill, and creative passion, ascended to the level of its greatest experimentation and achievement.

EISNER'S POSTWAR GRAPHIC STYLE was more confident, his line bolder. His sense of composition was surer: his figures seemed not just to occupy the panels but to fill them. And he used black more extensively, sometimes drenching whole stories in inky shadow. These, Eisner said, were "two bottles of ink" stories. The black pages of a two-bottle story set the somber mood for a serious story. "The colors of black and white are, in effect, my sound track," Eisner said. "It was the only thing I had to work with in the area of special effects. It's the only thing . . . that goes beyond what's on the paper. You reach out and try for any kind of device to secure the attention and control the mood of the reader."[18]

Not all the shadows were solid black. From the

Figure 35. *Eisner played with light and shadow, producing an endlessly fascinating series of moody effects.*

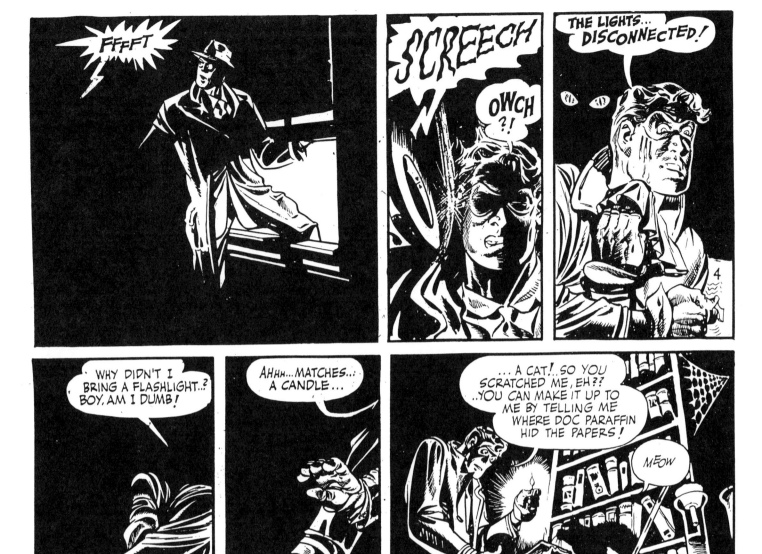

© TM Will Eisner

Figure 36. *Here Eisner brings the Spirit into a darkened room, which is illuminated (but only slightly), we assume, by whatever light is outside in the night—the stars, a street lamp; and the Spirit gropes around until he finds matches and a candle (March 7, 1948).*

illustrator J. C. Leyendecker, Eisner picked up the so-called trap-shadow technique of creating transparent shadows, shadows not quite as dark as others. "Leyendecker would outline the [shadowed area] and then stroke lines across [the outlined space] in a kind of grid," Eisner explained.[19]

In his stories, Eisner continued to peer into the lives and aspirations of ordinary people. And his villains were no more distinguished. As fellow cartoonist Jim Steranko has observed, the Spirit battled "worn-out felons, bowery pickpockets, nickel and dime shoplifters, street corner punks, city hall grafters, shabby con men, furtive sneak thieves, stripe-suited pimps, weak-willed winos, sweat-stained stoolies, baggy pants torpedoes and a rogue's gallery of other three-time losers."[20]

The Spirit himself was all too fallible. He had a sublime faith in himself, but events often proceeded beyond his ability to control them. The petty crooks he pursued frequently met their just deserts through some quirk of fate over which the Spirit had no control. His most outstanding trait as a criminologist was his ability to endure physical punishment: the Spirit is undoubtedly the most beat-up crime fighter in the history of detective fiction. But he always survived. And in so doing, he embodied an aspect of the theme that pervades Eisner's work—the conviction that the little man, ordinary people in general, can survive the vicissitudes of life and can, perhaps, rise above their apparent limitations, particularly when unexpectedly challenged by an unusual circumstance.

Newspaper editors sought more humor in their features in the years immediately after the war, and Eisner responded. "I always thought that humor and action weren't mutually exclusive elements and that humor could be used to leaven many scenes," he said.[21] Sometimes, focusing on one or more of a collection of street urchins that seemed to gather around the Spirit, Eisner would tell a strictly comic tale. Sometimes he ran a comic subplot that paralleled the story's serious main event, and most of his stories displayed some form of humor. Many of his humorous touches were purely visual—a comic facial expression, a clownish gesture, a funny hat. The Spirit himself became something of a tongue-in-cheek character: Eisner confessed both amazement and amusement at "a guy who would run around in a mask and fight crime." Acknowledging that his drawing style was only "somewhat realistic," Eisner said: "I employed exaggeration where I felt I needed it, and where I felt I wanted to be serious, I didn't employ exaggeration. I played it the way you might in music. You get louder when you feel you want to emphasize something; and you get quieter when you feel you want a downbeat. Use any device the situation allows."[22]

The storytelling devices Eisner had introduced before the war he took up again and honed to an acute rhetoric of comic book storytelling. He lavished particular care upon the splash pages.

> His use of The Spirit logo was awe-inspiring. The letters were formed by the tops of buildings in a Damascus bazaar, by the spinning waters of a whirlpool, on street signs, by the columns of a crumbling house, or on billboards, in newspaper headlines, on telegrams, spelled out by a rotting fencepost, or embroidered on a rippling veil through which the domes and minarets of Turkey could be seen. Three-dimensional objects were thrust out of a two-dimensional medium. Photographs, notes, messages were tacked and paper-clipped onto the page. The pages themselves were occasionally drawn as though ragged and torn. And the splash page sometimes became that of a book, drawn with depth and dimension, with bent corners and frayed edges.[23]

If Eisner had drawn in a straight illustrative style, the inventiveness of his splash page compositions would have undermined his realistic effects. But his humorous graphic style permitted this kind of playfulness on the splash pages. Eisner was always aiming for effect: "The big thing for me in any splash page is to secure control over the reader," Eisner said. "You set the mood and form your contact with the reader at that point." Noting that the reader would likely pause a millisecond or so before turning the page, Eisner said he had determined to use that moment to suggest the proper attitude to adopt toward the story that followed. During that brief pause, the reader, prompted by the picture before him, would decide whether the story was a mystery or a fable or a comedy and would assume the appropriate mental posture. "That's what I counted on, and it's really the logic with which I approached all opening splash pages. I'm concentrating everything on capturing the reader's imagination, on capturing his or her mood."[24]

Many of the splash pages were strictly mood pieces; some were the opening scene of the story. On several of the earliest, the giant figure or face of the Spirit hovered over the mean streets of the city like a silent guardian of justice. We enter a tale about a haunted house by coming through a cobweb-shrouded doorway (see figure 33). For a story that takes place in the sewers of the city, the letters of the title character's name are structured and stacked to represent the architecture of the world beneath the streets (figure 38). When we meet a treacherous femme fatale named Powder, we see her Circean form first through a spider's web—in the center of which the Spirit is dangling (figure 39).

Not all of the splash pages were so grimly serious. Eisner did comedy, too. Howard Hughes had

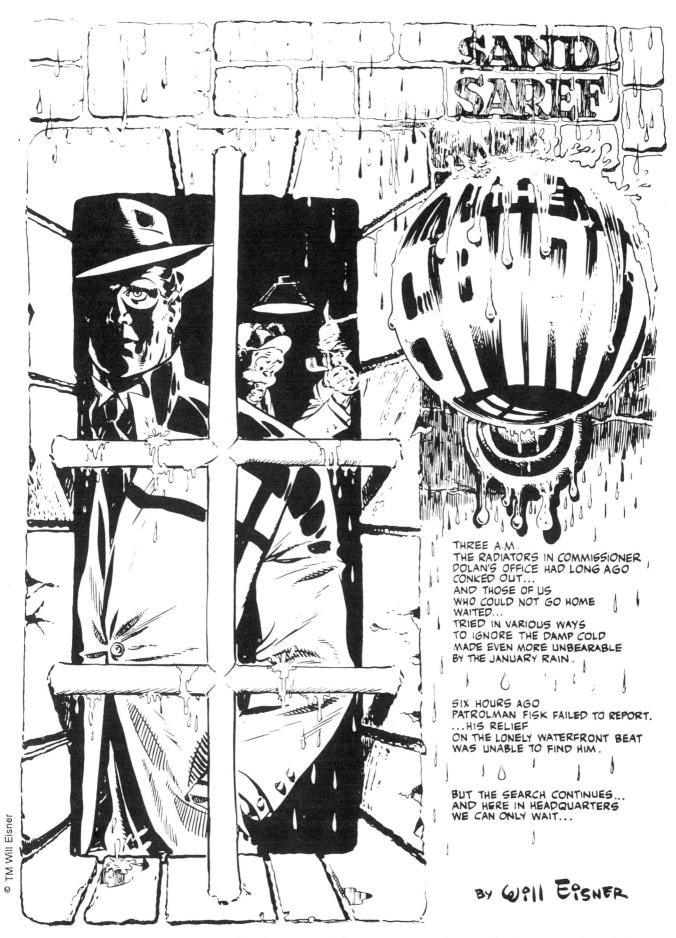

Figure 37. *With rain and shadow, two of his favorite visual devices, Eisner sets the mood for the story on this splash page from January 8, 1950.*

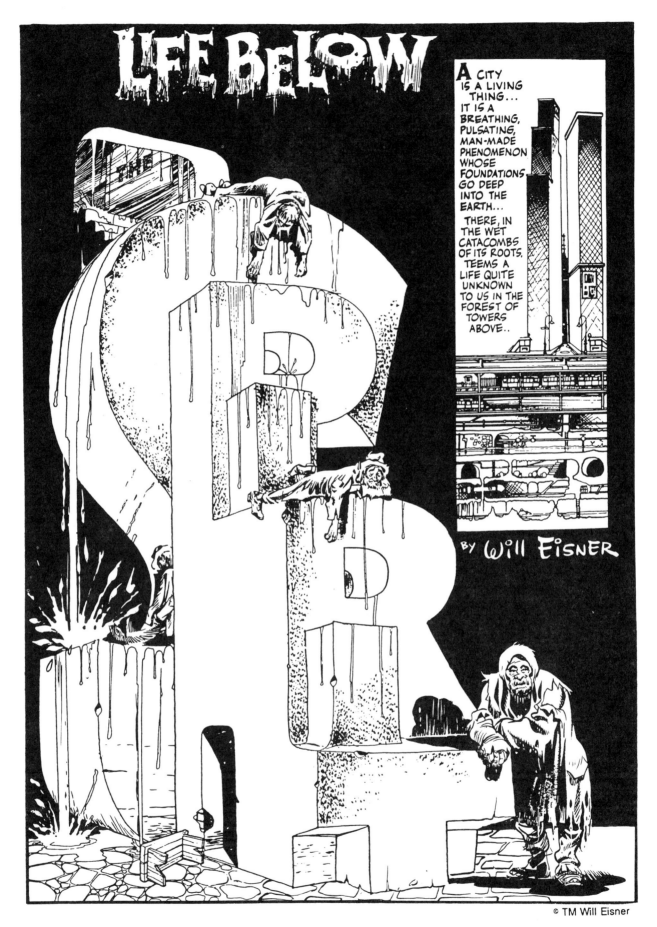

Figure 38. *Eisner was almost always able to incorporate the name of the feature into the splash page design. (February 22, 1948)*

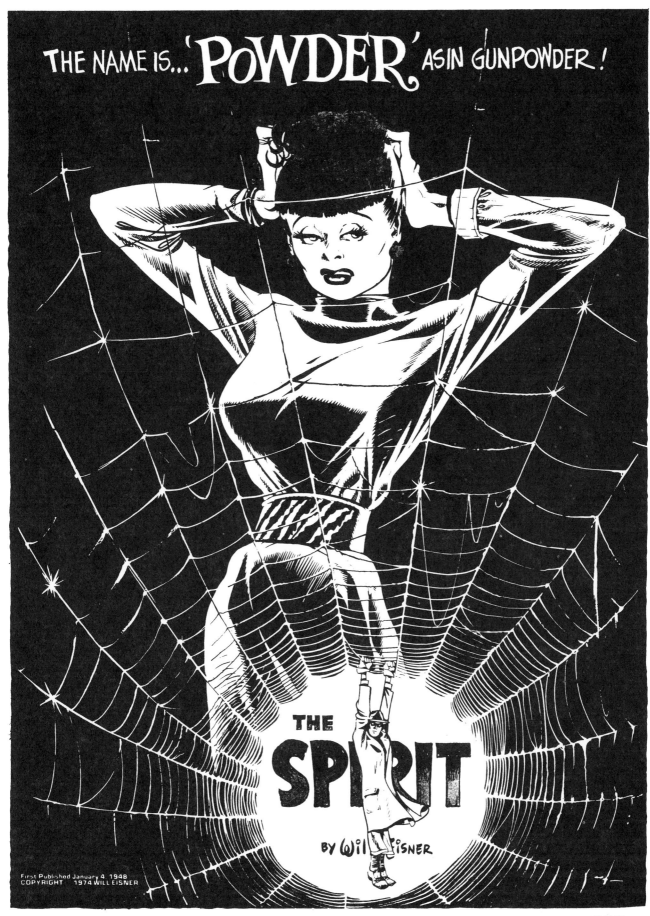

Figure 39. *When the Spirit's opponent in a particular story was female, the splash page could be used for an alluring display of femininity. And in this case, Eisner gave his picture a symbolism appropriate to the story. (January 4, 1948)*

caused a national sensation when he finally released in 1943 his 1941 production of *The Outlaw*, with Jane Russell in spectacular décolletage. In 1946 Eisner spoofed the movie's promotional poster (and the public's preoccupation with the movie star) by creating a parody splash page that showed "Olga Bustle—the Girl with Those Big, Big Eyes" in a characteristic Russell pose (figure 40). Sometimes, Eisner once confessed, his stories started with the splash page: his desire to draw a particular picture led him to invent a tale to go with it. This story, about an impressively endowed movie star whom the Spirit irritates by ignoring, is doubtless one of those.

Eisner's Spirit stories were laced with femmes fatales of the most glamorous sort. "Other artists have drawn [women] more voluptuously but never with more character," Steranko wrote.[25] And they had names that whispered romance while hinting at heartbreak—Autumn Mews, Wisp O'Smoke, Wild Rice, Thorne Strand, Flaxen Weaver, Silk Satin. All were petty criminals or gunsels' molls or otherwise persons of questionable character. The most insidious of them all was P'Gell, and the splash page by which Eisner introduced her in October 1946 is one of the most reprinted of his drawings (figure 44). Her name echoing the sound of the notorious Parisian district, Place Pigalle, P'Gell is not exactly a crook. She does not steal money; she marries for it. Her husbands are the crooks—crooks or con men of one description or another. They are also deceased: they tend to die shortly after marrying P'Gell. But since they are criminals, no one seems to mind very much. P'Gell is an international operator; her quest for wealthy husbands knows no borders.

The introductory splash page captures all of P'Gell's qualities. The minarets of Istanbul in the background imply her worldly milieu. Her full figure, revealing gown, and sensual pose tell us that she is a woman who uses her body as bait. The veil and the cushions upon which P'Gell reclines combine with the Middle Eastern scenery to suggest a harem setting for the story—or, at least, a bedroom—reinforcing our impression about P'Gell's use of her charms. And the Spirit's entrance, his face and form partially hidden (by means of a delicate deployment of Craftint), seems intrusive in this private, sexual sanctum. We cannot help but be intrigued and a little alarmed by

this tableau. Eisner carries the motif of the veil (and hence of the perfumed and sensual seraglio) forward onto the next page of the story (figure 45). P'Gell seems always to be in a curtained room, a boudoir (her place of business), and her luxuriant figure is on display throughout, a constant reminder of her sexual campaign. But we see her almost always through a veil that obscures our view, as if by looking at her we are performing some forbidden act. Despite P'Gell's allure, we sense danger in her proximity. And, as it turns out, rightly so: she polishes off two husbands in this story.

It was often raining on the splash pages. It rained in sheets; it rained in cascades. Relentless, driving rain that Kurtzman would call *Eisnershpritz*. Depicting weather, Eisner believed, was one of the few things he could do in the medium that would evoke a predictable response in his readers. "Rain, snow, cold, heat—all of the climatic extremes conjure definite feelings," he said. And so does rain. "You can have two men standing on a street corner talking about anything, but if you add a driving rain, it adds a drama to whatever they're saying."[26] And a lonely figure like the one beneath the Spirit sign in "A Legend" (figure 46) is made forlorn and therefore intriguing because he is standing in the rain.

The splash page for September 19, 1948 (figure 47) incorporates several favorite Eisner devices. It's raining, and it's inky with atmosphere, a two-bottle page. It's mostly silent—except for telling sound effects. And there's movement, progression, functioning as a sort of prologue. The dark enveloping cloak of night parts only for light sources—sometimes steady, like the light identifying the police station; sometimes intermittent, like lightning. Punctuating the darkness with instances of light, Eisner tells his story as a series of revealing glimpses. First, we make out a police station in the distance. Then by the flash of a lightning bolt, we see a figure walking in the storm. Since we are closer to the police light in the next panel, we know the figure is approaching the station. Next, he's inside—leaving puddles of water wherever he steps, his heels clicking regardless of the damp. The door to Dolan's office opens with a creak, and we see Dolan, sitting alone in his office, wholly in the dark except for the meager glow from his desk lamp. (We can see the front of his suit coat, so we know the desk lamp is on; further evidence, in

Figure 40. *The Spirit stories were often humorous, and here, the satirical mood is established on the splash page. In addition to parodying the Howard Hughes film,* The Outlaw, *Eisner's drawing includes some old-fashioned action, with the Spirit on the receiving end of a criminal assault. (September 1, 1946)*

Figure 41. *Here, the letters of the name of the feature create a kind of solitary street corner where Launcelot Cool stands alone (and forlorn!) under a street lamp (December 18, 1949).*

To the north of Central City, on a hill overlooking the bustling metropolis, lies abandoned Wildwood Cemetery. Here, hidden in the tangled weedy growth, is the hideaway of the Spirit. Accepted by the police as a friendly 'outlaw' and feared by the underworld, his true identity is still a mystery. Who is really the man behind the mask? Every so often, someone tries to find out...

Originally published October 9, 1949

The Story of GERHARD SHNOBBLE

Originally published September 5, 1948

BY Will Eisner

BEFORE WE BEGIN THIS STORY WE WANT TO MAKE ONE POINT VERY CLEAR...

THIS IS NOT A FUNNY STORY !!

WE MEAN TO GIVE YOU A SIMPLE ACCOUNT OF GERHARD SHNOBBLE... BEGINNING AT THE POINT WHEN HE FIRST DISCOVERED HE COULD **FLY.**

PLEASE.... NO LAUGHTER....

© TM Will Eisner

the CHRISTMAS Spirit

BY Will Eisner

nd on this day those who all the year are grasping, and seek riches from others, pause for one brief moment and become kind, human, generous beings... all that dreamers believe men should be...

r so the legend runs...

Originally published December 19, 1948

Originally published February 13, 1949

Figure 42. *An assortment of mood-setting splash pages: a towering figure of the Spirit asks visually the same question that begins the story; two pages composed chiefly of lettering suggest that the tales to follow are fairy tales or fables; and the outer space motif of the fourth splash correctly predicts a science fiction story.*

August 10, 1947

Figure 43. *Eisner did not overlook the storytelling possibilities in body language, which he explored in silent sequences like this one, in which the Spirit's posture and movements tell us as surely as words that he is exhausted, beaten.*

Figure 44. *On one of his most spectacular splash-page evocations of mood, Eisner introduced P'Gell, a particularly dangerous female of the species (October 6, 1946).*

Figure 45. *On the second page of the P'Gell story, Eisner continues the steamy sexual imagery.*

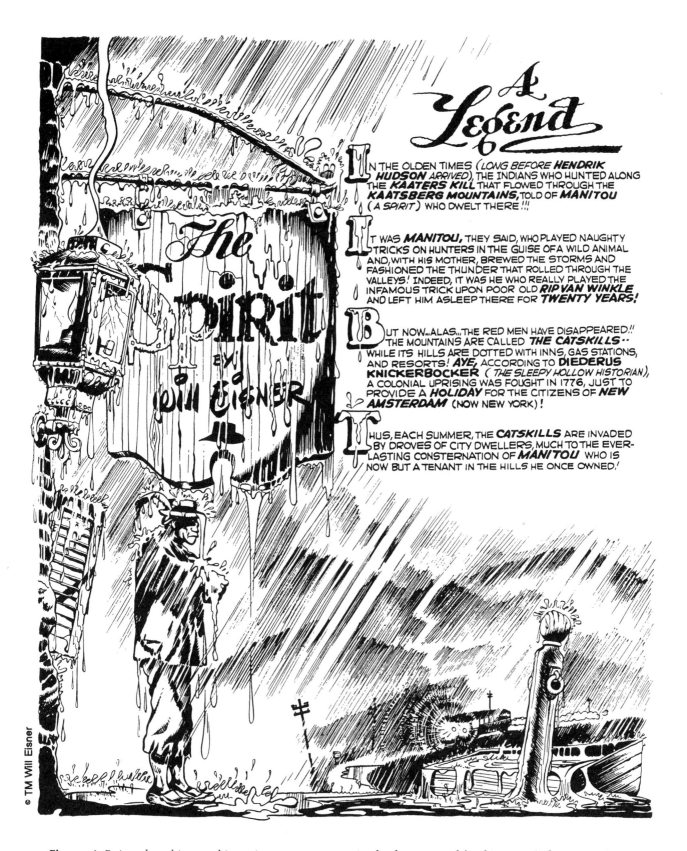

A Legend

I N THE OLDEN TIMES (*LONG BEFORE HENDRIK HUDSON ARRIVED*), THE INDIANS WHO HUNTED ALONG THE *KAATERS KILL* THAT FLOWED THROUGH THE *KAATSBERG MOUNTAINS*, TOLD OF *MANITOU* (*A SPIRIT*) WHO DWELT THERE !!!

I T WAS *MANITOU*, THEY SAID, WHO PLAYED NAUGHTY TRICKS ON HUNTERS IN THE GUISE OF A WILD ANIMAL AND, WITH HIS MOTHER, BREWED THE STORMS AND FASHIONED THE THUNDER THAT ROLLED THROUGH THE VALLEYS! INDEED, IT WAS HE WHO REALLY PLAYED THE INFAMOUS TRICK UPON POOR OLD *RIP VAN WINKLE* AND LEFT HIM ASLEEP THERE FOR *TWENTY YEARS!*

B UT NOW...ALAS...THE RED MEN HAVE DISAPPEARED.!! THE MOUNTAINS ARE CALLED *THE CATSKILLS*·· WHILE ITS HILLS ARE DOTTED WITH INNS, GAS STATIONS, AND RESORTS! *AYE*, ACCORDING TO *DIEDERUS KNICKERBOCKER* (*THE SLEEPY HOLLOW HISTORIAN*), A COLONIAL UPRISING WAS FOUGHT IN 1776, JUST TO PROVIDE A *HOLIDAY* FOR THE CITIZENS OF *NEW AMSTERDAM* (NOW NEW YORK)!

T HUS, EACH SUMMER, THE *CATSKILLS* ARE INVADED BY DROVES OF CITY DWELLERS, MUCH TO THE EVER-LASTING CONSTERNATION OF *MANITOU* WHO IS NOW BUT A TENANT IN THE HILLS HE ONCE OWNED.'

The Spirit
BY
Will Eisner

Figure 46. *Rain—drenching, soaking rain—sets an appropriately gloomy mood for this story.* (*July 21, 1946*)

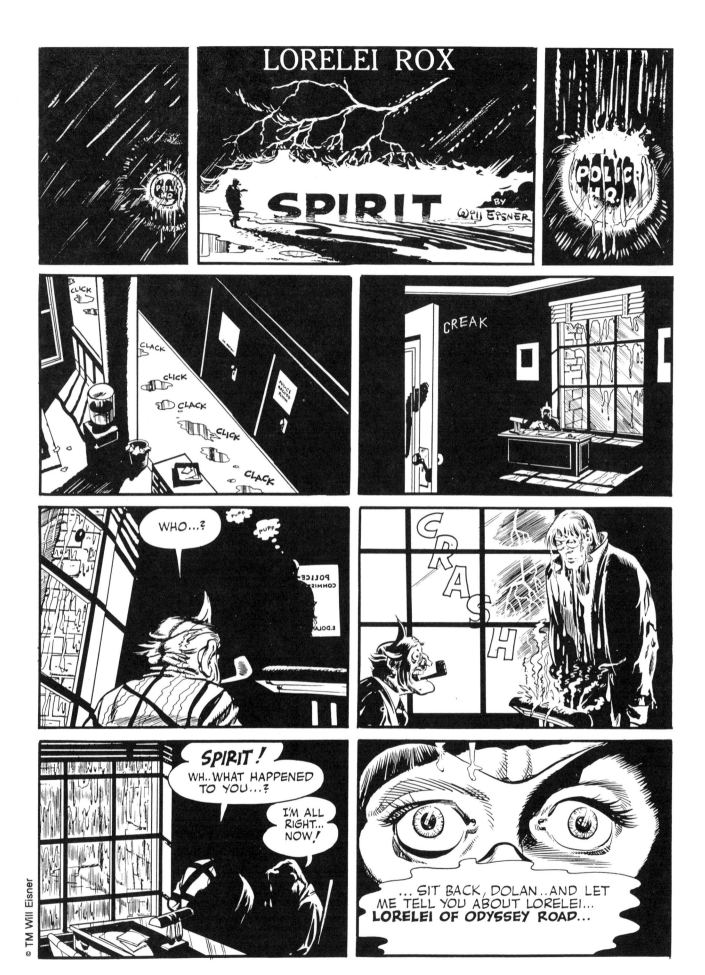

Figure 47. *This splash page is a particularly impressive demonstration of storytelling and mood-setting. (September 19, 1948)*

panel 7, the water falling from the Spirit sizzles as it strikes the heated metal shade of the lamp.) Dolan can't tell who his visitor is: standing between Dolan and the door, the figure is an anonymous silhouette against the light in the hallway. But when lightning crackles again, Dolan is astonished to find the Spirit before him. The successive moments of illumination are timed by Eisner's silent progression of panels, building suspense until the moment of revelation in panel 7. And then, as in any good prologue, one revelation leads to the next, and the Spirit begins to tell his story in the last panel.

The page is a study in visual storytelling. Nothing on this page is haphazard. The objects Eisner elected to show us, as well as the moments he chose to reveal those objects, have been selected with great calculation. Each illuminated detail tells us something that advances the story; each picture is a successive moment in a progression of moments. The use of light reveals not only the story but something of the storyteller: by controlling the light as severely as he does, Eisner demonstrates just how deliberate a craftsman he is. A virtuoso performance, the page sets the mood of mysteriousness and vague alarm for the story to follow by being itself a mystery with a moment of fright.

On November 30, 1947, Eisner told the story of Slippery Eall's attempted breakout of prison, a tale that began with another of his most celebrated splash pages (figure 48). Dramatic perspective directs our attention to the Spirit walking a deserted street at night, but the composition of the page forces us to focus next on the sewer drain grate in the foreground. In a discarded newspaper, we read about Slippery Eall's capture, and we also read a short sermon on crime, a sermon that gives symbolic meaning to the gutter water that drips into the drain before us. The motif of dripping water carries us into the story on the next page (figure 49): masterfully, Eisner moves us from above ground to below ground, into the sewer itself, by following the trickle of water. As we discover that the sewer flows by the subterranean windows of a prison, Eisner's method conjures up a powerful imagery of crime and criminals, of dank and odoriferous life in the sewer, and of sewer rats. The page continues to inch the story along in Eisner's best *film noir* manner—shadowy scenes shot from unusual perspectives, minimal verbiage. (The story

also includes an inside joke. The three convicts are caricatures of Eisner, who plays Slippery, and his letterer, Able Kanegson, the heavyset man with the hairy arms, and his background assistant, Jerry Grandanetti, the gaunt fellow in the upper bunk. The three men worked long hours together in Eisner's studio. "We used to talk in the studio about how if we were sent to jail, it wouldn't make any difference," Eisner said. "We could still turn out comics and our lives would not be a hell of a lot different."[27] Here, he gives metaphoric reality to his sardonic observation.)

Each story's splash page was an opportunity to experiment with attention-getting and mood-setting graphic devices. And each week's story was another opportunity to experiment with treatments and themes. Sometimes Eisner parodied popular radio programs or movies. He often told fables, modern morality dramas. He adapted fairy tales to contemporary life, devising splash pages composed of elaborately decorative lettering like that found on illuminated manuscripts in order to evoke a Germanic iconography that he associated with such tales—he and Walt Disney in most of his full-length animated features. He explored the supernatural, the inexplicable, and he dabbled in science fiction. He played with sound effects and time. He used music—song lyrics—and poetry. "I had total or near-total creative freedom," Eisner said. "There was nothing that stood in my way other than the dimensions of the paper and the restrictions of the print media. It made *The Spirit* years wonderful years."[28]

About his tireless experimentation, Kurtzman observed, "Eisner became a virtuoso cartoonist of a kind who had never been seen before in comic books—or, for that matter, in newspaper strips. He used all the elements of the comic book page—dialogue, drawing, panel composition, color—with great daring, but never at the cost of narrative clarity."[29]

The Spirit spent most of his time in the city, but he also went out West, and overseas to the Middle East and to South America. Eisner's imagination, however, transcended mere geographic locales. The action of one story took place entirely in an elevator. And because the Spirit himself was invented as a hook to hang stories on, he was sometimes elbowed out of the story almost entirely, especially when Eisner was exploring some new storytelling notion. In a story called "Two Lives," Eisner used

SLIPPERY EALL

Figure 48. *Perspective directs our attention to the Spirit, but the sewer grate in the foreground is our entrée to the story. (November 30, 1947)*

Figure 49. *Masterfully, Eisner next brings us into a prison cell by way of the sewer he'd displayed on the "Slippery Eall" splash page (figure 48).*

the comic book format to present the stories of two men side-by-side on the pages, events in one life virtually mirroring events in the other. The Spirit appears in only two panels and is entirely incidental to the plot. Similarly, he has only a walk-on part in "Ten Minutes," a memorable story that contradicts the assumption that nothing very important can happen in ten minutes (the time it takes to read a Spirit story). In the allotted ten minutes, we watch a punk kid commit his first (and last) crime: he robs a neighborhood candy store, accidentally kills the owner, flees the police, and is run down by a subway train. The Spirit shows up toward the end and, in an exchange with Dolan, asks the loaded question that gives meaning to the story's theme: "I wonder just when it was that Freddy started on his crime career." It was ten minutes ago, Spirit—only ten minutes ago.

It was this sort of ending that Eisner strived for. A student of O. Henry and Ambrose Bierce, Eisner knew that a short story was a literary exercise contrived for its ending. He liked a story that ended in a way that provoked readers to fill in some blank places to complete the tale. "That gives the story a resonance that goes on past the last panel," he said, "and that's what I would often try for."[30]

Eisner's endings were sometimes like puzzles: the stories propounded a theory, dramatized it, and then left the reader to decide for himself the truth of the matter. Such a story was "The Case of the Double Jones." On the splash page, the Spirit appears next to a filing cabinet from which he has taken the file on the Jones case. "There is an old legend in German folklore," the Spirit says, "which tells of the doppelganger, who was supposed to be a man's second self, or an exact physical duplicate, who pursues him relentlessly. Of course, this is only a silly legend. But take the case of Joe Jones, for instance . . . "

Joe Jones and his partner find a gold mine in Alaska, whereupon Jones kills his partner in order to reap the rewards himself. When he goes to file his claim, he discovers to his astonishment that the file clerk is his double—and even has the same name! Jones invests his money in a gin mill but gets into difficulty with the local mob, representatives of which show up to teach him a lesson. At the critical moment, a stranger walks in and kills the thug, saving Jones's life. The stranger is the double. Jones runs into his double a couple more

times before he arrives in the Spirit's home town, where he sets up in business again. Before long, though, he's in financial straits once more: he needs $100,000 to make up a shortage. As before, his double shows up and gives him the money. This time, Jones is alarmed. "This has got to stop," he says, and his double assures him that "tonight you will be rid of me forever." Jones thinks his double intends to kill him and goes to the police.

Dolan calls in a psychiatrist, who, after listening to Jones's tale, declares that he has "a doppelganger complex—he's suffering from hallucinations." At that moment, Dolan gets a phone call from the Spirit, who has trailed a bank robber to his hideout—"a guy named Joe Jones," he tells Dolan. While the Spirit lies in wait for Jones to return to his lair, Dolan turns to the Jones in his office and says, "Jones, I think you had better stay right here."

The action shifts to the hideout, where we see the Spirit and officer Klink searching for evidence (figure 50). The page is another two-bottle exercise in highlighting key visual moments. In panel 2, however, Eisner's effort is not altogether successful. The double is masterfully depicted: lighting his face from below gives him a suitably spectral appearance. But the angle required for that revelation creates other problems. The Spirit must be positioned in the foreground in order to shine his flashlight on the double. And if the Spirit is in the foreground, won't his body be between us and the flashlight? If so, how will we know where the light that illuminates the double's face comes from? Eisner's solution was to give us the Spirit's face in close-up, partially lit by the flashlight that he is presumably holding up near his face. The highlights on the profile indicate the presence of a light source; the muzzle of the flashlight at his chin confirms its presence. But the white space emanating from the flashlight—the light itself—is a makeshift maneuver: Eisner almost never depicted light in this fashion, as the equivalent of a physical object; he usually indicated the presence of light by showing us what it is shining on. Moreover, the close-up of the Spirit creates the illusion that the perspective is askew: perspective has been properly deployed, but there is not enough of the Spirit visible in the frame to convince us.

Other aspects of the page provide a vivid demonstration of the kind of compression Eisner some-

Figure 50. *Eisner crams this page with telling panels, some establishing mood, others advancing the story by ingeniously depicting more than one narrative element per panel. (October 19, 1947)*

times had to achieve in his breakdowns in order to get his story told in the prescribed seven pages. Panel 4, for instance, depicts two separate actions: the double's flight down the stairs, and the Spirit grabbing his cohort and indicating that they should pursue their quarry by going out the window behind him. The Spirit's gesture with his left hand is deftly emphasized by silhouetting his hand

against the open window—an expert composition, but the panel still attempts too much.

Eisner's dilemma was created by his artistic aspirations: in his storytelling, he tried for effect as well as simple narrative. Creating effects takes space. So does narrative clarity. And there wasn't much space in seven pages to begin with, and the more complex Eisner's story—the more ambitious his experimental efforts—the more cramped the space became. Both panel 1 and panel 2 are larger than the narrative requires in order to permit Eisner to create moody lighting effects. Panel 1, for instance, could have been a medium-distance shot, with the Spirit in the foreground from the waist up, holding some money in his hand, and Klink visible over his shoulder. (Compare a similar scene in figure 97 for an example of Eisner's alternative in another story.) Depicting that tableau would take only about half the space of the present panel 1. But Eisner wanted to bathe his principals in shadow, and he wanted to depict them in full figure; that takes space. Similarly, the essential narrative elements of panel 2—the arrival of the double, catching the Spirit and Klink in his hideout— could be depicted in a panel about half the size had Eisner not wanted a substantial area of solid black, substantial enough to create a dramatic contrast to the lighted parts of the panel. Consuming that much space for the action and atmosphere of the first two panels, Eisner didn't have room left to employ two panels in which to depicting the two actions he has collapsed into panel 4.

In panel 6, he again crams into one picture a number of objectives. The city lights glimmering in the distance are a nice effect, certainly worth the effort. To get that effect while simultaneously giving dramatic emphasis to the car chase required the unusual perspective adopted in the panel. A picture of one car chasing after another in a static medium is not inherently exciting, but it can be given some interest by twisting the angle from which the cars are seen. Depicting the lead car from below the front emphasizes the vehicle's forward thrust, but from that angle it's difficult to see the pursuit car—particularly with the distraction of the city's twinkling lights in the distance. Eisner's solution was to throw up a billboard to catch the pursuit car's headlights, thereby "reflecting back" upon the light source. In the next panel—a close-up with not enough room to show much of the pursuit car's interior—Eisner makes

sure we know where we are by showing the rear of the double's car in the distance.

That panel 6 was created largely for atmospherics (the city lights, the high-speed car chase) became apparent when Eisner recycled the story three-and-a-half years later. Two or three times in the last years of the feature's run, Eisner was so preoccupied with the educational enterprises of his business that he reprinted an earlier story in order to make his weekly deadline. When he used the Double Jones story a second time, he eliminated panel 6: the story went from panel 5 to panel 7. (And as a result, the composition of panel 7, showing the pursued car in the distance, became crucial to understanding the continuity.)

Eisner was always wrestling with questions about what to include and what to omit when mapping out his stories. "Whenever I consider how much story I was trying to tell in seven pages," he said, "I always had to pause and wonder if it was the wisest use of three panels to show what was basically the Spirit punching somebody in the face. But when I saw how much it added to the storytelling, if not the story itself, I would usually decide it was worth it to add a touch like that, even if it did eat up quite a bit of space."[31]

On the next page of the story, the Spirit and Klink trap the double in another hideout, and the Spirit is wounded. Klink radios Dolan, tells him the Spirit has been injured, and says he's going in after "Jones." At headquarters, we see the other Jones becoming increasingly agitated. "No, no, no," he cries. "Don't let them kill him. Don't you understand: if they shoot him, I'll . . . "

"Take it easy, Jones," Dolan says, the phone at his ear. "The wire's open. We can hear what's going on. Klink sounds shootin' mad."

And on the last page (figure 51), Eisner blends word and picture to conclude his story. The penultimate scene played out in the first five panels is exquisitely timed to create three separate dramatic moments. The first occurs in panel 3 as Jones crumples in an agony that proves to be his death throes. The first two panels prepare us for this event. Eisner puts Jones in the foreground to focus our attention on his mental state: attuned to his anxiety about his relationship to the double, forced to share that anxiety for two panels, we can almost anticipate the outcome in panel 3. The next dramatic moment comes in panel 4, a confirmation of our suspicion: Jones is dead, killed in

Figure 51. *A typical Eisner ending, presenting us with a puzzle that we must solve by supplying some sort of "conclusion" ourselves. (March 11, 1951)*

some mysterious fashion as a result of the double's death across town. Eisner shrouds Dolan's face in shadow in panel 4 in order to delay showing us his reaction to these events. The third moment of dra-

ma, then, comes in panel 5, when we see Dolan's stark stare of disbelief or astonishment. We learn in this panel that the Spirit has survived, but the dramatic purpose of the panel is to give us Dolan's

face—in which we see mirrored our own state of mind.

The next three panels build to another revelation of a sort. In the last panel, the verbal and the visual again blend to present us with a comic turn that threatens momentarily to unhorse Dolan's skepticism. The unexpected arrival of a Dolan double does not necessarily confirm the doppelganger legend. Or does it? We can't know for certain. And neither can Dolan, hence the laugh at his expense in the final panel.

We can understand, now, why Eisner overloaded the earlier page, cramming more narrative freight into some panels than they should be made to carry. He needed space at the end of the story so that he could time the action to produce the most dramatic conclusion—itself the culmination of a series of dramatic moments, as I've said.

The ending is typical of Eisner for this kind of story. After dramatizing a tidbit of legend or lore, he ends the story in a way that leaves us (like Dolan) to draw our own conclusions. This story, however, is different from most of the others of its kind in the Eisner canon. Eisner changed the ending when he reprinted it. The first issue of the story (October 19, 1947) finished with the prose explanation of a doppelganger that I quoted from the splash page. (The splash page of the initial version was different). The original prose ending included the following: "Some laugh and say this shadowy counterpart is man's evil nature. Some figure it's his conscience. And some say it's just a lot of eyewash. But we know better, don't we?" This explanation followed the last page's panel 5 as we see it here.

When Eisner reissued the story (March 11, 1951), he removed the concluding expository passage, put some of it at the beginning, and in its former place at the end, drew the three panels that we see here at the bottom of the page. Overall, I think the new ending is an improvement over the original: comics are inherently a dramatic medium, a medium of characters in action, and characters speaking and interacting make better drama than simple prose. Moreover, the conundrum with which Dolan is faced in panel 5 is given dramatic force with the appearance of Dolan's double in panel 8. While the reissued version has lost the key idea that the doppelganger is a man's "evil nature" or his "conscience," there's a good deal more resonance of the kind Eisner valued so highly in the notion of a

Dolan doppelganger lurking on the premises than there is in the straight prose explanation.

Although not heavy with complex moral freight, the story seems to me a convincing demonstration that comics can be art. Most of Eisner's stories are equally persuasive. And if most of them are but thumping melodramas, that merely promotes their artistry. As Michael Barrier, writing in *Print*, has explained:

> The more melodramatic Eisner's material, the better, because the more it lent itself to bizarre staging, oblique angles, and chiaroscuro lighting. . . . The more routine or outrageous the story . . . the greater the pleasure in making it a marvel of visual narrative. Eisner was in those years the comic-book equivalent of Orson Welles: he was the first complete master of a young and heretofore unformed medium. And, like Welles, he devoted his energies not so much to telling compelling stories as to showing us how comely his Cinderella was, now that he had waved his wand over it. We should not regret that Welles did not make something more "serious" than, say, *The Lady from Shanghai*, an endlessly fascinating film whose tangled script would have been a stupefying bore in anyone else's hands; if he had, his subject matter might have restrained him from showing us all the tricks in his magician's bag. Likewise, if Eisner had tried to do more with the Spirit—if he had tried to tell stories with greater moral and emotional weight—he probably would have done less. By concentrating on what is so often dismissed as superficial—as "style" or "technique"—he revealed his medium's unsuspected capacity for expression.[32]

He also revealed the art in telling stories in the visual-verbal mode.

Eisner's tinkering with the doppelganger story in its two published versions is also emblematic of his restless creative imagination, which never left him quite content with what he had done. He was always eager to pursue a new idea to completion. This passion led him finally to abandon his most memorable creation. His postwar experimentation with comics as an educational medium eventually so consumed his energies that he could not continue doing *The Spirit*. The decision to give it up was a painful one for Eisner: for years he had poured into the feature all of his hopes and dreams for the art form. "I felt that I was at the epitome of the medium," he told Steranko, "and that I was

helping in the development of a medium in itself. Comics before that were pretty much pictures in sequence, and I was trying to create an art form. I was conscious of that, and I used to talk about it." When cartoonist Jules Feiffer worked as his assistant in the late forties and early fifties in particular, Eisner recalled, "we used to have long discussions about comics as an art form. How can we improve this? How can we make this better. How can we do better things? It was almost a continuing laboratory, and I was very lucky because there wasn't anybody who could stop me from doing what I wanted."33

Having invested that much of his creative imagination in *The Spirit*, Eisner first sought in 1951 to have the feature continued by others under his supervision. For about a year, that seemed to work. Feiffer wrote many of the stories, and Eisner was happy with them; but he was restive about the drawing. Finally, he could no longer tolerate the violence other hands were doing to his creation. With the story issued on October 5, 1952, he discontinued *The Spirit* altogether.

CHAPTER 5
The Heroic Avenue to Art
Experimentation and the Mark of Kane

Whatever else superhero comics may have done, they championed figure drawing. It might even be said, with but a dash of hyperbole, that not since Greek antiquity has the human form been so absorbing an artistic preoccupation. The body was a thing of supreme beauty to the Greeks of the Golden Age. And their passion for sport and games that tested and displayed human physicality in turn required of their artists the utmost accuracy in anatomical detail. Nor were Greek artists alone in their obsession with anatomy. At roughly the same time in India, Hindu artists were similarly engaged, albeit concentrating on the body as erotic inspiration rather than as an anatomical marvel. In both civilizations, artistic enterprise worshiped the human form.

Just as the antique Greeks and ancient Hindus idealized the human form, raising observation to art through religious fervor, so do the artists who excel at illustrating the adventures of comic book superheroes take the figure in action as their votive exercise. Drawing the figure requires a rhythmic motion of hand and wrist, a symphonic gesture at once sweeping and magisterial as well as modulated and precise. Identifying with the anatomy they delineate, the artists become one with their subjects and find their reward in their work. To portray the human form in motion, contorted by the energy of action into every conceivable pos-

ture seen from every conceivable angle—to communicate on paper with mere lines some persuasive sense of the harmonious power and grace of muscle and sinew and bone united in fluid movement or dramatic stance—that is the compelling motive that makes the act of drawing itself the sublime consolation for the devotion of artists to the medium. And as they strive for perfection in their portraits, the body becomes the ideal and, hence, heroic.

For Gil Kane, the heroic was operatic: the power of the human figure could be translated into powerful drama, into inspirational action. Kane did not begin with this belief: it came to him through a lifelong career in comics.

Kane once called himself "an old dinosaur" in the comics business. By that he meant that he and Jack Kirby and a few others were older than most of the other comic book artists he found around him in the late 1970s as he finished four decades of work in the field. But if we linger over Kane's mesozoic metaphor a little, we can find other meanings embedded in it.

Dinosaurs were around near the beginning. And so was Kane. He did his first comic book work around 1941 at about sixteen years of age. He worked in the Binder Shop and the Baily Shop. He worked as Kirby's assistant. In the forties, he drew for MLJ, Street and Smith, Marvel, National, Qual-

ity, Hillman, Eastern Color, Fawcett, Fox, Holyoke, and Prize. He drew the Scarlet Avenger, Red Hawk, Vision, Young Allies, Sandman, Wildcat, and others. In the fifties and sixties, Kane worked for Marvel and National, Avon, Harvey, King, Dell, and Tower—drawing an assortment of characters that included Johnny Thunder (the cowboy), Captain Comet, Nighthawk, Dan Foley, the Trigger Twins, Hopalong Cassidy, Don Caballero, Plastic Man, Batman, Flash Gordon, Laramie, Hennesey, Frogmen, Noman, and Undersea Agent. He helped launch the so-called Silver Age of superhero comic books: for the second of the Golden Age superheroes that Julie Schwartz rejuvenated in the late 1950s—Green Lantern—Kane designed a streamlined capeless costume. "I was trying for a balance between power and lyricism," Kane said, "—a cape would have gotten in the way of the figure."[1] Kane also helped revive the Atom for the Silver Age.

Dinosaurs are also large. Very large. And when measured by his accomplishments in the comics, so is Kane. He is one of the masters of the medium. He has not only practiced his art with consummate skill, he has also experimented with it, extending its capacities. And he is passionate about the medium. As he explains it:

> The drawing is so rich. That's the value of comics art. That's why guys who outgrow reading it still don't outgrow the appeal of it. There is something in comics art, there is something in Kirby, in his massiveness. He was probably the most inventive artist in the entire business. I thought Lou Fine and Reed Crandall did miraculous things with the figure. In fact, what they did was more appealing to me than things that are supposedly held in higher repute. I have yet to see things as lyrical as Lou Fine's work. Comics art is marvelous. It's brilliant. It's beautiful. I'm not talking about every piece of comics art done; I'm talking about, as always, the best of comics art, which is what anyone talks about in any area. Ninety percent of everything is tenth rate. But the best—that's what you use as a yardstick—the best comics art is extraordinary; it's affecting; it reaches right past all your needs to have some kind of consequential story, and it registers, and it makes an impact, and makes you respond purely on the strength of the lyricism, the drama, the action, the shattering effect, the imaginative quality of the drawing.[2]

For the evidence of Kane's accomplishments—

Figure 52. *Kane drew himself looking over Will Eisner's shoulder during their interview. In the box, my caricature sketch of Kane.*

and of his passionate engagement with the medium—we have only to cast a glance back over the terrain behind us at the footprints left here in the rock by one of the giants as he passed.

Take, for example, this early Kane page (figure 53), signed "Eli," from the adventures of Don Caballero in *All Star Western* No. 60 (1951). Don Caballero swashbuckles his way through the Spanish West in the manner of Zorro, blade and teeth flashing. In the best tradition of the medium, Kane blends the visual and the verbal, but he also knows when to fall silent. Although pictures alone tell much of the story on this page, the first two panels blend verbal and visual elements to launch the following sequence. Panel 1 is a somewhat awkward composition: a straight shot from the rear doesn't offer the best possibility for showing Caballero in rapid motion. But the caption clarifies the situation, and thus word and picture in concert set the scene in motion. In panel 2, the picture completes the narrative begun by the caption. The next two panels carry the action forward as Caballero takes out the third of his adversaries. No words are necessary here. The full-figured action

Figure 53. *Careful staging of the action in this sequence from a Don Caballero adventure of the 1950s imparts to the swashbuckler's moves a realistic authority. (All Star Western No. 60, August–September 1951)*

shows us precisely, clearly, what happens in winks of time as close together as the frames of movie film. Such sequences give a visual art form much of its authority, convincing us by showing us. Not only are words unnecessary here, they would divert our attention from the action itself, diluting its momentum and undermining the sense of swift and sure accomplishment conveyed by Caballero's carefully staged moves.

With the villain's three henchmen out of the way, Caballero engages his foe in the last two panels—pausing in his onslaught only long enough to explain the deductive reasoning that led him to

suspect Ugalda. Although words and pictures have independent meaning in these two panels, the story itself continues to move forward: as we listen to the explanation that unravels the tale's mystery, we see the duel that is its finale proceeding apace, swords clashing and locking.

Narrative breakdown and careful panel composition work together to give the sequence the dash and sparkle we expect in the adventures of a would-be Errol Flynn. The first panel sets the scene, including the conspicuous positioning overhead of the lamp that Caballero will make such dramatic use of in the next panel. (Ol' Errol would

never enter into a duel with both feet on the ground if he could find a way to avoid it.) Breakdown moves events from one action-filled moment to the next, thereby giving to Caballero's attack the sensation of headlong swiftness, the power of an irresistible force. And the careful staging in panels 3 and 4 lends credence to the swordsman's actions by showing us exactly how one such action is accomplished. Thus the sequence as a whole conveys both the authority of realism and the impression of hurtling efficiency.

By the standards of thirty years later, the page layout here is not remarkable or particularly difficult to follow. But for its time, the layout was apparently unusual enough to warrant the use of arrows to direct the reader from panel four to five, five to six. The layout is arranged chiefly to accommodate the necessary action—including an establishing shot in the oversized first panel and then the panels that show Caballero dispatching Ugalda's three accomplices. But there are interesting and evocative by-products. The action topples diagonally across the page from the upper right to mid-page left, just as Caballero's foes topple before his onslaught. And (to wax poetic for a moment) the layout forces the eye to slash back and forth across the page, mimicking the movement of the combatants' weapons.

And through it all, we see Kane's love of the human form at work as he displays it in a variety of postures, bodies caught in motion. In an interview conducted by Will Eisner in 1981, Kane discussed his devotion to figure drawing: "The figure," he said, "is the measure of all things. My whole sense of design came from George Bridgman, the anatomy teacher, not from somebody from whom I studied composition. All of the natural twists and turns and rhythms of the human form created my whole sense of design in terms of composition."

Kane practiced, drawing pictures every day for an hour and a half. "I practice heads and figures. I draw from photographs, anatomy books, and medical texts. . . . I do it to maintain my rhythms in the figure. Every time I do it, I reveal something new to myself. It's not merely maintaining a facility. I do it for information. . . . The overriding consideration is exploring for ways to have more understanding."[3]

In the seventies, Kane was working at Marvel, where, in 1977, he penciled *John Carter: Warlord of Mars.* Let's look at a couple pages from issue

No. 10 (figures 54 and 55), in which we are shown Carter's encounter with The Great One, mastermind of a scheme to take over Mars and reduce the planet's population in order to stretch out the frail supply of atmosphere and resources as long as possible.

Written by Marv Wolfman, the Carter stories sometimes suffer from Wolfman's tendency to slip into a flashback at the earliest opportunity in each book. The practice often interrupts a story's momentum—without supplying any information absolutely vital to our understanding of events. (Interesting as background, perhaps—but not vital to the story.) More disturbing, however, is Wolfman's decision to make Carter the narrator of his own adventures. First-person narrative works in straight prose (under certain circumstances), but in comics it can only undercut the medium's effectiveness. The visual-verbal art form portrays events as they happen, and when the chief actor in those events prattles on in captions, commenting on the action or his feelings, the sense of immediacy is blunted by the essentially reflective character of first-person narrative. The pictures and speech balloons show us what is happening "now"; the first-person narration in the captions seems to be looking back on the action as if it had taken place in the past. This contradictory treatment has the effect of weakening a story's immediacy and with that, its credibility, its reality.

But the two pages we see here suffer very little from this misguided narrative practice: Carter "speaks" in only two panels. Verbal-visual blending is virtually nonexistent on these pages, but in looking for it, we discover the essential nature of the storytelling in this sequence.

The story—the progress of the battle between Carter and The Great One—is told almost entirely in pictures. The speech balloons carry The Great One's monologue, a diatribe of self-justification that attempts to win Carter to his cause. His words seem to have very little to do with the action depicted: the "sense" of the words is quite independent of the "sense" (or meaning) of the pictures. But words and pictures in this sequence are juxtaposed, not blended. And in the juxtaposition of the two independent "meanings" we find a third meaning, as the sequence puts the final touches on a portrait of The Great One's personality. Taken by themselves, the words explain his motives, but taken together with pictures that

Figure 54. *The juxtaposition of words and pictures on this page and the next (Figure 55) from* John Carter *No. 10 (March 1978) reveals the Great One's monomaniacal personality.*

show him in violent action, they acquire another shade of meaning. The violence of the action gives fanatical emphasis to The Great One's harangue, and he emerges as a full-blown monomaniac.

As I've said, successful verbal-visual blending is not the sole criterion for excellence in comic art. But a search for it can reveal instead the storytelling mechanism that animates a particular sequence. Narrative breakdown in this sequence times the action in explosive bursts, leaping from one second of visually exciting action to another

and leaving out the intervening minutes. This impressionistic treatment of events gives the sequence a pulsating vitality, as we watch, panel to panel, The Great One doggedly charging and swinging while Carter weaves, leaps, dodges, strikes, and sometimes topples as his opponent connects.

Although the layout is unusually pedestrian for Kane at this stage of his career, it does vary occasionally for narrative emphasis. The horizontal first panel on the left-hand page sets the scene,

Figure 55. *Kane's mastery of anatomy is so persuasive that his characters have expressions even when we can't see their faces.*

and the second panel's shape and height provide The Great One with the room he needs to swing his first haymaker. At the top of the second page, the first panel's elongated dimension echoes (and thereby stresses) the direction and force of The Great One's lunge at Carter. The nearly equal size and shape of all the other panels gives the sequence its pulsing regularity—from which the odd-sized panels derive their emphatic character.

Panel composition puts Carter with his back to us most of the time—probably because the four-armed Great One can be most recognizably depicted from the front. Back views are not the most expressive as a rule: the absence of facial expression, for one thing, robs the pose of much of its potential. Usually. But Kane's knowledge of anatomy and his great skill in delineating the human form invest even these back views with dynamic power and energetic life.

On the pages we've looked at so far, we see a

thoroughly competent professional at work. The page from the early fifties seems as polished as the pages from the late seventies: Kane mastered his art early. The confident line and composition is maintained across the years. And if the Carter pages seem perfunctory, almost routine, in their layout and composition, they are nonetheless enlivened by Kane's animated and vigorous portrayal of the human figure. With such touches does a master elevate the mundane. (In a discussion published in the *Comics Journal*, Kane implied that he was bored with the Carter material by the tenth book: Wolfman's treatment presented no challenge.[4] Perhaps in consequence, the Carter pages show none of the creative energy that sparks Kane's work elsewhere during the period— particularly in the newspaper strip, *Star Hawks*.)

But if Kane had maintained his mastery for well over thirty years, he had not done it by treading water, by standing in one place. The dinosaur was not a fossil, and we are not gathered here around a tar pit to inspect his bones. Kane continued to grow and to develop his artistry throughout his long career.

In the late sixties, Kane tried his hand at a new kind of comic art—a sort of illustrated novel, in which the sequential pictures of the comics medium were accompanied by narrative prose. The first of these efforts, *His Name Is . . . Savage*, appeared in magazine format in 1968 and recounted an adventure of the title character, a James Bond–style agent. As I said in the introduction to the Fantagraphics reissue of *Savage* (1982), the book was remarkable on two counts: for the violence of its story and for the extent to which it defined the characteristics of a new comics form.

Violence and brutality function simplistically in the story, but the function is dramatic: they define character and build suspense, both elements vital to storytelling. In an adventure story, a genre distinguished by high-risk physical danger, violence or the threat of it is probably essential. Critics might debate whether this particular story needs to be told at all, whether it does anything more than create excitement. But this story, like so many of our entertainments, pretends to do no more. The final justification for it lies ultimately in our love of stories, rather than in our desire to do social work or promote moral education.

However, *Savage* does not engage our interest

here because of the story it tells. For the student of the art of the comics, the chief interest in *Savage* is the book's claim that it begins "a new comics tradition." The tradition in question has since acquired a name. With the convenient perspective of hindsight, we can now see that *Savage* was among the earliest attempts at a new way of telling stories with pictures and words—the graphic novel.

Or is it a new way? Perhaps the graphic novel is no more than a revival of comics in their most primitive form. Perhaps there is nothing new except what has been forgotten.

In form, most early specimens of the graphic novel were distinguished from the ordinary comic strip or comic book by the presence of narrative text accompanying the sequential pictures. These graphic novels look remarkably like the prototypical comic strips of the nineteenth and early twentieth centuries—parades of panels with text underneath. Possibly the first of these harbingers was produced by a Swiss artist, Rodolphe Topffer, as early as 1827. Describing his new storytelling technique, Topffer wrote: "The drawings without their text would have only a vague meaning; the text, without the drawings, would have no meaning at all. The combination of the two makes a kind of novel."[5] The modern comic strip emerged when the text beneath the pictures disappeared. From that point forward, most of the words in comics were confined to speech balloons. But the words and the pictures still blended to tell stories, just as they did for Topffer—neither word nor picture conveying alone as much of the story's meaning as the two elements taken together could impart.

While most comic strip art jettisoned its textual ballast as we moved into the twentieth century, the technique was not abandoned all at once, or even entirely. C. W. Kahles, for instance, used it at least until September 29, 1907, the date of the *Hairbreadth Harry* panels printed here (figure 56). And Sunday strips aimed specifically at children (*Uncle Wiggly*, for example) were often little more than illustrated texts—as was the *Tarzan* strip when it first began in 1929. The custom was continued into the forties in *Flash Gordon* by Alex Raymond, who eventually discarded speech balloons in favor of textual narrative and dialogue. *Prince Valiant* also perpetuated the device throughout its run. And in many contemporary

Figure 56. *Akin to nineteenth-century prototypes of the comic strip, this sample from a 1907 Hairbreadth Harry adventure story shows how similar in form the early comics are to the so-called graphic novel. Here, text and picture run parallel to one another, each telling the story completely (albeit somewhat differently). If the graphic novel is to be any advance on its ancestor, text and pictures must be integrated, each augmenting the other.*

comic books, caption blocks give the pages as much textual density as any of the medium's nineteenth-century ancestors.

What, then, is new about the so-called graphic novel? Its form can be traced back from *Prince Valiant* all the way to Topffer's early efforts. The form may be strikingly similar, but the elements of that form function in markedly different ways whenever all the resources of the graphic novel are brought into play. Several passages in *Savage* reveal these differences and in doing so demonstrate the unique potential of the graphic novel. But before examining some of the more telling instances, let me loiter along for a couple of paragraphs in order to muse about aspects of comics art the functions of which, it seems to me, ought to be embraced by the graphic novel.

If the graphic novel is "a new comics tradition," the future of comics, then it doubtless ought to build on and develop the essence of the medium. The technical hallmarks of comic strip art (or "sequential art," as Will Eisner calls it; probably a better name, come to think of it)—the things about it that make it unique—are speech balloons and narrative breakdown.

Speech balloons breathe into comics their peculiar life. In all other graphic representations, characters are doomed to wordless posturing and

I reached back for a bottle of brandy, cracked it across the corner of the desk and splattered the widest area possible. I wanted to keep the boys busy on my way out, and flipped the butt into the spill.

"Think of me," I said as a sheet of flame swept across the top of the desk.

The stunt bought me the time I needed to get the hell out of there without a lead escort chewing up the back of my coat.

I placed Danzer in the race. He could easily have left the ship for ten minutes, rubbed Kubelik and returned. My little visit might make him careless.

I decided not to call the Crane number again tonight, knowing I'd be expected—and that walking out might not be as easy as getting in. On the way over to Tenth Avenue, I reminded myself to carry some protection, and whistled down another hack.

Figure 57. *In Steranko's* Chandler, *the pace of the story is controlled by the prose.*

pantomime. In comics, they speak. And their speeches are conveyed in the same mode as the rest of the medium—the graphic, visual, mode. We see and read the words of the characters just as we see the characters themselves and "read" their actions. Films are made in a hybrid mode—audiovisual. Comics are all visual, a seamless optic exercise. Moreover, the inclusion of speech balloons within the pictures gives the words and pictures concurrence—the lifelike illusion that the characters we see are speaking even as we see them, just as we simultaneously hear and see people in life.

If speech balloons give comics their life, then breaking the narrative into successive panels gives

that life duration, an existence beyond a moment. Narrative breakdown is to comics what time is to life. In fact, "timing"—pace as well as duration—is the second of the basic ingredients of comics. The sequential arrangement of panels cannot help but create time in some general way—but, as we have seen, skillful manipulation of the sequencing can control time and use it to dramatic advantage. To elaborate a bit, the sequencing of panels determines the amount and order of information divulged as well as the order and duration of events. Manipulating these aspects of a story creates pace, suspense, mood, and the like. Ordinary mainstream literary prose does all of this, too; comics differ in that the pictures as well as the words ma-

nipulate time. For instance, action can be speeded up by sequences of pictures in which the scene shifts rapidly from panel to panel.

Whatever the graphic novel is to be (or is), it seems to me that it must incorporate these two essential aspects of comics art if it is to be of the same species. The graphic novel may have other characteristics as well, but speech balloons and narrative breakdown seem to be vital ingredients: concurrence of speech and action, and timing. Without these traits, the graphic novel will simply be something else—another kind of graphic story, surely, but not of the same order as the comics.

Steranko's *Chandler* (1976), for example, is called a graphic novel, but it doesn't meet the criterion I've mentioned. For all its brilliant visual effects, the pace of the story is controlled by the prose that runs in uniform columns under the pictures (figure 57). The pictures create the story's mood, but they add no new information to the story: they simply illustrate the narrative. Although *Chandler*'s theme is a mature one, in form and function the book is no different from the average illustrated children's book (figure 58). It does not

represent a new art form—or a new development in the art of the comics.

Many of the pages in Kane's *Savage* do no more than Steranko's *Chandler*: the pictures illustrate the prose without adding much more than atmosphere to the story. Much the same can be said for *Prince Valiant* and *Flash Gordon*. But in many sequences, *Savage* is more than simply an illustrated prose narrative. And it is more, too, than its prototype of the last century, in which the text was often only tangential to the pictures, running parallel to the depicted action but not integrated into it.

One of the storytelling advantages inherent in the graphic novel's use of text is that complex ideas and emotions can be communicated economically. Kane promoted these assets during his 1981 interview with Eisner:

> In a small space, without intimidating the picture or overcrowding, you're able to convey an idea as fully as possible. I just think that each picture needs as much help as it can get. Sometimes, of course, a picture can be very informative without text. There are times when there's kind of a heartbeat, a silent moment, and you want to have that silence preserved in every way. But in other situations you want to suggest the temperature of the room, the impatience of people who are talking to one another, all of the things that are so difficult to convey merely from the picture. To try to convey them, you could spend days on one single picture.[6]

For a relatively simple example of the kind of dramatic economy that can be achieved with a verbal assist, we have only to look at the sequence recording the reunion between Savage and the daughter of his archenemy, Simon Mace, a cyborg megalomaniac who seeks, in this adventure, to seize governmental power. In this encounter (figure 59), the text accompanying panels 3 and 4 tells us something pictures could scarcely reveal: the years they've been apart suddenly evaporate as Savage and Sheila Mace embrace. But the capacity of the written language for conveying complicated or intangible ideas needs no advertisement here. The more pertinent question about a graphic novel is: do the pictures do anything for the story that prose could not do just as well?

In our next example (figure 60), we have one of those "silent moments" Kane describes. A boat is blown up—after which the text ceases its drone,

Figure 58. *On this page from Johnny Gruelle's* Little Brown Bear, *the pace is also set by the prose, not the pictures.*

But as he slipped into the lush interior of the penthouse he knew he hadn't forgotten the song, or the girl who had played it. The girl before him, lifting a phone receiver up to full red lips...Sheila Mace!

Savage was already halfway across the room as the liquid green eyes went wide with startled recognition. The length of his body uncoiled over the remaining distance in a smooth leap, one hand lashing out for the phone receiver...

The weight and force of his body drove her deep into the billowing cushions of the couch, pinning her beneath him...

Savage could feel the warmth of her body, hauntingly tempting, achingly familiar...

The moistness of her eyes, her trembling mouth, a flood of sudden memories made Sheila seem like a magnet to him. Savage kissed her strongly, hotly...

...Then she was kissing him back and suddenly the years they'd been separated seemed never to have existed.

Figure 59. *The text on this page from Gil Kane's* Savage *tells us something that the pictures do not, in themselves, reveal.*

and we have before us only a picture of the smoking sea to mark the place where the boat had been. And silence. The combination of those two panels creates more effectively than prose a sense of sudden and total destruction. We linger over the second, wordless, panel—looking, perhaps, for evidence of something's having survived. In the awful silence, there is nothing. It is a dramatic pause in the progression of events, the kind of pause difficult if not impossible to create in prose alone.

Likewise, later on, the visual treatment of the unmasking of the villain Simon Mace heightens the drama of that moment in ways impossible for prose to achieve (figure 61). Mace has reached his objective: he has secretly disposed of the president of the United States and has assumed his identity, donning a rubber mask that duplicates the murdered chief executive's features. Savage discovers the deception and attacks the imposter as Mace is delivering a speech on national television. As Savage strips the mask from the cyborg's polished steel face, the scene shifts to the control room from which the "president's" speech is being televised. In one panel, we see the unmasking in a series of monitors, the succession of images drawing us closer and closer to Mace and the shredding mask—until, at last, the horror of the villain's face is revealed in stark close-up. Our perception of the action is manipulated by the sequence in which the visual information is delivered. In short, the pictures time the action for the greatest impact.

In these two instances, the pace of the story is controlled by the pictures, and the pictures therefore contribute to the dramatic impact of events. In a graphic novel, we should expect no less. The visuals must do more than illustrate the text if the graphic novel is to be something other than an illustrated story. But words and pictures must work in concert in the graphic novel, too.

As a final example of the narrative technique of the graphic novel, then, let's look at the sequence from *Savage* that records the killing of Sheila (figure 62). Here, all the elements of the graphic novel—narrative text, spoken words, and pictures—are carefully integrated, each in its way conveying to us a portion of the information we need to understand what has happened, none revealing in itself the whole story.

In the first two panels of the sequence, the text reports the seeming success of the couple's escape from Simon Mace, and Savage's remarks seem to

Suddenly, the air where the boat had been turned fiery and bright with a thunderous flash...

Figure 60. *Silence is often more effective than verbiage.*

confirm that success. But in panel 2, the picture shows a spray of gunfire penetrating the car's passenger compartment—suggesting that perhaps the verbal verdict is premature. For the next three panels we are kept in doubt. In panel 3, Savage rattles on, eyes ahead on the road, oblivious of Sheila's condition. Whatever it may be. At this point, even we are ignorant of her fate: the picture's focus and the placement of the speech balloons deliberately conceal her (and any telltale evidence of a fatal wound) from us. When Sheila doesn't answer his question, Savage suddenly suspects—fears—the worst. The close-up in panel 4 establishes and emphasizes the intensity of his concern; his single-word question hangs pregnant in the air, one jarring sound in an otherwise fearfully silent frame one heartbeat long. The confirmation of his fear is postponed for one panel more while Savage brings the careening vehicle to a halt. Then the text over panel 6, after telling us how Savage feels, prepares us for the awful outcome. Sheila is slumped in the seat, unmoving. Wounded? Perhaps. But, no— Savage's anguished speech suggests that murder has been done. And as our glance drops to the bottom of the panel and we see Sheila's staring but unseeing eyes, we know Savage is right. She's dead.

The entire progression of panels is carefully timed to withhold as long as possible the information the page at last divulges. Suspense builds as both word and picture contrive to advance the action without telling us what we most want to know. And in the last panel, we need all the resources of the graphic novel to confirm our suspi-

And in the thunderous turmoil and excitement, even the crash of a side door being kicked open so hard it was all but ripped from its hinges was lost except to those nearby...

But as the glowing-eyed figure charged toward the podium, casting off Secret Service men unable to fire because of the crowd, all eyes fastened on him and heard his hoarse bellow...

Then the auditorium amplification system picked up the thudding impact as the shouting figure hurled himself onto the man at the podium...And the television monitors registered the bizarre image of Savage pounding and clawing the President's face into pulpy, hideous ruin.

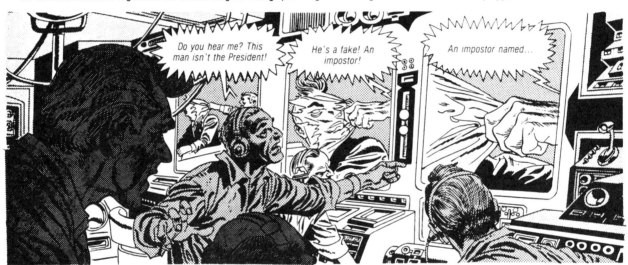

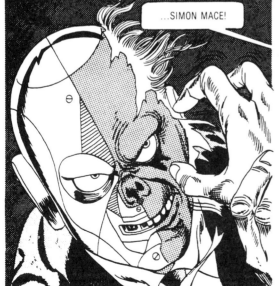

Even those some distance from the speaker's platform started back inadvertently at the glowering face of polished steel and livid scar tissue Savage had uncovered, and stared in numb confusion as Mace batted Savage away with a backhand stroke of his deadly mechanized arm.

Figure 61. *In this sequence from* Savage, *the action is paced by the pictures.*

Laying strips of burning rubber behind them, Savage sent the car shrieking and squealing up the ramp, winding the powerful engine higher and higher, until with a lurching roar it burst out of the garage into a rain of fire laid on by outraged agents of Simon Mace...

For one murderous instant the car was blanketed by a barrage, then surged at top speed into the clear, to be swallowed by the protective darkness enshrouding the streets of early morning Manhattan...

Savage's foot ground into the brake, sending the car into a long, fishtailing skid, before coming to an abrupt, jerking halt.

A wave of uncontrollable rage tinged with faint, creeping nausea flooded through Savage as he stared at the lovely, form slumped in the seat next to him...Lovely, but terribly, unbearably still...

Figure 62. *Here, Kane uses all the devices of his visual-verbal medium to tell his story.*

cion. The text assures us that Sheila is deathly still; but it doesn't say she's dead. Savage's speech takes us a step closer to verification: he clearly believes she's dead, but he hasn't felt her pulse or seen her face. We, however, see her visionless eyes, and that picture renders the verdict final.

In such passages as this, we see the graphic novel at the apogee of its form: the chief elements of the medium are artfully deployed, the import of each element supporting that of the others to create an impression that no single element by itself could create. The text details such nonvisual mat-

ters as emotions, confirming with verbal precision the hints supplied by the visuals. The pictures focus our attention and stress certain aspects of the story raised in the text. The visuals also pace the action, manipulating time and our perception of events for dramatic emphasis. And speech balloons give us the illusion that we are seeing living, breathing—and speaking—people.

The storytelling potential of the graphic novel is more than amply demonstrated in this early effort by Kane (produced with the scripting assistance of Archie Goodwin). The integration of word and pic-

A rain drop hit Blackmarks's face. His eyes shot open and his ears rang with his mother's screams. Before he could get to his feet, grimy, cal-lused hands locked on him like manacles. All his flailing, kicking, bit-ing could not free him as he was dragged roughly forward.

The Warlord pulled Marnie in tightly against him, her resistance futile in his iron grasp. Then with animal intensity he began kissing her; laughing at her panic and revulsion.

And Blackmark was held so no ghastly detail could escape him.

The boy was spared no-thing; not his mother's pleading cries, nor the obscene jokes of the foul-breathed men who held him. Then, Marnie's hands broke free and she raked the mouth of the Warlord with her fingernails.

With a cry of rage the savage figure viciously struck the sobbing Marnie again and again. He then flung her barely conscious form away from him...

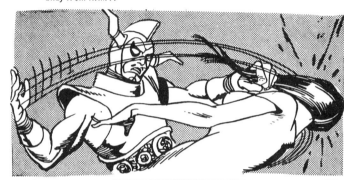

The Warlord's eyes never left her inert form as he slowly drew his sword from its scabbard.

Figure 63. *In this four-page sequence (the two pages here plus the two in figure 64) from the paperback* Blackmark, *Kane creates nightmarish horror by alternating prose and pictures.*

ture here has taken the form a long way from its prototypes in the nineteenth century. Nonetheless, the similarities remind us that Kane's graphic nov-el is of the same species as its predecessors. It is not merely an illustrated story.

Three years after *Savage*, Kane continued to ex-periment with this new form in *Blackmark*—this time, in paperback book format. Kane called the book "an important first. It combines all the ele-ments of painting and film, drama and novels."[7]

The story is set in that fictional age of sword and sorcery where science and magic mingle. Kane did two Blackmark stories: the first traced the title character's life from youth to maturity; the second

showed us Blackmark as ruler of his people. In these stories, Kane gives us several sequences that gain enormous power from the juxtaposition of pictures and prose. In the first story, for instance, we find the four pages that record the rape and murder of Blackmark's mother, Marnie, which the six-year-old Blackmark is forced to witness.

Upon first examination, it would appear that the pictures add nothing to the story that is not pre-sent in the words. In fact, in some instances, the pictures repeat information given us in the text. This sort of verbal-visual double exposure nor-mally signals inept use of the medium. But a care-ful reading of the sequence suggests that Kane's

Figure 64. *The nightmare concludes, and normal life—with speaking people—resumes.*

visual treatment has contributed a dimension of horror to the incident that is but hinted at in the accompanying words. Although the pace of events is controlled mostly by the prose, the words, unlike those in *Chandler*, alternate with the pictures throughout. Thus, as we read the story, we must also glimpse scenes of it in sequential order. As scripted by Archie Goodwin, the prose is spare, almost flat: it narrates the action in nearly emotionless descriptive language, much as one might describe a landscape or street scene.

Kane handles the accompanying visuals with similar restraint. With the exception of the fourth panel, all the pictures on the first two pages (figure 63) are close-ups. By this means, Kane removes all possibility of prurient excitation: there is no naked female flesh to leer at. Instead, Kane focuses on faces, where the emotional consequences of the action are registered. In the tight close-up of the second panel, Marnie's staring but unseeing eyes and her silent scream convey in an instant all the horror, revulsion, and sense of violation that the otherwise restrained sequence only suggests. It is perhaps the most powerful picture in the series, but it derives a good deal of its power from its contrast to the emotionless context in which it appears. The assaulting Warlord is himself the scene's touchstone: his pupilless eyes show no

emotion, human or otherwise, and his wolfish grin suggests only animal passion.

On the second page, we have a series of verbal-visual double exposures, as the pictures repeat information supplied by the blocks of text that precede them in the order we read. Normally such a practice undermines the dramatic economy of the medium. Here, however, the repetition enhances the drama: first the words and then the pictures, in rhythmic alternation. The close-ups narrow our focus, thereby emphasizing the details of prose narrative that are repeated. And the repetition itself seems to slow the action, forcing us, as if against our will, to witness again and again in nightmarish fashion the same events that young Blackmark is forced to watch. In repeating aspects of the narrative, the pictures brand upon the memory certain searing details, so that ultimately we cannot forget them any more than Blackmark can.

On the third page (figure 64), Kane skillfully manipulates time, building suspense. Following the layout of prose and pictures, we are forced to wait, to contemplate with scarcely credulous alarm the Warlord calmly aiming his sword, before the narration resumes to tell us what we are, by now, reluctant but resigned to hear. Then, as the episode ends, speech balloons once more appear on the fourth page, contributing their share to the narrative. Word and action are once again concurrent, lifelike.

We have emerged from a scene in which the actors have been horrifyingly silent. Words and pictures, alternating but separate, have acted curiously in concert, building with that alternation a world dreamlike, nightmarish, in its unreal silence and its meticulously descriptive prose. The nightmare tension is broken at last as the heartless Warlord wipes his sword: he speaks. The actor lives, no longer a phantom in a bad dream.

The spell is broken, and with the last panel the camera draws back for a long shot, distancing us from the agonies we've witnessed. As the camera pulls back, so do we, and the world seems to resume its normal sway—men mounting their steeds, announcing plans, pursuing ordinary (if bellicose) purposes. In this concluding maneuver, the horror of the episode gains dramatic power: that such a thing could happen seemingly without producing any disturbing effect among its perpetrators makes it all the more horrible.

This sequence derives dramatic power from its subject alone, admittedly. But Kane's treatment of the subject—the way he uses pictures in conjunction with text—has enhanced the inherent drama of the subject in ways that neither words nor pictures by themselves could achieve. A worthy accomplishment for the infant graphic novel form.

If the graphic novel is to be something more than a comic book while at the same time preserving the essential character of the comics medium, it will owe a good deal to Kane's work. In the stories of Savage and of Blackmark, he showed the potential of the form—in many instances, deploying that potential about as fully as it could, at the time, be envisioned. Will Eisner also explored this avenue of verbal-visual expression in such books as *A Contract with God* (1978), *The Life Force* (1983), and other titles as he resumed an active cartooning career three decades after putting the Spirit aside. But Eisner's blend of words and pictures in these works is fairly conventional; his use of the medium is, as usual, daring and often brilliant, but he does not plumb its verbal capacities to any greater extent than he did with the Spirit stories. These are still comic books, not graphic novels. The distinction, however, is moot.

While I have labored here to show how graphic novels can be distinguished from comic books, the industry itself quickly subverted the notion of a graphic novel being anything substantively different from a comic book in form and function. By the end of the eighties, the term *graphic novel* was being used on every hand to designate publications that differed from comic books only in number of pages and thickness of cover stock. Comic books with hardback covers or covers on heavy-coated stock were called "graphic novels," particularly if the length of the story between the covers was greater than would be found in a newsstand comic book in magazine format. In this context, *graphic* referred to the visual character of the narrative; *novel*, I assume, proclaimed that the narrative would be longer than the usual comic book "short story." In the subsequent proliferation of the term in marketing campaigns, we can also detect just a little pretentiousness—an effort to elevate the medium's artistic status by appropriating a respected term, *novel*, from the more highly regarded literary medium. Whatever the motive for using *graphic novel* to describe these long comic book stories sandwiched between cardboard covers, the formal nature of the medium itself was no different from

what was to be found between the flimsier covers of the magazine package. The graphic novel as I've been discussing it virtually disappeared. But Gil Kane did not.

In the late 1970s Kane conducted another experiment with the medium—this time, in the newspaper strip format. *Star Hawks*, which Kane drew and Ron Goulart wrote, ran for only about four-and-a-half years (from October 3, 1977 to May 2, 1981), but it was the most imaginative innovation in the newspaper strip since adventure stories invaded the funnies. Goulart furnished fast-moving stories, crisp and economical scripting, and more than an occasional flash of humor. This alone made *Star Hawks* almost unique among its fellows, whose stories so frequently plod humorlessly along through unending forests of verbiage. But *Star Hawks*'s toehold near the pinnacle of noteworthy comic strips is best secured by its graphic treatment.

In format, *Star Hawks* was a two-tier strip: it occupied the space normally filled by a stack of two daily strips. The notion of a double-decker strip was Flash Fairfield's. Director of Comic Art for the Newspaper Enterprise Association syndicate, Fairfield began toying with the idea of a space adventure strip in the summer of 1976. And he saw the double-truck format as a way of putting life back into the adventure continuity strip.

"Basically, we felt that continuity strips would never make it the way they've been presented in recent years," Fairfield recalled in *Cartoonist Profiles*: "They just don't have enough space. But with the success of TV [serial] specials such as 'Roots,' 'Rich Man, Poor Man,' and so on, we figured we could get back into the comic sections and demand more space. If we got more room in which to operate, then we could show newspaper editors how exciting a continuity could be if it had this extra space, and could demonstrate to them that readers would be receptive to the idea."[8]

Fairfield ran into Goulart, found out he was a science-fiction writer, read and liked some of Goulart's books and stories, and eventually enlisted him to write the new strip. It was an inspired choice: not only was Goulart an sf writer of years' experience, he was a collector and fan of comics and author of numerous books about the medium. Goulart knew and understood comics, and the *Star Hawks* stories reflected his thorough grasp of the form's nuances. Goulart then contacted his friend and neighbor Kane, and the creative team for *Star Hawks* was born. "We soon realized," Goulart later reported, "that because of its unique size, our strip had to have a look of its own. What we were providing was the equivalent of a full comic book page every day. Gil decided not to pile two dailies on top each other but to break up his space in much more effective ways."[9]

Speaking at a comics convention in Boston several years before, Kane had distinguished comic book art from comic strip art. In comic book art, he is reported to have said, "nobody is ever doing anything except in action; in strip art, nobody is ever doing anything except not in action." The "nonaction" in newspaper strips may be more naturalistic than comic book action, Kane observed, but comic strips are undeniably less lively than comic books. In transferring the comic book page to the newspaper, Kane hoped to import with the format "all of the vitality and the thrust that you get on a comic book page because it has the room and because it deals in romance and fantasy which the newspapers abandoned long ago."[10] And as *Star Hawks* took shape, Kane's hopes were realized.

In its unprecedented expansive format, the strip afforded Kane the space a high adventure story needs. Varying panel size and layout from day to day, Kane broke old molds for newspaper strips. His panels slashed vertically through the two-tier space allotment, and Kane filled the large panels with exotic scenery and complex machinery and crowds of fighting men. With this much elbow room, Kane could create and sustain an authentic futuristic atmosphere for Goulart's stories.

According to Kane, he and Goulart collaborated in a way that resembled the Marvel Method: "Ron brings in a storyline that consists of, say, the two main characters ending up on a prison farm. We sit down and spend an evening and work out a continuity about a prison farm. Then I work out the entire continuity [the breakdowns], day by day, on typing paper. Then Ron writes the copy in, and I use that as a basis for my drawing."[11]

Kane was most comfortable with this approach: it permitted him to contribute to the story. "I'm trying to create not a plot line," he once said, "but a line on which to hang dramatic sequences that reveal character and motivate the plot line."[12]

The spacious *Star Hawks* format enabled Kane to do more than set his scenes with impressive

Figure 65. *Kane uses the roomy resources of* Star Hawks' *two-tier format to give us an impressive view of the space station spa, the Hotel Maximus (March 24, 1978).*

splash panels. Kane cut up his space to suit each day's story installment. And on days when the narrative demanded it, he staged the story in five or six panels, timing the action in ways that the standard one-tier strip in the diminutive dimensions of the 1970s could no longer aspire to. Sometimes a series of stripwide horizontal panels emphasized the sprawling action of a sequence; sometimes the panels were narrow, vertical slices of time.

And throughout, Kane's distinctive graphic style—a crisp, almost brittle, line of unvarying width, whose delicate tracery is sharpened and made emphatic by the liberal use of strategically placed solid blacks. Kane's style contrasts what he calls "geometric" and "organic" qualities. The geometric line "drops precipitously and brilliantly from one point to another and actually accents the shape by being natural and geometric." A geometric illustrator, for example, makes fingers squarer—"but always with the idea of evolving the shape, the silhouette." As Kane explained to Will Eisner:

> I'm greatly attracted to that style because it was the first ordered quality I could impose on what I thought was an aimless style. Now that I'm older, I have a tendency to like natural forms. I like lines that constantly come in contact with all the subtle forms of anatomy—the head, the nose. If you draw as delicately and nuanced as possible, those forms that are so satisfying in the way they're pulled together, rolled together, make new forms—I call that an organic line,

one that accommodates all sorts of natural qualities in the figure. Somewhere in between the strength and power that the geometric line gives you and the lyrical quality that the organic line gives you is what I feel I want for myself.[13]

In *Star Hawks*, we see clearly Kane's stylistic objectives being realized: the rounded, flowing forms of the human figure stand in stark contrast to the flat planes of space machinery and buildings. But even in the human figures, knots of muscle, sinew, and bone take geometric shapes as they also mesh together to define the natural forms of anatomy in motion.

Stylistic achievement aside, Kane's signal accomplishment in *Star Hawks* lies in the manner in which he exploited the potential of his strip's novel format. To see how he did it, let's look at a couple of strips from 1978.

On March 24 Kane used half the strip's space to introduce us to Hotel Maximus, a space station spa and resort (figure 65). The design of this strip is unabashedly attention-grabbing. On the average page of newspaper comics, the two-tier height of Kane's panels would stand out anyway—but the vast final panel we see here, with the hotel etched against the black backdrop of space, positively screams for a reader's attention. Such use of space, however, is more than just visually riveting: an adroit graphic portrayal of the strip's setting and atmosphere gives the adventure story its authenticity, its reality. And Kane times the action, too—

Figure 66. *The sort of timing of action that is depicted here is not possible in most of* Star Hawks' *contemporary adventure strips, which were obliged to tell their daily tales in much less space. (May 10, 1978)*

giving us our first view of Hotel Maximus as a concluding visual crescendo for the day.

On May 10 Space Hawk Chavez ends his encounter with the giant robot, Tux (figure 66). Here the strip's ample format permits Kane to time the action with cinematic precision. Kane uses this layout frequently: the first panel, two tiers high, establishes the scene for the day's action, which subsequently unfolds in a double deck of conventional panel boxes. The first panel here plunges us immediately into the fray. We see Tux lunging at Chavez, the diagonal cut of the border directing us to the Star Hawk and emphasizing the difference in size of the two combatants. In the horizontal thrust of the second panel is the resonance of the direction of Tux's assault and Chavez's parallel countermove. The remaining three panels time Chavez's actions with dramatic precision. In the first of them, we see Chavez diving for his gadjgun as Tux picks himself up to renew his attack. Then Chavez unholsters his gun—just in time to meet Tux's onslaught.

In strips like these, Kane gives us impressive examples of the storytelling potential of comics art. The May 10 episode is particularly striking. Although this day's story is told chiefly in visual terms, the dialogue, spare though it is, adds essential details to the episode. Tux's opening remarks remind us of other story elements (Raker's capture of other Star Hawks) and make it clear that he isn't lunging at Chavez in order to embrace him lovingly. Much of the remaining dialogue preserves

the flip personalities of the combatants, while Chavez's remark in panel three blends with the action depicted to clarify his objective. Finally, the entire sequence is superbly paced to create the maximum dramatic impact in the concluding panel.

Not since the thirties had an adventure strip been afforded the sort of room that permits this kind of storytelling—the kind that displays the best of which the medium is capable.

The National Cartoonists Society recognized Kane's newspaper strip achievement by awarding him a silver plaque for best story strip in 1977—as it had honored his work in comic books with similar awards in 1971, 1972, and 1975. A recognized master in his field, Kane returned to comic books in 1981, bringing to the pages of Marvel's Conan saga an artistry and graphic imagination that had been forty years in the making.

In the first three Kane Conan books (*Conan* No. 127, *Annual* No. 6, and *Savage Sword* No. 65), we find a continuation of the freewheeling layouts that distinguished *Star Hawks*. Just as the newspaper strip benefited from Kane's comic book experience, so did the comic book reap rewards from Kane's strip experimentations. Having spent four years cutting up his strip's two-decker space into a wide variety of panel configurations, Kane applied his layout shears to the comic book's full pages with similar innovative enthusiasm.

Talking with Eisner, Kane said that he felt "imprisoned by the rectangular shape" of the usual

grid of comics panels.[14] In these Conan books, we can see him trying to break out of these confines by reshaping the grid. No longer do panels of nearly equal size march across and down the page in cadenced ranks. The pages are slashed into vertical, horizontal, or diagonal panels, their shapes and sizes underscoring the action. A sampling of Kane's rough layouts for *Savage Sword* No. 65 illustrates the effect: the pages bristle with energy because the panels, shaped to fit the activities depicted, are filled with dramatic action (figure 67).

The narrow horizontal panels of page 22 emphasize the adversary action by putting Conan on one side, his opponents on the other—and the narrow focus results in panels filled with figures, stressing the odds against the Cimmerian. The vertical panel at the bottom left dramatizes the height from which Conan seems to fall. On page 28, the diagonal cuts echo the action, giving power to Conan's blows in the top panel, impetus to the arrow he releases in the next. The configuration and size of panels on page 43-A keep the serpent looming before us, in threatening contrast to the comparatively diminutive Conan, while devoting the largest and therefore most dramatic panel to a demonstration of the barbarian's power as he splits the snake's head with an axe. And on page 44, the destructive power of the serpent's death throes is emphasized in vertical panels that keep its monstrous size in the forefront—that and the tumbling edifice that seems about to crush Conan as it falls about him.

Judging from Kane's remarks in his conversation with Eisner, the manipulation of time for dramatic effect through breakdowns is not as important to Kane in storytelling as it was, say, to Eisner. Kane uses pictures, he said, "to create character and mood."[15] Page layouts are overall designs that reinforce this effort. A three-page sequence from *Conan* No. 127 shows how Kane does it.

In wintery Cimmeria, Conan has fallen in with a mysterious snow-haired woman named Xean. A band of Vanir come upon the couple with the object of taking her back to their village, where she is revered as some sort of goddess. Conan defeats all the marauders except their leader, Grendel, whom he now faces on a snowy battlefield.

On the first page (figure 68), we don't need the words to make sense of the pictures—or vice versa. But, as in the *Carter* sequence we examined, the juxtaposition of pictures that show the ferocity

of Conan's assault with words that announce his purpose imparts to his remarks an intensity that they would otherwise lack. Narrative breakdown gives us a series of instants—visuals that depict the most vigorous of the conflict's actions rather than every movement. By such impressionistic treatment—blades ever swinging and clashing, bodies moving or tensed for action—Kane creates the battling mood of his scene. Layout and composition add to the effect: the panels seem to be shaped by the arcs of swinging weapons, and the camera angle shifts rapidly, enhancing the action with a visual excitement achieved through sheer variety.

To say that Kane does not usually manipulate time with his breakdowns as conspicuously, as theatrically, as Eisner does is not to say that Kane ignores the dramatic function of timing. This page builds to a conclusion: Conan's speech is timed, the layout arranged, and the compositions selected—all to create the dramatic impact of the last panel. And by the last panel, Conan is clearly more of a threat to his opponent than he seems at the beginning of the sequence.

The composition of the first panel dwarfs Conan: we see him from behind his foe and between the calves of legs made monstrous by their relative proximity to us. This trick of perspective may seem purposeless or unnecessary when we look only at the three pages reproduced here. But these pages are preceded by the one on which our favorite barbarian slaughters a dozen of Grendel's men single-handedly. Emerging triumphant over such odds, Conan is clearly not a man against whom any other single combatant is much of a threat. But by seeming to place Conan at a disadvantage in size through the device of altered perspective, Kane enhances Grendel's chances. The visual transition between Conan versus the mob and Conan versus Grendel thus builds up suspense that would otherwise be on the wane after Conan's victory against far greater numbers.

In the next three panels, however, Conan rapidly regains whatever he may seem to have lost through a trick of the eye. It's Conan's sword that clangs, metal on metal, time after time. Conan takes the fight to the Vanir, and Grendel can't land a blow. The two concluding close-ups give us the state of affairs after Conan's initial onslaught. The first reveals Grendel's growing sense of alarm; the second, the source of that alarm—Conan's rag-

Figure 67. *A sampling of four rough layouts from* Savage Sword *No. 65 reveals the kind of energy Kane infused into his stories by using unusual layouts. Kane began laying out a story by doing half-size thumbnail sketches for the entire book and then translating those into fairly detailed drawings, such as we see here. The final art for these pages duplicates the drawings almost exactly: Kane uses a felt-tip pen and light board, inking as he traces the rough layouts directly onto the final art board. Shown here are page numbers 22, 28, 43-A, and 44.*

Figure 68. *A three-page sequence (above and figures 69 and 70) from* Conan *No. 127 testifies to Kane's skill in using the medium to create mood and reveal character.*

ing ferocity, the grim motive power behind a seemingly unstoppable attack. These emotions acquire intensity through the close-up compositions, and the personalities of the antagonists are glimpsed through their emotions.

The second page in this sequence (figure 69) is a montage splash page that shifts our attention to the woman over whom the men fight, her mounting but unspecific fear as she watches the combatants. As she trembles, we see what she sees, even as her terror-widened eyes dominate the page. The

full-page montage is a device Kane frequently uses—with telling effect. It has the impact of a full-page splash panel, a visual crescendo that gives the action depicted dramatic power. But at the same time the montage treatment curiously suspends the action: the figures are lifted off the ground, divorced and isolated somehow from the real world upon which their feet normally tread. The narrative, the story, seems to go on without them as they hang there in lyric suspension—operatic figures posturing heroically, the music

Figure 69. *Suspended in space, Kane's characters seem godlike, heroic.*

building around them. Through this technique, Kane imbues his characters with a larger-than-life quality, and his story thereby visually assumes heroic stature.

The third page (figure 70) finds the antagonists with their feet on the ground again as Conan pushes the contest to its grisly conclusion. Again, Kane builds toward his final panel. Words and pictures blend in the medium's most effective manner, achieving a narrative economy that enhances the drama of the events. Although the pictures

make narrative sense by themselves, they also lend significance to the words, words and pictures together thus acquiring a greater meaning for the story than either has alone.

Narrative breakdown, layout, and panel composition combine to heighten the drama. The first two panels sprawl across the entire page, giving us both setting and powerfully moving figures in impressionistic glimpses. When Conan disarms his opponent at the battle's climactic moment, the camera closes in on Grendel as he realizes his

The Heroic Avenue to Art 123

Figure 70. *Narrative breakdown, layout, and panel composition act in concert to heighten the drama of the fight's conclusion.*

time has come. The close-up emphasizes his momentary terror, making his subsequent—and last—defiant gesture all the more revealing. Faced with certain death, the Vanir has pride and courage enough to overcome his fear and defy his opponent to the end. And by focusing on Grendel alone in the fourth and fifth panels, Kane gives his last moments a suitably isolated dignity.

The last four panels time the action with careful precision, and Kane shifts from horizontal panels to small verticals by way of stressing the closely connected moments being depicted. But the death-blow that must fall between panels 5 and 6 is not shown. By omitting it, Kane makes a narrative leap instantly from life to death: Grendel is alive in panel 5, dead in panel 6. The suddenness of the transition reminds us how fragile is our hold on life, how easily it can be taken from us. And by focusing on the dead warrior in the last panel, Kane forces us to pause and remember that but an instant ago this still form had moved with powerful energy, animated by a fierce barbaric pride. It is

not a corpse but a dead man—a once-living creature that, despite all its acts of viciousness, had both heart and head, feelings and thoughts.

Conan's last remark, "A fitting epitaph," thus acquires an ambiguous irony. He speaks scornfully of a hated foe whose merciless and murderous raid on a small town makes him no more worthy of remembrance than so much spittle. But Kane has structured his story to reveal that Grendel has qualities worthy of admiration, too—courage and pride. And in depicting Grendel's final moments, Kane has artfully deployed the resources of the medium to reveal those qualities. In that revelation, we have indeed "a fitting epitaph."

As the hero of bare-chested adventure, Conan could have asked for no one better than Kane to delineate his exploits. Kane's obvious pleasure in drawing the human figure in action found a perfect outlet in Robert E. Howard's barbarian. And Kane's style—his preference for creating figures using geometric components that knot muscles to make forms both solid and supple—gives the Conan tales a distinctive visual energy. Kane's heroic style is best realized in characters like Conan. And the character thereby achieved heroic stature.

But Kane is a master of the nuances of the medium as well as the creator of a unique graphic style. And the Conan books acquired more than heroic style under his hand. Kane brought to comic books a serious regard for the potential of the medium and an experimental creativity that expanded the possibilities for the comics. Unlike the dinosaur, Kane survived the Golden Age and lived into the next, and the mammoth potential of his experience, skill, and innovative artistry continued to tower over the art form, full of promise and fulfilling that promise. And in depicting the exploits of characters like Conan, Kane gave us a vivid demonstration of how the heroic could be transformed into art.

CHAPTER 6
The Comic Book as Individual Expression
Harvey Kurtzman and the Revolution

Harvey Kurtzman was another whose life's work in comics paid to the medium the respect it was due as an art form. Famous as the creator of that manic magazine of parody and satire, *Mad*, Kurtzman also told serious stories in comic books, deploying the rhetoric of the medium to achieve an unprecedented narrative intensity. His work is different from Eisner's. Both men viewed their endeavors in the literary tradition of the short story. Both were virtuosos of the verbal-visual blending that is at the aesthetic core of the comics medium. Each, however, achieved a slightly different emphasis in his work. In Eisner's stories, we are more conscious of atmosphere and mood than we are in Kurtzman's; in Kurtzman's work, of timing. Not that Eisner was in any way deficient in timing his stories; he emphatically wasn't. Nor was Kurtzman inattentive to atmosphere and mood in his stories. It is a matter of emphasis, as I said. Kurtzman was concerned about atmosphere, but he tended to create it by pacing the verbal and visual content of his stories. By the same token, Eisner was keenly aware of the narrative function of timing—and he was thoroughly master of it as an aspect of storytelling vital to producing a desired effect (as we have seen); but his work usually makes us, the readers of it, more conscious of atmosphere than of timing. Both cartoonists, regardless of the varying emphases we may detect in the

work of each, are indisputably masters of the medium; and the work of each had far-reaching effects, shaping the form in ways neither could have imagined.

Born in Brooklyn, Kurtzman was only seven years younger than Eisner, but those years were critical ones. Comic books did not exist when Eisner was a teenager aspiring to be a cartoonist; Kurtzman saw and read comic books as he went through high school. When Eisner began his career, he had to fashion the form as he worked in it; Kurtzman came upon comic books in full feather. He belonged to the first generation of comic book artists who had grown up with the medium and who were therefore familiar with it as a narrative form.

Kurtzman's first work in comic books was for Louis Ferstadt, whose shop produced material for Quality, Ace/Periodical, and Classic Comics—the latter, a series of comic books that retold such vintage works of literature as *The Three Musketeers*, *Ivanhoe*, *Moby Dick*, *Treasure Island*, and the like. Kurtzman's work began appearing in early 1943, but toward the end of the year he was called up for World War II. Identified as an artist, he was assigned to work as a draftsman in various ways, winding up, finally, in the Department of Information and Education. When he was discharged after the war, the comic book industry was no

Figure 71. *Kurtzman's self-caricature done for a class at the School of Visual Arts.*

longer in its infancy: it was a healthy, growing ad-
olescent.

Kurtzman formed a commercial art studio with
a couple of other artists (one of whom was Will
Elder, who'd been a classmate at New York's High
School of Music and Art), and he freelanced,
mostly selling humorous features—among them,
Silver Linings, a one-tier filler strip for the New
York Herald Tribune Syndicate to distribute as part
of its Sunday funnies package, and a series of
wacky one-page features called *Hey Look!*, which
he produced as fillers for Stan Lee at Timely Com-
ics. He did a *Hey Look!* page every week for three
years until 1949, when Lee stopped running fillers.

Kurtzman then tried doing *Rusty*, the Timely
clone of *Blondie*, but neither he nor Lee was happy
with the results. That's when Kurtzman went to
the EC offices on Lafayette Street and walked into
the history books.

EC stood for Educational Comics in 1949. It was
a mediocre line of comics founded by Max Gaines
chiefly to amuse himself. Shortly after he'd given
Superman away to Donenfeld, Gaines had entered
into an agreement with Donenfeld to produce a
line of patriotic and educational comic books un-
der the DC umbrella. Called All-American Comics
after one of the titles, Gaines's company eventu-
ally produced a modest collection of superheroes

The Comic Book as Individual Expression 127

(including Wonder Woman, Green Lantern, and Flash) in an assortment of titles, as well as the purely educational series, *Picture Stories from the Bible*. By the mid-1940s, Donenfeld had withdrawn from the arrangement, leaving his interest with Jack Liebowitz, his DC partner and former accountant. Unable to work with his new business associate without quarreling, Gaines sold his interest in All-American Comics to Liebowitz for $500,000. Max could have retired comfortably on the interest from this settlement, but comic book publishing was in his blood, so he continued producing his Picture Stories series (adding American and world history titles) as well as some mildly humorous comic books under the Educational Comics imprint. Then, on August 20, 1947, Max was killed in a boating accident, and his wife and twenty-five-year-old son Bill inherited the comic book company.

William C. Gaines knew nothing about the business, and neither he nor his mother needed any additional income: Max's half-million dollar nest egg generated ample annuities. But his mother wanted to keep the comics going for sentimental reasons, so Bill dutifully went to work every day and played at being a comic book publisher. His activities over the next couple of years echoed in microcosm the entire industry's feverish attempt to find a substitute for superhero comics, whose wartime popularity had slumped so drastically once the hostilities ceased. In this effort, he was aided and abetted by a young cartoonist who had wandered into his office in early 1948 to display his wares.

Al Feldstein had been doing teenage comics for Fox, and he showed Gaines some of his work. "All the broads had big busts," Gaines said later, "and I was so taken with those busts that I hired Feldstein on the spot to put such a book out for me."[1] They discovered immediately that teenage comics were losing money, so instead of publishing *Going Steady with Peggy* (the proposed title of their buxom new comic book), they imitated every other postwar trend they saw. They converted one of Max's humorous titles, *Happy Houlihans*, to a western, *Saddle Justice*, which lasted only until they saw that romance comics were selling better, whereupon the book became *Saddle Romances*. Similarly, Max's educational *International Comics* was transmuted into *International Crime Patrol* in early 1948 and then simply *Crime Patrol* that summer. Theirs was a wholly undistinguished effort until Gaines and Feldstein decided to start a line of books that reflected an interest they'd discovered they shared—a fascination with eerie tales of the supernatural like those featured on the popular radio programs of the day, "Suspense" and "The Inner Sanctum."

The first of these horror stories appeared in *Crime Patrol*, and when it generated favorable reader response, Gaines and Feldstein did what they were by then very good at: they followed the trend, but this time, it was a "new trend" of their own devising. In the spring of 1950 they converted *Crime Patrol* to *The Crypt of Terror*. The enthusiastic reception of the horror tales resulted almost at once in two more titles, *The Vault of Horror* and *The Haunt of Fear*. Delighted at their success, the two men indulged another common interest by cranking out a series of science fiction books, *Weird Science* and *Weird Fantasy*, followed by another that combined crime and horror, *Shock Suspense*. To reflect the shifting emphasis of the company, Gaines changed its name to Entertaining Comics.

Almost from the beginning, the EC books were some of the most literate and best drawn on the newsstand, although the headlong method by which they were produced would seem more likely to have resulted in an entirely opposite outcome. Gaines read science fiction and horror stories every night, bringing plot ideas to the office the next day to try them out on Feldstein. As soon as an idea ignited Feldstein's imagination, he went to his drawing board and laid out the story, writing dialogue and captions on the illustration boards as he went. The story was then completely lettered before the pages were turned over to an artist to illustrate. As they added titles, the need for material grew to such an extent that they had to do a story every day or else miss production deadlines. At that pace, Feldstein had little time to deliberate over his breakdowns or layouts; he relied almost entirely upon verbiage to carry the narrative burden. As a result, the comic books he produced were seldom very good examples of the art inherent in the medium. But the stories were gripping nonetheless, inspired by some of the best pulp fiction around. And the artwork was, simply, superior.

To do the drawing, Gaines was able to attract the best young talent around. He paid better than many of his competitors, for one thing: he wanted

good artists and he wanted them exclusively, so he paid them when they delivered the work; they didn't have to wait for publication as artists working for other publishers did. Moreover, he and Feldstein encouraged their artists to draw in their own styles rather than forcing them to adopt a "house style." And they all inked their own work, too. This policy resulted in the most distinctive-looking line of comic books on the racks. What's more, the artists were permitted to sign their work. With their names on the artwork, the artists, all young and ambitious, were spurred to do their best, and a spirit of friendly competition pervaded the EC enterprise. "You were embarrassed not to do your best because everybody was doing their best," Kurtzman said later; "it led to some of the finest work in the business."[2] The stable Gaines eventually assembled included men whose achievements would be enshrined in the memories of students of the medium for decades—Johnny Craig, Graham Ingels, Wally Wood, Jack Davis. And Harvey Kurtzman.

But when Kurtzman took his portfolio into the EC offices late in 1949, he thought the company was producing educational comic books, and that's the sort of work he thought he wanted to do. Gaines and Feldstein had yet to produce any of the titles of their New Trend, but they were by then committed to the idea. In any case, most of Max's educational titles had been converted into crime and love comics. They roared in appreciation of Kurtzman's *Hey Look!* samples, though, and Gaines, not wanting to lose Kurtzman to anyone else but not knowing, either, how to make use of this comedic talent, steered Kurtzman to his uncle, with whom Gaines sometimes packaged educational comic books. Kurtzman took an assignment to illustrate a cautionary tale about venereal disease called *Lucky Sees It Through*. By the time he finished that, Gaines and Feldstein were actively producing horror and science fiction stories for their new titles, and Kurtzman was given assignments in both genres.

Kurtzman wasn't particularly comfortable doing horror. The stories were rife with vampires, zombies, werewolves, treacherous spouses, disembowelments, rotting corpses and opening graves, vengeance murders committed in every imaginable mode, and a host of other assaults on civilized squeamishness. But Gaines and Feldstein were having great fun. They spun out these hideous yarns with fiendish glee. Never for an instant did they take the revolting activities of the characters in these stories as seriously as the critics of comic books soon would. Their tongue-in-cheek attitude was clearly signaled by the "Ghoulunatics" who introduced the stories. Each of these "mad mags" (as Gaines called them, coining a pregnant phrase) was "hosted" by some sort of old hag—the Keeper of the Crypt, the Keeper of the Vault, the Old Witch—who introduced each story with a diatribe of macabre puns and double entendre. Still, the stories were unsettling, and Kurtzman, perhaps looking for a way to do something more congenial to his bent, suggested to Gaines that they create yet another title, this one for rousing adventure in the tradition of Roy Crane's *Captain Easy*. Gaines was game, but since neither he nor Feldstein had either the time or the talent for doing adventure stories, he turned the whole project over to Kurtzman.

Two-Fisted Tales appeared in the fall of 1950, the latest in another series of mutations for which EC comic books are noted. The book began as a humorous title under Max Gaines, *Fat and Slat*; Bill converted it to *Gunfighter* and then *Haunt of Fear*. When wholesalers objected to the word "fear" appearing on the cover of a comic book, Gaines discontinued the horror title but gave the book to Kurtzman. The first *Two-Fisted Tales* was No. 18 because it had been preceded by seventeen issues published under other names.[3]

By the second issue of the adventure book, Kurtzman was writing most of the stories. Like Feldstein, he provided the artists with lettered pages to illustrate. But there the similarities ended. Kurtzman was driven more by storytelling passion than by compulsion to meet deadlines; he took longer than Feldstein to write his stories. Indulging a fascination with authenticity, Kurtzman spent days, even weeks, researching a story, digging up factual details as well as pictorial aids for the artists. Moreover, he took great pains to deploy the visual resources of the medium, eschewing words where he could make pictures tell the story more dramatically. He did complete layouts for each story, roughing in the composition of every panel. And as time went on, his layouts became more and more detailed. Feldstein let the artists draw whatever they wanted as long as it illustrated the story. But Kurtzman insisted that the artists follow his layouts exactly.

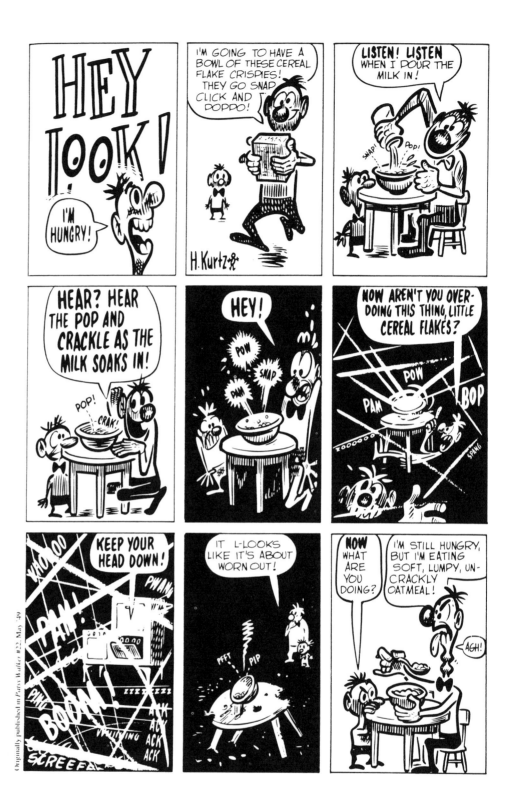

Originally published in *Patsy Walker* #22, May '49

Figure 72. *One of the celebrated* Hey Look! *pages.*

Years later, one of the artists, George Evans, appeared with Kurtzman on a panel presentation during a comics convention and kidded him about the precision of his layouts.

"The first thing I did for Harvey was the story of Napoleon [*Frontline Combat* No. 10]," Evans said, "and Harvey wanted me to draw every one of Napoleon's troops, and every one of the Austrians, the Prussians, the Russians and everything else. And he had taken the time . . . "

"Uh-uh," Kurtzman interrupted, "—not every one."

"Complete with uniforms and name tags!" Evans said.

"All I wanted was *half* the Napoleonic army, not all of it," Kurtzman continued. "We didn't have enough room in the panel. You didn't have to draw their feet."

"I drew little dots," Evans said. "But Harvey had meticulously done all those [in his layouts]. I think he knew every man's name that was in it."[4]

Some artists objected to being so tightly reined in. Others, like Jack Davis and Alex Toth, didn't. Toth was not one of the EC regulars, but he penciled a story from Kurtzman's layouts once and explained his feelings this way: "He wasn't easy to satisfy. He knew graphics, though, and I could accept his methods. In a way, it's offensive to be told exactly that you have to do something this way or that way, but it was just a matter of respecting the man who'd written the story and laid it out. You usually agreed with him."[5]

With the debut of *Two-Fisted Tales*, Kurtzman became what he called "a behind the scenes" cartoonist.[6] Most of his cartooning from then on would be in the form of meticulous layouts for other artists to follow in preparing finished artwork. Kurtzman prepared final art for the covers of many of his books, but only an occasional issue carried a story for which he did the finished art.

In devising his stories, Kurtzman began by writing a "treatment," a paragraph outlining the action. Like Gaines and Feldstein, he admired O. Henry's story structures. "It's like the basic structure of a joke," he explained, "where you draw your reader in one direction and then you hit him from another with the old twisteroo. I've always likened short story structure to the blowing up of a balloon. The more energy you put into blowing up a balloon, the scarier it gets. You don't know when the balloon will break, but suddenly— it does. Bang! Surprise! You expect it but it happens unexpectedly. You can't tell when it will happen. So you feel a jolt of shock inside. That jolt, that excitement, is what I want every reader to feel."[7] After settling on a subject for a story, Kurtzman then looked for an ending, a way to puncture the balloon.

Using the prose treatment as a guide, he made thumbnail sketches for the narrative breakdown and then wrote captions and dialogue. "Once I have my pictures," he said, "then I know what the characters have to say."[8] After completing the verbal script, he returned again to the drawing board and prepared detailed layouts. Kurtzman revised his compositions again and again, making adjustments on successive layers of tracing paper tacked on top of the previous drawing. Each of the final panels is a painstakingly crafted composition, a carefully conducted balancing act that juggles verbal and visual content. "Cartooning consists of the two elements, graphics and texts," Kurtzman believed. "Obviously it is to the advantage of the total product to have good text and good art and the more closely integrated the good text and the good art is, the greater the opportunity is to create the capital A Art."[9]

As an example of the art Kurtzman achieved, "Pirate Gold" is fairly typical. Published in *Two-Fisted Tales* No. 20 (cover-dated March–April 1952), the third issue, it is one of his earliest works, but Kurtzman's storytelling style is already clearly evident. This story comes to us with a bonus, too: it is one of the relatively few for which Kurtzman did the finished art, and his graphic style is as distinctive as his way of telling a story. Although he could draw in a convincingly realistic fashion, he increasingly chose to render his stories in an abstract and telegraphic manner. He used a line of uncommon simplicity and boldness for realistic storytelling, and his figure drawings were exaggerated and contorted, demonstrations of posture as drama rather than reality as perceived. By reducing his visual representations in this way to their absolute narrative essentials, Kurtzman achieved a reality in his stories that was stark and raw, as uncompromising as truth itself. Seldom, as his later war stories would vividly demonstrate, have subject and treatment been so perfectly matched in theme and tone.

"Pirate Gold" is set in the late eighteenth century and begins when two native fishermen find and rescue "a great big bull of a man" whom they find clinging to a spar in the sea. A cut on his head suggests that his dip in the drink was the consequence of some violence, but the blow has apparently addled the man's brain: he can't remember much. Although he recalls names, faces, and a casket of Spanish doubloons, he can't connect them all or attach much significance to them. He

searches his pockets and finds enough to remind him of his own name—"Captain Ben Sawkins! Long Ben Sawkins—that's me!"—and to suggest that his questions about the treasure of doubloons can be answered if he goes to Galveston. The fishermen are a bit wary because of the ferocity of Sawkins's manner and his threatening size, so they don't want to take him to Galveston. Not deigning to argue, he throws them both overboard and takes their boat to Galveston by himself.

As Sawkins strolls the waterfront of the Texas town, he is recognized by a passerby whom he fiercely grabs and roughly questions in order to find out more about his own vaguely recollected past. He finds out that the three men whose names and faces he remembers were members of his crew and that they left Galveston yesterday for Barataria Island, so he sets out after them. When he gets there, he comes upon his former shipmates, who are contemplating a cypress tree across a stretch of swamp. "It's Captain Sawkins! 'E's back from the dead!" says one. "Quick! Shoot him down!" In the ensuing scuffle, Sawkins dispatches two of the three men with his cutlass, then, facing the last of them, he wrings from him the explanation of the Spanish doubloons. It seems the four men buried a casket of stolen treasure in the very swamp in which they now stand, planning to return to divvy the swag. Since Sawkins's share was to be half and the other three wanted larger shares, they plotted to eliminate him. At this point, the story is taken up by the panels reprinted here, as Sawkins's captive finishes his narrative flashback (figure 73).

The first step toward appreciation of the storytelling artistry at work here is, I suggest, to notice the extent to which the story's conclusion is a verbal-visual blend. Neither the words nor the pictures alone make complete sense. Neither words nor pictures alone give the story its "end." Our understanding of Captain Sawkins's dilemma in the last two panels arises entirely from our simultaneous grasp of the implications of both the verbal and the visual. And the narrative economy that is achieved by this blending gives the story its peculiar dramatic momentum and impact.

These panels also illustrate that other unique aspect of the art of the comics: timing, the deliberate manipulation of verbal and visual information to achieve a dramatic effect. In Kurtzman's story, the narrative breakdown of the last five panels

paces the story's conclusion, slowly doling out information both visually (Sawkins's getting closer to the tree and the treasure) and verbally (his gradual recollection of the last forgotten bit of intelligence about the circumstances of the buried treasure). The timing and coordination of the visual and the verbal "messages" creates first suspense and then dramatic clout. By withholding until the last panel its final verbal-visual revelation, Kurtzman gives his story its shocker conclusion. The balloon explodes.

In the four panels at the top of the final page (the second tier as reproduced here), narrative breakdown times the action by repeating it, thereby building dramatic intensity as well as portraying personality. Repetition of the same action and the same words emphasizes Sawkins's obsessive character, his intense single-mindedness—with the additional suggestion in the eventually purposeless hacking (Tew is probably dead after a couple of blows) that Sawkins verges on madness so intense is his obsession. His teetering sanity is suggested in the panel preceding this series: Sawkins's eyes seem to burn with feverish insanity because all facial detail is enveloped in shadow.

Although the four-panel series is not a perfect visual-verbal blend (the pictures do make sense without the words), the words make little contextual sense without the pictures. But, when joined to the repetitive action, the words underscore the fierce intensity of Sawkins's emotional state. And the depicted action gives Sawkins's words their bitterly sarcastic ring. Thus, the meaning—the significance—of the series arises from our taking in simultaneously both words and pictures.

Color also plays a storytelling role in this series. Each of the four panels is a single color: the first is light yellow; the second, darker yellow; the third, orange; and the final panel, blood red. The color builds in intensity as Sawkins's emotions build in ferocity. Then in the next panel (the first in the third tier here), his fit of insane vengeance subsiding, normal color begins to return: the background is a pale yellow, against which Sawkins stands in solid blue—the muted monotone echoing his now more placid emotional state.

Another narrative role is played by the composition of the panels on the page—in cinematic terms, by the distance and angle of the camera. To begin with, there is graphic variety here: we don't see everything panel-to-panel from the same dis-

"ONE DARK NIGHT, JACK SHARP, BEN AVERY AND MYSELF THREW YOU OVERBOARD... AND I TOOK COMMAND."

THAT'S THE GOD'S HONEST TRUTH, CAPTAIN! NOW SPARE ME AND I'LL SHOW YOU THE CASKET!

I REMEMBER NOW! I RE- MEMBER! AND IT WAS YOU, TOM TEW, THAT STRUCK ME FROM BEHIND WITH A SABRE, THAT NIGHT I WAS THROWN OVER!

BUT I'M SQUARIN' WITH YOU NOW, CAPTAIN! YOU CAN HAVE THE WHOLE TREASURE! SPARE ME!

OH, THANK YE, MR. TEW! YOU ARE VERY KIND! NOW I CAN HAVE THE WHOLE TREASURE!

6

Figure 73. *Kurtzman's characteristic pacing is demonstrated in the conclusion of "Pirate Gold." (The top tier of panels is from the bottom of the penultimate page of the story; the next three tiers, from the last page.)*

THANK YE, MR. TEW!

THANK YE, MR. TEW!

THANK YE!

THANK YE!
HACK!

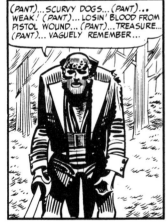

(PANT)...SCURVY DOGS...(PANT)... WEAK! (PANT)...LOSIN' BLOOD FROM PISTOL WOUND...(PANT)...TREASURE... (PANT)...VAGUELY REMEMBER...

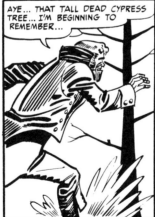

AYE... THAT TALL DEAD CYPRESS TREE... I'M BEGINNING TO REMEMBER...

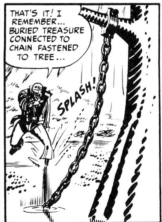

THAT'S IT! I REMEMBER... BURIED TREASURE CONNECTED TO CHAIN FASTENED TO TREE...

SPLASH!

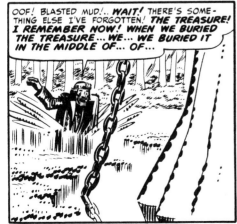

OOF! BLASTED MUD!.. WAIT! THERE'S SOME- THING ELSE I'VE FORGOTTEN! THE TREASURE! I REMEMBER NOW! WHEN WE BURIED THE TREASURE...WE... WE BURIED IT IN THE MIDDLE OF... OF...

...QUICK SAND!

7

THE END, IN MORE WAYS THAN ONE!

... WELL, DEAR READER! DID YOU ENJOY OUR BOOK? WE WOULD BE INTERESTED IN KNOWING WHAT YOU LIKED AND WHY! WON'T YOU WRITE US?

WRITE TO:

THE EDITORS TWO FISTED TALES RM. 706, DEPT. 20 225 LAFAYETTE STREET NEW YORK, 12, NEW YORK

tance or angle. Variety is a vital part of the visual excitement of the art of the comics. But the varied compositions are also selected with care to enhance the drama of events. The four-panel series, for instance, concludes in a tight close-up—a composition that suggests intensity by the narrowness of its focus. As the camera draws closer in the series, the maneuver emphasizes the feverish heightening of intensity that every other element of the series likewise conspires to create.

The camera backs off as Sawkins's fit passes, but it doesn't change distance much as he begins to run toward the cypress tree. He runs toward the next panel, a composition that capitalizes on the normal movement of the eye in reading to add momentum to his dash—and thereby to suggest his headlong, unthinking single-minded pursuit of the treasure. In the next two panels, the cypress tree—the object of the story's quest—looms in the foreground. The camera closes in slowly for these two panels; it is far enough away to show us what Sawkins is doing and, in the next-to-last panel, what is happening to him, but close enough to the tree to keep the as-yet-unexplained chain dangling before us, pregnant with significance. The meaning of the chain, its function, suddenly becomes clear as Sawkins remembers a crucially important forgotten fact. And as it dawns on him that his monomaniacal quest will result in his own demise, the camera closes in for one last look at the man in his self-inflicted agony. The close-up eliminates all of Sawkins's surroundings, thereby focusing our attention exclusively on the dilemma that now similarly absorbs the exclusive attention of the rampaging pirate captain.

At first blush, Kurtzman seems not to deploy layout—the size and arrangement of the panels on the page—for any narrative effect. But that impression arises simply because his use of layout is very subtle. As I've said before, the capacity to vary panel size and position gives the comic book format its most potent means of creating dramatic effects. Large splash panels have a crescendo impact in the course of a story (as opposed to their orienting or mood-setting function at the beginning of a story). A series of narrow panels may suggest the rapid passage of time; long vertical panels, height (or depth). It's my feeling that such effects are achieved best when the irregular-size panels break a pattern. Judging from the evidence of the page before us, Kurtzman shares this belief. To prepare

for these effects, then, most of a story must be devoted to constructing and maintaining a pattern, using panels of nearly uniform size; this uniformity creates the basic framework of time for a given story—its normal rhythm. An odd-size panel in such a sequence accordingly disrupts the established rhythm of the story, attracting attention to itself by the very act of disruption itself. The narrative content of the irregularly shaped panel then prompts the response appropriate to the story—joy, fear, sorrow, and the like. Although Kurtzman gives us no particularly spectacular example of the storytelling contribution of layout, he does illustrate the effect of breaking a pattern. He disrupts the story's rhythm with the four-panel series: he puts more panels than usual on a tier. And their quantity and similarity of size emphasize the repetitiveness of the action being depicted.

Kurtzman's story has a single plot that moves inexorably, virtually uninterrupted, along the path appointed to reach its conclusion. While there is a flashback that covers two-thirds of a page, that maneuver contributes directly to the movement of the main story line. This onward thrust of the story gives it dramatic power: the momentum that Kurtzman is able thereby to create and maintain heightens the dramatic impact of events. Momentum also derives velocity from the narrative economy inherent in letting words and pictures blend to tell the story. Since neither word nor picture is doing unrelated duty, each contributes to our understanding of the other, and there is consequently no excess, nothing to distract our attention from the forward movement of events.

This is not to say that every element of the story is bent to the single purpose of moving the plot forward to its conclusion. Kurtzman takes time—that is, space, panels—to develop the personality of his principal, too. Of the twelve panels we have before us, four are dedicated to this purpose—the four that show Sawkins slashing Tew repeatedly. And Sawkins's personality is integral to the theme of the story.

Thematically, Kurtzman's story deals with greed. The obsession of Captain Sawkins is an object lesson: greed, if indulged, has a way of shutting out all considerations except its immediate goals. The single-mindedness of greed is suggested here by the artifice of Sawkins's inability to remember much except the buried treasure. And the story leaves no doubt that obsessively greedy persons are

so enthralled by their *idée fixe* as to be vaguely insane and wholly self-destructive. Seizing upon the metaphorical import of the quicksand, we might even say that greed is so self-absorbing as to be fatal. (Puns, much as I love them, don't necessarily make good thematic summary statements; but this one is too apt to let slip away.)

The personality of Sawkins is pivotal in the tale's theme. And Kurtzman has exploited fully the capacity of his medium to portray both the personality of his protagonist and the progress of events. Our understanding of Sawkins's character—his maniacal ruling obsession—arises from our grasp of the implications of words and pictures, blended in mutual dependence for their meaning, just as our comprehension of the story itself—its outcome and significance—depends upon our correctly interpreting a visual-verbal blend. The story thus serves as a convincing demonstration of the artistry in the art of the comics—of the narrative use of visual-verbal blend to create the meaning of a story as well as to depict its actors and the events of which they are a part. Kurtzman's moral is scarcely a profoundly philosophical revelation, but his blending of words and pictures to tell his tale and to enhance its meaning, its import, is masterful. In the context of Western civilization, the moral point is a commonplace. But that is not a fault in Kurtzman's story: the greatest books in literature make moral points that are equally ordinary—ordinary because they are universal. The artistry in literature—and in comics—lies in how the moral points are scored. And how they are scored will in large measure determine how we react—whether we are moved and how much.

THE MORAL PASSION THAT FOUND EXPRESSION in "Pirate Gold" soon informed all of Kurtzman's work in *Two-Fisted Tales* and in a sister publication, *Frontline Combat*, which began in the spring of 1951 (cover-dated July–August). Within a few months after the launch of *Two-Fisted Tales*, it became apparent that the United Nations' "police action" in Korea was a full-scale war. As more and more Americans were called to the battlefield, public interest in the conflict grew, and with *Frontline Combat*, Gaines sought to capitalize on this interest. Directed to tell war stories in the two titles he was now editing (which meant he was writing both books, too), Kurtzman decided to tell the truth about war. The war stories in the

comic books produced by other publishers championed American servicemen at the expense of the enemy's humanity, proclaimed unequivocally the justice of the U.N. cause, and glorified battlefield action by making killing, bloodshed, and death seem patriotic. This, Kurtzman believed, was a lie. And he set out to erase the lie.

It was this crusade that inspired Kurtzman's passion for research. Only the truth can eradicate a lie, and to tell the truth, one needed to study history and news reports in order to unearth facts and then to be able to portray those facts accurately. Kurtzman had been impressed with Charles Biro's storytelling in the Lev Gleason crime comic books. "He offered stories based on fact, presented in a hard-edged documentary style, a highly original approach to comics back then," Kurtzman said. He recalled the excitement he felt when reading those stories, "the shock" of being brought "nose-to-nose with reality."[10] He set out to do the same thing with his war stories. He knew that young readers could not long sustain the phony glamorous vision of war once they knew the realities of the battlefield.

Kurtzman's war stories were not antiwar: in deglamorizing warfare, he did not oppose the effort in Korea. His stories acknowledged the necessity of the fight—not only in Korea but in wars generally. Against that necessity, though, Kurtzman balanced recognition of the overall futility of warfare. His unique achievement was to strike that balance. But in those days—in the wake of the superpatriotism of the world war just concluded, during another war in which veterans of the previous conflict were also fighting and dying—to publish such a balanced view was extraordinary, unprecedented. While Kurtzman's stories acknowledged the causes of wars and the necessity of fighting them, he dramatized the loss, the profligate waste of human life that has characterized wars everywhere in every time.

To show the effects of war, Kurtzman's stories often focused on the fate of a single individual. One story chronicled in elaborate detail the steps a Korean farmer took in building his house—picking a site, laying the foundation, erecting a framework, making bricks, putting it all together. Then, on the day he finishes his work, a bomb falls on the house and in a second destroys the painstaking labor of months. In another story, a dying soldier wonders about the arbitrariness of timing: if he

hadn't stopped for a moment to tie his shoe, he would have been twenty feet further down the road and when the bomb hit—he would have been far enough away to survive. In yet another tale, a soldier watches a body float down a river and wonders how it came there. Kurtzman turned to history for many of his stories, again directing our attention to obscure but ordinary individuals rather than celebrated personalities. Custer's last stand at Little Big Horn is seen through the eyes of one of the soldiers, who recognizes the general for the vainglorious grandstander he was. Kurtzman told stories of other famous battles—some in Korea, some from the Civil War. The starting point for most of his tales, he said, was "the observation. I would observe elementary truths and shape them into stories—for example, 'war's battles are fought by men, not machines'; 'death comes unexpectedly'; 'war is devastating, tragic'—any one of those ideas can be fleshed into ten stories."[11]

Kurtzman was justifiably proud of the work he was doing: he had dedicated his art to a serious, moral cause. No artist can aspire higher. But Kurtzman's greatest impact upon the moral attitudes of his society would come from another quarter. It would be as the founding genius of *Mad* that he would exert his most lasting influence. And *Mad* was started with no higher purpose than to increase Kurtzman's income in the simplest way possible.

By mid-1952 Kurtzman was spending almost every waking hour researching, writing, and laying out stories for the two titles he edited. As good as his work was, he was making much less than Al Feldstein, and he complained about it. Gaines paid his editors by the book, and in the two months Kurtzman took to produce an issue each of his bimonthly titles, Feldstein produced seven issues of his books. Gaines couldn't raise Kurtzman's salary without raising Feldstein's, and he couldn't afford to pay them both more without an accompanying increase in the company's revenues. Still, he wanted to do something. His solution was to offer Kurtzman a third book to do. Remembering the hilarious cartoons Kurtzman had showed him when he first came looking for work, Gaines suggested that Kurtzman do a humor book. Being funny, Gaines reasoned, would require no research; Kurtzman should be able to knock out an issue in a week. It would be a respite wedged between the throes of research for the war books. And he'd in-

crease his income by fifty percent. Gaines took the title of the new book from the expression he'd been using on the letters pages of the horror books—*EC's Mad Mag.* Kurtzman later shortened it to *Mad*—"a stroke of genius," Gaines said.[12]

The first issue hit the stands in late August 1952 (cover-dated October–November). The four stories inside were genre parodies of horror, science fiction, crime, and Western comic books. They were good parodies, but one could do only so many parodies of Westerns before that subject would be exhausted. Then, in the next issue, Kurtzman chanced upon what would become *Mad*'s métier. He did a parody of Tarzan and discovered an axiom: "Satire and parody work best when what you're talking about is accurately targeted," he decided. "Or, to put it another way, satire and parody work only when you reveal a fundamental flaw or untruth in your subject." To expose a fallacy, he had to be specific about where the fallacy lay. A parody of Westerns in general didn't have the satiric clout that a parody of *High Noon* had. In Kurtzman's view, *Mad* served the same gods as the war books: "Just as there was a treatment of reality in the war books, there was a treatment of reality running through *Mad*; the satirist/parodist tries not just to entertain his audience but to remind it of what the real world is like."[13]

For the next twenty-one issues of *Mad*, Kurtzman honed the insight he had gained from the Tarzan parody. In each issue, Kurtzman picked one newspaper comic strip or comic book to parody—*Little Orphan Annie*, *Terry and the Pirates*, *Smilin' Jack*, *Flash Gordon*, *Superman*, and *Blackhawk* among others. And his parodies had teeth. In one of the most popular, "Superduperman," he ridiculed the adolescent dream at the center of the Superman myth: when the mild-mannered reporter in Kurtzman's parody reveals his secret identity as the all-powerful Superduperman in order to impress Lois Pain, the object of his desire, she is not impressed. "Once a creep, always a creep," she says as she undulates away, leaving Superduperman (not to mention all us adolescent readers) forever crushed. In his parody of Disney characters, Kurtzman puts trousers on Donald Duck, making us aware of the sexless fantasy we'd always accepted without question. And in his treatment of George McManus's *Bringing Up Father* in *Mad* No. 17, Kurtzman turns his comedy into a power-

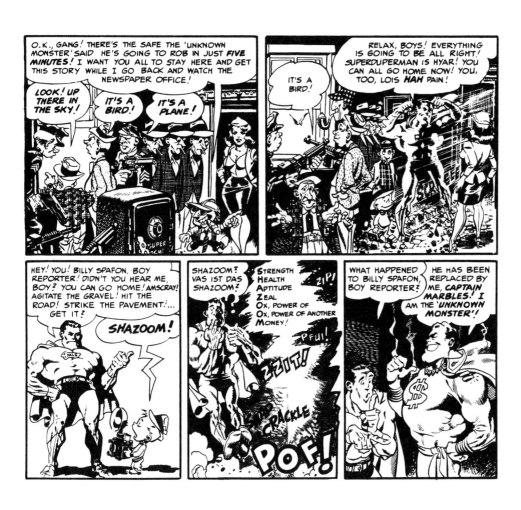

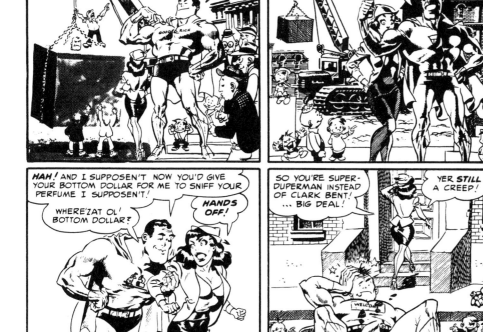

Figure 74. *Two segments from Kurtzman's "Superduperman" story for the third issue of Mad exhibit his usual manic nonsense and satirical thrust, especially as rendered by the supremely able Wally Wood. The centerpiece of the story, incidentally, is a battle royal between Superduperman and Captain Marbles, doubtless intended to evoke the legal battle between DC and Fawcett that had recently concluded, with Fawcett's retiring from the field and giving up its comic book line.*

ful statement about our tolerance of domestic violence. The story alternates a page drawn in imitation of McManus's style with a page drawn realistically. The McManus-style page ends with the usual hailstorm of crockery launched against the long-suffering Jiggs by his domineering wife, Maggie. The realistically rendered page picks up the action at this point, and we see Jiggs bruised and bleeding from Maggie's assault. The realistic Jiggs complains about his treatment, too, pointing out that there's nothing funny about being hit with flying kitchenware.

Kurtzman also needled movies, TV shows, advertising practices, literary classics, and the like. He pointed out the exaggeration (and hence, the fundamental dishonesty) in newspaper headlines. He compared the motion picture version of a book to the book itself (to the detriment of Hollywood). He explored the wasteland of goods in supermarkets. And he and the other cartoonists, led by Will Elder, filled all the space in every panel with "eyeball kicks"—chochkes, Kurtzman called them, sight gags irrelevant to the main story, tiny people carrying placards proclaiming nonsense, passersby with their own satiric axes to grind.[14] In no time, *Mad* was an uproarious success: the newsstands were awash in imitations from other publishers. Even Gaines, in a magnificent gesture that mocked his own industry, produced an imitation—*Panic*, edited by Feldstein.

Almost at once, it was apparent that Gaines's scheme wasn't working: instead of cranking out the humor comic book in a week, Kurtzman was pouring as much time and energy into *Mad* as he did into his two war titles. And he wasn't increasing his monthly income, because he was always falling behind the production schedule for one title or another. By the fall of 1953 he was only nominally editor of *Two-Fisted Tales*—and other circumstances were shaping events. The Korean War went on permanent hold in July 1953, and interest in war stories flagged; Gaines discontinued *Frontline Combat* that winter (with No. 15, cover-dated January 1954). Kurtzman maintained his income, though, because *Mad* became a monthly title with the April 1954 issue.

Meanwhile, the Wertham-inspired foes of comic books made their beachhead with the Senate Subcommittee on Juvenile Delinquency in the spring of 1954. By fall, Gaines's distributor would no longer handle his horror titles. Gaines tried to stay

in business by producing a series of new books— the so-called New Directions titles—but these were so poorly received that by fall 1955 he had shut down production of all comic books. Except *Mad*. And *Mad*, by this time, was no longer a comic book.

Fired up by the growing success of the title, Kurtzman had been increasingly impatient with the limitations of the comic book format. Some of his features, in fact, were no longer, strictly speaking, comics. In *Mad* No. 13, he did a photo feature, running witty remarks under photographs of cute babies. And he parodied the puzzle and game pages often found in other comic books. The covers of *Mad* betray Kurtzman's ambitions, too. He did a parody cover of *Life* and another of *Atlantic Monthly*. The latter was designed for readers who were ashamed to be seen reading *Mad*: with the cover camouflage, they could peruse *Mad* in public—on the subway, say—without fear of being ridiculed. Another cover looked like a racing form; another, like a composition notebook, so that it could be sneaked into schoolrooms.

In the spring of 1955 Kurtzman almost left EC to take a position with *Pageant* magazine, but Gaines persuaded him to stay by letting him convert *Mad* to a magazine format. Kurtzman stayed because the new format promised a broader, more flexible platform for satire. The new *Mad* appeared with issue No. 24 in July 1955. The interior pages were entirely black and white, no color whatsoever—a concession to budgetary limitations that also served to establish the title's new status as a more serious (well, purposeful anyway) publication. Kurtzman took advantage of the magazine format to poke fun at features found in popular magazines of the day. A page purporting to be a special report from "our Soviet correspondent" was entirely in Russian. A "Photo Quiz" mocked *Look*'s feature of that name. And a do-it-yourself article parodied *Popular Mechanics* and other similar magazines. The new *Mad* had the appearance of a picture magazine: in place of comic strip panels were Craftint drawings that looked somewhat like photographs. And the captions underneath were typeset. There was more straight text. Most articles were introduced with a page of prose in the style of *Life* magazine. Hemingway was parodied in a short story. And Alfred E. Neuman made his first appearance.[15] The new *Mad* was destined to be as popular as the old comic book *Mad*, Kurtzman

Figure 75. *Alfred E. Neuman had appeared earlier (during the run of the comic book Mad), but he assumed mascot status at the top of the cover border on the first issue of the new magazine format Mad. (The important message, by the way, was: "Buy This Magazine!")*

having set it on the course it would maintain for the rest of Gaines's life.

But Kurtzman left EC a few months later: his last issue of *Mad* was No. 28. He had asked for complete control of the publication, and Gaines had not been willing to give it to him. Kurtzman wanted to improve the quality of the product—pay artists more, add color features, and so on. But Gaines couldn't afford it. Al Feldstein took the editorial reins and held them for nearly thirty years. Kurtzman went on to other things—most of them, attempts to repeat his success with *Mad*. Each of these attempts was brilliant in its own way; all were innovative. None were financially viable. *Playboy*'s Hugh Hefner sponsored *Trump*, a truly luxurious magazine of satire and parody; it lasted two glorious issues in early 1957 before Hef's money ran out. Kurtzman next did a smaller, infinitely cheaper magazine called *Humbug*, which lasted eleven issues (until August 1958). Then came *Help!*—twenty-six issues over five years, ending September 1965. Meanwhile, in 1962, with his old classmate Will Elder at his elbow, he settled in at *Playboy* to produce the most lavish color comic strip of all time, *Little Annie Fanny*, a satire of hip society and sexual mores. It, like almost all of Kurtzman's endeavors, was a masterpiece. But Kurtzman will be more remembered for *Mad* than for any of his other work.

The manic, often adolescent, irreverence that Kurtzman fostered in the pages of the first two dozen issues of *Mad* determined the attitude and direction of the magazine for the next three decades. And *Mad* was not the only beneficiary of Kurtzman's inspiration. Writing in the *New Yorker* at the time of Kurtzman's death, Adam Gopnik counted the blessings:

> Kurtzman's *Mad* was the first comic enterprise that got its effects almost entirely from parodying other kinds of popular entertainment. Like Lenny Bruce, whom he influenced, Kurtzman saw that the conventions of pop culture ran so deep in the imagination of his audience—and already stood at so great a remove from real experience—that you could create a new kind of satire just by inventorying them. To say that this became an influential manner in American comedy is to understate the case. Almost all American satire today follows a formula that Harvey Kurtzman thought up.[16]

Through all the years of *Mad*, Kurtzman's influence on the American public was incalculable. For generation after generation, the young, at a particular age, read *Mad*. Reading *Mad* breeds a certain cynicism about the icons of American popular culture as well as the functioning of its institutions. Who can say whether the Vietnam War protest among American youth was not in some way inspired by the satire in *Mad* (if not, even more indirectly, by the realism in *Two-Fisted Tales* and *Frontline Combat*)? In the closing years of the twentieth century, it would be difficult to imagine an American under the age of fifty-five who does not look at the world a little askance, thanks in large measure to Harvey Kurtzman and his *Mad* legacy.

AMONG THOSE MOST OBVIOUSLY INFLUENCED by Kurtzman were the young cartoonists who began producing underground comic books in the 1960s. (Some of them had their first work published in *Help!*—Robert Crumb, Jay Lynch, Gilbert Shelton, and Skip Williamson, for instance.) The irreverence they witnessed in the early issues of *Mad* was inspirational: it showed them that comics need not be bound by the conventions of society. In fact, comics should attack those conventions. Their imaginations freed to soar wherever their risibilities took them, many underground cartoonists did what young people everywhere do: they rebelled against the authority of their elders. But they did it more outrageously, more scandalously, than any previous generation had since the Roaring Twenties. Their rebellion took the form of an all-out verbal-visual assault on the sensibilities of society at large. Their comics were the shock troops. Sex and drugs were the weapons. These underground cartoonists did not so much satirize social shibboleths as they flouted social mores. They slapped the puritanical middle class in the face by drawing pictures of people copulating and masturbating; these libidinous comics characters exposed hang-ups about sex by discarding every imaginable inhibition, thereby revealing the sexual neuroses of Western civilization. Comics that championed the drug culture of the sixties mimicked the tactic: in openly violating laws about drugs, the characters displayed their disdain for the society those laws were designed to protect. As heavy-handed as their satire was, underground cartoonists had changed

the focus of comics: they aimed at an audience of their peers—at adults.

Not all underground cartoonists dealt exclusively in the subjects of sex and drugs. Bobby London, Shary Flenniken, Lee Marrs, and Justin Green (among others) concentrated on everyday life, its vicissitudes and absurdities. And others (Lynch, Williamson, Denis Kitchen, Larry Todd, Jack Jackson, and Ted Richards, for instance), although occasionally dabbling in stories about fornication or dope, did not acquire their reputations solely on the basis of their treatment of these forbidden subjects. But the underground cartoonists whose work won the widest notoriety—Crumb, Shelton, S. Clay Wilson, Robert Williams, and Spain Rodriguez, to name a few—gained their infamy chiefly through their material on sex or drugs. Not only did these taboo topics attract more attention, they also excited more exuberant excess and innovation in execution than other subjects (including all manner of political pretensions and social abuses). And underground comics were characterized by this focus, virtually defined by it, for years. It was a preoccupation that may have resulted in a somewhat monotonous product, but the effort was liberating: it opened the way to other concerns eventually. In the beginning, however, it was as if the cartoonists had to experience their freedom to the fullest, to wallow in it—to flaunt it in the startled face of orthodoxy—before they could settle down and produce more focused work in more varied modes of presentation.

Many underground cartoonists did their first published work while university students, producing cartoons for campus and off-campus humor magazines (the kinds of publications that, in a celestial cycle of inspiration, had sparked Kurtzman's imagination in creating *Mad*). In the mid-1960s underground cartoonists drew comic pictures and strips for the newspapers and broadsides being produced by the growing counterculture in New York's East Greenwich Village and in Berkeley, across the Bay from San Francisco. But by the end of the decade the cartoonists were drawing and publishing their own black-and-white comic books, called "comix" to set them apart from their more staid aboveground brethren. In comix, the assault on conventional America continued at a shriller pitch than ever, and in some cases the cartoonists were inspired to commit ferocious indis-

cretions solely to demonstrate their absolute detestation of the Comics Code Authority and the repressive attitude it embodied—a hatred rubbed raw by the cartoonists' keen appreciation of the excellences of the old line of EC comics that had been choked off by the institution of the code. In their comix, underground cartoonists were free of the code, and they explored every code-forbidden subject with defiant vehemence. (Of course, as I've mentioned, there were exceptions. Not all of these cartoonists were rebels or outlaws; and a few drew comix simply because they had been unable to crack into the big publishing houses or newspaper syndicates in New York.) But comix soon began growing beyond simple rebellion. Although the books were published irregularly and there were seldom more than a few issues of a given title, the sporadic publication and the comic book format encouraged book-length thematic issues. Comix created by women cartoonists, for instance, explored American culture from the (then almost untapped) perspective of their gender. Comix also had a revolutionary effect upon the economy of the entire comic book industry.

Underground cartoonists were passionate in their desire to avoid the page-rate prison their aboveground colleagues found themselves in. And they despised the mainstream industry's confiscatory practice of seizing ownership of all characters created for comic books. They knew that Jerry Siegel and Joe Shuster had given up a fortune in 1938 when they signed away their rights to Superman in deference to the industry's corporate policies. Some underground publishers, like Denis Kitchen in Wisconsin (a cartoonist himself), conscientiously protected creators' rights. Cartoonists were usually paid a flat rate for their work at publication, and many of them earned a share in the profits if their books sold well enough. Moreover, they retained ownership of their creations. Through the 1970s similar practices were adopted by virtually all of a succession of small publishing companies (the so-called alternative press) that began producing "ground level" comic books during the decade. By the early 1980s both the major newsstand comic book publishers, Marvel and DC, had begun to feel the pressure. Soon, both companies developed policies akin to (albeit not quite as generous as) those first advanced by the underground press.

Figure 76. *With two strips drawn in the 1970s, underground cartoonist and publisher Denis Kitchen provides a vivid demonstration of the essential difference between the work of a conventional cartoonist (top) and that of his brethren in the underground (bottom).*

Another incident of the seventies doubtless nudged Marvel and DC onto the path of righteousness. In 1975, inspired by news that a Superman movie from a major studio was in the offing, Jerry Siegel began a campaign to get a piece of the action for himself and his co-creator. It wasn't his first such undertaking. After selling ownership of their creation for page rates, the duo had been employed by DC for years to produce Superman comic book stories and the newspaper strip, but by 1947 they had come to feel that their share of the bonanza was not enough. They took their case to court but lost. Understandably, they also lost their jobs with DC. They then collaborated on a new comic book character, a mock costumed crusader named Funnyman, but this effort was not successful. Although Siegel found a slowly dwindling number of assignments writing for a variety of comic book publishers over the next two decades, Shuster never again drew for a living. The cause that Siegel mounted in 1975 was joined by numerous professionals in the field, most notably, Neal Adams. Together, they were able to create enough bad publicity for DC and the movie's producers at Warner's that DC eventually offered Siegel and Shuster annual pensions in order to put the matter

to rest. "There is no legal obligation," a DC spokesman said, "but I sure feel there is a moral obligation."[17]

By the end of the eighties the situation in mainstream comic book production had changed greatly. In addition to being paid set fees per page, creators could earn royalties based upon the sales of the their comic books and sometimes a percentage of the ancillary revenue generated by merchandising the characters. They also retained ownership of their original art (another development originating in the underground), and they sometimes owned the characters they invented. As the 1990s dawned, the economy of the comic book industry had been so violently altered that a cartoonist producing comic books could become very wealthy. Indeed, some, riding the crest of momentary fan adulation, became millionaires overnight.

While undergrounds were revolutionizing the comic book economy in this country, they were also influencing content abroad. European comics blossomed under an arrangement quite different from the American system. Newspaper feature syndication doesn't exist in Europe; newspaper comic strips are produced for individual publications only. Most cartooning on a national scale takes place in magazine format. Cartoonists draw for weeklies that print multiple-issue stories in four- to six-page installments. After the initial printing in serial form, the pages are collected and reissued in hardbound "albums." Comic books in Europe are, therefore, real books, not magazines. And they have a cultural status that American comic books have yet to achieve. Moreover, the production values in European comics are much higher: the colors are applied in a painterly fashion, not mechanically by overlays (as in the United States), and the full-color art is printed on high-quality coated stock. Comic book art in Europe is consequently beautiful to look at because the visual character of the work is so carefully crafted and then enhanced by the manner of publication.

European cartoonists were as astonished and liberated by American underground cartoonists as those cartoonists had been by Kurtzman and *Mad*. *Mad*, in fact, was as much an inspiration overseas as it had been in its native land. (Kurtzman's connection to the European cartooning community was even more direct: Rene Goscinny, who had created the mildly satirical and internationally popular Asterix series with Albert Uderzo and had founded *Pilote* magazine in 1959, was a friend and admirer of Kurtzman's. Goscinny had spent several years in America, and during most of them he worked out of the studio Kurtzman and Elder operated in the late 1940s.) The weekly magazines in Europe were produced chiefly for young readers, but the American underground cartoonists proved that comics produced for a mature readership could be financially viable. Soon, Europe's albums of comics began to address adult themes in very sophisticated terms.

Meanwhile, on the American side of the Atlantic, underground cartoonists were becoming introspective, their treatments calmer, their subjects more varied. Perhaps their purely rebellious energy had been spent in the orgy of sex and drugs comix that reached peak production in the early 1970s. Or perhaps they had grown wary. A tide of censorship had washed over the land in the mid-seventies. In June 1973 the U.S. Supreme Court issued a new ruling on obscenity that gave local governments the power to determine what was pornographic. Comix had been sold almost exclusively through the "head shops" that had sprung up in large metropolitan areas to sell drug paraphernalia—bongs, papers, roach holders, and such—as well as exotic clothing and the other psychedelic trimmings of the counterculture. These outlets, already operating on the legal fringes of their communities, stopped carrying comix for fear that authorities would use local obscenity laws to shut them down. The market for comix eventually revived, but it was never as flush with product as it had been before the Supreme Court ruling. And in the interim, cartoonists had discovered less blatantly offensive subjects.

Robert Crumb, one of the most important figures in the underground movement, had always been a character in his own comix. He had developed other characters—Fritz the Cat, Mr. Natural—but he eventually wearied of them all. Only his Crumb creation, his alter ego, commanded his unflagging interest. In chapter 9 we'll take a look at Crumb and at other cartoonists who created similarly autobiographical works, odysseys in private exploration, sometimes searing in their self-revelatory themes. For our present purposes, however, it's enough to note that comix increasingly became personal artworks, individually expressive reflections of the interests of their creators rather than products of a publisher's mar-

ket research. Paralleling this development were the ground-level comic books of the alternative press, in which cartoonists examined slices of ordinary life, searching for the daily drama of living. We'll look at some of these, too, in chapter 9.

In a way, it was the underground that opened the avenue to a new marketplace. The counterculture's head shops had enabled comix to survive—even thrive—and in doing so, they proved that general newsstand distribution was not essential to economic vitality. The direct sale comic book shops that sprouted up all over the country in the eighties represented a merchandising network much like that which had been established by the head shops. Comix alone could not have supported the national circuit of direct sale shops specializing only in comic books. But once that network was in place, the market for the personal works of underground and unconventional cartoonists was ready. And the publication of such works was no longer confined to the alternate press. The success of the direct sales network had freed major mainstream publishers from their traditional economic bondage to an antiquated distribution system. Marvel and DC contemplated the direct sales shops and saw dollar signs. And before long, even these faceless corporate funnybook factories began to produce comic books that reflected the personal visions of their creators.

The earliest forays into this new territory took the form of "relevant" comics, of which the first, produced in 1970, preceded the direct sales market. The most astonishing effort of the decade, however, was Steve Gerber's *Howard the Duck*, a send-up of the Marvel Universe that graduated into social satire and then turned inward to evolve an intensely personal statement. But more of these anon: I'm postponing detailed examination of these endeavors until chapter 9 in order to conjure up in the paragraphs just ahead an overview of the mainstream developments of the thirty years that began in the mid-sixties.

Artistic expressiveness of a highly individualistic sort had never been particularly welcomed by traditional comic book publishers. The corporate mind, ever focused on the bottom line of the balance sheet, favored bland "house styles" of rendering and committee-generated stories, neither of which, given the compromise inherent in the process, would be likely to offend potential buyers. But the medium had always attracted creative people, and they had lived and worked within its commercial constraints, sometimes happily, sometimes restively. And as direct sale shops began to prove their viability, the economics of the industry seemed to invite more adventurous, more personal, endeavors. Still, the route to individual expression in mainstream publishing was a long and tortuous one; it was, in fact, not one route but several, each a tributary that followed a different course to a seemingly different objective. Some, however, culminated in the 1980s in an artistic renaissance that found its impetus in all of the creative impulses of the diverse endeavors. And the renaissance flowered in the fertile economic soil of the direct sale shops.

For the sake of the discussion, let me simplify the progression by positing that there are two traditions in comic book creation—the figure drawing tradition and the storytelling tradition. Neither is wholly exclusive of the concerns of the other, but each has pursued its emphasis with slightly different results. Jack Kirby belongs at the beginning of the figure drawing tradition, the artistic preoccupation of which is rendering the human figure. Kirby was not so absorbed in this endeavor that he neglected storytelling; that's one of the things that made him unique. But he helped to establish the importance of figure drawing in the superhero genre of comic book, and many of those who followed in his footsteps were polished artists without being storytellers at all. Others were both storytellers and graphic artists. Such artists as Gil Kane and Curt Swan and Murphy Anderson belong to the figure drawing tradition.

The figure drawing school may be said to have reached its pinnacle in the early 1970s in Neal Adams, whose skill and subtlety in rendering the human form in action was extraordinary. Kirby and Adams set the mold for house styles: those who began drawing for comic books in their wake were often directed to imitate their styles. Bill Sienkiewicz and John Byrne were, for a time, Adams clones, and to a lesser extent so were George Perez and Jose Luis Garcia Lopez. Sienkiewicz eventually changed his style radically; Byrne didn't, but when he began writing his own stories, he stepped from the figure drawing tradition into the storytelling tradition and stood there, a formidable foot in each camp. The figure drawing tradition would culminate in the poster pages of Image Comics, where picture reigns supreme almost to

the complete exclusion of story. But Image Comics would not have been possible without effusions from the more individualistic storytelling tradition.

I put Eisner and Kurtzman at the headwaters of the storytelling tradition. Their preoccupation was less with drawing and more with story, with content: their drawings were composed to serve the concerns of the narrative. And their work was also highly individualistic; it was therefore unsuited to anything so homogenized as a "house style." Those who were inspired by the work of Eisner and Kurtzman or who worked in the storytelling tradition produced comparatively idiosyncratic works, which, in turn, stimulated others of similar persuasion. We have seen the process at work in tracing Kurtzman's effect on underground cartoonists and on European cartoonists. But the storytelling tradition found champions in the American mainstream, too.

At Marvel in the late sixties Jim Steranko was renovating the rhetoric of comic books with an array of special visual effects. Many of these were gimmicky devices—color holds and hallucinatory optical effects—but Steranko's splash pages betrayed Eisner's influence, and in some of his sequences we find the kind of pacing for dramatic effect that distinguished the work of both Eisner and Kurtzman. Special visual effects intrigued several of Steranko's cohorts. Neal Adams sometimes did elaborately symbolic page layouts—once shaping his panels into profiles of his characters, once drawing a wavy grid of panel borders the seeming undulation of which reflected his hero's momentary disorientation (figure 77), another time superimposing the grid upon a full-page rendering of a face so that each panel focused our attention on a separate expressive feature. Walt Simonson in the early 1970s used typography in decoratively dramatic ways in his Manhunter series for DC, and he regularly discarded the conventional grid layout of pages in order to arrange panels of different sizes and shapes in ways that would give dramatic emphasis to the events of his stories (about which more shortly). Comic book pages began to have the quality of graphic designs. Of this development, Howard Chaykin is a particularly avid proponent.

Chaykin left comic books for a few years in the late seventies to do "visual novels" for Byron Preiss. For *Empire* (1978) and *The Stars My Destination* (1979), he produced fully painted illustrations—several to a page in the fashion of comic book panels—that shared the narrative with the original author's accompanying text. When he returned to comic books in 1983 with his *American Flagg!* series for First Comics, Chaykin brought with him a heightened sense of design. The pages of *Flagg!* are laid out like posters, panels alternating with full-figure renderings or lobby-card close-ups against a plain white ground (figure 78). Typography also plays a dramatic role in the page designs and in the narrative itself, different typefaces evoking a variety of emotional responses. The pronounced design quality of his pages gives sheer imagery a narrative role; there is little continuity of action in the usual manner of comics. Instead, the reader absorbs the story as a series of impressions, and Chaykin heightened the sense that the narrative progressed by imagistic fits and starts with a story line that is extremely elliptical, jumping from one incident to the next and landing his readers, often, in the midst of the action with little or no preamble. He also employed the cinematic maneuver of the voice-over: in the last panel of a sequence, the speech balloons of the next sequence frequently appear, creating a bridge between scenes. When more elaborate connective tissue was needed, he used television as his narrator: TV commentators supply explanatory background with their reports and analyses of the "news."

In subject, Chaykin's story is gritty and vulgar: it plunges through street-gang violence in a futuristic multiplex with Reuben Flagg's sexual dalliances as a leitmotif. In treatment, *American Flagg!* is sophisticated and intellectually intriguing, often in the manner of puzzle-solving. Emotionally, however, the tales are seldom engaging; none of Chaykin's characters are sympathetic enough to make us like them. Still, Chaykin's comics are for adults: they are mature in theme and in their style of presentation.

Meanwhile, at Marvel a young artist named Frank Miller was mastering the rhetoric of the medium and deploying it more and more expertly in each successive issue of *Daredevil*. As we shall see in the next chapter, Miller devoured the work of Eisner and Kurtzman and everyone else who came under his questing eye. He put the lessons he learned to work as he learned them. He seemed to move immediately, almost instantaneously, from mimicry to mastery: he understood a technique he

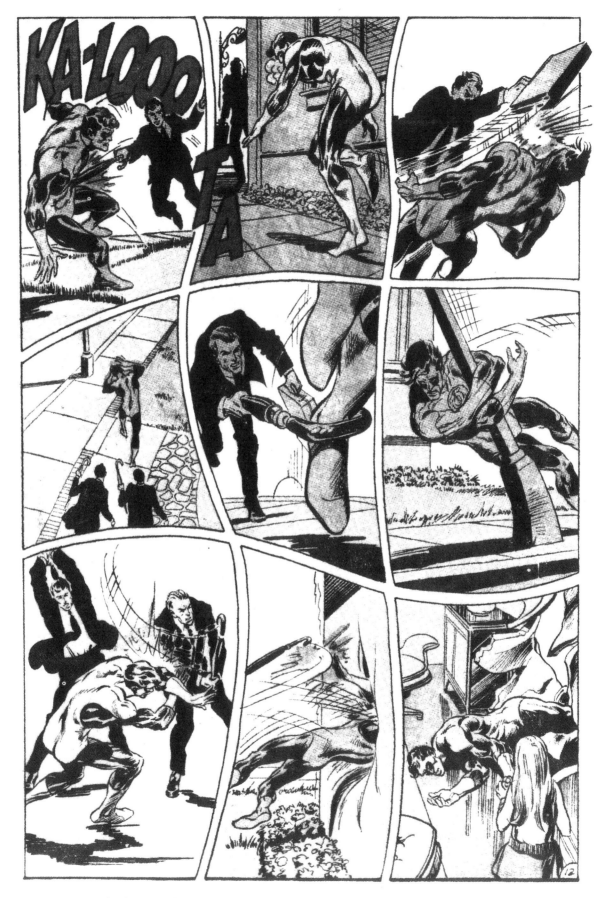

Figure 77. *Here, Neal Adams employs the panel borders to suggest the hero's state of mind.*

Figure 78. *Howard Chaykin told his* American Flagg! *stories as much with imagery on pages designed like posters as with narrative panels in a conventional sequence.*

observed so thoroughly that he seemed wholly in command of it the first time he employed it. And every device he used, he improved upon. Moreover, Miller had an impact. Other comic book artists watched him. Even more important for the evolution of the medium in the commercial arena, his work stimulated sales. *Daredevil* was one of Marvel's slow movers when Miller was assigned to it in the spring of 1979; within months, Miller had made it a best-seller. In the process, he had conducted a virtuoso demonstration of an astonishing variety of storytelling maneuvers (some of which will be on display in our next chapter). His aptitude for storytelling by yoking the visual to the verbal was so fecund that he soon left his writer behind; after only ten issues, he was writing his own stories. He wrote Daredevil into the same shadowy, grimy underworld of petty criminals that Eisner's Spirit had dwelt in; and he manipulated mood and time with an adroit skill that evoked both Eisner and Kurtzman.

Miller's success with *Daredevil* was emblematic of the last step in the evolution of individualized expression in mainstream comics: with the emergence of the artist-writer (the cartoonist), the committee-generated comic book went into decline. John Byrne had also made the transition from artist to artist-writer, but he drew in the conventional house style and so was neither disruptive nor inspirational as a creative personality. Miller, on the other hand, dazzled with technique and seemed to toss off innovations with every page of his work.

Miller left *Daredevil* and Marvel in late 1982 and produced a six-issue series for DC called *Ronin* (1983–84). Set thirty years in the future, the story brought the traditions of the masterless samurai into science fiction. But more significant than the substance of the story was the manner of its execution. Miller regarded the months he spent on the project as the most liberating of his professional life. He broke all the rules. His breakdowns and page layouts were startling departures. On some pages, all the panels were page-wide horizontals; on others, all page-deep verticals. Sometimes whole pages were devoted to a single drawing; some drawings took two pages, a double spread. Some pages had four panels; others, a score. He used color and imagery rhetorically. And all these pyrotechnics served the narrative, gave it emphasis and tone. Finally, Miller also broke with the tradi-

tional rendering style of superhero comics. He both penciled and inked *Ronin*, using a simple, often delicate, line. The pictures were textured with hachuring as well as cross-hatching, but his figures were frequently drawn in mere outline. In fact, the visual styling changed subtly from scene to scene to suit the mood of the sequence being rendered. *Ronin* was a vivid and persuasive demonstration of the medium's new direction in the mainstream: the story was drawn in a graphic style as personal in execution as it was individual in conception.

Freed from the time-honored graphic conventions of the medium, Miller took the next step with the spectacularly different visuals of his 1986 DC offering, *Batman: The Dark Knight*. In this four-issue, square-back paperbound series, Batman comes out of retirement, a rampaging psychotic. And the startling reinterpretation of this sacred superheroic icon was reinforced by Miller's sometimes unorthodox graphic treatment. He often simplified his rendering of the heroic figure into abstraction; the pictures, frequently almost caricatures—cruel in their exaggeration—give the story a raw edge. With the advent of *Dark Knight*, individual graphic styling invaded the sacrosanct precincts of the house style and laid it waste as nothing had before.

The series attracted national attention, proclaiming the literary and artistic legitimacy of the comic book form. And this success, both commercial and aesthetic, established the validity of eccentric, highly stylized storytelling techniques. Miller's other innovation, telling a story that dwelled on the dark side of Batman's soul, also ushered in a new era in superhero comic books. Slowly at first, then more and more frequently, stories about the traditional superheroes got grimmer, the streets meaner and grittier, and the personalities of the heroes more flawed. Some of these colorfully clad avengers, mostly notably Batman, teetered on the edge of sanity. By the early nineties some comics readers were beginning to complain about the "darkening" of heroism: their heroes not only had feet of clay, but they had dirty hands, foul mouths, and the ideals of psychopaths. Distasteful though this development was, it also signaled the emergence of a new artistic freedom in the industry.

The evolution of the medium was now virtually complete: both the stories and the manner of storytelling could be extremely individual, even idio-

Figure 79. *In his* Dark Knight *series, Frank Miller produced grotesques of characters rather than realistic portraits.*

syncratic. Teaming with Bill Sienkiewicz, Miller continued in this vein with *Daredevil: Love and War* in 1986 and *Elektra Assassin* later the same year. Sienkiewicz abandoned conventional linear comic book illustrative methods altogether for both books. Instead, the panels were painted in full color, shapes and figures defined and modeled by hues and tones rather than by line. His treatment of the human face and form was stylized, wrenched into abstract caricatures of the personalities of the characters. And imagery played a narrative role in both stories.

Printed in full color on glossy paper and squareback bound, both books reflected a growing European influence. Starting in the mid-1980s the higher production values of European albums were more and more to be found on the American side of the Atlantic. And as the decade drew to a close, another European practice was becoming almost commonplace: increasingly, publishers reissued a best-selling series of comic books in a single bound volume, an "album," often between hard covers and printed on higher quality stock than that used for the original printing.

The European influence was manifest even more directly in the eighties, when British writers began producing stories for American publishers. While Miller was doing *Dark Knight*, Alan Moore was writing *Watchmen* for fellow Briton Dave Gibbons to draw. A twelve-issue series that started in September 1986, *Watchmen* turned on the conceit that if superheroes and costumed crime fighters were real, they would probably be outlawed as vigilantes. Setting his tale slightly into the future, Moore crafted a multilayered, densely textured story, as laden with leitmotifs both visual and verbal as a James Joyce novel. The complexity of the storytelling made the series an intriguing read, but Moore's conclusion did not live up to the promise inherent in his premise. Although ostensibly debunking the superheroic mythology (albeit affectionately), Moore was at last driven by its conventions to end his story in a nearly traditional way. But he and Gibbons had demonstrated as never before the capacity of the medium to tell a sophisticated story in ways that could be engineered only in comics. And perhaps even more significantly, this complex work had been published by a newsstand publisher, DC Comics.

Watchmen's success (it was subsequently reprinted as an album)—coupled with that of Miller's *Dark Knight*—opened even wider the door in commercial publishing for the expression of a creator's personal vision. Neil Gaiman, another Englishman, soon began writing *The Sandman*, a haunting series of tales in which a modern version of Morpheus lurks around the edges of people's lives, uttering angst-laden psycho-profundities about the futility and meaninglessness of life. Gaiman worked with several artists, but his best effects are achieved verbally, in the poetic images and philosophical metaphors of his prose. As noted, the *Watchmen/Dark Knight* success had a profound effect on the treatment of the comic book industry's patented icons, the superheroes. While some of them got "darker," they all began to reflect the individual vision of writers and editors rather than corporate policy. Instead of producing stories the substance of which was controlled by licensing operations, the major publishers frequently permitted imaginative reinterpretations of the superhero ethos solely in the interest of telling good stories. DC even allowed Superman to be killed in the fall of 1992 in order to reinvigorate the Man of Steel legend, the manner of reincarnation being the chief appeal to the imagination. And Marvel successfully combined both ambitious production values and revisionist mythology in the 1993 series called *Marvels*. In masterful full-color paintings (watercolor and gouache), Alex Ross rendered Kurt Busiek's inventive retelling of the origins of the Marvel Universe from the point of view of a newsman.

By the dawn of the nineties the various currents of creativity in the storytelling tradition had come together to revitalize the commercial medium. The figure drawing tradition, on the other hand, had deteriorated into Image Comics. "Image" said it all: these comics are all picture and no story. Image Comics benefited from the pulse of individuality that coursed through the storytelling tributary: without the idiosyncratic styling of Miller and the poster-page design of Chaykin there might not have been any Image Comics. But what might have been the eccentricities of individual styles elsewhere became a house style at Image: many of the founding artists—Rob Liefeld, Eric Larson, Marc Silvestri—drew the human figure in the same monumental manner, with refrigerator torsos, elephantine limbs, and tiny pinheads. Several of the artists even modeled forms with the same fine spray of line fragments. The stylization of

anatomy culminated in a rendering of facial expression that consisted almost entirely of a single, teeth-bearing grimace of rage.

The founding artists of Image Comics defied the traditions of the industry by proclaiming they didn't need writers. And since the artists had little experience in writing stories, the first books they produced reflected their visual bias: they produced pages that were designed as posters rather than as increments in a storytelling process. Many of the titles featured teams of superheroes in the Kirby tradition, but the Kirby influence seemed to end with the concept: the covers and interiors of many Image titles depicted groups of colossally proportioned characters in monotonous heroic poses, these larger-than-life figures had no life, no personalities. The Dead End Kids had become, indeed, dead ends. Eventually, the Image founders turned to writers to assist in constructing stories, but the compelling attraction of the company's titles still resided in the visual stylings of the artists.

The founders were all "hot artists," artists whose graphic quirks, as displayed in Marvel Comics, had attracted enthusiastic and vocal followings. Image Comics was essentially a banner under which these artists collected in loose aggregation to produce comic books featuring their creator-owned characters, thereby catapulting their box-office appeal into healthy bank accounts virtually overnight—again, thanks to the network of direct sale shops that fomented the feverish passions of fanatic collectors, who hoarded titles by their favorite artists. The prospect of cashing in on creator-owned properties attracted other artists and writers to the Image banner, but the success of the enterprise seemed to rest entirely on the popularity of this artist or that. Given the fickle attention span of the American consumer, the future of Image Comics was scarcely certain. But the phenomenon of Image Comics demonstrated a new economic truth about the comic book marketplace: the direct sale shop network could create millionaires.

If the artistic energy of the figure drawing tributary seemed diverted into the eccentric eddy of Image Comics, at first a mere backwater of creativity, the storytelling tributaries converged into a confluence of growing narrative power, bending all of the medium's devices to the task of telling a story. In exploring the potential of the medium, the storytelling cartoonists seemed on much firmer footing than the figure drawing artists. In the next chapter, we'll see how some of the most adventurous of the storytellers deployed their resources.

CHAPTER 7
Style and Flash and Filigree
Manipulating Breakdowns, Composition, and Layout for Effect

While searching for a verbal-visual blend provides us with a way of entering the word-and-picture world of the comics (on the first floor, so to speak), once we have crossed the threshold into that world, we are subject to the influence of a range of special effects that can be achieved by mostly visual means. I've identified aspects of this graphic maneuvering by the terms *narrative breakdown*, *panel composition*, and *page layout*. And *graphic style*.

Style is the most illusive of the lot: it is the visual result of an individual artist's use of the entire arsenal of graphic devices available, including the very tools of the craft. An artist's style can be identified by describing the way he draws certain objects (shoes, hands, lips) or how he uses a brush or pen (thin lines, thick lines; sketchy or labored or detailed). Some artists display an individual style in the way they arrange panels on a page. But describing a style is about as far as criticism can legitimately go. Style is the mark of the maker. It is peculiar to the individual artist. And finally, style is too individual a matter to provide a basis for evaluation. One artist's style appeals to me; another, to someone else. We might safely say that a particular graphic style is inappropriate to the subject at hand (Charles Schulz's style in rendering the *Peanuts* comic strip, for instance, might not be as effective in telling a horror story as the style of

an artist who worked in a more realistic fashion), but even that call is questionable. As cartoonists began exploring different subjects in the 1990s, a great variety of eccentric styles were employed in telling stories, some of which are profoundly moving or insightful even if rendered in the simplest "big-foot" cartoony style. For the purposes of evaluation, then, style is useful chiefly as a way of identifying the artist.

Breakdowns, composition, and layout can be aspects of style: they can be manipulated in individualistic fashion, thereby becoming identified with a particular artist. But these elements of the art of the comics are more rewardingly viewed as they serve to enhance the drama of the story being told. We'll examine here some of the work of the medium's brightest stars, artists whose deployment of visual resources to narrative purpose is so integrated with the use of words that they are more than artists: they are cartoonists (even if they didn't script the stories they drew themselves). Some of the examples that we'll inspect are flashy and self-conscious—too contrived for everyday storytelling purposes; but we can gauge the power of the device by assessing its effectiveness in such extreme cases. By way of getting into this examination, let me pose a ponderous rhetorical question having to do with style. And then I'll try to find an answer for it.

Towards the end of 1980 George Perez began drawing a new series for DC, *The New Teen Titans*. The title characters were an aggregation of young superheroes: Changeling, a shape-shifter; Cyborg, half-man, half-robot; Kid Flash, superfast speedster; Raven, mistress of magic; Robin, the teen wonder (formerly Batman's buddy); Starfire, an alien supergirl; and Wonder Girl, an Amazon. The book was received with great enthusiasm, and Perez was suddenly a star. The question: What did Perez do in these comic books that made him so popular? Was it something about his style—about his individual way of using the medium?

Upon first looking into issues of Perez's *New Teen Titans*, I was struck by two aspects of his drawing style—how pretty his people looked and how copiously his detail abounded. Every panel revealed a finicky attentiveness to detail, a fussiness that approached obsession—all inked and embellished with a refined and delicate line by Romeo Tanghal. This prim meticulousness emphasized the mincing prettification of everything: the effect of rendering even the scruffiest back alley in fastidious detail was to bring pristine order to what ought to have been a jumble of dust and garbage. His people were statuesque hunks and glossy glamour girls, hothouse heroes and heroines cavorting in shapely perfection amid uncluttered and tastefully appointed settings. It was all too unblemished, too exquisite.

And it was all marvelously well drawn.

I also looked into three issues of *The Fantastic Four* that Perez did in 1977. The panels in these, too, were compulsively detailed. But as inked by Joe Sinnott, the faces of Perez's people took on the familiar House Look, and the wealth of detail, rendered with a line that varied in width more frequently than Tanghal's, seemed somehow less overpowering, because not every tiny squiggle was given the same visual impact. But there was another difference: page layouts in these issues of *The Fantastic Four* were much more conventional than in the *Titans*.

In attempting to account for Perez's seemingly overnight popularity with the publication of *The New Teen Titan* books, I'm tempted to seize upon his approach to page layout as part of the reason. Another part, of course, is his association with writer Marv Wolfman, which resulted in the creation of characters and situations and stories that engaged the imaginations of readers. But in the visualizing of those stories, Perez made his own individual donation to the success of the series. The task before us, then, is to analyze his method by way of identifying precisely his unique contribution.

In his handling of narrative breakdown—in timing the action—Perez's impact is modest. Although he sometimes times a sequence of panels for dramatic effect (most often, those involving the emotional lives of the Titans), there is nothing particularly innovative in his method. Take, for instance, a episode involving Victor Stone in *The New Teen Titans* No. 8 (cover-dated June 1981). When a child, Stone was injured so badly that half of his body had to be replaced with mechanical parts. By giving some of those parts special functions as weapons, Stone became Cyborg, a superheroic crime fighter. On the pages at hand, Stone is first seen wallowing in self-pity because of his unhappy love life; then he comes upon a bunch of kids with prosthetic appendages learning to play baseball in the park (figures 80 and 81). In a highly charged sequence, Cyborg discovers that the kids are handicapped in the way he is (but with less spectacular abilities). When he subsequently realizes that they do not regard him as a freakish monster—on the contrary, they seem to look up to him as a sort of model—his self-pity disappears, and he joins them in play.

Coming on the heels of Victor's rejection by a former girlfriend, the sequence is very effective. But Perez handles it in a thoroughly conventional way: his layout is a regulation three-tiered page, breakdown staged in simple units of narrative disclosure, three or four rectangular panels per tier. In contrast to his usual extremely varied layouts, his treatment here is markedly restrained. And the restraint, by muting visual excitement, adds considerably to the emotional impact of the scene. His storytelling instincts in this case are absolutely right: I'm not trying to fault him for his conventional approach, or even to suggest that he doesn't know how to manage narrative breakdown. I'm saying only that there is nothing unusual or innovative in his breakdown, or timing, of the action. I'm not saying that he fails to time events dramatically either: he clearly does achieve dramatic timing in this sequence. But his signal ability, his stylistic hallmark as a storyteller, does not lie in this department.

In another emotional scene, one involving Don-

Figure 80. *From* The New Teen Titans *No. 8: Victor Stone, a.k.a. the Cyborg, is rejected by his girlfriend and goes off for a walk in the park.*

Figure 81. *Stone's encounter with kindred souls in the park is recorded in a conventional but nonetheless effective manner.*

Figure 82. *From* The New Teen Titans *No. 28: Donna Troy (Wonder Girl) goes to her boyfriend's apartment, only to find him involved in a discussion with his former wife.*

Figure 83. *Donna leaves Terry's apartment, and the layout of the panels recording her departure stresses her loneliness and disappointment.*

Figure 84. *From* The New Teen Titans *No. 15: here, George Perez coordinates narrative breakdown, panel composition, and page layout for maximum storytelling effectiveness.*

na Troy (Wonder Girl), Perez times the episode more noticeably—that is, in a way that reveals a greater consciousness of the resources of his medium. In *The New Teen Titans* No. 28 (cover-dated February 1983), Donna goes to the apartment of her boyfriend, Terry Long, to keep a date (figures 82 and 83). She finds Terry with his ex-wife, discussing their daughter's education and related matters. It is obvious that this conversation will derail the plans Donna and Terry have made, so Donna bows out, canceling the date.

Perez builds toward this scene with three panels that show Donna approaching Terry's apartment and letting herself in, thereby conveying to us her pleasurable anticipation by way of dramatizing the disappointment to come. When Donna leaves Terry's apartment, Perez gives us two parallel vertical panels: in the first silent panel, Donna is shown leaving the apartment, the door just closed behind her; in the second, we see her walking away—all background detail gone, a tiny solitary figure surrounded by sterile white space, exclaiming quietly to herself, "Damn." Perez's method here underscores Donna's loneliness and disappointment. In presenting the final moments of the scene in two panels, he times the conclusion—heightening the impact of her last word, building suspense by prolonging the moments. But it is more with layout and composition that Perez achieves his effect. Breakdown helps: it creates a sense of time, and with it, a pause, a momentary lull. But the narrow parallel panels, with Donna but a small figure within them, enhance the feeling of isolation and loneliness that the scene conveys.

Perez's use of layout and composition for expressive purposes can be seen elsewhere, too—in that staple of heroic comic book literature, the fight scene. Perez almost never stages action scenes in continuous sequence—with a succession of panels depicting the progression of activity, movement by movement, as we saw earlier in the Tom Mix fight. Such maneuvering, although scarcely innovative, adds an element of time to a sequence, and time can be employed for dramatic impact. But Perez typically strives for excitement rather than drama in his fight scenes. He draws fights in explosive, individual panels—each one giving us a visually exciting moment of the action, each one virtually disconnected from the scenes in the panels before and after it. This method increases the

visual excitement of the sequence, even though it lacks drama.

For an action scene, Perez typically slices up the page into narrow horizontal or vertical panels, the shapes of the panels echoing the thrust of the action in them. And this technique is not restricted to action sequences. The narrow panel, a vertical slice of time usually, is a device he frequently resorts to. Often, the choice is dictated by the scene (which may call for stressing height, for example), but not always. Pages sometimes turn into collages, vertical panels overlayed by tiny square panels containing vignettes of action taking place elsewhere simultaneously or close-ups of the characters in the action. Sometimes this mosaic device is successful; often, not. Perez also shifts the camera rapidly from panel to panel, varying distance and angle. And he makes dramatic use of unusual angles and perspectives, particularly on splash pages.

All of these manipulations work to create graphically exciting pages through the wild, albeit meticulously coordinated, variety of their appearance. And Perez's scrupulous attention to detail is, in this context, a significant part of his storytelling style. No matter how narrow the panel, he successfully crams detail into it. Even tiny panels are banquets of visual minutiae, temptations for the feasting eye of the beholder. Seldom does Perez use a panel bereft of background detail: nearly every panel is filled with drawing. The reader, depending upon his proclivities, is either overwhelmed or wholly absorbed by such graphic profusion.

Clearly, then, Perez's storytelling style derives its distinctive character from his manner of composing panels and laying out pages rather than from the way he times action through narrative breakdown. But to identify the marks of his style is not to say that he is limited to stylistic performances only. Consider, for instance, the accompanying page from *The New Teen Titans* No. 15 (January 1982), which is, among other things, a particularly effective deployment of horizontal and vertical panels (figure 84).

At the top of the page, Cyborg has just been zapped by a beam from one of the baddies, and the narrow, horizontal cut of the panel accents the force of the blow. Perez's layout then dramatically shifts to a vertical grid, thereby emphasizing the course of the action. The abruptness of the change,

in combination with the plunging verticality of the first panel of the series, startles us into an immediate recognition of Cyborg's predicament. A stack of three tiny close-ups heightens the suspense by focusing on his situation, then another vertical panel sets up the circumstance he must face next. The shape of this panel permits Perez to show us, from an unusual bird's-eye perspective, Cyborg being approached simultaneously from opposite directions by two attackers in their jet-propelled biosuits. With the situation thus clearly established Perez can switch to another close-up in panel 7: Cyborg presses the button that will reel him upward. And in panel 8, with the image of Cyborg's relative location to his attackers at our elbow, he reveals the approaching denouement of the sequence. Here, the absence of background detail enables us to grasp the situation quickly, and panel 9 leaves us in no doubt as to its outcome.

It's a virtuoso piece of work. Although not an entirely typical Perez page, this sequence shows his mastery of the medium: breakdown, panel composition, and layout are carefully orchestrated into a telling whole, each operation reinforcing the effects of the others. It is not a typical Perez breakdown: as I've said, he seldom stages action as continuously as this, focusing from start to finish on a single piece of business, showing its development step by consecutive step. But the humorous—even punch-line—conclusion here requires careful, continuous staging and timing. And Perez is clearly capable of doing it. Well.

Otherwise, the page is fairly representative of his work—thin vertical and horizontal panels, rapid shifts in camera distance and angle. Atypically, though, there are several panels virtually free of background detail, doubtless a consequence of the setting: with the action taking place against the sky, there's no call for backgrounds.

Perez is also capable of the kind of visual gimmickry that delights by exploiting the nature of the medium. My favorite example of this kind of unabashed artifice is in *The New Teen Titans* No. 2 (December 1980). The Titans are swimming in the pool on Garfield Logan's estate when Kid Flash arrives. One entire tier on the page is devoted to a panoramic picture of the swimming pool with the Titans gathered around it (figure 85). The multiple images of Kid Flash work to impress us with his spectacular speed, but dividing the tier into four panels enhances that impression. Forced to focus

four separate times on facets of a static scene before us, we become increasingly aware of Kid Flash's speed: he is the only thing moving. He leaps to poolside, races along the edge, changes into swimming trunks, and dives into the water—all in so short a lapse of time that nothing else has moved. The Changeling, for the moment in the shape of a dolphin, is suspended in mid-dive in panel 3. Panel 3 is but part of the same scene through which Kid Flash flashes with such terrific speed that all other motion—like the dolphin's dive—seems suspended, stopped, in comparison.

It's a neat visual trick, and well done. At the same time, while it's amusing to see the resources of the medium employed in such a fashion, the display has little narrative impact except to demonstrate Kid Flash's well-known prowess. But that is not to say that Perez has made bad use of the trick: after all, he's done nothing to distract from his story, and he has made us smile—both at Kid Flash's showing off and at the cleverness of the trick. Making a reader smile is a worthy objective for a storyteller. And Perez has done it in a way that can be accomplished only in this medium—by skillfully marshaling panel composition and layout to the task.

For the sake of argument, I've constructed several phantom hurdles over which I've now tried to take Perez. I've suggested that his stylistic approach as a graphic storyteller could be identified by pigeonholing it into one or two of the three aspects of the art—narrative breakdown, panel composition, or page layout. His performance in one or more of these departments ought, I've implied, to isolate for us the uniqueness of his ability as a cartoonist—in short, his storytelling style. That this is a somewhat fallacious procedure ought to have been apparent from the outset. The practice of the art (as I strenuously implied, remember?) embraces all three operations simultaneously: one hand washes the others. It would be impossible to design a page without considering the composition of the panels within that layout, and the layout itself involves breaking the story into narrative units, the panels themselves. Moreover, the effectiveness of narrative breakdown is enhanced by layout and composition; composition, by layout and breakdown; layout, by breakdown and composition. But, for the purposes of discussion, it has been useful (to me, at any rate) to examine these aspects of the art as if they each involved a sepa-

Figure 85. *From* The New Teen Titans *No. 2. The panoramic breakdown is a neat visual trick, cleverly designed to emphasize the superhuman speed of Kid Flash.*

rate, discrete operation by the artist. While this perverse method of proceeding has enabled me to assert that Perez's storytelling technique relies more upon layout and composition than upon narrative breakdown, I hope it has become apparent that these three operations are not separable—either in execution or in effect. They work together in both.

And it should be equally evident that Perez is marvelously adept at enhancing the stories he tells by effectively deploying these techniques of graphic storytelling. His uniqueness as a cartoonist is probably most palpable in his graphic style alone—in the way he draws a picture, in his use of the pencil, in the shape and construction of a face, in the proportions of his figures, in his passion for detail and for cleanly rendered (and therefore prettified) pictures. As a graphic storyteller, though, he is not terribly unique. In his manner of telling a story, he is not particularly innovative: he uses the same devices and maneuvers that others have used just as adroitly elsewhere. But he is conscious of the resources of his medium, of the array of its properties and of the ways to develop them. And he uses those resources. He exploits them. He may not plumb the depths of the medium's potential, but he ranges widely across its possibilities.

Hmm. Now that I think about it, I take it back:

compared to many of his storytelling colleagues, Perez is unique.

OUR EXAMINATION OF PEREZ'S WORK has demonstrated rather vividly the workings of the most distinctive of the visual properties of the art of storytelling in comic books. Only in the comics does layout assist in storytelling. Layout—the arrangement of panels on the page and their relative size and position—can enhance a story by accenting certain aspects of it. The dramatic power of layout was not much explored in the early years of comic books. But starting in the 1970s some cartoonists rejoiced in experimenting with the special effects that only layout can produce, effects akin to those Perez achieved on the pages we just looked at. For yet another example, let us take this page from *Marvel Premiere* No. 56 (October 1980), featuring Howard Chaykin's Dominic Fortune (figure 86). By this point in his career, Chaykin had been away from comics long enough to illustrate the Preiss books, and while the page yonder is not a posterlike collection of images (as his subsequent work on *American Flagg!* would be), Chaykin's tendency in the direction of imagistic narrative is plainly on display.

The villain in the piece has kidnapped a woman with telekinetic powers; he has a safe he wants her to open—without touching it, because the safe is rigged to blow up "at the slightest jar." Dominic and his roughhouse buddy Dum Dum pursue the baddie to his boathouse hideaway, arriving (as we see in the first panel) by air. The breakdown gives us the action in impressionistic bursts: our brief glimpses of events suggest the swift, almost frantic activity of the rescue operation. Dominic and Dum Dum crash through the boathouse wall to get at the hoodlums, jolting the building enough to trigger the safe's bomb mechanism. The horizontal shape of the panel in which the rescuers make their entrance underscores the action by emphasizing the direction of the onslaught. Then the camera begins shifting focus, angle, and distance in the third tier of panels in order to convey a flickering sense of the rapidity of events: the safe's bomb being activated, the villain's warning shout, the confusion of the general mayhem in progress. The series of parallel vertical panels adds to this impression by giving us the pictures in equal-size doses, narrow slices of time that slip quickly by.

In contrast, the slightly larger panels across the bottom of the page slow the action ever so slightly as we focus on Dum Dum straining to remove the ticking safe from the premises. His exertion is so great that he breaks through panel borders in the first panel of the sequence; the close-up in the next panel again stresses the intensity of his effort; and the third panel sets the stage for the explosion that follows. The camera moves around Dum Dum, from side to front, and then pulls back in the sequence's third panel. The distance permits us to see what happens to the safe, but it also positions us strategically for the page's final effects. We are "in the water" with the safe, and our viewpoint in the concluding panel is the same. The eye flicks quickly from one panel to the next, to an identical spot in the scene before us, and then the scene—and our vision of it—explodes up the page.

Chaykin's page layout is a deft setup for the concluding panel. The eye moves across and down the left-hand side of the page, then moves to the right across the bottom, finally leaping back up the entire height of the page as if blown up by the force of the explosion itself. Only in the comics can the field of vision be so manipulated: the size and arrangement of images control our perception of the events depicted, contributing dramatically to the narrative effects produced.

The peculiar capacity of the medium for manipulating the way we see the images that tell its stories can lend dramatic power to the narrative. It can also lead to raging gimmickry when a cartoonist becomes so enamored of his medium's capacities that he simply plays with images and arrangements, neglecting to press them into narrative service. Many of the artists whose work appeared in the black-and-white Warren magazines of the 1970s, for example, produced the most wonderful visual displays around. But their stories are lost in the dazzling decoration of the graphics. A page of Alex Nino's art is often a tour de force of graphic technique and ornamental effect, but none of it contributes to the narrative. His pyrotechnic display is virtually disconnected from the story, with the result that no particular aspect of the tale is accented for dramatic or narrative impact (figure 87).

Jim Steranko is another whose visuals sometimes overwhelm his stories. I've mentioned his meteoric appearance in the Marvel firmament in the late sixties, when the brief but brilliant flash of his work illuminated afresh the potential of the

Figure 86. *From* Marvel Premiere *No. 56: Howard Chaykin's page layout provides an adroit preparation for the explosion in the concluding panel.*

Figure 87. *From 1994 No. 14: a two-page spread by Alex Nino—wonderful art and marvelously decorative but not very effective storytelling.*

Figure 88. *From* Captain America *No. 111: Steranko's treatment is flashy, but it serves his story.*

medium. Some of his books were jammed with special visual effects, each page a spectacular experiment. Most of his experiments worked. But because there were often so many of them in a given book, the narrative power of each separate undertaking was diluted, rendered less potent in the midst of the special effects being fired off on all sides. An embarrassment of riches. But Steranko's work, unlike Nino's, rewards careful study: Steranko's maneuvering of images did aim at creating narrative impact, not just visual decoration.

Here's a short Steranko sequence from Marvel Comics' *Captain America* No. 111 (March 1969).

In Marvel's incarnation of Kirby's World War II superpatriot, Cap's kid companion in arms, Bucky, has died. Cap has taken on Rick Jones as a sidekick, and Rick has spent days in the gym, honing up his acrobatic skills. Cap gives him an "A" for effort, but reminds him of the purpose of his practice: "We're doing combat gymnastics," Cap says; "acrobatic ability is only half of it. You have to land in such a way that you're instantly ready to attack." Then Cap gives the demonstration we see here (figure 88).

Both tiers give us multiple images of Cap: like the key drawings in sequence for animation, each

picture of Cap is one step, one movement, in a continuous motion. But the first tier is divided into four panels—even though the pictures of Cap seem to ignore the panel borders, and we see parts of two of him in most panels. One effect of this is that we are made conscious of the flowing continuity of the action. And that helps make Cap's point: one of his objectives is to make Rick conscious of the same thing. The panel divisions accomplish another narrative purpose. By dividing the action into four panels, Steranko makes us look closely at Cap at each step in the progression. We are thus forced to do just what Cap commands: "Watch me!"

The panel divisions disappear in the second tier (which appears, in the published book, at the top of the facing page). And now, behind the pictures of Cap completing the drill, we see Rick's face, his frown as he watches Cap doing something that he cannot yet do so well. In the next panel (not printed here), Rick says to himself: "Every time I think I'm getting it, he makes me feel like a stumble-bum." To appreciate the narrative force of this panel, we need to understand the context in which this episode occurs.

The incident we see illustrated here falls in the middle of a larger story in which Rick, while wanting to be Captain America's combat buddy, is jealous of Cap's memory of Bucky. Rick resents Cap's comparing him to Bucky, and he feels that Cap is always making the comparison to Rick's disadvantage. The images we've just looked at contribute effectively to the larger story surrounding this episode. We see Cap complete his demonstration, but Rick's face—and therefore his inner frustration and turmoil—dominates the scene. Here, although we are still watching Cap as he has directed, we see Rick, too. The picture reminds us of how Rick must be reacting to Cap's demonstration: how he must feel belittled rather than instructed. Steranko's sequence is thus much more than a conspicuous exploitation of the capacities of the medium: the manipulation of the images contributes to the story by emphasizing particular narrative currents.

Masterful as Steranko was, Frank Miller surpassed him in command of the medium and its resources. In an astonishingly short time, as I noted in the last chapter, Miller successfully rivaled his most worthy predecessors. As witness to his achievement, let us take the story "Expose," which appeared in *Daredevil* No. 164 (cover-dated May 1980). The story is simple but dramatic—and Miller's expert orchestration of narrative breakdown, composition, and layout enhances the drama of the tale. The blind superhero Daredevil is in the hospital, recovering from a bruising encounter with the Hulk. Newsman Ben Urich visits Daredevil to confront him with his suspicion that Daredevil is really Matt Murdock. Daredevil admits his secret identity, tells how he became a costumed crime fighter, and Urich decides not to reveal the secret.

As in all the most effective comics art, words and pictures blend to create meaning in this passage. There's more to good comics storytelling than verbal-visual blending, of course; but (at the risk of repeating myself—again) examining how these elements work together provides a way of entering into the workings of the medium. Here we find the hoped-for blend on the book's third page (figure 89), where Ben Urich confronts Daredevil with his suspicion. The six panels across the bottom of the page meld words and pictures to achieve their narrative significance. Without the words, we don't know what the object is that Urich holds up—nor do we know that Daredevil admits the truth of Urich's allegation. Without the pictures, we don't know what it is that causes Daredevil to admit that he's Murdock. The pictures and the words are thus mutually dependent for their fullest meaning.

But the drama of the moment is heightened by Miller's narrative breakdown and composition. By spreading Daredevil's encounter with the photograph and his confession over six panels, Miller stretches time in the best Kurtzman manner, thereby prolonging the encounter. And the composition of the first five of the six panels capitalizes on the available time to make a narrative contribution to the story. Although Daredevil moves about throughout the five panels (nervously, one supposes), Urich's hand and the photograph it holds up stay the same from panel to panel. The unmoving becomes immovable, stubborn, persistent, and, finally, undeniable. The unrelenting presence of the photo that constitutes Urich's "test" suggests the inconvertible efficacy of the test. Urich's "evidence" does not move, his accusation does not waver, and the truth of his assertion seems therefore inescapable. Daredevil seeks to

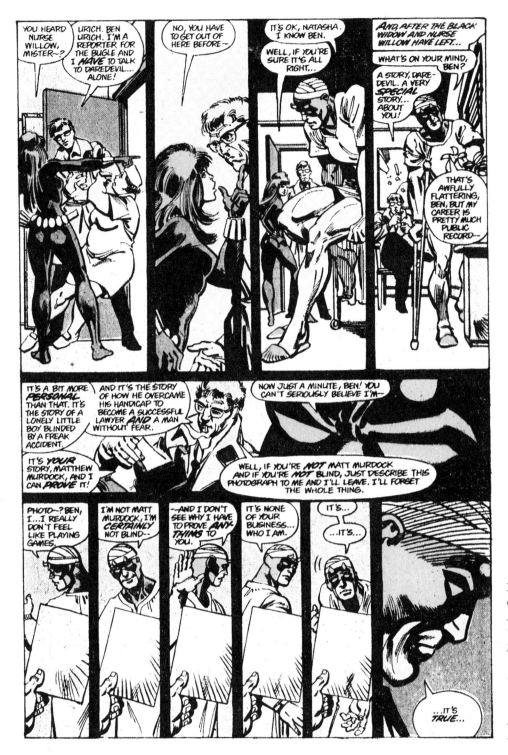

Figure 89. *From Daredevil No. 164: by prolonging this episode with the timing of the five slender panels at the bottom of the page, Frank Miller heightens the drama of the incident and reveals an aspect of his hero's personality.*

evade the obvious, but it won't go away. The implacable presence of the photograph bores in on Daredevil, nags at him, and, at last, forces a confession from him.

Nothing in the sequence explains why, precisely, Daredevil admitted his secret identity. Scripter Roger McKenzie could certainly have dished up an explanatory paragraph or two, delving into Daredevil's psyche for his motivation. But he didn't. By this time, Miller was in control of the stories, and he clearly felt no need for verbiage at this juncture. And I think the story is better in consequence. It's

more realistic, for one thing. We know about Daredevil's motivation only as much as we're likely to know about any individual's motivation in real life: we see and hear him doing something, and we have before us as clues to his motives only what we see and hear.

The pictures and Miller's construction of the sequence give us the best clue. From that and our general knowledge of Daredevil's personality, we can speculate reasonably about his motivation. Daredevil is "the man without fear," who never runs from a confrontation or turns away from a responsibility. For five panels, he faces a test—a photograph held doggedly before him, its unchanging position in the panel compositions suggesting that it won't go away. Daredevil initially tries to escape, to slide away. But it is not in his character to evade a confrontation, and since the photo won't go away by itself, since Urich won't take "no" for an answer, Daredevil does what he has always done: he does what he must. He faces the facts—and divulges them. He also, quite simply, tells the truth. When confronted, point-blank, with a circumstance in which he must either tell the truth or lie, Daredevil will not lie.

We learn a great deal about Daredevil's character in this sequence—and none of it by way of such simple-minded devices for revealing personality and personal anguish as the thought-balloon soliloquy.

The story concludes with another sequence in which a verbal explanation of motivation is eschewed, thereby achieving once again a realistic character portrayal (figure 90). Having told his story and revealed his secret identity, Daredevil now leaves his fate in the hands of the newspaper reporter. Will Urich print the story or withhold it? Urich's remarks are ambiguous: without the pictures, his words don't reveal his decision. While the pictures have an eloquence of their own, without the accompanying speeches the sequence has little suspense—and none of the sentiment so cryptically hinted at in the reporter's parting words.

Miller's handling of light and shadow in this sequence is as bravura a performance as any of Will Eisner's chiaroscuro effects (and foreshadows Miller's later efforts in *Sin City* and its sequels). And by shrouding Urich in inky gloom, Miller masks the reporter's face, keeping from us any tell-tale clue that we might find there about his intentions.

Once again, Miller manipulates time with his breakdowns. Much as in the previous example, the half-dozen panels across the middle of the page slow the passage of time. The action depicted— Urich putting a cigarette in his mouth and lighting it—suggests just how long he takes to decide. Not long, really. But by focusing on each facet of Urich's action in narrow, precisely parallel panels, Miller stops time with each panel. Those panels wink their visual messages at us in uniform increments, as if echoing the ticking of some relentless clock. As the clock ticks on, suspense is prolonged; we wait, not knowing what Urich will decide. At last, we see him burn his notes—his evidence.

The switch from Urich to Daredevil in the fifth panel of the sequence is a canny ploy: it reminds us that Daredevil, too, is waiting, more desperate even than we are to know the reporter's decision. The trick heightens suspense at a key moment— just before we see Urich apply his lighter to his notes. But the black holes in Daredevil's mask are unseeing: as a blind man, Daredevil cannot know what Urich is doing until the smoke of burning paper reaches his nostrils, confirming the hint in the reporter's last remark.

We can only speculate about why Urich decides to keep Daredevil's secret. And in this instance, the speculation is more than merely idle: knowing less about the reporter than we do about the superhero, we have virtually no character references with which to flesh out guesses. So I won't make any. But if we can't guess Urich's motivation, we can say something about his personality that we couldn't say at the story's beginning. Actions reveal character. And with the evidence of the story's conclusion before us, it appears that Urich's personality embraces a dimension of common human compassion expansive enough to overrule the knee-jerk journalistic compulsion to tell all without regard for the consequences. As in life itself, we must draw this conclusion about character from the evidence of our senses, since we have no other insight into Urich's mind and personality. And, in the spirit of realism, the script again refrains from telling us more about Urich than a human observer could know.

Layout also serves the story in the sequences we've examined. On both pages, the tiers of narrow panels that embrace almost unvarying compositions draw attention to themselves by their

Figure 90. *Miller's handling of shadow and mood is Eisneresque; his timing, Kurtzmanic.*

uniformity. Our eye is thus directed to the panels that carry the key scenes in the story; the visual emphasis underscores narrative importance. The long, horizontal panels that begin the last page set the motif for the page. The row of six panels in mid-page continues the page's format, their parallelism restating the general horizontal sweep of the layout. This layout permits Miller in the first two tiers to isolate Urich in corners of the panels—removing him from close contact with

Figure 91. *By stretching time over five panels, Miller prolongs Jack Murdock's humiliation.*

Daredevil, emphasizing that the decision Urich must make is his alone.

Miller skillfully exploits the medium throughout this book; two more samples reveal how adroitly. Our third example comes from the middle of Daredevil's story of his origins. As Daredevil's father, "Battlin'" Jack Murdock, grows older, he can't land enough fights to enable him to finance Matt's education. In desperation, he turns to a shady manager named Sweeney, who not only books fights for boxers but fixes the outcomes. Jack Murdock has steered clear of Sweeney during his career thus far, but now he needs the bookings. Sweeney, delighted at the prospect of snaring Murdock in his toils, gloats—promising Murdock the championship "with the *right* manager," and concluding, "How's about it, Jackie boy? You ready to sign with the fixer?" Reprinted here is the remainder of the scene (figure 91).

As (by now) usual, Miller expertly plays up the drama in the situation. Sweeney humbles the once proud fighter by dropping the contract he's to sign so that Murdock must kneel at his new master's feet. By breaking the action into five panels, Miller again prolongs the duration of Murdock's ordeal, further underscoring his humiliation. Compositions focus first on the contract, the instrument of Murdock's new servile status, and then on the box-

er's servility itself when he kneels at Sweeney's feet. The tall vertical panels themselves seem to suggest the distance Murdock has fallen as he grovels before the fixer. And the absence of dialogue and narrative caption renders the meaning of the pictures even more potent: they alone tell the tale.

After a string of victories (fixed, unbeknownst to Murdock, by Sweeney) comes the inevitable: Sweeney tells Murdock to throw his next fight. Murdock refuses, wins instead, and gets rubbed out by the fixer's minions. Young Matt vows revenge and, as Daredevil, eventually gets it. The showdown with Sweeney is the subject of our last example of Miller's artistry (figure 92). Pursued by the avenging Daredevil, Sweeney runs down into the New York subway system. There the physical exertion of his flight, coupled perhaps to fear of his mysterious pursuer, brings on a fatal heart attack. Daredevil has his revenge without striking a blow.

Here again, Miller paces the action using a tier of six syncopating parallel panels. Although this sequence is of interest chiefly for the special visual effect Miller introduces with the jagged red line that monitors Sweeney's heartbeat, the six slices of the mid-page action are timed to build suspense: as the subject moves progressively closer to the camera, the tension mounts. Again, words and

Figure 92. *At the conclusion of his story, Miller again exploits the capabilities of the medium, giving us a clinical assessment of Sweeney's status.*

pictures blend to tell the story. Sweeney's faltering words mean next to nothing without the accompanying pictures. And even though the pictures alone tell a tale of their own, Sweeney's words impart significance to the series: from the lips of a dying criminal whom Daredevil has run to ground, Daredevil is properly christened.

Then comes the remarkable panel that concludes the page—a panel in which visual effects are deployed in ways possible only in the comics.

The blind Daredevil's supersensitive hearing picks up Sweeney's heartbeat, and throughout the sequence, the jagged, bloodred line graphs those pulsations, letting us see what Daredevil hears. The line shows us Sweeney's excitement building, his heart working at the danger level. When his heart stops in the final panel, the graphing line ceases its pulsing, marking Sweeney's death with its final unwavering drone. Sweeney has at last come to nothing. Simultaneously, all background detail drops out of the drawing—signaling with barren, antiseptic white the absence of life and, by throwing into sharp relief Daredevil and his prey, stressing the just resolution of Daredevil's quest for revenge. For Sweeney, the beat does not go on: the dance of life is done. But without the pictures, we'd never know it.

CHAPTER 8
Only in the Comics
Why Cartooning Is Not the Same as Filmmaking

Perversity is the mother of contention. The social worth of this happy homily can be validated by any collection of two or more people bent on having a conversation. The proceedings are likely to lag along until someone stumbles over a flat statement that begs to be rounded out—an inert assertion that verges on universal acceptance without question or quaver. The mind could be well-nigh smothered in the warm and shapeless embrace of such comforting witlessnesses, and we'd all march mutely to our graves without once breaking step, leaving the art of conversation breathless and wizened behind us. Fortunately, we are too perverse for that.

A perverse desire to contend with anyone else's assertions has revived many an erstwhile gasping afternoon or evening. And in the resulting fireworks, sparks often generate light as well as heat. They also generate several hundred cubits of such garrulousness as this, which can be put to good use in plastering over the otherwise empty pages yonder. At the risk of being branded a pervert, then, let me introduce the flinty assertion that sparks this chapter's blasphemy: that oft-uttered axiom that comics are but "frozen film," that panels are merely frames rescued from the footage on the cutting-room floor. Not entirely so, I contend. By way of unearthing witnesses in defense of this

contention, let's look for a moment at the kind of storytelling that can be done only in the comics.

From George Herriman's classic newspaper comic strip *Krazy Kat*, here's a Sunday page that was published on October 10, 1920 (figure 93). A Sunday strip of this vintage occupied a full page in the newspaper, and, given those dimensions, a cartoonist had all the visual resources available to him that a page in a comic book affords. And this page of *Krazy Kat* is a remarkably ingenious composition. Few pages of comic art in newspapers or in books so dramatically demonstrate the unique storytelling capacity of the medium. The tale told here can be told in this way only in the comics, and the way Herriman tells it probably achieves the maximum possible effect from the elements of the story. (Herriman's plot, for those of you who came in late without reading my earlier opus, is always the same. Ditto the cast: a mouse named Ignatz, a bulldog of the law named Officer Pupp, and a Krazy Kat. In strip after strip, year after year, Herriman staged his dramas within this triangle. Ignatz always initiates the action by striving to bean Krazy with a brick, and Officer Pupp, secretly in love with Krazy, strives to prevent this vandalism to her "kranium." Into this wholly uncomplicated plot arrangement Herriman introduced a complication so transcendent that it transformed

Figure 93. *Only in the comics can this story be told in this way—and only by telling it this way is it funny. (Krazy Kat, October 10, 1920)*

his dramas into lyric poetry. The Krazy Kat, it seems, is passionately fond of the mouse and regards the hurled brick as a token of Ignatz's affection.)

As we move across Herriman's page from left to right, two subplots develop. What begins with the simple action of Ignatz Mouse's hauling up a brick develops a second aspect by panel 3, when a chorus of observers begins to comment about the levitating brick. And in panel 4, another subplot—involving the arrival of Krazy—begins to unfold. The vertical design of the page permits all three plot strands to develop separately but at the same time—until, for his punch line, Herriman gathers his three threads together in panel 7. The humor depends upon the simultaneous resolution of all three plots: Ignatz leaves the scene without the brick, convinced that his probable plan to "krease Krazy's bean" with it has been thwarted; Officer Pupp, smug in believing he has foiled Ignatz's plan, doesn't realize that his action has had the precisely contrary effect of accomplishing the mouse's purpose; and Krazy, starved as usual for a sign of his beloved mouse's ardor, receives the usual token in the usual way.

Irony abounds. Ignatz thinks he's failed, but he hasn't—thanks to his archfoe, Pupp, who thinks he's succeeded but hasn't. And Krazy, who pines away for Ignatz—for something she can interpret (or, more accurately, misinterpret) as a declaration of the mouse's love—is satisfied. Love is requited. But if love triumphs over all on this Sunday, it does so against all the probabilities: the final irony is that it triumphs entirely by accident. Not only does Ignatz's brick reach Krazy's head by accident: it is likewise an accident, a quirkish turn of fate, that fond Krazy should see Ignatz's vindictive toss of a brick as an act of affection. Love always triumphs in Herriman's strip. And most of the time, it does so more by happenstance than by design.

The Sunday page over which this discursive brew has been mulled is vintage *Krazy Kat*, a classic representation of Herriman's theme. It is also a classic display of the unique properties of the medium. Words and pictures blend to tell the tale here. Without the pictures, the words are nearly meaningless. Without the words, the falling brick becomes a vicious instrument of violence, not a token of love. But this strip is more than a perfect verbal-visual blend. It is a thorough exploitation of the medium's resources: narrative breakdown, composition, and layout are carefully orchestrated to the storyteller's purpose. Not all storytellers in the comics exploit so fully the capabilities of the medium. In fact, we seldom see the form as fully utilized as it is here (and Herriman doesn't do it so thoroughly all that frequently).

Although a film could give us the same story, it cannot give it to us with the same sense of simultaneity. The camera could either cut from Ignatz to an observer in a window to Krazy and back—or, in order to capture all three plot developments at once, the camera could pull far back. But then it would be so far away from its subjects that we could not see them clearly. Even though film can capture images and actions simultaneously, it cannot narrow our focus sufficiently to emphasize only the essential elements of the story as the layout of this page does. The story we see here can best be told in the comics medium. Indeed, perhaps it can be told only in the comics.

Film and comics are, after all, different media. And some of the difference lies in the way each is produced. To begin with, comics are hand-wrought, whereas motion pictures are produced by machines. The images in comics can be more readily tampered with and modified than the images in film, which must reproduce pretty much what the eye sees in nature. Animated cartoons have a foot in both camps: they use the mechanical methods of film to present images drawn by hand. Consequently, animated cartoons are a third medium. Much of what we can say about film in general applies to animated cartoons, but insofar as film is constrained to reproduce only what the eye can behold, animated cartoons are a different genre.

I don't deny that film and comics are related: they're both visual media. And the argot of the former (camera angle, close-up, establishing shot) is useful in describing the latter. Moreover, the two media have nurtured each other throughout their separate histories. But they are still not the same medium. Each requires a different quality of engagement from its viewers.

Film provides relatively effortless entertainment. We enjoy film and television effortlessly because these media pour their messages into our heads through the ear as well as the eye. And we therefore receive most of the messages without having to engage the brain. Much. Compared to reading, that is—even reading comics. And that brings us

to one of the most obvious aesthetic distinctions between film and comics. Film is audiovisual; comics are simply visual. Since film conveys information aurally as well as visually, it can use sound to achieve various dramatic effects. Comics, however, must achieve those effects by purely visual means—or forego them entirely.

Another difference: the images on film move; images in the comics are static. This seemingly commonplace observation embraces a more subtle truth: motion and time are related. The filmmaker is controlled by time: the motion he's filming needs a certain amount of time to show its completion. He can speed up the film or slow it down, but he must show enough of a motion to make it comprehensible. Depending upon the action being filmed, that can take a lot of time or a little. The analogue for the cartoonist is space: he needs space—large enough panels or enough of them—to depict an action comprehensibly. But space is not exactly time in comics. In the two media, space and time serve but kindred functions. In film, the image in motion, the narrative is measured in units of time; in comics, the image immobile, space is the measure.

The distinction is subtle, but it's there. To explore it, let's look at a page from one of Harvey Kurtzman's fabled EC war mags, *Two Fisted Tales* No. 31 (cover-dated January–February 1953). Jack Davis did the drawing, but the breakdowns, layout, and panel composition are Kurtzman's. Kurtzman's work is often called "cinematic," and this page is a typical example (figure 94).

The action takes place during the Civil War, and we're aboard a Union gunboat attacking a Confederate river fort. The fort's batteries have begun to skip cannonballs across the surface of the water at the gunboat, and on the page preceding this one we've seen one cannonball skim through a gun port to land harmlessly on the deck. Then comes this page.

The first two panels set the stage: one sailor is alarmed about the fort's bombardment tactics, but the others decide to continue their work. Then across the middle tier, we watch for four panels as a cannonball skips across the water toward our gun port—our heads where the sailors' would be. In panel 7, we see the cautious sailor hugging the deck while his mates are decapitated by the careening cannonball. The four panels at mid-page are clearly intended to build suspense. They force

us to watch the cannon ball as it splashes toward us, growing closer with each panel. And they thereby attenuate the action: they seem to stretch time by stopping it at four distinct moments. Time seems suspended. As we watch, we perforce must wait, while anxious terror accumulates. And then in panel 7, the clock resumes ticking, and the action reaches its grisly conclusion with a horrifying single-panel swiftness.

Suspense is built by slowing the passage of time. Granted, a filmmaker could produce an equivalent sequence—a sequence that permits us to see a cannonball coming toward us in slow motion. But when filmmakers employ this device, they almost seem to be tampering with the nature of the medium by prolonging time unnaturally. And what would seem unnatural in film seems quite at home in a comic strip. Unnatural—unrealistic—as the sequence may be, it works as dramatic storytelling in comics.

But is it actually time that is being controlled? In real time, it probably takes longer for the sailor in panel 2 to make his speech than it takes for the cannonball to make its journey. And the decapitation in panel 7 doubtless takes place in only slightly less time (if that) than it takes the cannonball (in four panels) to reach the gun port. Clearly, the panels on this page are not equivalent moments of time. Convenient as it is to describe the narrative breakdown of a page of comics as if it controlled time, the units of the page—the panels—are not equal units of time by which the page's action can be clocked. By the only other measurement possible, reading time, time is not much prolonged (if at all) across the middle of this page. It takes at least as much reading time to absorb the information in the second panel or the last as it does to "read" the mid-page tier.

In fact, the control of time on this page is mostly illusory. To the extent that our response is manipulated at all, it is manipulated by space—not time. The four-panel sequence attracts attention to itself by its unusual use of space: each panel is identically composed, each panel is the same size, and, comparatively speaking, a lot of panels are devoted to a single incident. The visual importance that the sequence thus assumes gives it narrative and dramatic weight. We *may* spend more time "reading" this sequence than is absolutely necessary for absorbing its information. We may not. But if we do, we do so because of the seeming

Figure 94. *In comics, space, not time, manipulates pacing and our response.*

significance imparted to the series by its unusual use of space. We are tempted to dwell on the pictures—to study them, as it were, in order to discover how each of these seemingly identical pictures is different. Hence, it is space, not time, that enhances the drama here. And space in comics is the equivalent of time in film only insofar as it manipulates our response as time does in film.

The cartoonist also influences us by the sheer amount of space he devotes to a picture. Large panels and splash pages engage the eye, thereby heightening our interest in them—and consequently adding drama to the events depicted. But the spatial narrative mode of comics permits another kind of emphasis as well. A cartoonist determines how much space to allot to segments of his story by breaking the narrative into separate pictures. The selection of what is to be pictured is greatly influenced by the quantity of story material (how much exposition is required, how much action, what must be depicted in order to prepare for subsequent events, and so on) and by the available space. The filmmaker goes through a similar procedure. In fact, many of them use storyboards of static illustrations to plot their films visually in advance—scene by scene, event by event—before exposing a single foot of celluloid. And storyboards are comic strips. But here the kinship between the two media once again becomes strained. Storyboards may be comic strips, but they aren't motion pictures.

Although both the cartoonist and the filmmaker must choose the images they need to tell their stories, the selectivity exercised is of a different order. The mode of emphasis is different. Moment by moment, frame by frame, the filmmaker needn't be quite as precise in choosing his images as the cartoonist must be. The cartoonist, though, must select exactly the right instants of a story for his drawings because what is chosen to be pictured necessarily acquires more dramatic emphasis than what is left out. The equivalent instant for the filmmaker is usually accompanied by several minutes of a longer sequence in which that instant occurs. The question of emphasis for the filmmaker is resolved not so much by *what* should be filmed (although that's clearly important) as it is by how much time should be devoted to each scene and how the motions within that time allotment should be portrayed in order to achieve the desired effect. While the cartoonist faces similar issues in composing each panel for maximum narrative impact, the piece of action he's selected to draw has already stressed that action dramatically. Simply by being chosen, it is captured and thus destined for longer contemplation than is possible for an equivalent action in a film.

Here is a Spirit story by Will Eisner, whose narrative technique is often as cinematic as Kurtzman's (figures 95–101). First published on November 3, 1946, the story achieves topicality by sending the Spirit after a petty crook named Beagle, who is making a fortune by bilking ex-GIs out of their savings and government loans. But Eisner is less interested in exposing postwar scams than in exploring another dimension of his protagonist's character. As always, it is the human dilemma that intrigues him: how does a personality react in a given circumstance? In this case, how will his hero settle an unusual moral debt? And will his sense of indebtedness divert him from his sense of duty?

The Spirit apprehends his prey, then lets him go when he discovers that Beagle was a childhood friend who once saved his life. But the reprieve is extended only once. When Beagle does not reform, the Spirit tracks him down again and turns him in. The story reveals that the Spirit has a human side. At first, he seems as relentless in his war against crime, in his pursuit of criminals, as an elemental force. He cannot be turned aside or diverted from his purpose. Nothing stops him. Nothing, that is, until the person within the crime fighter is touched. And then the person displaces the crime fighter. As usual, Eisner invokes the resources of the medium to invest his tale with mood and drama. He captures the moment of the Spirit's transformation in the pivotal third panel of the third page (figure 97): just as the action of the story halts abruptly with this panel, so is the crime fighter stopped short in his headlong pursuit. The composition of panel 6 on this page emphasizes the bewilderment we feel at the apparent motivelessness of the Spirit's action: our attention is directed to Beagle, who is similarly puzzled. He stares out at us, reflecting perfectly our own disbelief and wonderment, the inky shadows of the sequence deepening the mysteriousness of the incident. Later, we learn the reason for the Spirit's withdrawal, and, as Eisner intended, we sympathize. Despite his seemingly ruthless war on crime, the Spirit is not so different from us: some personal imperatives have a greater moral force

Figure 95. *On this and the following pages, we have Eisner's* Spirit *story published November 3, 1946. Once again, the splash page sets the mood.*

Figure 96. *Only in the comics are certain maneuvers possible—such as the Spirit's at the bottom of this page.*

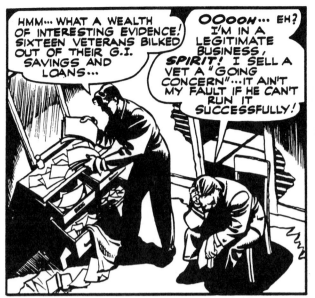

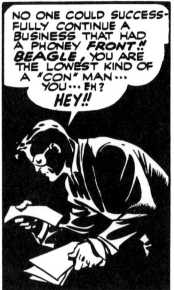

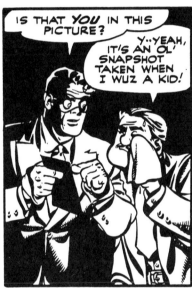

Figure 97. *Again, Eisner uses a virtuoso deployment of black shadow to evoke mood.*

Figure 98. *In the third panel, we see the distinctive window in the Spirit's underground lair beneath Wildwood Cemetery.*

Figure 99. *Rather than let the Spirit appear an irresponsible citizen in permitting Beagle to escape the clutch of the law, Eisner arranges for his hero to redeem himself a little by helping one of the con man's victims.*

Figure 100. *Ebony's predicament in panel 7 sets up a secondary plot line that runs a comic thread through the Spirit's struggle.*

Figure 101. *Only in the comics can two stories unfold simultaneously and yet command equal attention from the reader/viewer.*

than the law. But Beagle is entitled only to a second chance, not a third. Personal morality cannot be permitted to supplant the law entirely.

As overture to the story, a splash page drenched in black (figure 95) sets us up to expect a tale of pursuit and capture. Although we don't see the fugitive's face or his pursuer, we know he's a fugitive and we know he's being actively pursued. And the lowering visage of the Spirit in the midnight sky tells us by whom. Then the story continues on the next page (figure 96) with one of Eisner's dramatically unconventional angle shots—a bird's-eye perspective that enables the cartoonist concisely to establish setting and mood while also pinpointing the fleeing felon's whereabouts. In four pictures, Eisner tells us that the Spirit has pursued his quarry across the rooftops, down a fire escape, and through a window into his shabby room. Then the Spirit batters down the door to the room and apprehends the culprit. It's a simple visual narrative, to which Eisner gives a shadowy underworld atmosphere through liberal use of shrouding black. After the first panel, a consistent camera angle gives sharp clarity to the action by providing us the same orientation throughout the sequence. No words are needed to tell us the story on this page. We could be watching a silent movie, so completely visual is the narrative. But a film would give us more—and, at the same time, less—than we have here.

A film would show the movements that are here lost between panels: we would see Beagle slam the door behind him after entering the room, we'd see him throw himself against the door, we'd see him picking himself up after the Spirit's entry knocks him down, and we'd see him grab the chair that he crowns his pursuer with. But comics don't often make the attempt at depicting action as continuously as film. When this does happen in comics, it has the effect of slowing the action by giving each movement equal space. Equal space, as I've said, is not equal time, but it is equivalent emphasis.

Eisner, however, has selected only the most telling moments for his pictures—those that depict the actions essential to our understanding of the sequence and those that best reveal personality. Each picture on this page emphasizes what is depicted by its very presence. We fill in the gaps between these pictures with imagined movement, but the pictures confront us directly with their images. Because we see rather than imagine these images and because we stop briefly at each one, they each acquire greater dramatic power than they would if they were simply images in a continuously moving series of images—in a film—where each picture here would be but one image among many. And because the pictures do not move or change in comics as we watch, we have the images before us longer than in a film, and they each therefore have greater narrative impact.

Beagle's desperation in trying to keep the Spirit out of the room is given dramatic emphasis in panel 2, which shows in face and figure the strain his effort costs. The force of the Spirit's assault is underscored in the next panel: caught in midair, the Spirit seems to float (note the absence of speed lines), creating the impression that he enters the room almost effortlessly. His strength is so great, his moral fervor so fierce, that a barricaded door is virtually no obstacle at all. And the next two panels emphasize the brute force of the conflict by focusing on the exchange of blows just as they are struck. The full impact of the Spirit's blow in panel 5 is conveyed by the rendering of Beagle's figure: so powerfully is he struck that he seems not just to shudder but to vibrate.

The panels skip from one critical moment in the sequence to the next, each panel depicting the most dramatic actions—the most visually exciting. The action is almost continuous, cinematic, but in seizing on only the key moments, Eisner makes the sequence rush headlong to its conclusion. Film can achieve the same sort of emphasis, but it must do it some other way. The actions emphasized here in separate images could be stressed in film by sounds, by slow motion, or by quick cuts to close-ups and back. The point is not that film cannot do much of what this page of comics does: the point is that film must do it differently.

But Eisner's page also does something that would be nearly impossible for film to accomplish without using special effects. In comics, it seems possible for the Spirit to whip a chair under his falling victim in time to seat the unconscious body. After all, we see it happen: on the authority of our eyesight, we know it happens. But could it actually happen in real life? Doubtful. The pictures here suggest that Beagle is falling slowly—slowly enough to permit the Spirit to shove the chair under him. In the real world, a falling body probably moves too fast for this maneuver.

Eisner's visual rhetoric nonetheless convinces us

that the improbable is possible. Panel borders drop away, the background pales to blank whiteness. Reality is thereby suspended. At the left, we see only two figures, poised in an unreal void. The Spirit seems contemplative, pondering his next move at leisure—his expression and pose reinforcing the impression that time and motion are standing still, that Beagle's body has all the time in the world to fall and that it takes all that time. Time enough to permit the quick-moving crime fighter to make his lightning move with fluid assurance, putting a fine comic touch on the episode's conclusion. The second image presents the fait accompli. Among the rhetorical tools of Eisner's argument is the narrative mode of the medium: the breakdown of the action omits the motion between the two images—as if the Spirit moves faster than the eye. We see only "before" and "after" shots, with speed lines supplying all the sense of the now completed action. But seeing that much is believing. We're convinced. We're convinced that the Spirit ends his bout with Beagle by executing flawlessly and without visible effort a sleight of hand and arm that is all but impossible. And the risibilities are tickled here by the accomplishment of the impossible as much as by the gesture itself, which is both incongruous and supremely, ingeniously, fitting.

Could film do as much? In slow motion, perhaps? Not likely. The camera would slow both movements—that of the falling body and of the moving chair. And the maneuver on this page requires that the chair move faster than the body can fall. (Or, at least, that the one *appear* to move faster than the other.) Film might stage the sequence differently: Beagle could stagger slightly, giving the Spirit time to make his move. But then Beagle would not be felled like an ox, as he is on the comics page. It could be done on film through the use of special effects. Special effects in film can presumably accomplish anything. But special effects are just that—special; they are not the stuff of ordinary live action committed to celluloid. Natural phenomena are not filmed mechanically when special effects are brought into play. Instead, the intervening human hand slips between eye and image, tampering with the latter. In short, special effects are more like comics than film: they are animated cartoons, a third medium.

The Spirit lambasts Beagle again later in this story, as recorded on the last two pages (figures 100

and 101). Once again, comics do something that, if not impossible for film, cannot be carried out as effectively in film.

Ellen Dolan and Ebony have been captured by Beagle. And in the tradition of a good Saturday afternoon serial, Beagle binds Ellen to a chair and begins cuffing her about (Figure 100). Ebony gets tied to a pillar, and Beagle's henchman starts a small fire under his feet. Their predicament is, as they say, dire. Suddenly, Beagle thinks he hears something in the hallway outside the room. He opens the door to investigate, and the picture in panel 3 captures and thereby emphasizes the moment of his apprehension: the action stops for the heartbeat of his fearful darting glance into the hall. Then the Spirit enters—fist first.

The mid-page panels that portray the Spirit's entry into the room throw us immediately into the ensuing fray. We (and Beagle) meet the Spirit's fist, fist first, in a panel that dramatizes both the surprise and the force of the Spirit's assault. In the next panel, the camera shifts so that we can confirm the identity of the rescuer. Although the gloved fist in the preceding panel is a more than adequate clue, the picture of the Spirit—cloaked in shadow, eyes glowing behind his mask—dominates the scene with the threat of his mysterious and unconquerable presence. In the third panel of the tier, the Spirit quickly disposes of the thug who seemed so threatening just the panel before. Narrative breakdown and panel composition combine to delineate the action in the most dramatic way—by focusing on three visually exciting moments.

In the next panel, the story picks up a subplot. The smoke from the fire under Ebony hangs over the three preceding panels, and here we finally get a view of his dilemma. Fortunately, the flames have burned through the ropes that bind him, so he is able to make his escape. On the next page (figure 101), Eisner develops the comedy he derives from Ebony's predicament while at the same time carrying on the Spirit's fight with Beagle and then bringing it to a close. The punch line is that it takes the apprentice crime fighter so long to have his dignity repaired that he misses the action: by the time Ebony is ready to do battle, the Spirit has already settled Beagle's hash. But Eisner enhances the humor in the situation by exploiting the capacity of his medium with skillful panel composition and narrative breakdown.

Ebony leaves the scene to extinguish the fire

that is at the seat of his discomfort; then he reenters, trailing clouds of smoke and glowing with indignation. The two panels that depict this action also present us with pictures of the ongoing struggle between the Spirit and Beagle. And the fight is scarcely in the background: the battling figures occupy most of the panel space, and it looks as if the Spirit is getting the worst of it. We are kept in suspense about the outcome of the main plot even as trailing plumes of smoke keep the comic Ebony subplot before us all the time. Thus, we follow both facets of the story simultaneously: as the Ebony plot unfolds, we're constantly kept in touch with the progress of the Spirit-Beagle battle. Contributing to the comedy is the contrast between Ebony's comparatively trivial predicament and the grim circumstance facing the Spirit as he appears to be losing the fight. And Eisner heightens the contrast by depicting the elements of it simultaneously in the two panels.

Film could present us with the same images—and simultaneously, too. But one (or both) of the story lines would fray as a result. In a motion picture version of this sequence that duplicated it exactly, the audience would devote more attention to one of the story elements, neglecting the other. It is virtually impossible for a viewer to devote equal attention to two sequences of action both of which are taking place at the same time. One sequence will automatically take precedence; the other will be noticed (if at all) as peripheral activity. If we tried to watch both sequences at once, we would be unable to devote sufficient attention to either. Images in motion can distract the eye as well as attract it. Two simultaneous motions inevitably compete for attention, undermining our ability to concentrate on one or the other. The effectiveness of both is thereby diminished. But the static medium of the comics permits us to give more or less equal attention to both sets of actions. We are not rushed by the necessity of keeping up with images in constant motion. We can linger, taking as long as necessary to drink in all the visual information from each panel.

Film could give us the same comedy, but to do so effectively, the two sequences, or "stories," would have to be presented in alternating visual doses, so that we would not be distracted from attending to one by the visual attractions of a competing action. The story could be told in film. But it is impossible for film to do it effectively in precisely the same way—with simultaneously presented images.

Splash panels sometimes exploit the unique capacity of comics to tell a story using several images at once—those sprawling fight scenes, for instance, in which several superheroes are shown battling the enemy hordes all at once. In a motion picture, a similar scene would waste its dramatic potential because the audience would be able to focus only on small portions of the scene at a time, thereby missing other pieces of the action. But viewing the scene in a comic book, we can move at leisure from one part of the action to another, eventually taking it all in. Each combatant receives our attention in turn; none need be overlooked. At the same time, the splash panel itself, absorbed as a total gestalt, gives us an impressive image of the overall battle.

The capacity of comics to convey a lot of information in a single panel is sometimes misused. How many times have you seen a panel in which a character speaks several speech balloons? Or a panel in which two or more characters exchange witticisms, one character speaking at least twice? The medium makes it possible. But such maneuvers necessarily diminish the impact of some of the talk: in the last analysis, the picture is appropriate to only some of the conversation—and the remainder of the speeches lose dramatic force because they lack the narrative reinforcement of suitable accompanying visuals.

By way of furnishing this diatribe with a grand finale, let me direct your attention to a Walt Simonson page from the acclaimed Manhunter series. This page comes from chapter 4 of the saga, "Rebellion," which first appeared in *Detective Comics* No. 440 (January 1974). Manhunter, a creation of an outfit called the Council that seeks world domination, has revolted against the scheme of which he is a part, and with Interpol agent Christine St. Clair, he seeks to derail the Council's plans. In the scene we have here (figure 102), a Council operative tries to eliminate Manhunter and Christine by running them down with a land rover. The page at hand does more than demonstrate the capacity of comics to depict something nearly impossible for film to capture. It also illustrates a sophisticated use of the medium's most unique narrative resource: its capacity to vary layout for narrative effect.

The narrow, horizontal panels that make up the

Figure 102. *Layout, a distinctive property of comics, manipulates our attention and therefore our response in this Manhunter page by Walt Simonson.*

first and third tiers on the page stress the action: their shape underscores the speed of the vehicle. And the hurtling velocity of the assassination vehicle is further emphasized in panel 5, when the machine breaks through the boundaries of the panel. Along the second tier, three panels capture key moments in the unfolding action: Manhunter rolling beneath the wheels, whipping out a knife, and puncturing the land rover's gas tank. By focusing on Manhunter's hand in panels 3 and 4, Simonson makes sure we don't miss the development crucial to understanding the rest of the sequence. And again, as is customary in superhero comics, the pictures convince us that the impossible has actually happened. Not only is cutting into a speeding vehicle's gas tank a virtually impossible feat, but capturing this action on film could not be done without the intervention of special effects—without, in other words, a species of animation, of hand-wrought image making.

In the stack of three panels at the lower left, Simonson begins to build toward the conclusion of the episode. Tight close-ups focus our attention exclusively on that which is absolutely necessary for us to comprehend the action: a match is struck, thrown, and ignites the spilled gasoline. Our attention is riveted by the solid black backgrounds of all three panels: all distracting, superfluous detail is eliminated. And by breaking the action into three distinct steps, Simonson builds suspense by prolonging the action, postponing the outcome.

Layout eases us toward the episode's explosive conclusion and increases its impact. The eye moves effortlessly from the ignited gasoline in the corner of the page to follow the burning trail of fuel until it reaches the land rover and blows it up. Layout controls not only our attention but the only action of which a reader is capable—eye movement. And our eye movement echoes the action of the story. The eye moves down the page as the match falls in the three stacked panels; then it moves up the page as the land rover blows up. It's a neat trick of comics artistry, in which the resource of space is deftly exploited for its dramatic potential. Then Simonson gives the sequence a visually eloquent aftermath in the last panel: the camera draws close to the burning wreck, and we feel the scorching flames as we see Manhunter shielding his face against the heat.

The sequence takes advantage of the medium's verbal-visual nature, too. Word and picture blend with telling economy: Manhunter disagrees that the assassin will turn his weapon around for another onslaught while the pictures give his words meaning and authority. And Simonson dramatically enhances his assertion by surrounding the speech balloons with visually silent black.

This entire sequence might well be described as "cinematic." And film could, indeed, give us the same story. But it would do it differently. The action of the second tier could be presented only through special effects. And for the conclusion, film would manipulate our attention and response by timing sound and image rather than through canny development of images in space.

No, comics aren't film. Both are visual media; but the one isn't quite the same as the other. Skillful use of the comics medium requires the engagement of a slightly different set of sensibilities than skillful filmmaking. The difference may be slim, but the effect is somewhat greater. The cartoonist cannot transfer to filmmaking all the techniques of making good comics any more than the filmmaker could employ all of the devices of making motion pictures if he were to undertake producing comics. I recognize that this notion runs counter to the claims of those young Lochinvars of the comics industry who see their work in funnybooks as an apprenticeship for a career in the movies. (This oft-espoused aspiration may be inspired by a desire to graft onto their present vocations as much dignity as possible—an inspiration grounded in the misguided belief that the movies of Hollywood and television are somehow a superior art form. True: there are good movies, worthy of the name of art. But there are comics that qualify, too. Neither medium is inherently more dignified, more adult, more deserving of creative artistry, than the other.)

While there is a modicum of truth lurking behind the claims that film and comics are related, that truth can be misleading. Those who see comics as a proving ground for filmmakers are not likely to see comics as a storytelling medium with capacities peculiar to it alone. Without recognizing those capacities, these would-be filmmakers will not explore the potential of comics as fully as possible. To the extent that comics are cinematic, the aspiring filmmaker will be challenged by and interested in the medium; but the other wholly unique capacities of comics will remain untapped. And

the art of the comics will be poorer in consequence.

However much these two visual media may nurture one another in the marketplace by creating audiences for each other, the art of one medium is not likely to be much enriched by the art of the other. For that sort of enrichment, we need storytellers who apprehend the singular potentials of their medium—who see them clearly and explore them creatively.

CHAPTER 9
The Lonely Hearts Club Band
Autobiographical Angst and Other Adventures in Topics and Treatments

During that storied hippie Summer of Love in 1967, an estimated seventy-five thousand young Americans put a flower in their hair and went to San Francisco, and as soon as they hit the City by the Bay, they gravitated to hippie Mecca, "the Haight," where they started getting better all the time.[1] On any late afternoon that summer, Haight Street between Central and Shrader swarmed with humanity, both on foot and in cars. Vehicles moved at a dead crawl because the streets were jammed, sometimes with pedestrians who chanted "Streets are for the people" as they walked beatifically into intersections without regard for four-wheeled traffic. The scene was part Old Calcutta and part carnival midway. The teeming throngs, mostly young people, were dressed in Indian paisley prints and T-shirts, Levis and boots and psuedo-Western garb, scraps of Army and Navy surplus, and remnants of bygone fashions culled from local thrift shops; some wore beads and tinkling ankle bells and buttons with cryptic messages on them ("Frodo Lives," "Haight Is Love," "Freak Freely"). A few of the milling multitude passed out flyers and broadsides or, on Fridays, sold copies of the radical underground paper from across the Bay, the *Berkeley Barb*, or the milder neighborhood publication, *The Oracle*, which, by summer, was being printed in a rainbow of changing hues that rendered it all but unreadable; others along the street unabashedly hawked drugs ("Acid? Speed? Lids?"). Some gathered around the Grayline tour bus as it made its daily rounds and held mirrors up to the windows for the tourists to see themselves in. (An ironic exercise, since most of those in the street were themselves visitors to the vicinity rather than residents.) A few carried tiny bells or tambourines or feathers or bits of fur that they would hold in the faces of other stoned trippers to "blow their minds." Teenie-bopper runaways with dirty faces hoped for a little help from their friends and begged for spare change.

It was street theater, a participatory art form peculiar to the sixties, particularly to the psychedelic community in the Haight, which Charles Perry, an associate editor of *Rolling Stone*, once described as "a perfect theater, a large territory full of stoned people making the scene and vaguely waiting for something to happen."[2] The world's first Be-In had been held earlier in the year (on January 14) in the polo grounds at the Golden Gate Park, a few blocks west of the Haight; it was a "happening" at which the only event of note was simply the presence of people, amply entertained by themselves and a selection of speakers and rock bands. It was the kind of thing for which the Haight was, by then, renowned.

"The Haight" was hip for the Haight-Ashbury district, a huddle of run-down Victorian houses

and somewhat seedy storefronts at the east end of Golden Gate Park, separated from the rest of the city by the wooded hills of Ashbury Heights. Although the population was chiefly Poles and Czechs who had lived there since before World War II, students at the nearby University of San Francisco had begun to infiltrate the neighborhood a few years earlier to take advantage of the low rents, and an art colony was in full flower. By 1967 there was also a conspicuous infestation of dope-using dropouts and hippies. For many of the latter, life revolved around periodic psychedelic-rock dance concerts and the musicians and the poster artists whose works celebrated the dances they advertised. The first of these dances—"A Tribute to Dr. Strange"—had been sponsored by the Family Dog in October 1965. That a Marvel Comics character should be so honored was not, at the time, remarkable: Ken Kesey (of *Cuckoo Nest* fame), an early apostle of acid, had toured the vicinity frequently, proclaiming the heroism of everyday life and asserting that the costumed superheroes of Marvel Comics had as much to say about life as most contemporary literature. And his Acid Trip retinue included the Merry Pranksters, who dressed in costumes like superheroes.

The dances at the Fillmore and Avalon were conceived and staged as participatory art. The stoned crowd circling the dance floor chanted and sang and painted each other's bodies with bright colors, blew whistles and played flutes, vibrated in the strobe lighting, and gawked intensely at the walls and ceiling, against which light shows splashed changing colors that throbbed to the tempo of the music. The sound overwhelmed all the senses, enhancing the drug-induced oceanic feeling that "all is one" and that, therefore, everyone was "on the same trip." It was, they believed, a trip of love, peace, beauty, and freedom. Others might observe (more or less correctly) that the trip chiefly featured drugs and sex and rock-and-roll parties all night long. But even so, the antics of the psychedelic community were astonishingly peaceful—compared, say, to the beer-guzzling orgies of college students on spring break at Fort Lauderdale.

The posters that announced the times and places of the dances had become objets d'art in themselves. In defiance of conventional marketing custom, content on the posters was subordinated to design. Early poster artists Wes Wilson and Stanley "Mouse" Miller became adept at using bold colors

and abstract, mushrooming, twisting shapes that incorporated pop images and virtually undecipherable lettering into the same design (creating a product that "made sense only when you were stoned," according to Perry). The Print Mint, initially founded by Don Schenker as a framing and printing establishment for fine prints, soon concentrated on producing dance posters.[3] Then it began commissioning artists to do posters in a satiric vein.[4] And soon the Print Mint would be publishing yet another satiric product, comic books.

Robert Crumb arrived in the Haight in January 1967, fleeing a wife and an unwanted marriage and a stultifying job at American Greeting Cards in Cleveland. There he'd been taking LSD and using a little pot for a couple of years, so when he saw some dance posters from San Francisco, he understood the source of the poster artists' inspiration. And he was primed for what he called "the wild and wacky hippie scene at its high noon of acid-induced euphoria."[5] Guilt-ridden about his wife, Dana, he sent for her after three weeks, and they took an apartment in the Haight; she worked, and he "hung out," smoking dope and listening to antique records and drawing drug-inspired comic strips in his sketchbooks.

He also hitchhiked back and forth across the country, and it was perhaps on a springtime stop in his hometown, Philadelphia, that he met Brian Zahn, who was about to publish an underground newspaper that he called *Yarrowstalks*. Zahn took one of Crumb's cartoons, and so "Mr. Natural" saw print in the first issue of the paper, dated May 5, 1967. Zahn liked Crumb's work so much that he invited him to do an entire issue. And when that issue (No. 3) sold well, Zahn suggested that Crumb do a comic book, which he would publish. Crumb was delighted: he'd been filling his sketchbooks with comic book stories for years and had even designed and drawn covers for such a publication. He completed a twenty-four-page issue of *Zap Comix* in October and sent the artwork to Zahn, then did another twenty-four-page issue in November. Hearing nothing from Zahn for months, Crumb phoned Philadelphia, only to find out that his patron had left the country. And the first twenty-four pages of comic book art were missing.

About that time, Crumb met Don Donahue at the home of a friend. Donahue had seen Crumb's work in the underground newspapers *Yarrowstalks* and the *East Village Other* and had tried in vain to

Figure 103. *At the top is Mr. Natural as he looked when he first appeared in print in* Yarrowstalks *No. 1 (May 5, 1967); at the bottom of the page, three tiers from a four-page story published in* Zap Comix *No. 4 (June 1969).*

locate the cartoonist. Crumb had some of his *Zap* pages with him, and when Donahue saw them, he eagerly offered to publish the comic book. Donahue traded his hi-fi tape recorder to an old hipster printer named Charles Plymell in exchange for five thousand copies of what became *Zap Comix* No. 1. It was a uncomplicated production: two colors on the cover; all black and white inside. Its simplicity kept its cost low—and it set the mold for the genre.

"The first issue was printed in February 1968," Crumb recalled. "We folded and stapled all 5,000 copies ourselves and took them out and sold them on the street out of a baby carriage. At first, the hippie shopkeepers on Haight Street looked down their noses at it—'A comic book? No, I don't like comic books.' It looked just like a traditional comic book. It had none of the stylings of your typical psychedelic graphics—the romantic figures, the curvy, flowing shapes. It took a while to catch on."[6]

But not as long as Crumb implies. Responding to demand, Donahue (calling himself Apex Novelties) did a so-called second printing of the first issue within a month or two, in order to replace the inventory that had been destroyed in a fire at his establishment. (It was actually more of a second edition than a second printing, because Donahue added four more pages of Crumb material, thus producing a twenty-eight-page magazine.) Donahue also printed *Zap Comix* No. 2 in June, but Crumb was unhappy with the quality of the printing. Fortunately for Crumb, Moe Moscowitz, of Moe's Books in Berkeley, put up money for the Print Mint to do the later runs of this issue and all subsequent issues. *Zap* No. 2 included contributions from two poster artists, Victor Moscoso and Rick Griffin, and another cartoonist, S. Clay Wilson. By late fall, Crumb comix had become popular enough to stir up a flurry of publishing activity. In December, using photocopies Crumb had made of the "first issue" that he'd sent to Philadelphia, the Print Mint published *Zap Comix* No. 0 and, at about the same time, *Zap Comix* No. 3, which added Gilbert Shelton to the roster of Zap regulars. Of the Zap crew, Wilson probably influenced Crumb the most.

Wilson had drifted into Crumb's apartment one day from Nebraska. An art school graduate, Wilson saw himself as an art outlaw, whose function was to use his talent to puncture the "booshwah" balloon, to strip "the mass delusion" from the eyes of the American middle class. Wilson was a heavy drinker, preferring wine and beer; Crumb went drinking with him, and they talked into the night. "A seething, visionary kinda guy, Wilson was very inspiring to be around in those days," Crumb wrote. "I learned a lot from Wilson. He had evolved and articulated his artist-rebel thing to a high degree. He lived the role. By comparison, my conception about what I was up to as an artist was murky, unformed. I was coming from a rather more conventional cartoonist-as-entertainer background. We had long discussions about what this work we were doing was all about. Wilson once said to me, 'Fuck entertaining the masses, Crumb! You're just feeding the hungry dog.'"[7]

Wilson's contribution to *Zap Comix* No. 2 was violently different from Crumb's good-natured big-foot material. Wilson drew stories about bikers and pirates and lesbians and all kinds of unsavory demonic freaks. And he drew them as grotesque gargoyles, ugly and malformed and repulsive—covered with blemishes and scars, warts and unruly hair. His graphic style was raw and uncompromising, and his characters were relentlessly brutish, violent savages who stabbed and chewed each other to bits whenever they weren't committing bizarre sex acts. Wilson held nothing back, made no concession to social convention whatsoever; he relished offending every civilized sensibility. And he had an effect on Crumb. As Crumb said: "Getting involved with these other artists who had very strong personal visions of their own threw me off my track. For better or worse, the influence of Wilson and [Los Angeles poster artist Robert] Williams began to show in my work. I, too, became more of a rebel. I cast off the last vestiges of the pernicious influence of my years in the greeting card business [and] let it all hang out on the page—the raging Id. Seeing what Wilson and Williams had done just gave me the last little push I needed to let open the floodgates. Blatant sexual images became a big thing, still happy and positive at first—a celebration of sex. [But as time went on], I moved further and further away from mass entertainment. The sexual element became increasingly sinister and bizarre.[8]

Crumb and Wilson collaborated in the fall of 1968 on another comic book. Called *Snatch Comics*, it dealt explicitly with sex. Crumb and Wilson showed penises and penetration, cunnilingus and fellatio. Not since the infamous homemade eight-

Figure 104. *A Rick Griffin page from Zap No. 3 (December 1968) displays his talent for highly fanciful design, much in demand among poster manufacturers in the Haight.*

Figure 105. *At the top of this page is a panel from a strip by Victor Moscoso called "Hocus Pocus" that appeared in Zap Comix No. 4; the strip is designed to be read backwards and forwards, and rightside up and upside down—an extraordinary achievement. At the bottom are four panels from one of S. Clay Wilson's grotesque works from Zap No. 4, this page featuring a character who was a favorite among Wilson's fans, the Checkered Demon.*

page Tijuana bibles of the 1930s and 1940s had sex acts been so graphically depicted. Graphically and joyfully. These pages are infused with a giddy glee; even Wilson's contributions are cheerful evocations of sexual fantasies rather than his typically brutal confrontations. Donahue agreed to publish the book on the condition that no one would know he printed it. His association with Crumb was coming to a close, now that *Zap Comix* had been taken over completely by the Print Mint (which would venture even further into comix publishing that fall, launching the tabloid newspaper *Yellow Dog Comics*, to which Crumb contributed).

Coincidental with the production of material for the first issue of *Snatch*, Crumb went to New York and made a startling discovery. He was a celebrity. And his fame was not confined to the counterculture enclaves served by the underground papers he'd cartooned for or by the comic books. He was photographed by *Life* (although the article never appeared). "I had suddenly become a phenomenon, another hippie counterculture personality—Mr. Keep-on-Truckin', Mr. Zap Comix. If you were a hip college student, you had to have a *Zap* comic next to your dope stash. I didn't have any money but I had glory! I was America's best-loved underground cartoonist."⁹

Just as head-turning as this overnight fame was his sudden success with women. In New York, he met other underground cartoonists—Spain Rodriguez and Kim Deitch and Art Spiegelman—and one night, Spiegelman brought his date and another girl to a restaurant dinner with Crumb. Suddenly, Crumb said, he realized that the extra girl was being "presented" to him. And that she would be completely accommodating. "I didn't have to say or do anything to earn this wondrous creature's favors," he wrote. "She was mine for the taking simply because I was Thee Famous, Thee Ultra-hip R. Crumb. That was it. If I wanted the chick, I could have her. So *this* was fame. Incredible—the girl was stunningly cute—a baby-faced seventeen-year-old. I stared at her speechless. Never in my wildest trembling dreams—I was twenty-five, and never in my life had a girl this attractive, this perfect, ever looked at me twice."¹⁰ Now, he was to learn, stunningly cute girls of this sort would flock to him, offering their favors without being asked.

Crumb did not consider himself physically at-tractive to women. Beak-nosed and slightly buck-toothed, he was tall, alarmingly skinny, and wore glasses. The classic adolescent nerd. He had been this gangling clod, it seemed, all his life—but particularly in high school, when, like any healthy teenager, he began to notice girls. Alas, they didn't notice him. Instead, they fawned over boys who were handsome and charming—and also egotistical, aggressive, rough, and even mean. Crumb couldn't understand how girls, who had always seemed to him more sensitive and more sympathetic than boys, would consistently fall for such "louts," instead·of gentler artistic souls like himself.¹¹ And because he was too introverted to devise any way of claiming female attention, he continued unnoticed throughout his high school career.

Born in 1943 in Philadelphia while his father was serving in the Marines during World War II, he was the third of five children. The second born, Robert's older brother Charles, was the leader of the troupe, devising games for them all to play. He and Robert very early discovered a common interest in comic books, and they began writing and drawing their own single-copy comics, imitating the animal characters they found in *Walt Disney's Comics & Stories* (Carl Barks's ducks), Dell's *Animal Comics* (where Walt Kelly dominated the pages), *New Funnies* (Andy Panda), and *Terrytoons* (Mighty Mouse, Gandy Goose, and Heckle and Jeckle). Their method in creating these "two-man comics" was unique: they worked together, each drawing and dialoguing his own character, to which the other made his characters respond. It was an absorbing amusement, but it isolated them from other children. For the time being, though, they lived happily in their own fantasy world.

In 1959 the brothers did a story called "Cat Life," in which a cat named Fred starred; Robert did the hero, and Charles did the villains in the story. In the next cat story, Fred stood up and wore clothes. And he changed his name to Fritz. Robert was comfortable working with animal characters: "I can express something with them that is different from what I put into my work about humans," he wrote to his friend Marty Pahls at about this time. "I can put more nonsense, more satire and fantasy into the animals. They're also easier to do than people. With people I try more for realism, which is probably why I'm generally better with

Figure 106. *A pencil drawing from one of Crumb's 1962 sketchbooks depicts what I take to be a self-caricature, as well as a frog that was then a frequent object of his drawing. The panel at the upper right is another self-caricature, this time from* Snoid Comics *(1980).*

animals."[12] He would continue drawing Fritz the Cat for years—and would come to despise the character.

By 1960, after he graduated from high school, Charles had lost interest in cartooning. But Robert kept on drawing, focusing on alter-ego characters that represented "the inner me . . . with the emphasis on the lovelorn side of my nature."[13] He finished high school in 1961 but stayed at home, drawing, until the fall of 1962, when, prompted by an invitation from Pahls, he went to Cleveland and soon found a job with American Greeting Cards. Although his memories of his training period are tinged with a measure of bitterness about the often arduous, factorylike mechanics of company operation, Crumb learned a great deal and developed facility with a variety of drawing tools and techniques. By the summer of 1963 his doodling on scraps of paper at his drawing board had attracted the attention of Tom Wilson. Wilson, who would later create the put-upon cartoon character Ziggy, was then head of the Hi Brows department, which

produced the company's new line of wisecracking cards. That fall, Wilson had Crumb transferred to Hi Brows, where creativity was encouraged and rewarded, and Crumb began to enjoy his work more.

Pahls and Crumb rented the third floor of a rooming house on East 115th Street, and the two of them cruised thrift stores and other secondhand outlets for old 78 rpm records, magazines, newspapers, advertisements, and posters—any and all artifacts of American popular culture dating from 1920 to 1940. Pahls also encouraged his roommate to hang out with him at local bars frequented by coeds from nearby Case-Western Reserve University and high school girls visiting from Cleveland Heights. But Crumb was still a virgin in the spring of 1964, when he met Dana Morgan, an eighteen-year-old Cuyahoga Community College student with middle-class parents who lived in Cleveland Heights. She had seen some of his drawings and loved them. Crumb still considered himself "a freak, a four-eyed, star-crossed, skinny loner, with a message impossible to communicate to an uncar-

ing and uninterested world" according to Pahls. He was therefore easy prey for a girl like Dana. He was immediately smitten by her plump, "robust" figure ("big legs and all that," he said) and "beautiful Krishna-like face with big oval brown eyes."[14] And Dana wanted Crumb. At first, he rejoiced in their relationship (which was consummated only after a two-month courtship), but before long, her possessiveness began to suffocate him. He fled. Applying to Wilson for a leave of absence, Crumb went to New York that summer.

In New York he sought out Harvey Kurtzman, whose *Mad* had stimulated some of the "twomans" of his youth. Kurtzman was then producing *Help!* for Jim Warren, and he put Crumb to work assisting Terry Gilliam (later of Monty Python fame) in production chores. And he bought "Fritz Comes on Strong," a two-page episode in which Fritz disrobes his date, apparently intent on having sex with her. He removes one article of clothing at a time (thereby prolonging the suspense), and when she is at last naked, the cat suddenly behaves like a grooming animal: "Now be patient, my sweet," Fritz murmurs, "—them little fleas are hard t'get a hold of."

Crumb also found work in a Greenwich Village quick-draw portrait gallery, a job that moved to the Atlantic City boardwalk for the Democratic National Convention that summer. There, suddenly, Dana appeared and hauled him back to Cleveland and marriage. Then they went to Europe. Crumb arranged a freelance-by-mail contract with American Greetings: Wilson would send him card ideas, and he'd send back finished art. At about twenty-five dollars a card, it would be enough to keep the couple afloat. They spent the winter in Switzerland, and Crumb filled sketchbooks with comic book stories, many starring Fritz.

The cat was Crumb's stand-in: he was successful where Crumb was not. He was a glib-talking ladies' man and bon vivant, master of any situation in which he found himself (particularly those involving the female of the species). Nevertheless, Fritz was flawed: he was a self-centered hedonist and prankster, without the slightest moral or ethical qualm. He was, as Pahls said, "a poseur," a phoney. And although Fritz's posturing was taken seriously by all those around him, Crumb always arranged a comeuppance, thereby keeping his egotistic protagonist in hot water. It was, psychologically speaking, the cartoonist's revenge upon those more socially adept than he: he may have envied their success, but by making it clear that their attainments were founded on insincerity and blatant self-interest, he demonstrated that those he envied were not as worthy as, say, he was.

During this period, Crumb's graphic style was forming, too. Using the Rapidograph drafting pen that he'd learned about while in training at American Greetings, he gave his outline drawings texture and volume, using shading techniques that became increasingly intricate.

Crumb and Dana returned to Cleveland in the spring of 1965, and Crumb resumed his work at American Greetings. Shortly thereafter he took LSD for the first time; then marijuana. And his marriage, never quite stable (based, as it was, more upon Dana's desire than Crumb's), began to fall apart. He started seeing other women. Then, in August, he responded to a call from Kurtzman, who wanted him to replace Gilliam on *Help!* But when he and Dana arrived in New York, Warren had just pulled the plug on the magazine. Kurtzman, feeling responsible for Crumb's presence in New York, tried to find work for him. He also invited him to his house for dinner frequently. "Kurtzman was my hero," Crumb said. "Hanging out with him was very instructive. He showed me a lot of techniques and told me a lot about the commercial art business, how it worked and what to look for and the pitfalls. He gave me a lot of good advice. He headed me in the right direction. He's probably the only person in my whole life who was a good teacher. The only one. The only person I ever learned anything useful from."[15] Although Crumb didn't work out as an assistant on *Little Annie Fanny*, he did work for Topps bubble gum cards, a Kurtzman referral. This led to assignments on several projects being launched privately by the head of Topps's creative department, Woody Gelman, under the imprint of his Nostalgia Enterprises.

Crumb and Dana moved from their Yorkville studio apartment to the East Village in late 1965. Always a bohemian haven, the Village was now making room for the last of the beatniks and the first of the hippies by expanding eastward into the low-rent, threadbare district around Tompkins Square. Crumb, taking LSD more and more often, continued to draw his own comics in sketchbooks. And then he picked up a copy of the *East Village Other*, an underground newspaper, in which he

Figure 107. *This page from one of the sketchbooks Crumb created during his winter in Europe (1964–65) gives us Fritz the Cat in all his least admirable aspects.*

saw his first underground comic strip—Bill Beckman's *Captain High*, a cartoon celebration of drugs. Dana found a job in the pharmacy at Roosevelt Hospital and brought home handfuls of Methedrine tablets. Friends from Cleveland moved to New York, and they spent evenings chez Crumb, dropping acid and popping pills and talking. Among the friends was a girl with whom Crumb had enjoyed an affair before coming to New York. They resumed their relationship. And Dana went back to Cleveland. A few weeks later, Crumb left for Chicago, where he lived with Marty Pahls. While there, and under the influence of some "fuzzy" acid he'd taken in New York, he spent days drawing in his sketchbooks, creating the entire cast of characters that would populate his comics for years thereafter—Mr. Natural, Flakey Foont, Schuman the Human, the Snoid, Eggs Ackley, the Vulture Demonesses. "It was a once-in-a-lifetime experience," he wrote, "—like a religious vision that changes someone's life, but in my case it was the psychotic manifestation of some grimy part of America's collective unconscious."[16]

Later, Crumb would attribute his emergence as a cartoonist to the "fuzzy" LSD trip (and to taking LSD generally). "I could show you in my sketchbooks where that period starts," he told Gary Groth, "when I was in that fuzzy state, and how my art suddenly went through this change, this transformation in that couple of months." Without this experience, he claimed, his work would have taken a more serious turn. "I probably never would have gotten into that real ridiculous cartoony phase, where I was basically doing throwbacks to the Popeye-Basil Wolverton-Snuffy Smith style of cartooning. I did that as a joke. That absurdity was such a deep part of the American consciousness, that way of seeing things, and I suddenly rediscovered that in that state. All the dancing images were in that grotesque funny cartoony style with big shoes."[17]

All the same, Crumb was homesick for Dana. So he suddenly took a bus to Cleveland and rejoined her in the spring of 1966. He also returned to American Greetings and Hi Brow cards, where he worked for the next eight months. It was, he said, "the last time I ever held down a nine-to-five job."[18] Restless, he started frequenting bars, and one afternoon in January 1967, two friends told him they were setting out for San Francisco that

evening. He went with them. As simple as that: he got in their car with about seven bucks in his pocket and left Cleveland—without so much as a phone call to Dana. And eighteen months later, he found himself a famous cartoonist.

The hippie community was ready for comix. For some time the underground newspapers of the growing counterculture had been publishing comic strips that urged revolution and turning on to drugs (among other things). Underground comic books were the next logical development. And Crumb had already been toying with the idea, producing sketches and plans as early as the fall of 1965 for a comic book to be called *Fug*. He was in the right place at the right time—the Haight in 1967. And as it turned out, he was the right person. That summer, he sold a few strips to the *East Village Other* as well as to *Yarrowstalks*. But Crumb's greatest contribution to the medium would begin with the comic books he created that fall.

Crumb's work is not remarkable for any great degree of formal experimentation. Except for an early foray or two into eccentric page layout that attempted to suggest the euphoric disorientation of being stoned, most of his work is quite straightforward and conventional comics storytelling. The story unfurls in a quiet succession of regularly shaped panels arranged with drill-team precision in two or three tiers per page. No flashy special effects. No layout tricks. No dramatically engineered timing. Just storytelling straight ahead in plain black and white. In his selection of subjects, though, Crumb opened broad new vistas by venturing into hitherto unexplored territory. And it was adult territory. At his most sensational, he broke age-old taboos, shattered them; and comics would never again be quite the same.

The first two issues of *Zap* that he drew, however, are distinguished by their good-humored playfulness rather than by any adventurousness in content. Crumb accurately catalogues his work of 1967–68 as a "sweet, optimistic, LSD-inspired mystic vision drawn in the loveable big-foot style that everyone found so appealing."[19] His old-fashioned-looking drawings enliven every page with their purely visual comedy: the goofy galoot-style characters look funny. And they also do funny things, often in baffling ways (which nonetheless seem funny because of the farcical appearance of the characters). In his shorter one- and two-page

Figure 108. Several of Crumb's efforts for the first issues of Zap Comix were as lighthearted as this two-page sample (which doubtless made the best comedic sense to a reader who was appropriately stoned).

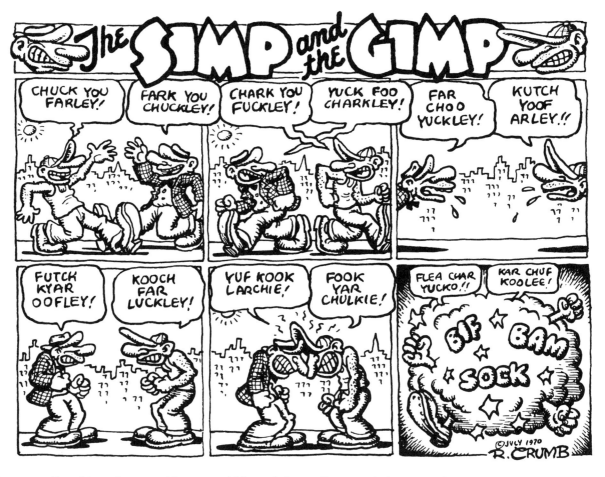

Figure 109. *Crumb's antic sense of humor could be verbal as well as visual (from* Uneeda, *1970).*

features, Crumb seems to be toying with the medium, giving us coherent images that, despite their orderly sequence, ultimately make no comedic sense in the ordinary, everyday way. And they doubtless were not intended to make sense in the usual fashion. As fellow underground cartoonist Jack Jackson (Jaxon) said in recalling the early days of comix, "Comix were for aficionados and dopers and whatnot from the beginning. We were just entertaining our friends, so to speak."[20] In short, these comix were likely to be funny only to those readers who were stoned at the time. (Jaxon—who produced in 1964 one of the earliest comix, *God Nose (Snot Reel)*, about the hilarious dilemmas of a bearded, bulbous-nosed dwarf-sized god trying to fit into the twentieth century—shed additional light on the matter when he explained the origin of the book and its title: "We were doing a lot of peyote in those days, quite legal at the time, and among other things, it makes your nose drip. So under the influence of this stuff, sitting around with some of these loony guys, we came

up with a character called 'God Nose.' It was strictly drug-induced. . . . Anyway, *God Nose* was an attempt to render some of the ridiculous absurdities that had come through from these peyote sessions.")[21]

A couple of Crumb's earliest stories are satirical in an almost traditional way, such as "City of the Future," which ridicules blissful futuristic visions, and "Whiteman," which lays bare the repressed middle-class male. But in stories like "Meatball" (about an inexplicable rain of meatballs—hits of acid—that transform everyone they hit) and "Hamburger Hi Jinx" (in *Zap* No. 2), Crumb continues to play with the subjects in ways that are most amusing, probably, to tripping readers.

The longest stories in both the first issues of *Zap* record adventures of Mr. Natural, Crumb's Afghanistani cab driver cum guru and con man, a diminutive bald, bearded, and robed "wise man" with gigantic feet, whose Zen-like pronouncements doubtless make the best sense only to readers who are high. Mr. Natural's nemesis is an

uptight youth named Flakey Foont. After a frustratingly unsatisfying counseling session with Mr. Natural in the desert, Flakey turns to leave, saying, "Ah, you're nuts." "Don't you wish," responds the irrepressible Mr. Natural. "Hey," he goes on, "—know what?" "What?" asks Flakey. "That's what!" says the wise man, exiting stage left. Funny if you're ripped, no doubt.

The joyful exuberance of this sort of nonsense is repeated in the first issue of *Snatch Comics*, too. But these comix, with their raw and unbridled portrayal of sexual activity, begin to plumb a personal well of sexual hang-ups that Crumb will continue to explore the rest of his career. Starting with *Zap* No. 2, in the stories about an African amazon named Angelfood McSpade, Crumb gives us an unthinking, absolutely uninhibited child of nature, a wholly sexual creature for whom life and sex are one. And in *Home Grown Funnies* No. 1 (1971), Whiteman—Crumb's embodiment of repressed American middle-class sexuality—is captured by wild female yeti, who makes him her sex slave. He is rescued when she is taken captive, but back in civilization, he finds he isn't happy without her. Arranging for her discharge from the institution in which she's being housed and studied, he tries to make a place for her in his urban household but perceives it's hopeless; in the last panel of the story, he's back in the woods with her. And he's happy.

Again and again in his work of the next several years, Crumb depicts characters with the most insatiable of sexual appetites, endlessly rutting, sweating, gasping, spurting, oozing, and crying out in ecstasy, often in outrageously acrobatic postures. Crumb knew he was breaking taboos: "I still have doubts sometimes while I'm [working]. It's my linear mind telling me that. There's always a battle with it; you might call it ego. That civilized part of you that always wants to be rational and logical. And the real self that wants to be magical. . . . We all—everybody—[have] this weird shit going on in our heads. I used to censor myself when I drew cartoons. I just stopped censoring, that's all."[22] On virtually every page, the cartoonist proclaims his own ideal of femininity: a "robust" woman with "big legs" and a generous derrière. For all his championing of sex, however, Crumb still seemed to harbor a deep distrust for the opposite sex, a resentment stemming, no doubt, from his lack of success

with girls as a teenager. In two stories about Eggs Ackley and the Vulture Demonesses (*Big Ass* No. 1 and No. 2, May 1969 and August 1971), Crumb subjects the female characters—who are attired in leather and metal—to the most outlandish (and hilarious) physical abuse in the contortions Eggs forces them into. Despite the degrading treatment, the demonesses continue to display a sexual appetite as voracious as anything in male fantasy.

Almost as soon as the first issue of *Snatch* appeared, Crumb was in trouble with his female readers, most of whom supported the feminist cause. In "Lenore Goldberg and her Girl Commandos" (*Motor City* No. 1, April 1969), Crumb offered up a heroine for the women: Lenore is a militant, jackbooted feminist who triumphs over male opposition by sheer brute force. But at home, Crumb shows us, she appreciates the sexual attentions of her lover. He repeated the same theme a year later in *Motor City* No. 2. Over and over again as he labored through the years to purge himself of his "sex rage," Crumb displayed his contempt for women—who had the bad taste to reject him as a teenager and the equally poor judgment later to flock to him simply because he had become famous. At times, though, he could show sympathy for women's timeworn sexual frustration. In "Don't Touch Me," a two-page story that devotes a page and a half to depicting an apparent rape, he concludes with the woman in the last panel screaming, "I never get to come!" (*Snatch* No. 3, August 1969).

Crumb was also concerned with larger issues of the human condition. In *Despair* (1970), for instance, he delivers a sermon on social responsibility by conjuring up a grim view of society overwhelmed by its excesses and negligence. He would return to the theme repeatedly. He consistently attacks the "McDonald's–shopping mall" materialism of modern America and the abuse of power, along with selfishness, greed, and hypocrisy. And in every story dealing with social issues, he unfailingly invokes the better instincts of human nature (often sexual instincts) as a way out. He advocates authenticity as a standard for behavior and self-fulfillment as a goal.

Crumb subscribed to no particular panacea for the social ills that he saw all around him. In fact, he was largely detached from the energizing political passions of the counterculture—just as the per-

Figure 110. *At the lower right is Crumb's self-caricature from* Snatch *No. 2. The other sketches display his penchant for putting his female characters through comic contortions that somehow indulged his own private sexual fantasies.*

Figure III. *On the page at the left, from* Big Ass No. 2 *(August 1971), Eggs Ackley engages in some imaginative abuse of one of the Vulture Demonesses. Above, one of the Demonesses in a less stressful moment.*

petually observant humorist and satirist should be. As R. Fiore says:

> He was in the sixties but not of them. . . . Much as he might have sympathized with the simplistic radical politics of the time, he was always a bit too smart for them. The True Believer is just not in him. No matter how much

he tried to submerge his doubts, his attempts to conform to other people's programs lacked conviction. The peace-love-and-mysticism business had very little attraction for him. Crumb envisioned the upheavals of the sixties not so much as the birth of a new consciousness as a bridge to an older one, a return to something like the rural radicalism of the nineteenth century.[23]

Figure 112. *The endings of some of Crumb's early stories could at times be fairly predictable—as if they were exercises in logic. Here the comedy derives as much from the visual inventiveness of the last panel as it does from the satiric anti-bomb message, which concludes in much the way we might expect.* (Hydrogen Bomb, *1970*)

Not even the drug culture escaped Crumb's diabolical scrutiny. Although he was an enthusiastic cheerleader when it came to turning on, he could also see cracks in the euphoric facade. In "Ducks Yas Yas" (*Zap* No. 0), he dwells for all three pages upon the nearly purposeless wanderings of an anonymous doper who is clearly not having a very good time. (Not that he's having a *bad* time; he's just not having a good time.) The episode is oddly cheerless and bleak, despite the character's advocacy of grass and acid.

As a storyteller, Crumb had difficulty with endings in his early work. His tales seldom conclude with the kind of epiphany of meaning that give short stories their characteristic impact. The resolution of the story about Whiteman and the fe-

male yeti, for example, is almost a letdown. No balloon bursts. It's very nearly a predictable, commonplace resolution, such as one would expect from a "back to nature" advocate. And in stories like "Stinko's New Car" (*Your Hytone Comics*, 1971), the ending is thoroughly ordinary. Here Crumb shows us Stinko the Clown indulging the aggressive behavior that having a powerful new car fosters in the male animal: he speeds, he runs down pedestrians, and he bumps into other vehicles, all the while exhibiting the most antisocial conduct. At the end of the story, he crashes his car and winds up swathed in bandages and casts in a hospital bed, saying, "Sigh—you can't win." He gets his just deserts—but we might well expect precisely that outcome.

Nonetheless, Crumb's stories are effective satire: throughout the body of the narrative his message is delivered in a perfectly unabashed, undisguised manner. He makes his statement by means of an outrageous assault on orthodox sensibilities. Whiteman is revealed as a wholly repressed male, who discovers happiness only by discarding his inhibitions; Stinko shows us just how nasty a person can become when he gives in to the fantasies of power that driving a new car can evoke. Shock is the essence of Crumb satire. His work explodes the conventional facades behind which we hide, thereby revealing what we really are. And depending upon the subject at hand, what we really are might be better—or worse—than what we believe about ourselves.

Crumb's nonchalance about social taboos did not escape notice by the up-tight establishment he was ridiculing. Here and there, bookstore and headshop operators were arrested for selling *Zap* and *Snatch* on the grounds that the books were obscene. In almost every instance, these obscenity busts came to nothing. In one case involving *Zap* No. 2, for example—in which one of Wilson's scarred pirates slices off another's huge penis—the judge ruled that the episode was not obscene because it did not arouse prurient interest. But such decisions did not resolve the issue, and Crumb continued to expand the arena of satirical expression.

Then, in August 1969, copies of *Zap* No. 4 were seized almost as soon as they appeared for sale. The chief offense—incest depicted in a Crumb story called "Joe Blow." In concocting the tale, Crumb took great pains to establish the Blow fam-

ily as a model of bland middle-class virtue. Their recreation seems confined to harmless pursuits—chiefly television viewing (the father) and cooking (the mother). And in rendering their faces, Crumb gave them indistinct, generic features and vacuous expressions that radiate a kind of insipid wholesomeness. And then he showed the parents engaging in sex acts with their children. Crumb's satiric objective, however, was not just to point out the discrepancy between appearances and reality. He had a more illusive goal in view. After their sexual exercise, the family members all glow with self-righteousness, saying what a great time they've had and how much they've learned and recommending that "people should get together with their kids more often." The story concludes with the son and daughter going off hand-in-hand while Father says, "There they go—off to make even more new discoveries and to build a better world." And Mother says, "Yes, youth holds the promise of the future." The object of Crumb's ridicule is the rosy, middle-America notion that families should do things together because they'll all be better for it. But for Crumb, that's too easy a cure for the ills of contemporary America: what, exactly, these families do together is clearly more important than simply "doing things" together. (Moreover, as the metaphor of incest suggests, perhaps family members would become better people if they made connections with people outside their families, people whose differences might enrich their lives by, say, widening the gene pool. But that might be pushing the metaphor a little too much.)

On the West Coast, charges were soon dropped, but in New York, the case reached the docket, and *Zap* No. 4 was declared obscene in March 1973. But there were no obscenity cases involving comix for several years thereafter, which "led many cartoonists to declare that the *Zap* trial was not an obscenity trial at all but a political bust of the counterculture, deliberately planned to come at a time when the underground comics were beginning to reach a wider audience."[24] If comix hadn't been underground before, they were now—in New York at least.

Meanwhile, back on the West Coast, Dan O'Neill had kicked a sleeping giant and provoked a new threat to comix. O'Neill had been producing a vaguely philosophical strip called *Odd Bodkins* for the *San Francisco Chronicle* since about 1967. Parodic versions of Disney characters frequently wan-

Figure 113. *The open, vacuously happy faces of Joe Blow and his family give visual emphasis to Crumb's satiric purpose by making them appear so thoroughly wholesome.*

dered through the panels, but the Disney lawyers took no action until 1971, when O'Neill and some friends published the first number of *Mickey Mouse Meets the Air Pirates*, a comic book that called unwanted attention to some ordinary facts of life. Disney's signal achievement was the creation of a fantasy world so sanitized as to be perfectly harmless entertainment. But what was harmless in entertainment could be dangerous self-delusion in real life—at least, so O'Neill believed. Ergo, he set out to correct some erroneous impressions he felt Disney had foisted onto innocent Americans. Most significantly, O'Neill reminded his readers that all animals (including, we assume, humans) have sex lives: he showed Mickey and Minnie Mouse copulating. Uncle Walt's minions were furious and sued to block publication and distribution of the offending comix, which, they asserted, tarnished the Disney image. The Air Pirates were shut down forever. And a frost settled on the underground.

When the U.S. Supreme Court sent an equally chilling message across the entire land with its obscenity decision in June 1973, comix could well have dried up and blown away like autumn leaves. But by then, comix were healthy enough to sur-

vive the season of discontent. Their direction had been set. And it had been set by Robert Crumb more than any other single practitioner of the underground art.

Comics historian Clay Geerdes argues that Crumb's importance at this juncture in the history of comics does not derive from the comix he drew: it originates, rather, in his publishing underground comics in magazine (comic book) form. "It was the *book* that turned on all those light bulbs and taught people they did not have to submit to the East Coast comic book monopoly and wait for acceptance or rejection. *Zap* taught them they could do their own."[25] The first issues of *Zap* were undeniably a persuasive demonstration that artistic freedom could be achieved through entrepreneurial initiative. But Crumb's obvious zest in playing with the medium and his ebullient selection of unconventional subjects to rejoice with were, in my view, just as much the stuff of precedent as the happenstance of his being published in comic book format.

His pacesetting performance aside, Crumb was not responsible for the first underground comic book. That distinction belongs to Frank Stack (with an able assist from Gilbert Shelton). While

an art student at the University of Texas, Stack was editor of the campus humor magazine, the *Texas Ranger*, in 1958–59. During this time he met Shelton and published his cartoons. The two aspiring cartoonists became friends, and Shelton eventually became editor of the magazine. As editor, Shelton published in the December 1961 issue of the magazine an installment of his Wonder Wart-Hog—"the Hog of Steel"—a screamingly funny send-up of Superman and the traditions of the long-underwear legions, the writing of which was credited to Bill Killeen.

According to Stack, Shelton had been producing stories about the "Big Pig" since high school. And he recruited everybody he knew to help him write the stories: "I spent hours with him, talking about drawing and jokes in Wonder Wart-Hog as did Lynn Ashby and Bill Helmer in the fall of 1961— probably others did, too, including nonsense poet Lieuen Atkins with whom Shelton collaborated often. He gave credit to Bill Killeen, who actually published some of the first stories, but I'd say he was just being generous. He was the sole owner and proprietor of Wonder Wart-Hog, script and character and concept. He was, perhaps, despite what some people said of him, very modest about his talent and generous in acknowledging help he got from his friends."[26] (Killeen later went to Gainesville, Florida, where he started an off-campus humor magazine, *Charlatan*, to which Shelton contributed more of the Hog of Steel.) In the spring of 1962 Shelton made one of his periodic trips to New York to storm the bastions of professional cartooning. He was largely unsuccessful, but he spent some time there with Stack, who was then finishing a stint in the Army. They both went back to Austin that summer, Stack en route to graduate study in art at the University of Wyoming in Laramie in the fall.

About that time, Shelton, who was perpetually launching one underground project after another, started a renegade broadside, *The Austin Iconoclastic Newsletter* (called "The" for short), and, from Wyoming, Stack occasionally supplied him with some cartoons and single-page comic strips about Jesus Christ in which the Savior is viewed, somewhat (no—entirely) irreverently, from the twentieth century perspective of a person who has read the New Testament with an appreciation for the human predicament rather than an appetite for the divine message. For example, when Jesus stops a group of men who are stoning a woman and admonishes them, saying, "He who is without sin should cast the first stone," one of the stoning party, grasping the situation instantly, hands a stone to Jesus and says: "Gosh! Sorry we started without you, Jesus. We didn't know you went in for stuff like this. Here—bop her a good one."

Shelton, vastly amused by these productions, decided to disseminate a collection of them. He took eight of Stack's single-page strips to a friend who had access to a photocopying machine and together they ran off about fifty copies of each page. Shelton supplied the cover, a thumbnail-size drawing of the head of Jesus, with the title, *The Adventures of J*, and the byline, "By F.S.," and stapled all the pieces together, thus creating the first booklet of comix.

Jack Jackson had just arrived in Austin with an accounting degree and was working in the state capitol and hanging out with Shelton and others who produced the *Texas Ranger*. "It was rather like a little oasis for us, this wonderful little thing called *The Adventures of J*," he said. "For somebody like me, who had all these religious hang-ups that I still hadn't shaken, this was just a breath of fresh air. It poked fun at the Scriptures and the sanctity and Godhead of Jesus and all that, and rather made him like a normal guy. Frank Stack, bless his heart, is finally getting some belated recognition on that."[27] Two years later, Jaxon published his own "breath of fresh air"—*God Nose*. And shortly after that, all the Texas alums were in San Francisco.

By 1966 or so the campus humor magazine scene "fell apart," according to Jaxon ("People did things that alienated the school censors"). Shelton and Jaxon had heard about the poster business in the Haight; Chet Helms of the Family Dog was an expatriate Texan ("one of the old peyote party"), and so Jaxon went to San Francisco to make posters for Helms. Shelton made the trip in 1968—also intending to cash in on the poster trade—and about the same time, so did two other Texans— Dave Moriarty and Fred Todd. The four of them pooled their resources and bought an old Davidson printing press, moved it into Don Donahue's loft upstairs at Mowrey's Opera House, and began providing an alternative to the Print Mint for both comix publishing and poster production.

In January 1969 they started calling themselves Rip Off Press, and their first publication under

that name was a collection of Stack's cartoons and strips about Jesus. Called *The New Adventures of Jesus*, this was in regular magazine format, and it identified "F.S." as "Foolbert Sturgeon." The name, Stack told me, although inspired by the initials, was intended to sound like Gilbert Shelton, "deliberately to confuse."[28]

By this time, Shelton had gone beyond college humor as a cartoonist. In 1967, while still in Texas, he had created a 16mm movie called *Texas Hippies March on the Capital*. To promote the film, he drew a comic strip about three potheads desperate to score some grass. The trio—Phineas, Freewheelin' Franklin, and Fat Freddie—were better received than the movie, so Shelton gave up his film career and began cartooning the Fabulous Furry Freak Brothers. Shelton's strips appeared in the *L.A. Free-Press* and in various underground outlets, but their splashiest debut was in Shelton's first comix book, *Feds 'n' Heads*, published in 1968.

Harvey Kurtzman reportedly thought Shelton the most professional of the underground cartoonists.[29] And certainly if professionalism means consistent quality and long-range commercial reliability, Shelton qualified. In the Freak Brothers, he created idiotic icons for the youth drug culture: sex-starved and dope-hungry, they are perpetually seeking a girl or a stash and are almost always frustrated, ludicrously, in the attempt. Shelton's work fits the classic mold for comic strip comedy. And he deployed the medium with a sure hand; his stories always conclude with a comic punch. Comix by Shelton do not leave the reader befuddled by philosophical conundrums or enraged by social injustice: they make the reader laugh. (Well, sometimes a bit of philosophy creeps in—like Freewheelin' Franklin's immortal axiom, uttered in the very first postpromotional appearance of the trio: "Dope will carry you through times of no money better than money will carry you through times of no dope.")

Rip Off Press published the first collection of Freak Brothers strips in 1971. Since then, dozens of Freak Brothers books have appeared. By 1984 over two million comix, books, and posters about them had been sold worldwide, and their adventures had been published extensively in foreign translations.[30] Their popularity easily outlasted the counterculture that spawned them. The secret of the Freaks Brothers' appeal to the youth of subsequent decades is doubtless a certain timeless-

ness: as potheads perpetually in pursuit of an illegal substance, they are in active rebellion against the rules of their society, just as most young people are in rebellion against the customs of their elders. Says Shelton (with a perfect awareness of exactly what he is doing): "They're traditional literary characters just doing the same things that people have always done in more or less contemporary garb."

The Haight and the Village were not the only venues for comix in those formative years. In Chicago, Jay Lynch, another thoroughgoing professional humorist and cartoonist, was also nurturing the infant medium. Like virtually all underground cartoonists except Crumb, he spent his fledgling years on college humor magazines. While studying at the Art Institute of Chicago, Lynch contributed to *Aardvark* ("The Kicked-Off Campus Humor Magazine" of Roosevelt University). He also sent cartoons to Killeen's *Charlatan* in Florida. Between 1962 and 1966 (when he was a student in college) he wrote for *Cracked* and *Sick*, the *Mad* imitations. He was in touch with almost all of the cartoonists whose work would shape comix. Through a letter he read in *Cracked* in 1961 when he was about sixteen, he met (by exchange of letters) Art Spiegelman in New York and Skip Williamson, who was growing up in Canton, Missouri. And when he visited Killeen in 1963, he saw Shelton's Wonder Wart-Hog and was soon corresponding with Shelton and Jaxon. Lynch would make trips to New York to hang out with Spiegelman, who later started a humor magazine at Harper College called *Mother*, and he also journeyed to Missouri to see Williamson.

In 1967 Williamson moved to Chicago with the object of joining Lynch in producing a humor magazine. They launched the *Chicago Mirror*, "a kind of magazine somewhere between the *Realist* and *Mad*," Williamson said.[31] Lynch elaborated: "It was a satire magazine for hippies—which was a contradiction in terms since the hippies en masse seemed, by this time, to totally lack a sense of humor. By 1967, hippiedom had become a national fad and converts to it were predictably humorless."[32] Then Lynch saw a copy of *Zap Comix* No. 1 and changed direction. He and Williamson preferred cartooning to the comic journalism of the *Chicago Mirror*, so they abandoned their firstborn and conceived *Bijou Funnies*, destined to become one of the longest-running early anthology titles in

Figure 114. *Fragments from the underground: at the top, Shelton's Freak Brothers in a characteristic pose, followed by the opening panels of a strip in which they are characteristically sans dope; in mid-page, a panel from "Foolbert Sturgeon's" New Adventures of Jesus in which Jesus finds out what happens when he tries to enter the water to join his disciples in swimming; at the bottom left, a panel from Jaxon's God Nose; and at the lower right, Lynch's characters.*

the underground. For it, Lynch produced stories about Nard and Pat, an Andy Gumpish bachelor and his ne'er-do-well pet cat (whom Lynch had invented earlier while contributing to the *Chicago Seed*), drawing in a meticulously clean and uncluttered manner and modulating the stark black-and-white pictures with a range of grays in zipatone. Williamson's graphic style is similarly unencumbered, but his work has an entirely different appearance. Affecting an Art Deco flatness and adding texture with a variety of cross-hatching and patterning, Williamson created Snappy Sammy Smoot, a counterculture Candide who, despite repeated defeats, never loses his innocence.

Crumb came to Chicago to observe the "yippies" at the Democratic National Convention that summer, and he stayed with Lynch. While there, he drew the comics that he contributed to the first issue of *Bijou*, which was published shortly after the Chicago Convention debacle.

Meanwhile, in Wisconsin, another humor magazine was about to give birth to a comix magazine. In Milwaukee, Denis Kitchen was fermenting his own homebrew of comix in the fall of 1968. He'd been art editor and the chief cartoonist for the first issue that spring of *Snide*, a humor magazine for students at the University of Wisconsin. And when the editor scarpered with the first issue's profits, Kitchen was left with a pile of cartoons he'd prepared for the second issue. Not wanting to have his effort come to naught, he decided to do some more comics and publish the lot in his own magazine. A bohemian denizen of the postgraduate enclave on the fringes of the college campus, he frequented the local head shops and counterculture boutiques, where he came across copies of *Zap Comix* and *Bijou Funnies*. Inspired by what he saw, he completed his project, publishing *Mom's Homemade Comics* No. 1 ("Straight from the Kitchen to You") in the spring of 1969. A roommate took copies to San Francisco for sale through Gary Arlington's shop, the San Francisco Comic Book Company, and made arrangements with the Print Mint for reprinting the first issue (which had successfully sold out) and for printing the forthcoming second issue. But Kitchen eventually decided he would be happier publishing his own comix, so he severed relations with the Print Mint and began preparing material for the third issue of *Homemade Comics*.

Kitchen sent copies of his comix to Crumb and Lynch and other worthies. Crumb wrote to encourage him. And later in 1969, when Crumb was visiting Lynch again, the two of them took a trip to Milwaukee to meet Kitchen. The Print Mint was also publishing *Bijou Funnies*, and when Lynch found out later that Kitchen was jumping ship to publish on his own, he asked Kitchen if he would publish *Bijou*, too. "Sure," Kitchen said, "—two's as easy as one." A fateful comment. And naive, as Kitchen was soon to discover (and always to admit).[33] But it was the cornerstone of a publishing empire: Kitchen Sink Press prospered, going on to establish new standards of quality in product and of equity in the treatment and payment of cartoonists.

Despite all the innovative enterprise in the Village and in the country's heartland, San Francisco was still the hub of the comix movement. Bill Griffith (whose underground character, Zippy, was eventually syndicated by King Features in 1986) started in the Village but moved to San Francisco immediately after his first visit there in April 1970. He had been contributing strips about Mr. Toad to the *EVO* and *Screw*, both published in the East Village. But San Francisco was "a magnet," he said; "there was no resisting its pull." For an underground cartoonist, it was, by then, about the only place to be. The underground newspaper comic strip in New York had expired by the end of 1970; comic books were the only outlet, and they were published most regularly in San Francisco. "Within a very short time, almost all the cartoonists had either come out to San Francisco," Griffith told me, "or had stopped doing comics. Everybody came out. I was just part of a wave of people coming out here."[34]

For most cartoonists, cartooning is essentially a solitary occupation, but the ambiance of San Francisco at that time was more like the fabled Mermaid Tavern of Elizabethan England, where people got together frequently and talked about what they were doing.

"It was like an art movement," Griffith said. "You joined an art movement; that was the feeling. It was a lot of things. First of all, it was a definite part of the hippie movement, the counterculture. We were part of the whole Haight-Ashbury scene. By 1970, it had started to fade—or change, at least, the tail end of the counterculture—but it was still very much alive in the social sense of everybody feeling connected. There was a kind of

Figure 115. *Williamson could deploy solid blacks to great effect, as in this one-page story from* Bijou Funnies *No. 7 (April 1972); at the upper right, Snappy Sammy Smoot in a typical pose.*

Figure 116. *Some of Crumb's early work championed drug use. His verbal-visual playfulness is amply manifest in the above page excerpted from a three-page strip published in* Cavalier *magazine in October 1967. Later, though, Crumb gave up turning on. At the right, four panels from a nine-panel page in* Hytone *done in 1971 depict the dubious consequences of getting stoned.*

party atmosphere to some degree; and then there was the sort of salon atmosphere. We hung around a comic book store—the San Francisco Comic Book Company on 23rd Street in the Mission District—which still exists [1992] and is run by the same owner, Gary Arlington, who eventually became a publisher and then that faded, and he's still at the stand selling comic books. If we were a salon, he was Gertrude Stein. In fact, he kind of looks like Gertrude; he looks more like Gertrude Stein every year.

"We would hang out at the comic book store," Griffith continued, "and we would have regular parties at the publishers' offices, Rip Off Press and Last Gasp." The last of the major underground presses, Last Gasp Eco Funnies was founded in late 1969 by Ron Turner to fight for the preservation of the ecology; its first title, *Slow Death Funnies*, was published in 1970. The salon atmosphere often crackled with discussions of the causes taken up by the counterculture's crusading spirit. "There were plenty of factions within underground comix," Griffith said, "just as there were within the prevailing counterculture, so some cartoonists felt a responsibility to promote certain ideas."

In the midst of this cultural ferment, Crumb felt no more a part of his society than he ever had. "I was taking LSD along with a lot of other people," he said, "and had the same values that a lot of people were expressing, but I wasn't really a hippie. I didn't get out there and play my bamboo flute and dance in my bare feet in Golden Gate Park with the rest of the hippies. I just wanted to sit in my room and jump on big women if there happened to be any around."[35] But Crumb was scarcely staying in his room.

He was running all around the country, visiting other underground cartoonists and conferring with promoters and lawyers who wanted to help him cash in on his fame. He took very few of their offers, but he always used the airplane tickets they provided. He was in Chicago, Milwaukee, Detroit; he made the collegiate hippie scene in such places as Madison and Ann Arbor. And everywhere he went—girls and sex. "I got the clap; I got crabs," he said. "Lucky for our generation there was no AIDS yet."[36] Regardless of where he was, he drew comix. Most of *Big Ass Comics* No. 1 was drawn in Los Angeles; most of *Motor City Comics* No. 1, in Detroit. It was his most productive period.

Crumb credited this creative energy to taking

acid: "It enabled me to separate my ego from the drawing a little bit, which allowed this whole flood of inspiration. If you have a heavy ego involvement which makes you worry about what you're doing all the time, it stiffens you up and causes a loss of spontaneity. Taking all that acid made my work very spontaneous." Years of drawing had given him the technical facility; LSD freed him to exercise it. He couldn't draw while high, though; his inspiration came then, and he drew about it afterwards. But in the mid-seventies, beset by a variety of legal and financial problems, Crumb suddenly gave up using dope. "I thought I would never have another source of inspiration," he said. "But as you get older, just the accumulation of your life becomes an inspiration. It's so rich and interesting in itself that you don't need anything else as inspiration except that."[37]

Although Crumb smoked grass and dropped acid for several years, he never actually bought any of the drugs. "There was so much around that people were giving it away," he told Groth. Besides, he couldn't afford dope. Despite his fame, he said, he and Dana were living on her welfare checks until late 1971.[38] She had worked in a home for unwed mothers until she became pregnant; after their son, Jesse, was born, she no longer worked. Luckily, living in the Haight was cheap then: they rented a two-bedroom apartment for $70 a month.

His dubious financial situation aside, Crumb was a celebrity and was being courted mercilessly by all sorts of hustlers and hangers-on, journalists and promoters, sharpies and high-powered operators, and every other kind of wheeler-dealer imaginable. "It was like being gang-banged your first day in prison," he once wrote. Too young and inexperienced (and too stoned some of the time) to understand what was happening, Crumb was sometimes trapped into participating in schemes he really wanted nothing to do with. For the most part, however—miraculously, it seems—he resisted these aggressive blandishments. He was able to do so chiefly because he was, in his phrase, "a committed bohemian." He was wary of the "big time." He believed he'd be better off without it, and he was determined not to sell out.[39] But animator Ralph Bakshi and producer Steve Krantz found a way around Crumb's defenses.

The men's magazine *Cavalier* had printed a series of Crumb's Fritz the Cat stories from February to October 1968; and that summer Viking had

Figure 117. *The death of Fritz the Cat. The "foolish female," incidentally, is an ostrich, and it is presumably her habit of hiding by burying her head that inspires Fritz's ire here.*

brought out a book of Crumb's comix, which also included stories of the fated cat. Of all Crumb's characters, Fritz the Cat was probably the best known outside the counterculture. Bakshi was animating Saturday morning cartoons for children and saw Fritz as a portal to fame and fortune. He was apparently so eager about the prospects that he began doing the animation for a Fritz the Cat film even before consulting Crumb. Finally, some of the film having been completed in pencil animation, Bakshi and his producer, Krantz, approached Crumb. Crumb wanted no part of it but, reluctant to slam the door in their faces, he told them he'd think about it, and they went away to continue to work on the film. Then, however, Bakshi and Krantz discovered that Dana had Crumb's power of attorney. Quickly seizing this golden opportunity, they convinced her to sign, giving them permission to make movies starring the cat. They gave her a check for $10,000, and she immediately bought property in Potter Valley a few miles north of San Francisco.[40] Crumb was eventually paid another $38,000 to $39,000 for the film; the checks came along every so often over the years.

Fritz the Cat came out in April 1972. Crumb hated it. He disowned the character. Then, seeking to destroy the movie moguls' options, he drew "Fritz the Cat, Superstar" later that year (published in *People's Comics*). At the end of the story, the callous and unfeeling lover, Fritz, is killed by a girlfriend who plunges an ice pick into his head. But Krantz and Bakshi (whose career was suddenly on the upswing, thanks to the film) were not deterred. After all, they owned all movie rights to Fritz the Cat, and so Krantz proceeded to make a second film, giving it the ironic title *Nine Lives of Fritz the Cat*.[41]

And Crumb had other troubles. In 1976, after losing a legal fight to retain the rights to his "Keep on Truckin'" slogan and drawings (figure 118), he found he owed the Internal Revenue Service $20,000, ostensibly on income he derived from lawsuits brought against those who had used this creation without permission. Apparently, after raking off their share, his lawyers had neglected to set aside any of the money for withholding tax. And neither did the fiscally carefree Crumb. The windfall of cash from the Bakshi film was still years in the future (he received the last check, for $31,000, in 1982). Crumb began paying off the debt in installments, but the penalties continued to mount on the unpaid balance. The nightmare didn't end

Figure 118. *Crumb's celebrated "Keep on Truckin'" cartoon, which others appropriated and made fortunes on, and which gave its creator nothing but trouble with the Internal Revenue Service.*

until 1978. Long before then, Crumb had had enough.

Overwhelmed by the fame and its attendant complexities, Crumb fled to Potter Valley and holed up in a little shack on the property. It was a cozy warren, crammed floor to ceiling with old records, magazines, toy cars and robots and airplanes and other detritus of his forays to flea markets. Thomas Maremaa, writing in the *New York Times Magazine*, described Crumb's working style: "He works more or less when he feels like it—often at night—drawing new strips spontaneously in either pencil or ink. His habits are almost spartan—he neither smokes nor drinks—and he abhors televi-

sion, calling it an 'energy rip-off' and 'bad medicine.'"[42]

Crumb and Dana were effectively separated even while living in Potter Valley: she lived in the main house with her new boyfriend; Crumb lived in his little cabin, visited by a stream of admirers both male and female ("hippie floozies," Crumb called the latter). For a time, he was surrounded by small assemblies of fans, who gathered in his cabin to smoke pot and listen to records and talk. In this convivial setting, Crumb couldn't work. And he wouldn't tell them to leave: he had for so much of his youth been excluded from such groups, and now that he was accepted, lionized, he was loathe

to deny himself the pleasure of the experience. He talked with them all through the day and evening, passing the joints around, and then after they'd gone late at night, he'd turn to his drawing board and resume work on the comix pages in front of him.[43] As the seventies came to a close, the hippie fad passed away. Underground comix seemed to disappear (they hadn't; they just seemed to), and Crumb was able to work undisturbed.

He continued to produce comix regularly throughout the seventies and eighties and beyond. Although he was never again as prolific as he'd been in the first flush of the comix phenomenon—when he produced over 150 pages a year in 1969 and 1970—he generated fifty to eighty pages annually for most of the period.[44] His style became more ornate as he studied and employed the profuse cross-hatching techniques of old-time cartoonists like Thomas Nast to give his pictures texture and depth. And in the selection and treatment of subjects, he grew more serious, not to say dour. Some of his stories read like strident sermons, and his satire is often pitilessly grim. The playful one-pagers of the early giddy issues of *Zap* and *Snatch* were not reprised.

The Crumb character—his autobiographical caricature—was still the most constant presence in his work. Although the two installments of "My Troubles with Women" might appear in their unvarnished candor to have exhausted him at last on the subject, Crumb disagreed. "That can go on forever," he told Groth. "The first time I did that, by the time I finished, I realized that I had barely scratched the surface. And when I finished Part Two, I realized I was still just beginning to deal with it. That's a subject where the more I think about it the more I realize. I could go on to Part Twenty-five of that."[45]

Crumb has appeared as a character in his own work ever since the first issue of *Zap*. And autobiographical creation held a special fascination for him. Although the earliest manifestations of the Crumb caricature were self-deprecating comic turns, Crumb gradually began to see the character as a way of getting to the truth and thereby of achieving authenticity. "To tell the truth about your own experience and do it in a way that's funny and entertaining is really a gift," he said. "I'm real attracted to that whole self-deprecation thing where you make yourself an absurd character." Not surprisingly, he's put off by cartoonists who make themselves cool and heroic in autobiographical works. "It's like neutralizing yourself," he said. "Everything around you is nuts, but you're cool? Dishonest. They aren't being honest with themselves. It's hard to admit that you're not perfect, especially publicly." When he began editing his own magazine, *Weirdo*, in 1981, he looked for material that had some subconscious truth in it. "That's the only way I can explain my editorial policy: gotta be something like personal truth in this stuff."[46]

Crumb divorced Dana in March 1977, and in January the next year he married Aline Kominsky, with whom he had been living for several years. In the early nineties, he moved to Europe, seeking refuge from the shysterism of the American system that he so despised (not to mention a better tax situation). His work has been extensively reprinted ever since the second printing of *Zap Comix* No. 1, and his income from these projects proved ample enough to support him in the modest fashion he enjoyed. And he continued to produce powerful, albeit more deliberate, comics—as always, with the complete artistic freedom that he exercised when he first catapulted himself into the public eye, a freedom he had been at great pains to preserve from the time fame first washed over him.

In his 1987 interview with Gary Groth, Crumb explained his motives—perhaps every artist's motives—revealing once again the kind of insight and passion that has distinguished his career: "One of my main reasons to go on living is I still think I haven't done my best work. I get scared and think I'm running out of time. I've still got a body of work to do. I can't leave it at this, you know—it's not good enough. I'm just getting there."[47]

THE UNDERGROUND WAS NOT THE ONLY SITE of innovation during the seventies. Even in the mainstream, fresh ground was being cultivated. The earliest forays into new territory took the form of "relevant" comics, the first of which preceded the advent of the direct sales market. In 1970 DC had teamed writer Denny O'Neil and artist Neal Adams to perform their sales-revival magic on the flagging *Green Lantern* series. Earlier, O'Neil and Adams had transformed Batman from the camp figure he'd become during the sixties back into the more sinister crime fighter of the night that he had originally been. Now they turned their atten-

Figure 119. *Crumb's satire became bleaker and bleaker. On this page from "Trash," his gross images, however ingeniously devised, are wholly uncompromising—and not at all humorous. (CoEvolution Quarterly No. 35, 1982)*

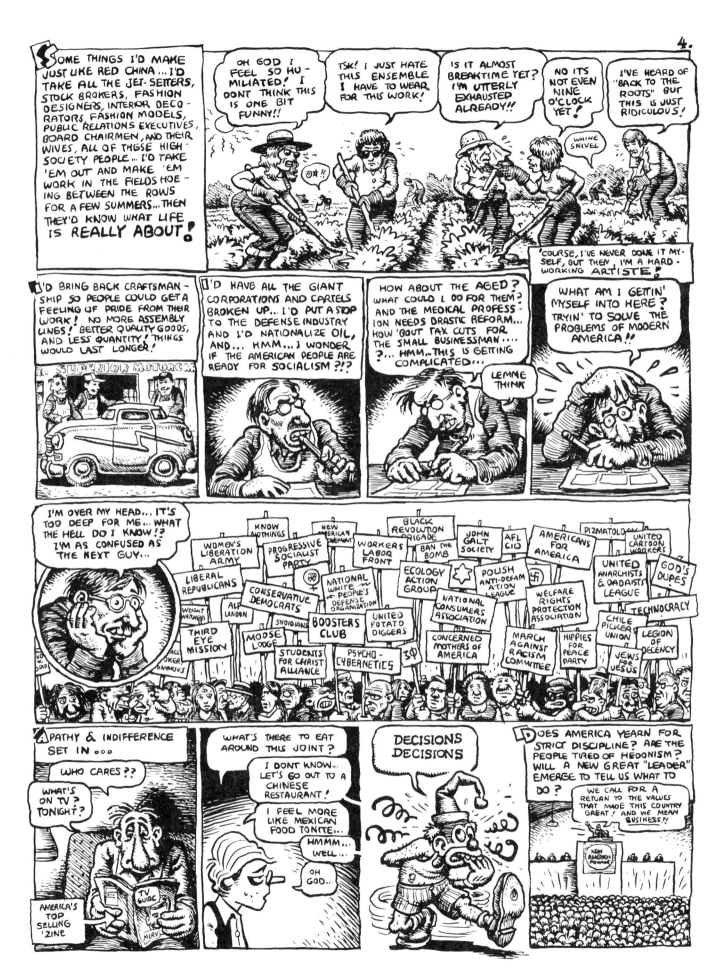

Figure 120. *But Crumb the crusading satirist remained cartoonist enough to find humor in his predicament—and honest enough to take a jab or two at himself. (Arcade No. 2, 1975)*

Figure 121. *In this frequently reprinted scene from the O'Neil and Adams Green Lantern series, the Emerald Crusader and the Green Arrow are brought rudely face to face with their inadequacies as superheroes.*

tion to Green Lantern. O'Neil, who had been doing reportage as well as fiction for comic books, wanted to combine these interests. To this end, he asked himself provocative questions: "Could we dramatize the real-life issues that tormented the country in the context of superheroics? Could we fashion stories about drug addiction, environmental destruction, corporate rapacity, cults, racism, poverty, bigotry—the whole catalogue of national discontent that energized the era—and still deliver the heroic fantasy that people bought comic books for?"[48] To provide a dramatic foil for the Green Lantern's stalwart but blandly conservative intergalactic cop persona, O'Neil teamed the character with a volatile and radical wise guy, Green Arrow. The series lasted thirteen issues. O'Neil's experiment was an artistic and critical success, inspiring the usual sincere flattery from Marvel (which produced a drug-abuse story in *Spider-Man*, all three issues going bravely to press without the Comics Code Authority's seal of approval), but the books didn't sell very well. Relevancy came and went. The industry's next venture in personal expression was, however, both more aggressive and more intensely personal.

Howard the Duck is, in fact, so wildly different a comic book that its release by a major producer must be viewed as one of the most astonishing publishing events of the 1970s. Writer Steve Gerber introduced his cigar-chomping duck (attired in coat and tie and hat and nothing else) in mid-1975 in a special issue of Marvel's *Man-Thing*, an otherwise serious science fiction title about a manlike creature born of compost in a swamp. (Yes, serious.) Because of a freak shift in the cosmic axis, an alien from another universe is transported to Earth, where he suddenly appears in the shape of a duck about three feet tall. And he talks. Like Disney's Donald—and he's just as irascible. Howard's unexpected visitation was intended as something of a joke, the tag end of a plot having nothing to do with ducks at all. But once the character wise-quacked one of his sardonic observations about life as *we* know it, he almost instantly won the affection of readers, readers mature enough to appreciate the satirical content of his quip.

In response to Howard's overnight popularity, Marvel soon authorized a title for the character, and Gerber was off and running. Howard was the perfect vehicle for social satire. At first, Gerber simply mocked the superhero world in which the alien duck found himself, but a more profound question hung over even the earliest jabs at the Marvel Universe. Stranded on Earth, far away from

his native world, Howard wonders what a "person" does to survive in a world where he doesn't belong. His question becomes the cover banner under which he appears in his own book: Howard the Duck is "trapped in a world he never made." And which of us is not? The similarity of our circumstances makes Howard a kindred soul, and the unexpressed question of the cover's banner ("How do *we* survive in a world we never made?") poses a philosophical problem worth pondering. And Gerber pondered it with a passion.

Howard is more than a sympathetic character with existential problems akin to our own. He is also an alien—and a duck. The former circumstance gives him clarity of vision: he can see through the conventions of our world and pinpoint the folly in them because native custom hasn't blinded him. Like Oliver Goldsmith's Chinaman (or like Robert Heinlein's Valentine Michael Smith), Howard is not acclimated to his new surroundings, and since he was not born and raised with our social traditions, they strike him as arbitrary phenomena—sometimes meaningless, sometimes harmless, but to his alien vision, divorced entirely from the business of living, at least until the reasons for them become apparent. The satiric advantage of this perspective is that the reasons for social behavior must be demonstrated as sound or else the behavior appears foolish.

All this makes for a deadly brew. But the medium supplies the antidote: Howard's being a duck is the saving grace in an otherwise potentially depressing philosophical treatise. It is here that Gerber's creation approaches high comics art. Only the art of the comics can give us the pictures as well as the words—pictures that temper the satirical diatribe. The pictures give the satire a sharper cutting edge, but they also confront us with Howard in all his duckishness. While his duckishness emphasizes his existential problem, it also makes his predicament comic. And if we can laugh at Howard, we can laugh at ourselves a little, too.

Gerber's method was to throw his web-footed alien into some situation typical of American life and then see what happened. As Howard interacts with the humans he encounters, he makes pungent observations about the social mores and madnesses around him, sarcastic comments that strip pretensions away to reveal the often self-serving motives that lie beneath some custom of ordinary life. Because the America that Howard wanders

through is also the Marvel Universe, the population bristles with demented scientists who have partaken of elixirs from their labs and turned into superpowered beings. Very early in the series, the hapless duck is befriended by a young woman of suitable embonpoint, a would-be model and actress named Beverly Switzler, who calls Howard "ducky." Their companionable relationship turns into love, which, though unconsummated, creates an interspecies predicament that not only adds spice to the stories but underscores with its impossibility Howard's existential dilemma.

In the first issue of the initial thirty-one-issue run of the *Howard the Duck* comic book (dated January 1976), Gerber establishes a pattern that he will follow in many of the subsequent stories. Howard, depressed by his frustrating alien situation, is in Cleveland, where, standing on the banks of the polluted Cuyahoga River, he contemplates suicide. Seeing a tower in the middle of the river, he decides to go out to it and fling himself from its pinnacle to his death. Once he gets there, he finds that the tower is made of plastic credit cards, and when he enters the building, he is taken captive by its inhabitant, a mad sorcerer named Pro-Rata, who harbors aspirations for conquest on a celestial scale.

"Gaze upon the office of Pro-Rata," the madman intones, "soon to be Chief Accountant of the universe. And note especially my prize of prizes," he continues, as the camera shifts our attention to a curiously equipped antique calculator, "—the Cosmic Calculator." At midnight, he tells Howard, the Stellar Balance Sheet comes into alignment, the Astral Audit may be taken, and Pro-Rata will "collect the Cosmic Dividend."

In Gerber's morality play, Pro-Rata represents man's capitalistic ingenuity run amuck, and his absurd vision of the world in accounting terms ridicules both man's globe-controlling economic pretensions and the Marvel Universe's supervillains, with their galaxy-conquering ambitions. Howard meets Bev in Pro-Rata's tower: the madman has dressed her in a costume suitable for the mythical realm of sword and sorcery tales from which he has fashioned his vision of himself. Seeing that she is chained to the wall, Howard resolves to rescue her. Pro-Rata orders that Howard be garbed as a barbarian mercenary—thereby completing the casting call for Gerber's lampoon of the sword and sorcery world of Conan the Barbarian, who was at

the time one of Marvel's most popular heroes. In the midst of a fight that pits Howard and Spider-Man (who has wandered into the book) against Pro-Rata's incantations, Pro-Rata is killed, engulfed in the river that catches fire because it is so polluted. In the satiric metaphors of the tale, the capitalistic genius of man is defeated by the environment that his genius has polluted. That all of this takes place under the rubric of "barbarianism" sharpens the sting of the satire. And Howard adds the final ingredient: the duck in barbarian garb evokes derisive laughter at Gerber's targets.

In realizing his vision, Gerber received superlative assistance from the artists who brought Howard to life visually. Frank Brunner did the first couple of issues, John Buscema then did one, and finally, with the fourth issue, Gene Colan took over the penciling chores more or less permanently. All were ably inked by Steve Leialoha, but in particular Colan's sometimes wispy feathering technique seemed to encourage Leialoha's best efforts. Colan was known for his skill in depicting facial expressions in whatever subtle variation was necessary. And he seemed to delight in shading Howard so delicately as to give a three-dimensional reality to the otherwise flat, circular shapes of the duck's cartoony anatomy, thereby persuading us to accept the incongruity of a duck in a hat and jacket afoot among realistically rendered humans.

In successive issues of the comic book, Gerber continued to ridicule the Marvel Universe, and he also took satiric swipes at the romantic visions of superheroism, the pop street-culture ideal of macho violence, the demeaning nature of most jobs, the conventions of gothic romance novels, our tendency to see evil in anything we don't understand, fanatic religious cults, the show-business aura of politics, the inherent dishonesty in political life, the influence of special interests on politicians, and virtually any custom or facet of social convention that struck the writer as ludicrous. In the fourth issue of the series, however, Gerber began to use his stories to explore issues that are intensely personal.

In "The Sleep of the Just" (*Howard the Duck* No. 4, July 1976), Gerber undertakes to depict the deleterious effects on the individual of the ruling opinions of conformist society, the establishment. Howard meets Paul Same, an artist, whose nonconformist (that is, creative) attitudes have been stifled by society's educational efforts. Paul retreats from the real world and its smothering

threats by sleeping. Asleep, he lashes back at society—its hypocrisy and its antagonism toward individuality—as a Marvel-type supervillain named Winky-Man, a vengeful sleepwalker. With Winky-Man serving to release his hostility, Paul finds his creative juices flowing again: he paints during the day and finally gets a one-man show. The expression of anger serves as a metaphor for ignoring the oppressive impulses of conformist society; when those are ignored, creativity can bloom, and honesty and the truth prevail. Paul emerges as a whole man and an artist when he acknowledges that he *is* Winky-Man and can express his hostility in a waking state.

On the one hand, this is a parable of the creative artistic consciousness. And it is a quite personal parable: Paul Same looks unmistakably like Steve Gerber. But, on the other hand, the tale has larger implications. In a flashback to Paul's youth, the educational system (through which we must all progress) is seen to be the villain: it is the schools that enforce conformist behavior, stifling any deviant (that is, creative) expression. Occasional satiric comments suggest that we are all sleepwalkers like Winky-Man—all forced to suppress our creativity (or sensitivity), our very selves, in deference to society's mores. Thus, suppression makes us insensitive; it destroys our alertness. And it fosters dishonesty and artificiality. For a better world—and for personal fulfillment—we must all do as Paul does: we must wake up, express honestly both our hostilities and our sensibilities, and live the truth of our lives. Otherwise, as the story's title suggests, justice sleeps. But the effort is not without hazards. Howard points to the dangers in "waking up" (that is, in expressing truthfully our innate humanity, sensitivity, and alertness): "The crowd won't cheer if you yank off a bald lady's wig," he says. In subsequent outings, Gerber returns again and again to the issues he first raises here.

Turning to contemporary election-year antics for material, Gerber runs Howard for president of the United States. The duck attracts the attention of the All-Night Party by his frank expression of honest opinions: novelty, as anyone in show business knows, is good for the box office, so the party naturally nominates Howard. As the candidate, however, he is repeatedly urged to restrain himself, to refrain from the very uncompromising declaration of commonsense ideas that first attracted the party's attention. But Howard rejects all attempts to

Figure 122. *On this page drawn by Frank Brunner, Howard and Bev meet the Kidney Lady, Gerber's enduring symbol of the idiotic fanaticism that he saw around him in American society.*

Figure 123. *Gene Colan's Howard looked somewhat more pliable (and therefore more real) than Brunner's. Bev's income, by the way, is earned by posing for a life-drawing class, from which she has "a standing offer—there's always work."*

package him and goes on speaking his mind with relentless candor. ("My god!" says an aide, "he's telling the truth! He'll be dead in a week!") At a press conference, Howard launches an anti-establishment attack against the emotional and intellectual sterility of a society that promotes nothing but the pursuit of possessions.

Howard's candidacy is eventually destroyed by a sex scandal (the rival party doctors a photograph to show the duck naked in the bathtub with Bev, similarly unfrocked), but Gerber continues to pursue the questions raised by his hero's political career. In a story that mocks the Marvel superhero

traditions, Howard refuses to do battle with the supervillain, thereby rejecting stereotyping and asserting in its place the uniqueness of his own personality.

In the ensuing five-issue series, Gerber takes the duck to the brink of sanity, and his adventures again take on the distinctly allegorical cast of a morality play. He shows Howard searching for meaning in his life, for his "true self" and for the way of allowing expression of it. But it is difficult to discover one's true self: in reviewing his own life, Howard sees the socialization process as an "indoctrination" in society's mores and customs—

without regard for individual desires. Howard says he didn't "take to it," but the result of his resistance is disillusionment and the cynicism of the fallen idealist. The world is a chopping block where life is cut off. The promise of life with Bev is as hollow a joke as anything else. Facts are only relative, assumptions based upon past observations. Given the relativity of facts and the effects of the indoctrination process to which we are subjected, what can be identified as the "true self"? Only this much is certain: conforming is self-destructive. But the alternative, Gerber shows, is no more attractive: "If I skip out," Howard says, "I flip out." Resisting the impulses of cultural conditioning is disorienting; it is, after all, a rejection of part of one's self, the part created by the conditioning.

The resolution of this conflict occurs, appropriately, in a mental hospital to which the iconoclastic Howard is sent. The hospital quickly emerges as Gerber's metaphor for society itself, its doctors and nurses imposing standardized behavior upon the inmates. Although Howard at first refuses medication, he soon capitulates—in short, he conforms—because he can't stand being alone.

By this time, Howard seems to sense the futility in his quest for a way to assert his individuality in a world that demands conformity. "Life's too far in the future to think about," he says; "right now, I could use a good cigar." Perhaps he has profited from the "sequin of questionable wisdom" (lovely phrase, that) imparted to him by the rock group Kiss: "When you meet reality head on," he is advised, "kiss it, smack it in the face. That's the word. Pass it on. Kiss it, you're the target but you don't have to be a sitting duck." The implication is that metaphysical questions about the nature of individual existence in the social world are relatively unimportant. What's more, they only breed hang-ups. More important for personal well-being is engagement—meeting the world and living in it. Shortly after this moment in Howard's mental growth, he lashes back at his nurse in a reversal of his earlier behavior, when he docilely accepted medication. Howard has begun his comeback.

Gerber constructed a series of episodes in the duck's life in which we see him wrestling with questions that are as old as the human condition. We are social animals: we live in a community with other people. To function smoothly, society requires that we adhere to certain forms and customs. By their very nature, some of those customs restrict our individual behavior. But we still have individual desires, the achievement of which sometimes forces us to break with the traditions of our societies—or to change those traditions. The situation—the human condition—fosters this fundamental conflict, the conflict between individual desires and social expectations. It is inescapable; it is the nature of humankind.

Howard strives through several issues of his comic book to reconcile this dilemma, but he winds up reconciling himself to it. He begins by rejecting society in order to "be himself." In the end, however, he abandons the search for self because it is ultimately life-denying and therefore pointless. Instead, he embraces life with all its contradictions. Rather than resolve the struggle, he resolves to continue it—to continue to assert his individuality in the face of the pressure to conform, to continue with no real hope of ever finishing the battle. Howard's decision is clearly existential. Like Albert Camus, he chooses to perpetuate the absurdity of life as an act of affirming it; like Camus, he chooses to remain faithful to the world rather than to question it.

All this is pretty weighty material for a mainstream comic book. It is a measure of Marvel's publishing courage at the time that it permitted Gerber to explore in these unaccustomed regions, that it dared to allow him to approach philosophy protected by only a thin veil of satire. *Howard the Duck* clearly aimed at an older audience than had the newsstand comic books of even a half-dozen years before. Unhappily, Howard was destined to be a flash in the pan rather than the harbinger of the future in mainline comics.

The creative dynamic of *Howard the Duck* was also the title's hubris: emerging as the extraordinary personal philosophical odyssey of its creator, the creation was so idiosyncratic that its success was entirely dependent upon Gerber's continuing involvement with the project. But Gerber's identification with his creation may have lead to his departure from the book—and from Marvel.

By 1977 Howard was starring in a syndicated newspaper comic strip as well as the comic book, both produced by Gerber and Colan. Then Gerber began to think about ownership of his creation. The issue of creator's rights was much in the air then: Siegel and Shuster had just secured pensions from DC in recognition of their creation of Super-

man (and the character's appearances henceforth carried the notice "Created by Jerry Siegel and Joe Shuster"), and the policies of the underground press were starting to impinge upon the mainstream. In 1974 Stan Lee at Marvel had launched the *Comix Book*, an avant-garde Marvel title with an underground aura that Denis Kitchen had agreed to edit for him—on the condition that the cartoonists would retain ownership of their characters. But Marvel wasn't ready for Gerber's claim: after all, he had created Howard on company time. When Gerber's lawyers notified Marvel in the spring of 1978 that he intended to take legal action to secure ownership of his creation, Marvel fired the writer from both the comic book and the syndicated strip.[49] The ensuing legal struggle over Howard took several years to resolve, but Gerber finally won in court. During this period (and perhaps partly in consequence of the Gerber assault on the ramparts of corporate ownership), both Marvel and DC adopted more liberal policies toward their artists and writers: they began paying royalties based upon circulation, and a couple of new lines of titles were started in which creators retained the rights to their creations.

Meanwhile, Gerber took Howard to Hollywood and managed to interest George Lucas in a live-action film interpretation of the character. *Howard the Duck* made it to the silver screen in 1986, but the film was a gigantic disaster. (So much so that Lucas subsequently disowned it.)[50] Historically, comic strip creations have seldom made the transition to motion pictures successfully, a circumstance that loudly proclaims the fundamental differences between the two media. And in the case of Howard the Duck, the difficulty was compounded by the protagonist's being a duck. Movie producers had successfully combined animated cartoon characters with live actors before (and within a year or so of the release of *Howard*, Touchstone Films launched a film that revolutionized the way such combinations should be treated—*Who Framed Roger Rabbit?*). But it was a profound mistake to arrange for a human being to enact the character of a comic book "talking animal." If nothing else, the failure of the movie demonstrated convincingly that the "life" created in the comics medium is peculiar to it and to it alone. Howard the Duck animated the comic book and the comic strip precisely *because he was a duck* "trapped in a world he never made" and because

the peculiar nature of the comics medium is such that we can be persuaded that a "duck" can talk and live among humans as a fellow being. But we cannot be persuaded, apparently, that a human being dressed in a duck suit is a duck—even if we see it on the screen before our very eyes. After the movie flopped, we neither heard nor saw much of Howard the Duck again.

Forays into personal cartooning in mainstream comic books had always been rare. So when something like Howard came along, it occasioned rejoicing. And happily, just as Howard was flying off into the sunset, another inspired creation was about to take wing.

Every once in even these benighted whiles, a unique coinage is minted from the cartoonist's art, a fabrication so inflamed with its creator's imagination, so enraptured by his participation in the fiction of its life, that it emerges on the shoddy pulpy pages of the medium to dance with a vitality wholly its own. To give life to four-color fictions is the name of the game in comics, but, as I've said, in mainline publishing it seldom happens that committees of writers, plotters, pencilers, inkers, scripters, and editors produce lively and memorable characters. As these groups grope toward their collective conception, they must satisfy the egos and visions of their several parts. The result is often all thumbs—the proverbial camel designed by a committee charged to make a horse. It may hold water, but it is awkward and cantankerous and smells bad.

Sometimes such a process gives rise to vibrant creations. Usually, though, the most memorable characters are the products of a single imagination. Like Howard was. But the imagination under scrutiny on this page is Frank Thorne's. It was his imagination that gave to the airy nothing of his erotic fantasies a local habitation, Alizarr, and a name, Ghita. And both came to unabashed and ribald life in the pages of one of Jim Warren's black-and-white comic books. As newsstand periodicals, Warren's magazines were mainstream by sufferance rather than by hallowed custom. They were defiantly black and white, a little larger than traditional comic books (both in number of pages and in page dimensions), and, in an age of rampant superheroics, they shunned longjohn legions, offering instead some science fiction, a little supernatural horror, and a lady vampire in scanty attire. And they aimed at adults. Thorne's Ghita burst

forth upon the reading audience in the seventh is-
sue of a magazine called *1984* ("Provocative Il-
lustrated Adult Fantasy") in August 1979. (Six
months later the magazine changed its name to
1994 in order to prevent its readers from confusing
it with George Orwell's book. Or so they said.)
About a warrior woman in an ancient (or future?)
age beyond our ken, Ghita's story was serialized in
the magazine for seven issues; and then Thorne,
who owned the character, reissued all seven in-
stallments in an album called *Ghita of Alizarr*.

At the time of her debut, Ghita was widely
viewed as a raunchy reincarnation of Thorne's Red
Sonja, a skimpily armored female comrade-in-arms
(so to speak) who appeared in Marvel's comics fea-
turing Robert E. Howard's brawny sword and sor-
cery barbarian, Conan. With writer Roy Thomas,
Thorne had done seventeen Red Sonja books, and
he frankly admitted his infatuation with the char-
acter ("my madness for Sonja"). In the afterword of
The Art of Frank Thorne, the cartoonist wrote:

> To cast Red Sonja aside as a sexual dream of ad-
> olescence is missing the thrust of this mythic
> figure. Granted, Sonja *is* that dream, but beyond
> lie the Himalayas. True, amongst those peaks
> roams this magnificent, near naked woman.
> The child's infatuation with nudity is there,
> combined with the mature wisdom of combat.
> Venus with a sword, stalking the once and fu-
> ture kingdoms. She is formed energy, she is the
> sound that Siegfried harkened to. Red Sonja rep-
> resents the total possibilities in *all* of us.[51]

Thorne saw Red Sonja as "the ultimate woman,"
"the epochal female." In stage shows at comic
book conventions, Thorne dressed as a wizard,
telling the mystical story of Sonja and then invok-
ing her in the flesh (as played by actresses or mod-
els or, more often than not, by cartoonist Wendy
Pini, who was on the cusp of fame herself as the
creator of the Elfquest series of comic books).
Thorne's special affection for the character shone
in the pages of the comic books; if ever the female
face and form were lovingly rendered, it was in
Red Sonja.

But Roy Thomas didn't like Thorne's treatment
of the character. Too sexy. Too baby-doll in the
face. Nor did Thomas participate in the myth that
Thorne was enthralled by. And so Thorne was
eased off the book in 1978. And a good thing, too,
because Ghita—a more fully realized version of
Thorne's vision of Sonja, written as well as drawn

by him—would not have appeared among us other-
wise.

Ghita is, indeed, the spitting image of Red Sonja.
She looks like Sonja, and we see more of her: she's
discarded the tin bikini armor that Sonja affected,
and although she picks up and dons an occasional
piece of armor, mostly, she's naked. Like Sonja,
Ghita is a swordswoman in a world of swords and
sorcery. But there similarities end. In the unre-
strained pages of the Warren magazine, Thorne's
vision of a swordswoman's life in an antediluvian
world took more sexually explicit form than it was
permitted in Marvel's books under Thomas's direc-
tion. For one thing, Ghita didn't start out as a war-
rior.

When we first meet Ghita, King Khalia's favorite
harlot, she's lounging naked in the royal bedcham-
ber with an old friend and fellow thief, Thenef, a
would-be wizard whose sleight of hand and mum-
bo jumbo have earned him a place as a court mage.
When Khalia is mortally wounded in battle against
invading trolls, he gets the idea that the kingdom
of Alizarr can be saved only by reincarnating the
warrior-king Khan-Dagon, whose remains are
mummified in the basement of the palace. Khalia
introduces Ghita and Thenef to Khan-Dagon's
corpse, commanding Thenef to bring him back to
life.

The fake wizard fails (more or less), but Ghita
seizes the magic gem from him and thrusts it into
Khan-Dagon's innards. The mummy duly comes to
life, and the first thing he sees is the toothsome
Ghita. In the fashion of slavering warriors every-
where, he mounts her without further ado. Such
are Khan-Dagon's proportions, however, that
Thenef fears for Ghita's life, so he slips her a dag-
ger, whereupon she "drives the blade deep into the
flesh of the heaving brute, exchanging stroke for
stroke" until the animating force escapes Khan-
Dagon through the holes she's made in his body.

Meanwhile, the city is overrun by the trolls.
Hearing the hubbub, Ghita and Thenef arm them-
selves for their escape by picking up a few of the
weapons that lie about the burial chamber and
then head for a tunnel that will take them out of
the metropolis. En route, they encounter a half-
troll named Dahib, who immediately takes the na-
ked Ghita for a goddess and begins his lifelong
worship of her. Before they leave the tunnel, Dahib
bends up some old pieces of Kahn-Dagon's armor
in a laudable attempt to cover—however scantily

—various parts of Ghita's otherwise bare body. And then Ghita, still aching from the dead warrior-king's ruthless ravishing, chances upon Khan-Dagon's sword and immediately recognizes its phallic character. "Eternally erect, forever hard," she says. "I will make love to it," she declares and proceeds at once to do so, thereby making Khan-Dagon and his sword symbolically one—and taking possession of both. (And in the extravagance of this conceit we can see Thorne's byzantine if earthy sense of the human comedy running rampant.) Following this extraordinary feat, Ghita is transformed. Inseminated with the phallic conquering spirit of the dead warrior-king, she is no longer the fleeing courtesan: she is now a bloodthirsty swordswoman, bent on battling the invading trolls and winning Alizarr back. By the end of the adventure, she has done all of that.

Although the tale clearly falls within the tradition of sword and sorcery, it resonates with aged archetypes and largely forgotten beliefs that hark back to the shadowy dawn of the species. The modern cynic might see Freud's celebrated penis envy manifest in Ghita's assumption of warrior power, but Thorne's source does not lie in the subconscious. He reached instead into a dark well of human memory and reshaped ancient fertility rites to commemorate the unconquerable human spirit. Inspired doubtless by James Frazer's *The Golden Bough* (or something akin to it), Thorne constructed a new mythology from the wispy memories of the old.

In antique times, when the secrets of reproduction (animal and plant alike) had not yet been fully revealed, primitive peoples found religion in the cyclical rhythms of renewal in nature—in seasonal birth and flowering, decay and death, and ultimate rebirth. Rituals invoked this mysterious power of regeneration in a variety of ways—among them, symbolic (and often real) sexual activity. The chief figure in such rituals was, according to Frazer, the King of the Wood, whose function was to control and regulate fertility and vegetation. A feature common to many rituals involved the death (real or symbolic) of the King of the Wood, who, when he began to show signs of age and debility, had to be disposed of so that his power could pass to a successor. In some variations, royal succession was achieved when another managed to slay the reigning incumbent in single combat. (Shades of Red Sonja, who could love only the man who defeated

her in battle.) Frazer demonstrated that most primitive rituals rested upon two principles of magic: first, that like produces like, effect resembling cause; and second, that things that have once been in contact continue ever afterwards to act on each other.

Echoes of these ritual customs can be seen in Thorne's Ghita. But here the fecundity of nature is expressed in terms of female sexuality. Ghita inherits kingly power through the sex act itself—first with the rejuvenated mummy of Khan-Dagon, then with his phallic sword. Her kinship to the dead king, her legitimate succession to his power, is manifest in her use of his weapon.

Plunging the sword into a troll, Ghita says: "Taste the wrath of Khan-Dagon. This blade is a hard, cold penis. It is the virile stem of Khan-Dagon. The great staff of annihilation. Its prize victim is Ghita. I faded as Kahn-Dagon thrust his living yard into me. Khan-Dagon died by my hand, yet he lives in me. His penis is now a shaft of Baalzarrian steel. His blade is my lover—and plunderer of my identity as a female."

As a reincarnation of the warrior-king, Ghita partakes of the masculine urge for conquest, thus assuming both feminine and masculine aspects to represent the spirit of the species.

So much for heavy meaning. Too much, in fact: Ghita is more profane than profound. After all is said and done, it is less the action of the tale, for all its echoes of antiquity, than its atmosphere that constitutes the captivating charm of *Ghita of Alizarr*. And the atmosphere emanates from the personality of Ghita.

Thanks to the license granted to Warren artists and writers, Ghita is a ribald original. As Thorne says, she is "the outrageous warrior woman of Alizarr, the Winged Victory of the sexual revolution. Ghita is absurd—a libidinous clown of heavenly proportions in an ancient festering world of benign and lethal nightmares." She is "the final lewd monument to a battle long over." In Thorne's purposefully overblown language we see the rollicking sense of fun that pervades the work. Archetypal underpinnings aside, *Ghita* is essentially a romping tale of sex and swordplay in which an arch sense of humor enlivens picture, plot, and dialogue. (After all, no one who depicts so outlandish an act as a woman having sex with a sword can be entirely, grimly, serious.)

Thorne has endowed his creation with a volup-

tuous body and the living, breathing personality of a streetwise trollop who has a lusty appreciation of her trade. Says Thorne: "Ghita burps, boozes, copulates, wields a sword with deadly accuracy, breaks wind, swears like a peglegged Philistine, and on occasion runs around joyously naked. Hardly ladylike behavior. Ghita of Alizarr is no lady—but she has class."[52] She speaks a bawdy argot, suggesting the arcane lingo of the streets of a long forgotten city. Raucous and ribald, her sexual assault on the world celebrates both appetite and epidermis. Her forthright sexuality is reminiscent of no less than Joyce's famed Molly Bloom. To her old friend, the fraud wizard Thenef, she's the champion whore of Alizarr; to the venerating half-troll dung carrier Dahib, she's a goddess. And as whore-goddess of Alizarr, she's a profane earth mother, whose sexual vitality animates the world.

Although the fun begins with Ghita, it doesn't stop there. Throughout one of the tale's funniest sequences, Ghita is completely unconscious, having passed out from consuming too much ginmead. A half-troll named Sef comes upon the naked wanton as she is sleeping off the effects of her party with Thenef and resolves to take her as a sacrifice to his cave god, Drill. Unfortunately for Sef, he is somewhat smaller than his victim and has a deuce of a time figuring out the best way to haul his burden. For two pages, he explores various possibilities—dragging her by the arms, hoisting her by waist and thigh, then by armpit and leg. But his cumbersome cargo seems to slip through his hands no matter how he grips her, and with each of his attempts, Ghita sprawls into another grotesquely awkward and increasingly difficult to handle position, arms and legs unmanageably akimbo, first this way, then that.

Thorne deftly augments the comic effect of his pictures with the words of an accompanying monologue. As he struggles, Sef mutters to himself, affirming loyalty to his god by announcing his determined rejection of Ghita's voluptuous attractions. "Do not be so foolish as to tempt me with your luring wiles," he cautions the slumbering strumpet; "I know well the ways of harlotry." No response.

"I have but one true love in the abyss," Sef goes on, "—Drill, my adored one." No response. "I will be true to Drill." No sound from Ghita, but her bosom hangs nearly in Sef's eye. "Be still, harlot," he warns. No comment. "I will not fondle and nuzzle and pet and stroke your full and shiny breasts," he continues. No response. "Silence!" he warns. Silence he gets. As always. "I refuse to cover those alabaster spheres with caresses. Absolutely not." Nor will he ravish her, he announces in seeming response to the same unspoken invitation. "Do not insist," he says. "I will not ride twixt your savory thighs and send you to the climax of passion."

And so Sef staggers on, the unconscious Ghita now astride his shoulders, bum up. And he mutters to himself as he goes, his every word revealing the desire that he denies, and the pictures of this pilgrim's progress heighten the comic effect by showing us Ghita's bountiful body in a succession of awkward postures.

But such broadly comic bawdry is balanced by scenes that plumb deeper feelings—scenes that reveal the enduring camaraderie that exists between Ghita and Thenef, for instance. Or the sequence in which the bearded old wizard comes upon Ghita making love with a handsome young man.

As Ghita's oldest friend and ally in petty street crime, Thenef occasionally enjoys her sexual favors. But his "turn" (as Ghita puts it) at "tum-bumping" is, for her, more in the spirit of fellowship than of romance. So when she insists on her freedom to choose other bedfellows, Thenef asserts no prior claim. But he loves her deeply nonetheless—albeit without declaring his affection. When he turns away undetected from Ghita and her "pretty boy" in flagrante delicto, Thenef looks sadly out at us and uncorks his ginmead flask. The sequence wordless captures the poignancy of his predicament.

Among us there are doubtless those who would find *Ghita of Alizarr* pornographic. No surprise. But *Ghita* is not, by most definitions, pornographic. The function of pornography, one could argue, is solely to excite. *Ghita* does that—but the book also delights. Joyfully. In pornography, there is typically little evidence of artistic concern, whereas *Ghita* furnishes us with ample evidence of Thorne's endeavor to create a work of art—in character development, in language, and in the pictures he draws. And it is a successful endeavor.

Thorne's delicate lines lovingly limn the body of his heroine, but the same lines also create the world of Alizarr—and almost as lovingly. The carefully rendered setting, bedecked with appropriate accoutrements, is as important to Thorne's tale as

Figure 124. *Here, Thorne's votary of the lusty life, the voluptuous Ghita, goes on a ginmead binge with her friend and ardent admirer, the phoney wizard Thenef (drawn, as Thorne said, in his own image—his homage to the goddess who ruled his imagination).*

his central character: the setting establishes the place and the ambiance in which Ghita is at home, alive and spouting the picturesque language that also contributes to the sense of place. Enhancing the arcane atmosphere that permeates the work is the ornamental page design that Thorne employs. The filigree that defines the panels on most of the pages gives the book a strangely Oriental motif that speaks of a distant time and place.

For me, the book is a highly moral one. In the face of Ghita's frank and uninhibited acceptance and enjoyment of human sexuality, furtive guilt about such matters scurries into the shadows and disappears. Such openness banishes mystery, with its accompanying aura of dirty secrecy. To foster acceptance of any facet of the human condition, to nurture enjoyment of it, and to vanquish meaningless guilt seem to me to be acts of high morality: such acts elevate the human spirit. If this be pornography, we need more of it.

Ghita is vulnerable to the charge of sexism, too, I suppose. Anything with naked women in it must be. But if we examine Ghita's character and actions rather than ogle her flesh, we find the strong and independent personality of a champion of female freedom. In the context of the story, her role as harlot is scarcely demeaning. Nor is she any kind of victim. She has the air of one who commands her own life: she proclaims her freedom and enacts it. True, when possessed by (and possessing) Khan-Dagon's phallic sword, Ghita is not her own woman. And she resents it. In one battle, she holds the sword close, murmuring, "Khan-Dagon . . . you are within me, and I loathe your presence." But at the end of the story, Ghita sheds the spell, giving the sword to a young girl of the woods, a sprite of a thing with the telltale aura of an infant goddess. (And so the fertility monarch's mantel passes to the next generation.) As Ghita turns away from the girl, she reasserts her independence, declaring with characteristic verve: "Bulldung! I'm full up of swords and soldiery. To hell with the shaft! Ghita has gained enough from this merry chase. Take the sword and with it my lunatic visions. The blade is steel, not flesh." And with that, the whore-goddess proclaims both her preference and her freedom.

The book's afterword by Thorne bears remarkable witness to the creative process. Thorne describes his creation with grace and wit. And he also testifies to his affection for and involvement with the character. "This fey heroine has seized my inner being," he writes; "I cannot help myself. I must draw her and make her speak." He continues: "In Ghita's adventures, I have crafted Thenef the wizard in my own image. I have allowed my hair and beard to grow to flowing lengths as a device to make it easier to imagine myself as Ghita's comrade-in-arms and ginmead-guzzling cohort. Thus I gain entry into her world."

But Ghita's creator lives in two of his other characters, too. Dahib proclaims his love for the heroine; "the wizard is dumb to the task." Together, Thorne says, the two characters are "fragmented aspects of their creator's personality. I, as the wizard, indulge in her as a fantasy, but the guilt of betraying the most splendid real life partnership forbids me to speak of loving the wench. To play out in reality the perfumed urges within all men would be unconscionable, but not unimaginable."

Thorne's imagination and his craft have given more than two-dimensional life to his erotic fantasy: his creative and personal involvement have invested those two dimensions with such affectionate energy as to give us a clutch of memorable characters, rounded and whole personalities, brimming with vitality and joie de vivre. His achievement would have been virtually impossible in the run-of-the-mill mainstream press, which dares too little and too seldom. Only in the benignly negligent backwaters of the oft overlooked Warren tributary could Thorne have hazarded his bold and bawdy voyage. There, or in any number of smaller independent publishing houses that had begun cropping up almost everywhere.

BY THE MID-SEVENTIES THE BLOOM had gone off the rose of underground comix: they were still being produced but not in the quantity or with quite the subversive effervescence that had characterized their first few years. Still, they had paved the way for another breed of comic book—the so-called ground-level comics produced by the "alternative press." Although manufactured by small, independent publishers like those who produced comix, ground-level comic books were much less intemperate in content. In fact, many of the earliest of these comics were almost indistinguishable from the mainstream comic books of DC and Marvel. Among the first of the ground-level enterprises was Mike Friedrich's *Star*Reach*, and the principal contributors to its premiere issue in 1974 were Jim

Starlin and Howard Chaykin, each of whom supplied stories that differed from the usual mainstream material chiefly in a display of female nudity and occasional profanity. But content here was beside the point: Friedrich's purpose in starting Star*Reach Productions was to provide artists and writers with an outlet for more personal works, works they created themselves as expressions of their individual visions. (And Friedrich also arranged to share the profits with the creators.) Friedrich's modest success blazed the trail for others, and before long, several independent publishers had followed the same path. Among them was Harvey Pekar.

Pekar had grown up in Cleveland and was, by his own admission, a man with no marketable skills. Between 1957, when he graduated from high school, and 1966 he held an array of jobs that required virtually no talent or training: janitor, sales clerk in a record store, laborer, shipping clerk, microfilmer, photocopier, and elevator operator. In 1958 he briefly attended Western Reserve University. He got married to his first wife in 1960. In 1966 he found a job as a file clerk in a veteran's administration hospital: it was as menial as any of his other occupations, but it was steady employment, and it left him free to write in his spare time.

Pekar was an avid jazz buff and collector of records from the 1920s. An articulate critic, he contributed occasionally to *Downbeat* and other jazz magazines. He was also a passionate reader, with a particular fondness for naturalist and realist novelists of the nineteenth and early twentieth century. Among his favorite authors were George Eliot, George Gissing, Balzac, Flaubert, Chekov, Nathaniel West, George Ade, James Farrell, and the children's book author Eleanor Estes. In 1962 Pekar had met Robert Crumb, who shared his passion for collecting records from the twenties. Crumb and Marty Pahls reacquainted Pekar with comic books by showing him the work of Will Eisner, Jack Cole, Walt Kelly, and E. C. Segar. Pekar also saw some of Crumb's sketchbooks, including *The Big Yum Yum Book*, a long narrative done painstakingly in color and intended as a gift for a girl Crumb admired at American Greeting Cards. (That girl never saw it; Crumb eventually gave the book to his first wife, Dana.) Pekar saw possibilities in the medium, but it wasn't until after Crumb began producing comix all over the map

that Pekar started thinking about doing realistic stories in the comic book format. In 1972 Crumb visited him in Cleveland, and shortly after that, he began writing comic book stories. And he wrote them, unabashedly, for adult readers.

Inspired doubtless by the autobiographical content of some of Crumb's work, Pekar wrote about incidents in his own life, creating vignettes and epiphanies that revealed something about the common humanity that underpins everyone's endeavors. "I want to write literature that pushes people into their lives rather than helping people escape from them," Pekar said. "Most comic books are vehicles for escapism, which I think is unfortunate. I think that the so-called average person often exhibits a great deal of heroism in getting through an ordinary day, and yet the reading public takes this heroism for granted. . . . Also, I think we see and hear stuff during the course of our ordinary days that is a lot funnier than what's happening on situation comedies. I incorporate some of this everyday humor into my work. Truth is funnier than fiction."[53]

Having no discernible skill as an illustrator, Pekar wrote his stories in comic book page format using stick figures and speech balloons, and then commissioned artists to illustrate them. He had an ear for the medium: he'd worked as a street-corner comedian, and doing stand-up comedy was good training. "Using panels," he observed, "you can time stories the way a good oral storyteller would, sometimes using panels without dialogue for punctuation."[54] He published the first collection of his stories in 1976 under the title *American Splendor*, and he has produced an issue of *American Splendor* every year since. Crumb was one of the artists who contributed to the first several issues. (Reportedly, he was a reluctant collaborator, ultimately agreeing to do the work only if he was paid in old records that he wanted from Pekar's collection.)[55] Among the other artists Pekar most frequently employed were the team of Greg Budgett and Gary Dumm, along with Gerry Shamray, Kevin Brown, and Frank Stack.

Pekar once said that he thought of himself as a sort of recording machine: "I look at myself sometimes when I do these shorter pieces like a photographer walking down the street who runs into things; he sees things and he shoots them."[56] But he was scarcely a dispassionate observer. He was a committed working-class social critic and a bundle

of quirks and obsessions. He got "messed up" if his daily routine was disturbed. He loved his apartment, crammed with books and records and videotapes. Pahls noted his "frenetic style . . . the distilled energy, waving arms, beads of sweat, flashing eyes." And Crumb remarked about "this wild, intense Jewish guy into bebop music . . . this real seething character."[57] In other words, Pekar was an active and often eccentric participant in the stories he retailed—not just a reporter.

In telling his stories, Pekar aimed for accuracy and plausibility as well as realism, and since he was a character in most of the narratives, his own credo required that he be as truthful about himself as possible. Although he admitted that if something was too embarrassing or painful he simply didn't write about it, he regularly revealed himself, warts and all, to his readers. In "Holding On" (*American Splendor* No. 17, July 1993), he upsets a fellow worker by taking shortcuts in processing the records she gives him. When she insists that he do it her way, he gives in but makes such a fuss that she offers to do it herself. "Oh, no you ain't," he declares, "—you ain't takin' no work from *me*!"

In the same issue's "Cat Scan," Pekar bores a friend by telling him all about his hopes for an article that he's submitted to a West Coast magazine and his fear that the magazine isn't going to publish it despite the editor's having told him she would. Later in the day, he gets a report on a cat scan that shows he is "clean" of the cancer he'd had (about which, more shortly), and so that evening, feeling good, he phones the editor of the magazine to find out about the status of his article. Fearful of upsetting the editor, though, he decides to speak only to her assistant. But the assistant, juggling several phone calls, responds hurriedly, saying he'll tell the editor that Pekar called, and then hangs up. Pekar is plunged into despair: reporting his phone call to the editor will make him appear to be a pest and thus might jeopardize future sales to the magazine. His wife is upset by his behavior: "You come home feeling good about your cat scan results and two hours later you're moping again. It makes me feel that I can *never* make you happy, that your obsessions will always dominate you and make you miserable. And when you're depressed, you make me depressed." Pekar ponders this for a single, silent

panel, then puts his arms around her and says, "Aww, honey, please don't take it that way." End of story.

But Pekar isn't in every story. Sometimes he tells stories he's heard others relate. And sometimes he's just an observer. In a one-page story, "Distancing," he watches a stout woman sweating and puffing down the hallway; then another woman comes along and asks, "How far aheada me is she?" Pekar says, "Oh, pretty far—maybe twenty-five yards." "Good," says the other woman, "I don't wanna ride on the same elevator with her."

Pekar's most ambitious undertaking in eighteen years of *American Splendor* is the 252-page graphic novel, *Our Cancer Year*, written by Pekar and his wife, Joyce Brabner, and illustrated by Frank Stack. The book records the chief events in Pekar's bout with cancer in 1990. The trauma of this encounter is complicated by Brabner's long-distance involvement with a number of young people she has met at an international youth peace conference, by the couple's moving out of an apartment in which Pekar has been living for nineteen years, by a painful attack of shingles that Pekar contracts in the midst of his debilitating chemotherapy, and by Pekar himself, a man for whom any change is anathema and every undertaking a potential disaster that he is sure to bring to fruition by prophesying it relentlessly.

A powerful and often moving narrative, *Our Cancer Year* reveals in the everyday details of the ordeal the couple's steadfast and sustaining love for each other in the face of this life-threatening calamity. As the particulars of Pekar's medical dilemma multiply, his wife's pragmatic heroism takes center stage. But she shares the spotlight with her husband. Pekar does not suffer his illness stoically; and as usual, he has the courage, as well as the honesty, to expose himself as he often is, obsessed by petty preoccupations. Yet he is as often concerned with the burden he has created for his wife.

The drama of the book is not an accidental thing. The subject—cancer, its threat and its treatment—is bound to foster drama of a sort. But the drama of this story has been deliberately crafted by its authors, who selected and arranged the order of the events depicted in ways designed to produce the greatest emotional impact. Again and again, they make the details of everyday life

serve their purposes. For example, Pekar loses his wedding ring because it slips off his finger, grown thin as a result of the customary weight loss accompanying treatment. Brabner, although disturbed by the lost ring, hides her dismay from Pekar, who feels bad enough as it is. Later, she and a friend find the ring and, as a joke, return it to Pekar in his mashed potatoes at dinner that evening. But neither husband nor wife is persuaded by the prank to treat the matter lightly: the ring is an emblem of their union, and they embrace at its recovery.

In illustrating the entire story—a prodigious undertaking—Stack varied his treatment, often from panel to panel, seeking to reflect the moods of the moments he pictures. Sometimes he drew in stark outline; sometimes, in elaborate cross-hatching. Sometimes he drenched panels in black; sometimes he flooded them with light by leaving out all detail and hachuring. His gestural drawings have a blunt, nearly crude, spontaneity—a seedy sort of reality akin to that of the world he is depicting. But he also captures tender moments with a deft hand, and he is clearly at home in this moving story of frustration and survival and the transcendence of the human spirit.

While Pekar continued exploring the autobiographical avenues that made *American Splendor* a beacon for those who sought to make comics intimate and personal and therefore individually expressive in ways not hitherto attempted, others were deploying the medium in another nonfiction arena—history.

In Last Gasp's *Slow Death* No. 7 (1975), Jack Jackson undertook to expose the history of the American West in a shockingly graphic retelling of the 1864 Sand Creek Massacre, in which a regiment of soldiers brutally maimed, raped, and slaughtered a sleeping encampment of peaceful Indians, mostly women and children and old people. Jaxon continued his unblinking investigations into Western history in 1977 with a three-issue series of comix about the life of Texas Comanche leader Quanah Parker; these were subsequently published in a single volume in 1978. The next year, Jaxon began another meticulously researched series about the life of a controversial figure in Texas history, Juan Seguin, who was accused of being a traitor to both sides in the Texas war for independence with Mexico; this series, too, was eventually re-

printed in one volume, *Los Tejanos*, in 1982. Jaxon's work in all these enterprises was marked by a studious attention to visual detail and a concern for historical accuracy.

Larry Gonick applied the same careful scholarship to a hilarious retelling of history in *The Cartoon History of the Universe*, a series of comic books he initially produced with Rip Off Press. He just walked in off the street one day in 1978 with the material for the first issue. Shelton and his partners appreciated the excellence of the work but didn't know quite how to market the product. They sold individual issues to various universities and schools, but, stymied by their inability to effectively exploit such a vast market, they eventually gave up and let Gonick take his book to a commercial publisher. At this time, underground publishers like Last Gasp and Rip Off Press were not so much consciously expanding their product line (that would come later) as they were simply responding to cartoonists' desires to explore new territory in the art form. And in New York, as the seventies sputtered out, one of the medium's foremost experimenters was about to combine autobiography and history in a work that would win widespread critical acclaim.

Art Spiegelman was a thinking cartoonist. His creations were invariably intellectualized, carefully designed to exploit the resources of the medium. In 1977 he published many of his more adventurous experiments in a book called *Breakdowns*. And then, in 1980, he and his wife, Françoise Mouly, began producing *Raw*, a giant-sized avant-garde comic book that would continue the inquiry on an annual basis, publishing comics that challenged the traditional limitations of the form, written and drawn by Europeans as well as Americans. And it was in *Raw* that Spiegelman published installments of a long work called *Maus*, which was later reprinted in two volumes.[58]

At first blush, *Maus* seems to be just another Holocaust tale. But as Spiegelman presented his rendition of the century's most infamous horror story, he introduced two novelties, one of which was startling in its daring. First, he paralleled his account of the historical atrocity with another narrative, the much more mundane story of how he, the author, acquired knowledge of the Holocaust. In this story, Spiegelman appears as a character—Artie, a cartoonist—who interviews his father,

Figure 125. *The top panel, from Jaxon's* Red Raider *(1977)—an installment in the story of Quanah Parker and the Texas comanches—is a far cry from the images of the comical deity found in his* God Nose *of the previous decade. The two tiers below are from* Our Cancer Year, *the autobiographical book by Harvey Pekar and his wife, Joyce Brabner, illustrated by Frank Stack.*

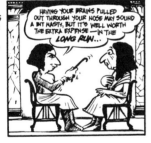

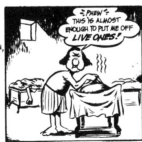

Figure 126. *Larry Gonick's comic (but carefully researched) history of everything gives a humorous turn to nearly every fact it retails.*

Vladek, about the latter's experiences living through the Nazi occupation of Poland and surviving Auschwitz. Artie and Vladek are based upon Spiegelman and his father. The parallel plot is, we are persuaded, both autobiographical and biographical, and its principal interest lies in the strained relationship between father and son. Spiegelman's riskier novelty, though, lay in his decision to cast his story with animals: the Jews he depicts as mice; the Nazis as cats, and the Poles as pigs. Whether Spiegelman was able to deploy these in-

novative devices with complete success is debatable. But that is a success of another order: his choices give the work as a whole the kind of ambiguity that qualifies it for interminable analysis and discussion (making it eminently suitable for college literature courses).

Given the parallel structure of the work, we would expect the two stories to act in tandem, one impinging upon the other and vice versa, in a series, perhaps, of reciprocating illuminations. And, to a considerable degree, that happens. When Artie

Figure 127. *An admirer of Ernie Bushmiller's iconic surrealism on display in the comic strip* Nancy, *Spiegelman pays the strip cartoonist homage twice in the above self-portrait: first, by including Nancy among the characters he consults; and second, by imitating the composition and gag in Bushmiller's own self-caricature (below).*

interviews his father, we see Vladek going about his daily routines. He is revealed as a fastidious (not to say fussy) old man, meticulous and methodical in his living habits, parsimonious in his economies, and demanding and exacting in his expectations. Artie is concerned about what he sees in his father: "It's something that worries me about the book I'm doing about him," he confides to his stepmother, Mala (the woman his father married after Artie's mother, who also survived Auschwitz, died in 1968); "—in some ways he's just like the racist caricature of the miserly old Jew" (II:131).[59] "Hah!" says Mala; "you can say that again!" Artie speculates aloud that he used to

think that it was the war that made his father the way he is. But Mala, another survivor, snorts: "Fah! I went through the camps—all our friends went through the camps; nobody is like him!" Artie's wife, Françoise, also finds Vladek difficult, a strain to be around (II:74).

Despite what Mala says, the evidence Spiegelman provides repeatedly throughout both volumes of the work demonstrates that the traits that now make Vladek so annoying are the very traits that enabled him to survive his experiences in the ghetto and in Auschwitz. For instance, the postwar Vladek is an inveterate pack rat: he saves everything. Not just souvenirs like menus he picked up on cruises, but even such trivial items as bits of wire, string, matches. In the camp he also saved things. If he acquired a delicacy like chocolate, he saved a portion of it; later, when the opportunity arose, he used the chocolate to bribe a guard for a favor. Likewise, by saving scraps of paper, he was able to send a message to Anja, his wife, who was incarcerated in the next camp, because he had paper to write on. Vladek may not have acquired his hoarding habits at the camps, but his camp experiences confirmed in him the tendencies that would later prove so irritating to Mala and the rest of the family.

And the son is as irritating as the father. From the very first, Artie is shown to be impatient with the old man and his whims and crotchets. Even when Vladek wants his son to listen to his complaints about Mala, Artie—instead of serving as the sympathetic listener Vladek so obviously needs—begs off: "Let's talk about it next time. I'll call you. Besides it's getting late, and I oughta get home before curfew" (I:67).

That Artie is somewhat less than the son every father desires is made even clearer at the conclusion of the first interview session. Vladek tells Artie about his youthful affair with a girl named Lucia, which took place before he met Artie's mother. Lucia was more beautiful than Anja, he acknowledges, but Anja was from a better family, a wealthier family. After telling Artie of this relationship, and of his subsequent desertion of Lucia in order to marry Anja, Vladek asks his son not to put this story in the book: "It has nothing to do with Hitler, with the Holocaust," he says. Artie protests: "But Pop—it's great material. It makes everything more real, more human. I want to tell your story the way it really happened." Vladek,

Figure 128. *In the interludes between Vladek's recitation of his Holocaust experiences, Spiegelman explores the relationship between Artie and his father, revealing characteristics of the latter's personality that enabled him to survive life in the Nazi camps. Ironically (and perhaps purposefully so), Spiegelman's stylistic simplicity in rendering the story reduces all his characters to virtually identical beings, depriving them of visual individuality.*

however, is implacable: "This isn't so proper, so respectful. I can tell you other stories, but such private things, I don't want you should mention." Artie gives in: "Okay, okay," he says, "I promise." But then, as we can see on the pages before us, he breaks his promise. Artie is not only insensitive and inconsiderate but ungrateful and perfidious.

If Artie is a somewhat contemptible and egocentric young man, we must remember that Spiegelman made him that way. He selected the character traits on display in the story, and he presumably did so purposefully. One effect of this ploy is to enable us to feel compassion for Vladek's ordeal. Artie is the character who ought to display sympathy for his father, but he doesn't. And because neither he nor anyone else in the story seems to feel the appropriate anguish or outrage about the Holocaust, we are free to do so. It's clear that someone must: the story cries out for some sort of human response. In discerning Artie's insensitivity, we realize our superiority over him. We are not like him: we feel for his father and the rest of those whom the Nazis persecuted. If Artie demonstrated some measure of compassion, we might not need to: he would do it for us. He would become a sort of emotional stand-in, giving voice to our feelings. In effect, by making Artie so callous, Spiegelman forces us to step into the vacuum he has created. But Artie is not callous about everything. He is, after all, an artist.

Thematically speaking, Part I of *Maus* is essentially a portrait of the artist as a young man obsessed with his art. The only kind of relationship he can have with his father is that of artist and subject. And the only thing that matters to the artist is his art. Part I concludes as Vladek and Anja enter Auschwitz. They have evaded the Nazis by hiding in a succession of bunkers and secret rooms, but they are at last betrayed into the hands of the oppressor. But in spite of the accumulating horror that the survivor's tale presents, Artie's overriding concern at this point is his book. During one of the interviews with his father, he learns that his mother kept a diary in which she recorded her version of the events Vladek is recounting. Artie is astounded at this stroke of luck. Recognizing at once that his mother's observations could enrich his book, he wants to include them and is eager to get his hands on the diary. His father at first claims that he doesn't know where the diary is but promises to find it; later, he admits he destroyed

the diary in a fit of grief after Anja died. Deeply disappointed, Artie rages at his father: "Christ! You save tons of worthless shit, and you . . . God damn you! You, you murderer! How the hell could you do such a thing!" (I:159). Vladek's state of mind when Anja died means nothing to Artie; the horrific events they survived together mean nothing. All that matters is his book—his book and his frustration at being denied a valuable source of insight into the events he wishes to record. Although as he leaves for that day he apologizes to his father for his burst of temper, in the last panel we see Artie walking away, muttering to himself, "Murderer." It is the last word in the book. What has been murdered is Artie's vision of his book.

If we had only Part I of *Maus*, we would be forced to conclude that it is a book about the compulsions of the artistic personality rather than a book about the Holocaust. And in fact, when Part II was published five years after Part I, it did not much alter the thematic impact of the work as a whole.

Because Spiegelman so elaborately spliced the story of his relationship to his father into the father's story of the Holocaust, we might reasonably anticipate that as the latter's tale unfolds, something would happen to the relationship between father and son. And because that relationship is so tense and uncompromising, we look for that tension to be modified or ameliorated by what each of the principals learns about the other. To some extent, our expectations are gratified. Vladek doesn't seem to change, but we don't need him to change: although his personality is annoying, his quirks are so thoroughly justified by the contingencies of his personal history that we tend to tolerate his deficiencies. We come to accept them. But we are less willing to do the same with Artie. Artie, however, changes. A little. In Part II, we see him soften in his attitude toward his father. He even professes sympathy and understanding on one occasion, saying to his wife: "It's a miracle he survived. I'd rather kill myself than live through all that—everything Vladek went through. Maybe we should stay with him a few days longer. He needs our help." But Françoise says: "Are you kidding? I don't think *we* would survive" (II:90). They don't stay.

Earlier in the volume, in a session with his analyst, Artie says that he's tried to be fair in his portrait of his father—"and still show how angry I

felt" (II:44). Artie has undeniably changed in his opinion of his father, but his overweening concern is still an artistic preoccupation—to be accurate as well as fair in his portrait of his father and of himself. The Holocaust story ends with a scene that reunites Vladek and Anja at the end of the war, after their ordeal. It is a moving finish to a moving story. The father and son story ends with Artie at the bedside of his ailing father—asking questions and taking notes for the book. Despite the alteration in his attitude toward his father, the artist is still an artist, driven by his peculiar passion.

In recounting the story of Vladek's survival, Spiegelman meticulously assembled the facts, and, as the details mount up, the experience of the Holocaust emerges in all its grim horror. The artistic achievement in this aspect of the work alone is impressive. But the Holocaust chiefly functions here as the illuminating backdrop in the story of a relationship between son and father. And yet what Spiegelman ultimately shows us in this story is not the relationship between son and father but the relationship between artist and subject. In the last analysis, the book is not so much about the experiences of the Auschwitz survivor as it is about the obsessions of the artistic temperament.

Spiegelman's storytelling style throughout is fairly conventional. He employs a grid of regularly shaped panels in his page layout, and his pacing is similarly routine. He uses an occasional splash panel for dramatic display of, say, the entrance to Auschwitz, and he sometimes drops the panel borders around scenes between Artie and Vladek, contrasting these with the bordered pictures of the Holocaust narration. In one of only a few departures from these regular cadences, when Vladek takes out photographs of his friends from the old days in Poland, the photos pile up around him and then spill over panel borders, seeming in their profusion to drown the old mouse in memories.

The work's most arguable aspect is undoubtedly its most conspicuous visual novelty. *Maus* is not the only book about World War II experience to employ talking animals to represent the nationalities involved. *The Beast Is Dead*, a French graphic novel by Calvo and Dancette, presents the Germans as wolves, the French as squirrels and rabbits, the Russians as polar bears, the English as bulldogs, the Americans as buffalo, the Dutch as cattle, and so forth. The Jews (I am told) appear in only one panel—as rabbits.[60] In deciding to use mice to represent Jews, Spiegelman gave *Maus* a metaphorical patina of equivocal significance, imparting to the work an ambiguity that threatens to erode its moral underpinnings.

Using animals as the actors in this drama reduces the sheer scale of the Holocaust, thereby bringing it within the grasp of our imaginations. Somehow it is easier—more possible—to contemplate the enormity of it if we don't see it happening to fellow human beings. But depicting the Jews as mice and the Nazis as cats immediately establishes the "cat-and-mouse game" as the books' overarching thematic image—and the expression has an unfortunate resonance. As anyone who has watched a cat toy with a mouse knows, the "game" has a humorous aspect, despite its grisly outcome. Nor is the seeming playfulness of the cat in this tableau something I associate with the Nazi persecution of European Jewry. It is clear to me, however, that the "cat-and-mouse game" was not the metaphorical image Spiegelman had in mind when settling on the conceit. He chose animals, it seems, as a way of distancing himself from the Holocaust material and at the same time authenticating his presentation of it:

> If one draws this kind of stuff with people, it comes out wrong. And the way it comes out wrong is [since] I've never lived through anything like that . . . I'm bound to do something unauthentic. Also, I'm afraid that if I did it with people, it would be very corny. It would come out as some kind of odd plea for sympathy or "Remember the Six Million," and that wasn't my point exactly, either. To use these ciphers, the cats and mice, is actually a way to allow you past the cipher at the people who were experiencing it. So it's really a much more direct way of dealing with the material.[61]

But Spiegelman didn't pick cats and mice for his story so much as the cats and mice picked the story. In 1971 he attended a class in animated cartooning, during which the instructor pointed out how similarly mice and black people were portrayed in early cartoons. Said Spiegelman:

> For about forty-five minutes, I wanted to do a comic strip in which the mice were blacks and the cats were whites—a metaphor for some kind of oppression. Then I just short circuited. I realized that I was never going to be able to give this any authenticity. I just didn't know the material; I'd be just another white liberal. Then it

happened. There was an involvement with oppression that was much closer to my own life: my father's and mother's experiences in concentration camps, and my own awareness of myself as a Jew. I wasn't in contact with my father anymore, but remembered the stories from my younger days at home. That was the genesis.[62]

Subsequently, Spiegelman conducted extensive interviews with his father and researched the Holocaust itself, with particular emphasis on assembling visual references.

The cat-and-mouse metaphor is undeniably a legitimate way of suggesting the power relationship between the Nazis and the Jews, "the predatory nature of the Nazi oppression," one which "makes the term 'extermination' resonate powerfully," as Joseph Witek has pointed out.[63] But cats and mice as visual metaphors for the oppressor and the oppressed, well intentioned though the device may be, cannot entirely escape the overtones of playfulness inherent in the "cat-and-mouse game" notion. Moreover, mice alone—tiny, furtive creatures that they are—conjure up a couple of other associations that are equally unfortunate, it seems to me. Timidity is a mousy trait; "meek as a mouse" is a familiar phrase. And then there's that notorious propaganda movie produced by the Third Reich in which Jews are depicted as vermin.

One of the ways that the gentile world sought to assuage the guilt it doubtless felt for somehow standing by to watch the slaughter of millions of Jews without doing anything to stop it was to wonder aloud about why the Jews made no objection themselves. Why did they allow the Nazis to lead them to slaughter? Why was there no outcry, no massive protest? Why, once the camps were in operation, didn't the incarcerated population—who were much more numerous than their captors—simply rise up and overpower the guards? One way to answer such questions was to offer up a stereotype of Jews as meek, submissive people, too timid and cowed to protest their treatment (ignoring, at the same time, the similarly passive response of the gentiles). Spiegelman's metaphor plays directly into this racist vision. And he is scarcely ignorant of it. On the contrary, he has Artie and Vladek discuss precisely this question: "[Resistance] wasn't so easy like you think," Vladek says. "Everyone was so starving and frightened and tired they couldn't believe even what's in front of their eyes. And the Jews lived always with

hope" (II:73). All the same, while the monstrousness of their circumstance surely helps to explain the failure of the Jews to resist, it does little to diminish the power of the mouse metaphor for meekness and submission.

Spiegelman was also well aware of the propaganda film, in which, as he said, "Jews are shown swarming around a ghetto, then a cut to rats swarming around a sewer, then back to Jews." Furthermore, he knew that Kafka had depicted Jews as mice in "Josephine the Singer."[64] But, knowing these things, he nonetheless employed a metaphor that can be interpreted as perpetuating a stereotypical image of Jews. And in deciding to draw the story in a very simple, albeit realistic, style, Spiegelman again played into the racist aspect of the Holocaust drama. His visual simplification renders all Jews in virtually the same way: the stylized mouse faces all look very much alike. Individuality is thereby eliminated—and with that, the presumed humanity of the characters is annihilated. We cannot recognize as fellow beings those who appear to us to be identical and, perforce, faceless, devoid of any individual personalities. It was precisely this sort of dehumanizing of Jews that had to take place before the Nazis could persuade themselves to "exterminate" the "vermin."

But almost none of this quibbling about stereotypes matters. Spiegelman's material—the Holocaust itself—is so powerful that it rises above any attempt, whether deliberate or accidental, to trivialize or diminish its impact. Our morbid fascination with the Holocaust, our consuming curiosity about the gruesome details of this repulsive blotch on the escutcheon of humanity, our overwhelming revulsion at the heinousness of the undertaking—all act in concert to blind us to whatever faults may lurk in Spiegelman's approach to storytelling. Method is subsumed by subject matter, obliterated by it.

Spiegelman is a very deliberate craftsman. His deployment of the medium is carefully thought through, very intellectualized. And because of that, I'm tempted to suppose that he knew exactly what he was doing—that he persisted in using a metaphor whose wickedness he recognized because he thought that this very usage might destroy the metaphor's effectiveness. Even when visually dehumanized, Spiegelman's mice emerge as people, sharing a common humanity with his readers. The drama of the Holocaust—a drama that pits inhu-

manity against humanity, with the latter ultimately triumphant—speaks to us in such elemental terms as to transcend the stereotypes that function to blur its message, thereby rendering them meaningless. But I doubt Spiegelman planned so precisely the destruction of the mouse metaphor: he has described his objectives and his working methods at great length since the publication of *Maus*, and if he had so Machiavellian a motive in mind for his mice, we surely would have heard about it.

The mice do not function in their story as Howard the Duck does in his. Howard's incarnation as a duck honed Gerber's satire to its point: Howard's alien origins gave him the perspective needed to reveal human folly, and his duckishness made his (and our) existential dilemma comedic rather than tragic. Howard had to remain a duck for the satire to work. But at some point Spiegelman's mice cease to be mice. Instead, we tend to see them as people. And in the last analysis, their mouseness does not add much to the story. In fact, as I said, the story is so powerful that their mouseness does not matter.

Whatever the flaws in *Maus*, the work demonstrates beyond any possible caveat that the medium is capable of achieving the status of serious literature, that it can tell serious stories with serious purposes in mind. In this alone, Spiegelman did his part to elevate the medium into the realm of respectability. But there was more. The book won praise from book reviewers writing for the *New York Times*, the *Boston Globe*, and the *Washington Post*, to name a few of the first-rank newspapers that gave *Maus* space in their columns. And in 1987 Part I of *Maus* was nominated by the National Book Critics Circle for its annual award in biography. Although the honor eventually went to another work, Spiegelman received a Guggenheim fellowship that enabled him to complete the second volume of *Maus*, and the entire work was given a special award by the Pulitzer Committee in 1992, accolades that drew attention to the medium and what it could accomplish.

On the evening of Tuesday, August 11, 1992, a tiny group of cartoonists and comics scholars and other interested parties collected in the Cardiff Room of the Marriott Hotel and Marina in San Diego, where they nibbled on cheese and crackers and sipped glasses of wine. The next day, they would reconvene in earnest to deliver or listen to a series of papers on the art of the comics. Carpeted luxuriously in Marriott mauve and draped in complimentary shades of beige and burgundy, the Cardiff Room was small as hotel meeting rooms go, but even furnished with a scattering of minuscule cocktail tables, it afforded ample space for the gathering. It was in this room that I met cartoonist Scott McCloud, who was seated with his wife, Ivy, at one of those wee tables. A rumpled-looking young man whose cheerful aspect was composed of equal parts glistening smile and serious eyes, McCloud showed slides the next afternoon, using pictures from a book he was doing on comics. Among the things his slides illustrated was his definition of comics as "juxtaposed pictorial and other images in deliberate sequence, intended to convey information and/or produce an aesthetic response." Predictably, at the wrap-up session at the end of the day, I disagreed with him, pointing out his definition's apparent slighting of the verbal component in comics. About a year later, McCloud's book appeared, and a remarkable tome it is: *Understanding Comics* discusses and dissects the medium, and it uses the very format of comics to achieve its purpose. It's a comic book about the theory and practice of comics.

In the book's opening gambit, McCloud introduces himself as a cartoon character who becomes our guide and lecturer throughout the book, a sort of one-man show-and-tell safari. One purpose of the expedition, the McCloud character suggests, is to demonstrate that comics are perceived as "crude, poorly-drawn, semiliterate, cheap, disposable kid's fare" because the definition of comics has been too narrowly conceived. The "proper definition" that McCloud offers (as above) widens the embrace of the term to include an entire realm of pictorial narratives—such as a pre-Columbian Mexican codex, ancient Egyptian tomb painting, the Bayeux Tapestry, and the sequential tableux of William Hogarth in eighteenth-century England. This broader definition not only affirms an enhanced social and artistic status for comics but also suggests a greater potential for the medium than a narrower definition could accommodate. By way of demonstrating that potential, McCloud goes on to analyze the way that comics function.

Leaving aside the matter of definition, which McCloud and I might debate endlessly, his book is an ambitiously conceived and brilliantly executed

work of cartooning. And its most telling moments, ironically, are those in which word and picture blend to make a point more vividly than either could make alone. It's a work that could be produced only by a cartoonist, an artist who thinks and creates by blending words and pictures.

McCloud allows that the verbal content of comics is important: "Words and pictures in combination may not be my definition of comics," he says, "but the combination has had tremendous influence on its growth. . . . And indeed, words and pictures have great powers to tell stories when creators fully exploit them both."[65] But the significant thing about the medium for McCloud is *sequence*—the pictorial content arrayed in a deliberate order.

The book brims with insightful moments, but perhaps its most provocative section (particularly for other cartoonists) concerns what McCloud calls *closure,* "the phenomenon of observing the parts but perceiving the whole."[66] For McCloud, closure constitutes the very heart of the medium. Displaying two panels that depict separate moments in a continuous action, he points to the space between the panels. In that space, he asserts, the reader (and the cartoonist) imagines the intervening movements between the two actions depicted, thereby completing the action. The reader, in effect, does what the "in-betweener" does in animated cartoons: he "draws" the movements that occur between the key actions illustrated in the two panels. Although this may seem a commonplace notion, so elementary that it has been overlooked to a fare-thee-well, what McCloud does with the concept next may very well revolutionize the way comics are created in this country.

Looking at the panel-to-panel transitions in comics, McCloud identifies six kinds of transition: (1) moment-to-moment, as in an animated cartoon where a subject's action is shown virtually continuously; (2) action-to-action, where the key moments in a continuous action by the same subject are depicted; (3) subject-to-subject, in which the camera shifts from one subject to another but stays within the same scene; (4) scene-to-scene, which changes the focus from one scene to another; (5) aspect-to-aspect, in which "different aspects of a place, idea, or mood" are displayed; and (6) the non sequitur, "which offers no logical relationship between panels whatsoever." McCloud then ana-

lyzes a selection of comic books and charts the kinds of transitions found in each. Most American comic books mainly use action-to-action transitions, with some subject-to-subject and scene-to-scene series; ditto European comics. In Japanese comics, however, the cartoonists employ a significant number of aspect-to-aspect transitions, the kind virtually ignored by American and European cartoonists. The act of closure in aspect-to-aspect transitions requires more of the reader: rather than simply bridging the gap between two instants in the same motion, the reader must "assemble a single moment from scattered fragments."[67] In depicting aspects of a moment, the cartoonist becomes a poet. And by directing attention to our neglect of this kind of sequencing, McCloud issues a challenge to his brethren in the inky-fingered fraternity to produce poetry.

Although I launched into the diatribe at hand by pointing to the area of disagreement between us, McCloud and I would probably agree more than we would disagree were we left alone together in the same room for several uninterrupted hours. But we would doubtless continue to emphasize different aspects of the medium. We begin, after all, at different conceptual points: for McCloud, sequence is the essential character of the medium; for me, it's the ingredients, the verbal content and the visual content. Sequence is vital to McCloud because it creates the opportunity for closure—and, hence, for the creative participation of the reader. In asking this of its audience, he maintains, comics are unique. I see the medium as unique, too; but the closure I emphasize is the closure between word and picture.

Such cavils are, of course, the stuff of unremitting debate, like arguing about the number of angels that can foxtrot on the head of a pin. For our present purpose, however, the overriding significance of *Understanding Comics* lies in its vivid demonstration of the capacity of the medium for serious and prolonged discussion of a complex subject. In more ways than one, McCloud's book expands the medium.

Others have also worked consciously to plumb the potential of the art of the comics. In the late sixties, for instance, Neal Adams and Jim Steranko dazzled their peers with the brilliance of their innovative graphic experimentation. But the economies of the day forced them both to work in the

Figure 129. On these two pages (left and above), McCloud makes his point about Art in the most vivid of ways—by blending perfectly the verbal and the visual, neither of which, in the last two panels, would make any sense by itself, without the other.

Figure 130. *Throughout his book, McCloud sprinkles brilliant insights into the nature of the medium, such as the one he affords us here, a demonstration of the static nature of comics—their ability to present the past and the present and the future virtually simultaneously.*

superhero genre. Limited to creating action-oriented adventure stories, they were offered very little opportunity to explore other concerns or subjects in any depth. By the end of the eighties, however, the industry had blossomed to such an extent that the variety of subjects being treated was, comparatively speaking, endless. And in selecting their subjects, the creators were able to follow their own private passions as storytellers and artists rather than obeying the dictates of conglomerate committees or corporate editors. It doubtless goes without saying that the emergence of such personal works saw the concomitant ascent of the cartoonist, that singular artistic intelligence who creates stories by blending words and pictures in symphonic concert.

Not all personal works were outright autobiography. Starting with the first issue of *Love and Rockets* in 1982, the Hernandez brothers, Jaime and

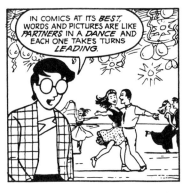
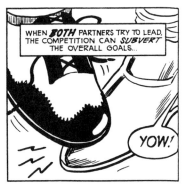
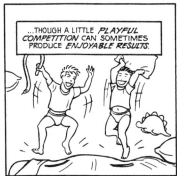
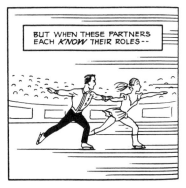

Figure 131. *While McCloud does not consider the verbal content of comics as essential to the nature of the medium, here he uses words and pictures together to create a memorable image of the way the verbal and the visual combine for narrative impact.*

Gilbert, crafted stories based upon their lives in the barrio: Jaime, the adventures of a group of young women in a vaguely futuristic punk world; Gilbert, tales of life in a small Mexican village. Drawing in markedly different styles (Jaime with crisply etched images and brilliantly spotted solid blacks; Gilbert with a homey, comfortable line and texture), they had produced an impressive body of work by the end of the decade. In all their efforts, it is the personalities of their characters and the relationships among them that command the Hernandezes' attention. Roberta Gregory was devoted to the same concerns. In *Naughty Bits* and *Artistic Licentiousness*, both dating from the late 1980s, she examined the relations between men and women—sometimes raging at the sexual ob-

jectification of her gender, sometimes pondering the clumsy poignancy of personal encounters. In *Naughty Bits*, we meet Midge, the protagonist of the "Bitchy Bitch" stories, Gregory's most sustained creative effort during this period. In these stories, Gregory deftly deploys the resources of the medium in the best traditional fashion to register Midge's exasperation at the indignities and inconsistencies of modern life. By drawing in a simple, big-foot style that permits her the wildest exaggeration in depicting Midge's state of mind, she achieves both hilarious comedy and biting, often ironic, commentary at the same time.

The more individual the works became, the greater the range of subjects. In the early 1970s Howard Cruse created (or recreated) the absurdist

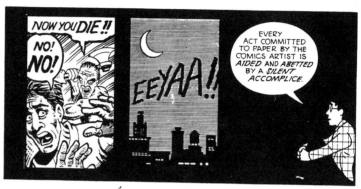

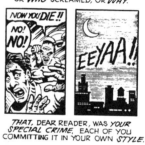

Figure 132. *One of McCloud's most compelling sequences blends the verbal and the visual—neither one alone making the sense that the two together achieve—to demonstrate, through the most vivid of images, the way that closure enlists the reader as a participant in the creative process at work in comics.*

Figure 133. *In another sequence from* Understanding Comics, *McCloud renders palpable, with yet another blend of word and picture, his plea to cartoonists to create poetry in their work. Note the way his extension of space to the right of the figure in the last panel makes space in which the reader can "create"; McCloud is practicing what he preaches.*

Figure 134. *Through his insightful analysis of the six kinds of panel-to-panel transitions cartoonists use (left), McCloud suggests ways to exploit the medium's capacities more fully. In the four-panel sequence below, he offers an example of aspect-to-aspect transition.*

Figure 135. *As long ago as 1968, in* Nick Fury, Agent of Shield *No. 2, Jim Steranko was exploring the evocative (not to say suggestive) possibilities in aspect-to-aspect transitions. Here he depicts a time of well-earned relaxation for Nick Fury, whom we see lounging in his apartment with his paramour. The concluding panel, showing Fury's gun in its holster, is a symbol doubtless lost on the younger readers—but scarcely likely to be overlooked by the older ones.*

Figure 136. *At the top, Gregory uses the exaggerative capability of the medium to make Bitchy Bitch's emotional life more vivid. The two strips at the bottom (the first one, but a fragment of a longer strip) demonstrate Cruse's delicate use of his visual resources as well as his off-the-wall sense of humor.*

comedy of the drug culture in his engaging *Bare-footz* strips. Initially aiming at an audience of campus dopers, Cruse produced strips whose "first order of business was to disorient" the reader, he said; "not only were there no jokes, there was no rationality."[68] The result is a marvelously inventive and richly humorous creation, exquisitely wrought with an immaculate simplicity of line that is often elegantly and painstakingly embellished with stippling and a variety of zipatone grays. In 1980 Cruse became the founding editor of *Gay Comix* at the urging of its publisher, Denis Kitchen; and in 1983 Cruse began exploring gay life in *Wendel*, a humorous, albeit sensitive, comic strip treatment of the subject for the *Advocate*; the strip has been collected twice into book form (*Wendel* and *Wendel on the Rebound*). With its fifth issue in 1984 *Gay Comix* began publishing Tim Barela's *Leonard & Larry*, a strip about the lives and families of a couple of homosexual men, whose personalities Barela develops as he shows them reacting to growing older, to their parents, and to their children by previous marriages.

Early in the eighties Kate Worley and Reed Waller took the license afforded them by the unfettered attitudes toward sex in comix and used it to create the series *Omaha the Cat Dancer*, a tasteful celebration of sexuality as experienced by anthropomorphic cats, one of whom is an exotic dancer by vocation. Daniel Clowes examined the social and personal detritus of popular culture in such eighties' undertakings as *Lloyd Llewelyn* and *Eightball*. Donna Barr applied her antic comedic imagination and fustian graphic styling to come up with *Stinz: Horsebrush and Other Tales*, about a centaur growing up as a farmer in the Geiselthal. She also created a longer-running series *The Desert Peach*, which recounts the outlandishly amusing adventures of Rommel's homosexual brother in the African campaign of World War II. Remarkably—considering the crassly commercial history of the medium—all these extremely personal endeavors found a market. And it was necessarily a market of adult readers: the more intimate the works became, the more they were addressed to the creators' peers.

Jim Woodring went even further in the direction of individual expression. Discarding all conventional story material, he produced comics for which he created a fantasy world that bears only a surface resemblance to the reality we all live in.

Woodring's linear graphic style is a striking blend of bold, flexing outlines and fine-line detailing, rich texturing with distinctive undulating contours and clean, solid blacks—making his work a pleasure to behold whether we understand it or not. And understanding it requires a suspension of more than just disbelief. Many of his stories are pantomimes featuring a vacuous bobtailed black cat named Frank (who in his appearance reminds us of vintage Felix the Cat) and his disturbing encounters with "Manhog," a creature part man and part hog who seemingly represents all the selfishness and evil of mankind. In another series, Woodring draws himself as the protagonist, a long-haired, bearded and bespectacled and mildly crazed artist, and then sends himself off on spooky meanderings in the course of which he is haunted by horrifying, inexplicable apparitions.

In one such tale, "What the Left Hand Did," Woodring comes upon two men torturing a third, whose arms and legs have been cut off. The two leave Woodring with their victim, who tries to tell Woodring something; but he can only blurt out incomprehensible syllables because his lower jaw has been removed. When the two tormentors return, they tell Woodring to stab their victim with a knife. Reluctantly, he does so—and the victim turns into a gigantic creature vaguely resembling a spinning top or possibly a hot-air balloon. Woodring talks to it for awhile, then it vacuums his clothes off, and when Woodring finds himself naked on the street, he throws a stick at the top/balloon, which punctures it. He then wraps himself in the deflated remnant in time to avoid arrest by a policemen who is looking for a naked man. In the very next panel, though, Woodring is fully attired in a pinstripe suit, talking to an attractive woman at a cocktail party.

Like many of Woodring's stories (particularly those in which he is a character), this one has about it the dreamlike quality of a children's tale. Laced with magical personages and unexplained happenings, the story proceeds like a fairy tale through a period of nightmarish danger, only to conclude happily when the danger is past. As in many such tales for the nursery, the crisis dissipates through no particular action by the protagonist: like a child, the central actor in the story is largely ineffectual (compared to an adult). And yet he survives the peril—perhaps because he is among the Elect, the cosseted children of the

TIPS & TECHNIQUES
OF CARTOONING AND HUMOROUS ILLUSTRATION

HOW MANY OF YOU ARE REALLY DISAPPOINTED BECAUSE YOU DON'T GET TO USE COLOR? OR CAN'T AFFORD DUO-SHADE®? (OR JUST LIKE B+W!)

(CONSIDER IT A LICENSE TO SCRIBBLE LIKE CRAZY!)

TRY THESE LITTLE TRICKS TO SUGGEST TEXTURE AND DEPTH.

TWEED AND HERRINGBONE

SWEEPING LINES FOR LOOSE FABRIC

DARK COLORS? DON'T WORRY ABOUT STAYING WITHIN THE LINES; TELL FOLKS THE MAN'S WEARING KNOBBY WOOL.

TINY STITCHES SEW TOGETHER A MUSCULAR LOOK

TINY LOOPS ADD HIGHLIGHTS

AND IF YOU EVER GET TO ADD THE COLOR — WAIT 'TILL YOU SEE HOW SPIFFY IT LOOKS WITH ALL THOSE BLACK ACCENTS!

EEK!

DONNA BARR 93©

Figure 137. *Here, Barr demonstrates her quirky but appealing style in hints to fellow cartoonists (and throws in a self-caricature as a bonus).*

world. But even so, he feels no sense of security during the threatening part of his ordeal: the dream is real, the terror likewise.

Woodring's stories bubble with symbolism, both visual and narrative, but they are not symbols that hold any particular external meaning for us. This private whimsical imagery is made coherent through the sheer narrative current of Woodring's storytelling, the symbols and signs acquiring whatever meaning they have from the context he supplies in the flow of the story. And that is precisely his achievement: he has made us believe in this very personal world of his imagination, a fantastic

world in which reality has come apart and nightmare has seeped in, a world where magic is accepted and horror, though palpable, is transient. It is a world more invisible than visible, and perhaps that is what makes it vaguely frightening. And it is a world not altogether unlike our own, as we are reminded by an unattributed quotation from a Woodring story, "Screechy Peachy": "The stars shine during the day though we cannot see them."[69] The horrors can be rendered invisible, too (but that doesn't mean they are not always there).

A much more conventional storytelling tech-

Figure 138. *A page from Woodring's story, "What the Left Hand Did," reveals just what it is the left hand did—in a fairly good demonstration of the nightmare vision that haunts his work.*

nique is on display in George Dardess's *Foreign Exchange*. But Dardess also exploited the peculiar capacities of the art form. The book tells the story of Rudi, a foreign exchange student who comes to this country to stay with Alvin Spratt and his family and attend Alvin's high school. But—and here is where Dardess began to deploy the resources of his medium—Rudi looks something like a dog. Actually, he looks exactly like a dog—except for his face, which is neither animal nor human. It's a sort of whiskery fringe wrapped around bulging eyeballs and a bulbous nose. Alvin knows immediately that Rudi is a dog. So do we: that's what we see in the drawings on the pages before us. But Alvin's mother does not see Rudi as a dog. She and most of the adults in the book insist that Alvin is a person. He is, after all, an exchange student, and he must perforce be a human being. When Alvin's classmates enter into a conspiracy to pretend that they, too, see Rudi as human, they lay the groundwork for Rudi's transformation and eventual tragedy.

Rudi is injured at a sporting event and taken, unconscious, to a hospital. (Everyone maintains he is human, so why not a hospital?) When he finally regains consciousness several days later, he has somehow acquired a human form. Instead of the dog Rudi, we see a handsome, dark-haired young man. Rudi is increasingly popular with his classmates. Smarter than many of them, he helps them with their homework; he begins dating one of the most attractive girls. Then one day we watch as he looks at himself in a mirror and sees, unexpectedly—the old dog face. Alarmed, Rudi flees, shoving his way through crowds of his fellow students. He bites one of them on the arm, and as he pushes past the janitor, he knocks the old man over; the old man suffers a stroke and dies. Rudi is now a wanted man, possibly a murderer. Rudi returns to the Spratts' home just as the young people are discussing him. He joins the discussion, telling them that at last he has come to recognize himself as he really is. Suddenly, he sees a cat outside the window and dashes from the room in pursuit of it. He runs out into the street, right into the path of an oncoming car. He is run over and killed. And when Alvin and the others come running up, they find only the body of the dog Rudi.

The story Dardess tells can be told only in comics: only a verbal-visual medium can do what is necessary to make this story work. For only in this medium can our perception of Rudi be manipulated as it is. And the book is about perception—or, rather, our tendency to have expectations that affect our perceptions of ourselves and others. It is a thoroughly human story. There is tragedy in it—but there's triumph, too. And by the end, we have learned something about the frailty of the human condition and how we must rise above it in order to become what we can become. Rudi's tragedy would not have occurred had he not allowed others' perceptions of him to chart a course he was not equipped to take.

Drawing in a style reminiscent of Winsor McCay's in *Little Nemo in Slumberland*, Dardess made his renderings more and more complex as the story unfolds, suggesting with the very pictures (as he says) the increasing richness of the inner lives of the characters, as the story builds in its contrasts and meanings. A teacher of literature in high school and in colleges, Dardess understood how literary narrative works. Moreover, he understood how comics are similar to—and how they differ from—strictly literary enterprises. And he was a thoroughly deliberate artist. In the "Instructor's Guide" he wrote for teachers who wished to use *Foreign Exchange* in their classrooms, he stated his purpose with lucid brevity:

> *Foreign Exchange* was made in the belief that the cartoon medium could meet the demands of mature fiction—that it could show character development, that it could be organized according to classic ideas of novelistic structure, that it could bear the weight of serious, complex themes. Yet the result should not, I believed also, have the effect of a bizarre tour de force. The novel in cartoon form should seem inevitable and right. It should be persuasive both as a novel and as a cartoon, and as both together. The novelistic elements should lend intellectual force and dignity to the cartoon medium, and the cartoon medium should bring to life the key visual elements of the story.[70]

Without question, Dardess succeeded in achieving what he set out to do. He structured his story like a classical drama, with conflict, climax, discovery, and denouement. He infused his tale with visual metaphors and narrative symbolism. In short, *Foreign Exchange* is as complex and mature a work of narrative art as we are likely to find, and it merits the kind of careful study we lavish on purely literary works. Serious in its purpose and skillfully executed, Dardess's book deserves to be read for its

Figure 139. *In Dardess's Foreign Exchange, Rudi takes up baseball because his classmates have accepted him as human, even though he obviously isn't. Notice the image in the last panel—the cloud of baseballs over the head of the pitcher, which suggests visually that he is about to experience a "rain" of baseballs as Rudi masters the batter's role.*

own sake—as an engaging story with a message worth pondering. But it is also worth examining as a thoroughly accomplished example of the art of the comics at its best—when words and pictures work together to convey a meaning that neither could alone.

As the nineties reached their midpoint, many others were telling stories in more or less conventional comics fashion, stories with beginnings, middles, and ends. But the arena in which they worked was now larger; a greater diversity of subjects was being explored. And a greater diversity of storytelling methods and graphic styles were possible. Mike Allred, for instance, mocked costumed

heroics with *Madman*, whose title character (calling himself Mr. Excitement) runs around in a pair of longjohns and combat boots seeking good deeds to do. But this is not a simple send-up in the *Mad* tradition. Drawn in a simple, unembellished, but realistic manner, the stories are full of quirky characters and clanking coincidence, and the masked Madman—an amnesiac who can't remember much about his secret identity—stumbles through a crime-ridden and nearly incomprehensible world, benignly pitting lunacy and innocence against evil idiosyncracies.

Also mocking the conventions of comic book heroicism, Sergio Aragones (with script assistance

from Mark Evanier) produced *Groo,* in which a co-lossally stupid itinerant warrior in an age of un-specified antiquity unfailingly destroys his foes, as well as all signs of civilization around him, in a carefully orchestrated series of flukes and misun-derstandings, the farcical uproariousness of which is enhanced by Aragones's flat-out big-foot draw-ings. Launched in 1982 as a backup feature in *Destroyer Duck* (a fund-raiser in support of Steve Gerber's suit against Marvel), Groo went on to star in his own magazine for three successive publishers—a success that, for such an offbeat sub-ject and eccentric treatment, would have been im-possible a dozen years earlier.

Even mainstream publishers climbed on the bandwagon when it came to unconventional mate-rial. Both DC and Marvel launched imprints for creator-owned stories, which were often decidedly innovative. And DC also struck a distribution deal with Milestone Comics, a company dedicated to racial and ethnic diversity in comics. In 1993, un-der the guidance of editor-in-chief Dwayne Mc-Duffie and creative director Denys Cowan, Mile-stone launched a series of titles starring blacks and Latinos in the roles of the superheroes. These were more than "Superman in blackface": the adven-tures were set in the fictional city of Dakota, but they rang true to the realities of inner-city life. In ambiance and language, *Static,* a title starring a high school superhero, seemed an authentic reflec-tion of teenage urban black America. And the quirky artwork by John Paul Leon and Steve Mit-chell gave the book a distinctive and attractive flair.

In *Hardware,* we meet Curtis Metcalf, a black scientific genius who has forged high-tech battle armor for himself so that he can wage war against injustice while working for millionaire industrial-ist Edward Alva, whose business Metcalf has en-riched with scores of inventions. The earliest stories in this title gain emotional impact from their allusions to America's racial history. The first issue begins with a parable about a parakeet, which, freed from its cage, flies about an apart-ment and runs its head repeatedly into the glass of the window. "He mistook being out of his cage for being free," a caption concludes. Later in that is-sue, Metcalf discovers that he has made the same mistake by thinking that his contributions to Alva Industries have won him some measure of status. He realizes that his enemy—the symbol of what is keeping Metcalf from being truly free—is Alva himself, "my benefactor," Metcalf says, for whom Metcalf's inventions have generated profits in the millions. The parallel to white enslavement of the African is clear: the wealth of the landed gentry of the antebellum South was, like Alva's fortune, built on the labor of others who did not share in the profits.

Metcalf then discovers that Alva is at the center of an "incredibly complex web of corruption" in-volving industry and politics and organized crime, and he resolves to destroy that empire. To this end, he assumes the identity of a superpowered hero named after his battle gear: Hardware. The book is not an out-and-out allegory, but the allu-sion lying behind the relationship between Metcalf and Alva gives the Hardware's crusade a thematic resonance missing from all other superhero titles on the newsstands. The reality it speaks to is a genuine reality, not a storybook one. The emotion-al undercurrents here are real, springing from a long history of racism and oppression. While Hard-ware's creators do not advocate racial warfare, they clearly urge an end to racism.

But McDuffie and his minions have the story-telling sense not to be somberly significant all the time. In the third of their initial titles, *Icon,* an alien who landed on Earth in the last century takes on the guise of an American black man. When his superpowers are discovered by an inner-city teenage girl, she talks him into becoming a superhero named Icon. But when he tries to help the police in pursuit of some wrongdoer, they question his motives, as they would any black man's. Icon mutters to himself in mock frustra-tion: "I bet this never happens to Superman."

While Milestone was establishing a record of re-liability, cranking out issue after issue of its maid-en flight of titles, every one on time, Frank Miller was at last doing what he most wanted to do. He had come to New York eager to do comic books about crime ("about tough guys in mean cities," he said) but had wound up doing superheroes be-cause that's all there was in comics at the time.[71] Then for Dark Horse Comics in 1991 he created Sin City, a fictional, crime-infested metropolis where he could explore in unrelieved black-and-white drawings the brutality and ruthlessness of the two-fisted denizens of the underworld. In the series of books that followed, Miller once again as-tonished the industry with his stylistic innova-

Figure 140. *It's always darkest night in Frank Miller's Sin City.*

Figure 141. *Bagge's visual exaggerations give his otherwise naturalistic version of the world a comedic flair (top tier); Sakai's beautifully rendered tales of a samurai rabbit often touch the heart; and (at the bottom) Martin creates manic mischief with Montgomery Wart and Cicero Buck.*

tion: all the pictures are drenched in solid black—the images, in effect, defined by silhouette and by highlighting features and portions of figures as if the subjects were standing in rooms completely dark except for a single light bulb, dangling naked (no doubt) from the ceiling. The lighting effects are wholly unrealistic but stunning in creating the uncompromisingly sordid world of Sin City.

At the opposite end of the spectrum of realistic rendering is the wildly exaggerated iconography of Peter Bagge. In successive issues of his comic book *Hate*, Bagge regales his readers with Pekar-esque

stories that would be bleakly naturalistic if it weren't for the stylistically comic representations of people, so comically extreme in abstraction and in reaction that they convert naturalism into a vitriolically funny satire about American society. In somewhat the same graphic mode are Mark Martin's manic "funny animals" in *Tantalizing Stories*, whose pages Martin shares with Woodring. Unlike the savagely satirical Bagge, however, Martin seems perfectly content in creating comedy of the most freewheeling and good-natured kind. Stan Sakai also works in the "talking animals" tradition, but his stories about a wandering masterless samurai rabbit named Miyamoto Usagi are told in all seriousness. Rendered in black and white with a pristine line and beautifully spotted blacks, *Usagi Yojimbo* often tells stories as emotionally touching as they are action-packed.

And this may be a good place to stop. The list has grown longer as the century draws to a close. But Usagi, the rabbit with a sword, allows me to segue into something George Dardess wrote, which offers an insightful way of ending this chapter:

Mickey Mouse is amusing, not because he is a mouse, but because he is a mouse behaving in some of the silly ways in which we behave. But silliness doesn't tell the whole story of our behavior. Mickey's least humanlike trait isn't his big ears or his long tail. It's his lack of a tragic dimension. The absence of this dimension in Mickey limits his appeal and seriousness. He can only be "cute." And just as Mickey has been limited, so has the American cartoon environment which he grew up in and came to define. It too has been limited by its emphasis on cuteness and superficial humor. No wonder that efforts to convince the American public of the medium's serious potential have often been met by skepticism.[72]

But that appears to be changing even as I write these lines at the end of 1994. The scope and variety in the work of this generation of comic book cartoonists is changing the public's perception of comics. The art of the comics is now, it seems to me, on the cusp of maturity in readership as well as content. Another golden age lies just ahead.[73]

Chapter 10
All Together Now

A wandering minstrel I—
A thing of shreds and patches
Of ballads, songs, and snatches . . .

Gilbert and Sullivan's song from *The Mikado* drifted into my head one day and wouldn't go away—an idea cast up on the beach of the brain, a bit of flotsam that wouldn't jettison. And what, I thought, has become of the wandering minstrel of yore? He's still with us, of course.

When we troop to the tube like so many children parading after some flickering pied piper, we may not know it, but we're participating in one of the more antique rituals of humankind. The glowing coals of a primitive campfire have been replaced by a glowing tube, but we're still gathering around a storyteller just the same. And we wait quietly there for him to weave around us his strange and magical spell. The troubadours, scops, jongleurs, and other kinds of wandering minstrels may answer to different names these days, but they're as capable as ever of holding us rapt for the nonce in worlds of their own fabrication—tangled webs of friendly fictions, things of shreds and patches, carefully raveled skeins of yarns through which are threaded the lore and laughter of this age and times past. They beckon to the ear but hold the heart.

If we revere today's storytellers less than we once did, it is merely because they've grown so numerous that we take them for granted. Not always, perhaps, but often. Still, we honor them with attentive ears (and eyes), even if the number of testimonial dinners is small.

By way of making up for the neglect—and as a grand finale to this epic opus—let us contemplate the cartoonist one more time as a simple storyteller. Storyteller, not technician. Cartoonists, illustrators, and writers—storytellers all. Just as surely as Gilbert and Sullivan wedded words to music, so have writers and comic book artists created stories by marrying words and pictures. It is sometimes an uneasy marriage, as I've frequently said: sometimes the words elbow the pictures out of the panels, and sometimes the images blot out the words. But Gilbert and Sullivan didn't always get along either—yet they worked together consistently enough to produce enduring stories.

For the occasion, I've chosen a story from the 1950s—a straightforward tale, told without fancy footwork. No razzle-dazzle layout or artful timing. Just a plain story, told with words and pictures by a master storyteller. Jack Kirby. Under Kirby's spell, comic books became a viable, lively entertainment medium: he gave us action-packed superheroics, and superheroes sustained the medium. He gave us romance as well as action. He gave us heroes with human dimension. And that is not all he did for the medium. Sometimes he elevated it to an art form. In the *Boys' Ranch* series, he did so often.

BOYS' RANCH ™

Figure 142. *Simon and Kirby give us Western action in their last book to feature a team of kids.*

For some, Kirby's name conjures up visions of the Fantastic Four or the Incredible Hulk or the Uncanny X-Men. For others, Captain America. The Boy Commandos, the Young Allies, the Newsboy Legion, the Young Explorers. Young Romance. The Forever People. The New Gods. For me, Jack Kirby means Boys' Ranch.

Created in collaboration with his associate, Joe Simon, *Boys' Ranch* ran to only six issues, but at least the first three of them were classics. And Kir-

by did most of the work. By this time, Simon was deeply engaged in managing their many joint enterprises. Much of *Boys' Ranch* was inked by Kirby as well as plotted and penciled. And it was magnificent. When the first issue of *Boys' Ranch* came out, I was a teenager aspiring to be a cartoonist, and Kirby's art left me gasping in awe.

In those days, Kirby's figures were supple and energetic, not ponderous and wooden; his style craggy but not massive. The elaborate cross-

Figure 143. *Kirby's craggy, chiseled graphic style had reached a peak in the 1950s, when* Boys' Ranch *was produced.*

hatching and feathering that marked the work Simon had inked early on in the partnership had given way to a simpler treatment. Thin angular lines chipped out the figures into geometric but sinewy shapes, and then a brush with a distinctive touch modeled the figures into fully rounded forms: clots of black, precisely placed, and trap-shadow shading gave the fine-line outlines mass and texture, form and depth. Kirby's inking preserved much of the free-flowing appearance of his penciled drawings, in which he often seemed to use the edge of his pencil point to shade a figure or strengthen a line, defining forms by accenting them with tiny dark wedges of graphite.[1]

But the artwork, so hypnotically appealing to a neophyte cartoonist like me at the time, was only part of the distinction of *Boys' Ranch*. The content of the stories was ingeniously selected and arranged so as to broaden and deepen our involvement with the series and its milieu. The books all opened with a frontispiece, a full-page pinup of the characters to be featured (figures 143 and 144). And each issue included a two-page center spread, presenting panoramic views of the characters at the ranch or in town. (In the third issue, it was a sa-loon brawl—"The biggest fight scene ever seen in comics," touted the cover.) The first issue included two pages that gave us biographical portraits in prose next to full-length pictures of each of the four main characters.

And the books' stories were among the most carefully crafted in comics. Attention to detail in the artwork seasoned the narratives with an authentic flavor of the old West, and care with characterization, plot, and motive lent the tales conviction, suspense, and moral fiber. Perhaps the most complex and profound of the stories was "Mother Delilah," which appeared in the third issue.

This story features the usual cast of characters, a team formula that Simon and Kirby had perfected in the Boy Commandoes. Dandy Dolan, a Union army veteran, is the "average boy"—bright, cheerful, confident, as eager for a good time as for a fight. Wabash, a veteran of the Confederate army, is a gangling youth whose antics and drawling sense of humor made him the chief source of comic relief (at least until a picaresque old desert rat, Wee Willie Weehawken, became the "oldest boy at Boys' Ranch"). Then there's Angel, a beautiful boy,

Figure 144. *On display here is more of Kirby's impressive 1950s styling.*

but with an ugly temper and a mean hand at gun-play. Finally, Clay Duncan, respected Indian scout and gunfighter, serves as the boys' mentor and guide; he's the adult figure in the series. Although each is a distinctive individual, in Angel Kirby achieved a minor masterpiece of characterization, a portrait that is also a penetrating psychological study.

His cherubic face framed by long golden hair, Angel looks his name, but looks are deceiving. He has a spiteful streak and a hair-trigger temper, backed up by unmatched skill with six-guns. Or-phaned like the other boys, Angel bears his fate as a grudge against the world—specifically, the adult world. He survives his sense of abandonment and loneliness by turning it into bitter hostility against all adults, who, in Angel's subconscious, represent the parents that he never had—the parents who in-explicably "deserted" him (by being killed in an Indian raid). The very mention of "parents" acti-vates Angel's psychic survival mechanism: six-guns blazing, he attacks whomever reminds him of parents—and in so doing, he strikes back at the mother and father he imagines were faithless, while at the same time asserting his independence from them.

"Ain't like other kids," he says when we first meet him. "They got mothers and fathers to fuss over 'em. Well, I don't need anybody. Nobody."

In his fierce denial of dependence, though, Angel unconsciously asserts the opposite—his deep need for parental affection and nurturing. His need is his Achilles' heel, and in the third issue of *Boys' Ranch*, Angel is nearly destroyed because of it.

In the twenty-page "Mother Delilah" tale that begins the issue, Delilah shears Angel's golden locks, destroying him as surely as her biblical namesake destroyed Samson. In the familiar Bible story, a tale of betrayal and revenge, Delilah is an agent of the Philistines, who pay her to discover the secret of Samson's strength. She uses Samson's love for her to worm the secret out of him, and then she cuts his hair. His hair shorn, Samson loses his great strength and is imprisoned. During long months in prison, his hair grows long again and his strength returns, and when next his ene-mies bring him out for their amusement, Samson destroys his tormentors by bringing their temple down upon them.

Predictably, "Mother Delilah" is a story about betrayal and revenge, too. But Kirby gave the tradi-tional tale new dimensions. His Samson and De-lilah story is also about redemption and love. And hate.

Delilah Barker, owner of the local saloon and gambling hall, is in love with Clay Duncan. One day in her saloon, she asks him to stay for dinner with her, but he refuses. The barflies who overhear this exchange roar with derisive laughter when Del doesn't get her way. Humiliated, she seeks revenge. Noticing Clay's fondness for Angel, Del decides to get even with Clay through the boy. "Angel with-out his guns," she muses, "is only a little boy."

Delilah befriends the long-haired Angel. Pretend-ing to be a lonely woman searching for a lost son, she appeals deliberately to Angel's need for a mother. Before long, they are playing the roles of mother and son every night over suppers that De-lilah herself fixes. She succeeds in getting Angel to take his guns off when he comes over to her house, and she begins to teach him how to read. And she starts to love the boy.

Just when Delilah's feigned affection for Angel begins to turn into something real, Clay Duncan comes calling. He tells Del to end her relationship with Angel. They're both living in a dream world, he says, and when Angel realizes it, he'll turn meaner than ever.

"You're fooling yourself," Clay says, "fooling the boy. End it now. I don't care how you do it, but do it."

"Even . . . even if it hurts Angel?" Del asks.

"Hurt Angel if you must. It's best for both of you," Clay replies.

Delilah cuts short her relationship with Angel by cutting his hair. Remarking one evening that his hair is so long it's messy, Del convinces Angel to let her give him a haircut—even though Angel says he'll be "the laughing stock" of the town if she does. The three pages of the story that follow are masterful examples of comics storytelling. Words and pictures blend to advance the story; nar-rative breakdown times the action, one increment of Angel's humiliation at a time, one charged in-stant after another.

On the first page (figure 145), Del cuts Angel's hair. He grabs a mirror to see what she's done. Panel 3 focuses on his clutching hand; unable to see what Delilah has done, our apprehension builds with Angel's. In panel 4, Kirby puts us in Angel's place. We look into the mirror just as he does. Uneven sprigs of hair have replaced the flow-

Figure 145. *Delilah sheers her Samson . . .*

ing locks. The wordless pictures enhance the horror of what he experiences with their unrelenting silence: words would reduce the impact of the pictures by dividing our attention, providing momentary relief from our forced contemplation of the ugliness of Angel's shorn head. Horrified at what

he sees, Angel turns to her in alarm, eyes wide with anguish—and she laughs at him. For two panels she laughs at him. And her laughter cuts into him as much as the barflies' laughter had cut into her when Clay refused her dinner invitation. Angel rushes from the house (figure 146), fleeing "that

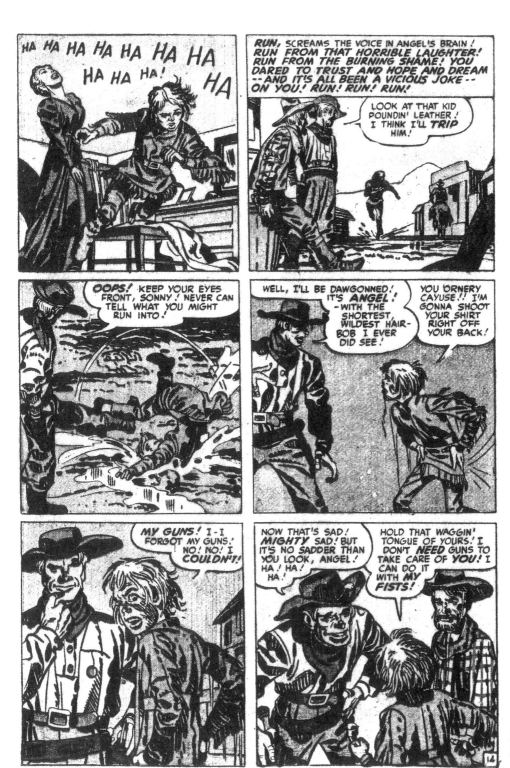

Figure 146. . . . *who finds himself helpless before his enemies . . .*

horrible laughter . . . the burning shame! You dared to trust and hope and dream, and it's all been a vicious joke—on you! Run! Run! Run!"

Is this Del's revenge on Clay for making her a temporary laughingstock? The parallel scenes, the echoes of the earlier laughter, suggest that it is.

But even as Delilah cuts Angel's hair, her agonized expression all but derails the parallel. We can almost see a tear glistening in the corner of her eye.

Running blindly down the street, Angel attracts the attention of some local toughs, who, recognizing him as the once long-tressed fire-eating Angel,

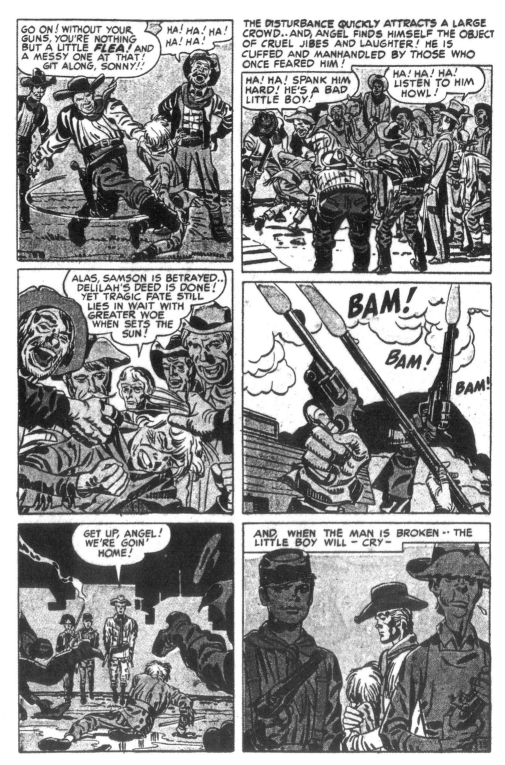

Figure 147. . . . *but is rescued by his friends.*

begin to ridicule his new haircut. In response, Angel slaps leather, intending to strike back at these adults in his usual way—with blazing guns. But he has left his guns at Delilah's house! Seeing him defenseless, the men gang up on him, cuffing and manhandling him. "Without your guns, you're nothing but a little *flea*!" "Spank him hard! He's a bad little boy!" "Listen to him howl!" The ruckus attracts a crowd, and all join in the fun (figure 147).

Gunshots still the commotion. Clay, Dandy, and Wabash stand at the crowd's edge. "Get up, An-

gel," says Clay, "we're goin' home!" In the page's last panel, framed by Dandy and Wabash standing guard, Angel clings to Clay, sobbing, while the caption intones, "And, when the man is broken—the little boy will cry." End of third page.

Back at the ranch, Angel burns with his need for revenge. But he's lost his touch. He spends hours target shooting but can't hit a thing. His friends observe that there's no fight left in the once ornery youth. At last Clay takes a hand and urges Angel to act like a man. Angel sobs that he can't: "I've got no more self-respect than a desert varmint. I can't stand up to the lowest cayuse in town. I can't even shoot straight anymore. I'm a kid, I tell you— just a harmless kid!"

Remarking that "your self-respect was clipped with your hair," Clay observes that Angel's hair is growing back. Angel feels his hair in amazement. Just then, a volley of gunshots rings out: Curly Yager and his cronies have come to Boy's Ranch to shoot it up. Angel quickly grabs Clay's guns and proves himself suddenly as adept as ever. Then, after the rowdies leave, Angel straps on his own guns, vowing to go into town and teach Curly and his boys a lesson.

In town at Del's saloon, Del overhears Curly and his pals planning an ambush of Clay and the boys. The raid on the ranch was intended to provoke a response, and Curly has his men stationed in the four corners of the barroom so that they can gun down Clay and the boys when they enter. Just then, in walks Angel. "Oh, no," Delilah breathes to herself. But before Angel can do more than pistol-whip one of his former tormentors, Clay and the others enter. Del leaps between Clay and the ambushers. "Clay! Look out!" she yells, "It's an ambush!"

Then the saloon explodes with gunfire. Curly and his men are killed. Clay and the boys emerge intact. But Delilah, caught in the line of fire, is dying, and when the acrid gunsmoke clears, we see Angel holding her in his arms. The story ends with a picture of him kneeling over her crumpled body on the saloon floor.

The story parallels its biblical model in its main features. Delilah betrays her Samson, and he loses his power but regains it when his hair grows back. But Kirby has enriched the original by imposing upon it a loftier moral than the exhortation to seek revenge for betrayal. Indeed, he discredited that motive altogether. Angel witnesses the de-

struction of his tormentors but does not, himself, destroy them. And his motive for seeking a confrontation with them is not revenge: it is to prevent their escalating a raid on the ranch into murderous warfare.

Kirby begins his embellishment of the biblical original by supplying a psychological explanation for "Samson's" loss of power and its subsequent return. Angel ostensibly loses his skill with guns because he loses his flowing locks. But what he actually loses is his self-respect. Without self-respect, he hasn't the confidence that his skill requires. Angel's self-respect is undermined and destroyed by his humiliation first at Delilah's hands and then at the hands of the street toughs who taunt him. Self-respect is an intangible facet of character; it is not bestowed from without but must grow from within. As Clay suggests, self-respect is as much a growth of the personality as hair is a growth of the head.

But it is not so much the return of Angel's long hair that restores his self-respect (although his improved appearance cannot but help improve his idea of himself in some measure) as it is his own skillful performance in response to Curly Yager's raid on the ranch. In the emergency, Angel sprang into immediate action—without thinking. Habit reasserted skill. At target practice, no real emergency existed, and Angel was governed only by frustrated rage, smoldering humiliation, and a burning desire for revenge—powerful feelings that consumed his attention, choking the habitual actions essential to his skill. But in the face of a real emergency, all such preoccupations were dashed from Angel's head, and the old habits and skills returned as if by magic. And with them came confidence and self-respect. And so the reciprocating engine of self-respect is kicked into cyclical motion: skill nurtures confidence, both produce self-respect, and self-respect, in turn, creates the confidence that contributes to skillful performance, and so on.

Thus is the Old Testament story's encouragement of vengeance discredited: the desire for revenge, Kirby shows us, is debilitating and is likely to end in frustration. But this story is more about love than it is about self-respect or revenge. And it is about Delilah as well as Angel. Both need love but discover that need alone will not generate it. Del wants Clay to love her, but he doesn't. To get even with Clay, she fakes affection for Angel. In re-

turn, she gets Angel's love—albeit under false pretenses. And Angel's need for a mother's love is so desperate that he cannot recognize its counterfeit.

Both orphaned boy and the spurned gambling queen seek love because they believe it will give them something. They are takers, but love does not come to those who seek to take it: it comes only to those who give it. As a sign that she is beginning to love Angel, Delilah starts to give him books and to teach him to read. But this is not yet true mother love. Clay is correct: they are living in a dream world, this phoney mother and this phoney son. The real world is quite different. In the real world, no mother would subject her son to the ridicule Del inflicts on Angel. And in the dream world, the false love Angel took for real plays him false, and nearly destroys him.

The story's title is a cryptic warning, certifying Clay's judgment. Coupling "mother" with a proper name, "Mother Delilah," suggests that the relationship is not a natural one (we call our real mothers simply "Mother") but adoptive and therefore potentially weak. And the proper name itself, with its biblical overtones, warns that this relationship will end with an unnatural betrayal.

But Delilah finally learns to give: she gives her life, the ultimate giving act of loving, to save the lives of Angel and Clay and the rest. In so doing, she earns honestly the love she had sought by trickery: Angel signals his love for her by holding her tenderly as she dies on the saloon floor. And Angel's last act of love is performed without hope of any return. At last both love by giving, not taking.

Delilah redeems herself by giving her life. Angel is motherless again, but he has known something approaching a mother's love. And although his "mother" has once again "left" him by dying, this time he knows why she died: she died not because she wanted to "leave" him but because she wanted to save him.

It is a moving story—more so than most of the comic book tales of the day (with the possible exception of some of Harvey Kurtzman's EC war stories). In some ways, the preceding issues of *Boys' Ranch* had been building to the culmination this story provides. At least, most of what we need to know about Angel in order to grasp the full import of this story, we learn in the stories that come before.

It is odd, perhaps, to find a comic book Western that takes love as its theme. Most Westerns are epic tales of law and order and justice, the fabric of the American mythology. *Boys' Ranch* deals with these themes, too. And the books blister with gunfire and danger and action. But Clay Duncan, surrogate father and older brother, presides over the boys' adventures. And he brings to the ranch not only knowledge and skill: he brings experience of life, wisdom, and counsel.

Every adventure has in it the seeds of a lesson in growing up, and Clay sees to it that the boys learn those lessons. It sometimes takes more courage to avoid a fight than to fight, he says. Don't out-fight: out-think. Reason like a man. Guns are for self-defense. Thus, the *Boys' Ranch* books are essentially stories about love, parental love—about caring and counseling. The "Mother Delilah" story emphasizes this underlying theme more than other stories, but it runs through them all. Perhaps that accounts for the profound and enduring appeal of *Boys' Ranch*. Parental love is vital to us all, and it can be broadened to embrace all forms of love, thereby achieving a universal quality.

The story of "Mother Delilah" is bracketed by poetry that extends its theme to universal dimensions. A derelict versifier begins the tale with a warning: to Delilah, he says, "Those who find love are indeed fortunate, but woe betide them who demand it." And he ends the story with a poetic coda, recited over the forms of Delilah and the kneeling Angel:

> And thus it ends. But ever to repeat
> Again and again in reality and rhyme—
> Love's ever new as morning's dew,
> And hate is old as time.

From hate springs the desire for vengeance, and that desire, as Angel discovers, is debilitating. And even love can turn to hate unless love's motive is a giving spirit. But a giving love is the ultimate redemption.

KIRBY WAS PROUD OF HIS LIFELONG PERFORMANCE as a storyteller. Like every performer, he knew he had to win his audience anew every time. And he never questioned that condition. It had kept him going at the drawing board for over fifty years. At a celebration of his art during the 1992 San Diego Comic Convention, he stood in front of an appre-

ciative audience waiting for the applause to stop. When it did, the old trouper said: "You've given me *the* reason for doing the best I can. I'll be devoted to you as long as I live."

At his seventy-fifth birthday party the night before, I had gone up to shake his hand. I told him that of all his works, *Boys' Ranch* was my favorite. Jack Kirby grinned. "It's mine too," he said.

NOTES

CHAPTER 2

1. Charles Wooley, *Wooley's History of the Comic Book, 1899–1936: Origin of the Superhero* (Lake Buena Vista, Fla: By the author, 1986), p. 5. The modern newspaper comic strip was only just taking shape when *Funny Folks* was published, but Howarth had been producing humorous narrative sequences of pictures in pantomime for over a decade for the weekly humor magazines. And so, indeed, had other cartoonists, but Howarth seemed to specialize in the format. Thus, pantomime cartoons employing a sequence of pictures were not particularly new by the end of the century, when the modern comic strip emerged (with much subsequent hullabaloo among historians); the thing that distinguished the modern comic strip from its predecessors was the incorporation within the pictures of speech balloons. The comic strip comedy of Howarth, like that of his contemporaries, was accomplished, as it were, in silence.

In recent years, a certain amount of to-do has attached itself to the unearthing of copies of the *Yellow Kid Magazine*, which was published by Smith and Street, beginning in March 1897. It ran for only a few issues, but it has been widely proclaimed as the first comic book because it is supposed that the magazine reprinted Richard F. Outcault's seminal comic strip from the pages of the *New York World*. If this supposition is true, then the *Yellow Kid Magazine* is probably the first of the genre that reprinted newspaper comics—and, hence, the precursor of the modern comic book. (The Yellow Kid would then become, loosely speaking, both the first comic strip character and the first comic book character, a serendipitous confluence of celebrity simply too auspicious to be endured.) I have seen the first issue of the *Yellow Kid Mag-*azine and thumbed carefully through it, page by page. It contains no reprints of Outcault's celebrated feature. The only Yellow Kid in evidence is the one on the cover. Otherwise, the interior is indistinguishable from that of any of the weekly humor magazines: it offers a certain number of humorous drawings, a couple of single-panel cartoons, and some short text pieces. On the evidence of this issue alone, it's clear that Outcault's famed Yellow Kid was being employed mostly as a device to attract buyers (much as the character had been used by Joseph Pulitzer and William Randolph Hearst to sell their papers in the famous New York newspaper circulation wars of the 1890s). Subsequent issues of the magazine might well have reprinted Yellow Kid cartoons, thereby asserting the publication's claim to being the prototypical comic book; but I doubt it. I suspect that all of the issues were pretty much like the first.

About another recent contender for the first comic book, the verdict is still out. Also starring Outcault's jug-eared waif, *The Yellow Kid in McFadden's Flats* (1897) is reported to feature prose narrative by E. W. Townsend with reprints of Outcault's cartoons as well as some pictures drawn expressly for the publication. I haven't seen this specimen, but it could be the first comic book.

2. The cover dates on comic books are not equivalent to the months of publication. Because of the vagaries of newsstand sales, comic books are cover-dated a month or more after their scheduled publication date. Any given issue of a periodical is presumed to be outdated by the time the next issue appears, so retailers customarily dispose of "last month's" issue of a comic book or magazine when "this month's" issue arrives. But if this month's issue is late in arriving (or never arrives—always

a possibility in the early days of comic book publishing), last month's issue will stay on the stand until the month of its cover-date is past. Thus, cover-dating a comic book a month or more after its actual date of publication provides a way of giving it a longer newsstand life. For example, if a comic book is published in January but cover-dated March (a typical interval between dates), it can stay on the newsstand for as long as three months, during which time it is more likely to sell out than if it were cover-dated February and removed from the stands at the end of that month.

3. "Joe Kubert Interview by Gary Groth," *Comics Journal*, no. 172 (November 1994): 63–64.

4. Ron Goulart, *Over 50 Years of American Comic Books* (Lincolnwood, Ill.: Mallard Press, 1991), p. 78.

5. Ibid., p. 75.

6. Tom Andrae, Geoffry Blum, and Gary Cuddington, "Of Supermen and Kids with Dreams," *Nemo: The Classic Comics Library*, no. 2 (August 1983): 11.

7. Goulart, *Over 50 Years of American Comic Books*, p. 78.

8. Jerry Bails and Hames Ware, eds., *Who's Who of American Comic Books*, vol. 4 (Detroit: Jerry Bails, 1976), pp. 335–40.

9. Ibid., p. 338.

10. Tom Heintjes, "Setting Up Shop," *Spirit: The Origin Years*, no. 2 (July 1992): 8.

11. "Len Wein," interview by Roger Slifer, *Comics Journal*, no. 48 (Summer 1979): 78; "Chris Claremont," interview by Margaret O'Connell, *Comics Journal*, no. 50 (October 1979): 55.

12. Daniel Mishkin, letter to the editor in "Blood and Thunder," *Comics Journal*, no. 47 (July 1979): 20–21.

13. "Jack Kirby Interview: Part One," *Nostalgia Journal*, no. 30 (November 1976): 21.

14. "Shop Talk with Jack Kirby," interview by Will Eisner, in *Will Eisner's Spirit Magazine*, no. 39 (February 1982): 24, 23.

15. Joe Simon, *The Comic Book Makers* (New York: Crestwood/II Publications, 1990), p. 47.

16. "Jack Kirby Interview: Conclusion," *Nostalgia Journal*, no. 31 (December 1976): 26.

17. James Steranko, *The Steranko History of Comics*, vol. 1 (Reading, Pa.: Supergraphics, 1970), p. 55.

18. Quoted in Goulart, *Over 50 Years of American Comic Books*, p. 117. See also Greg Theakston, *Jack Kirby Treasury*, vol. 1 (New York: Pure Imagination, 1982), p. 17.

19. Eisner, "Shop Talk with Jack Kirby," p. 26.

20. "Jack Kirby Interview," by Tim Skelly, *Nostalgia Journal*, 27 (August 1976): 17.

21. Steranko, *Steranko History of Comics*, 1:52.

22. Although in the postwar years Simon and Kirby were making good livings as comic book creators and producers, they were in the not unprecedented—and galling—situation of knowing that their most celebrated creation, Captain America, had earned great pots of money for other people. Like Siegel and Shuster (and every other comic book creator of the time), Simon and Kirby had given away ownership of their creation for a

page-rate fee. Then, in the anticommunist fervor of the early fifties, they perceived echoes of the anti-Nazi sentiments of prewar America: the time was ripe, they thought, for another comic book superpatriot. While much of their motivation for creating Fighting American was rooted in an entrepreneurial instinct to cash in on public enthusiasms, they also saw an opportunity to repeat their earlier success with Captain America and his young sidekick, Bucky—but this time, as Simon said, "the copyright would belong to Simon and Kirby." It was the work of but a few minutes to create and name the new superhero with a kid for a buddy. "Guess where we got the idea?" Simon asked in the introduction to the book in which all of *Fighting American* is reprinted (New York: Marvel Entertainment Group, 1989).

"Fighting American was the first commie-basher in comics," Simon continued. Caught up in the patriotic spirit of Senator Joe McCarthy's crusade against the Red Menace, he and Kirby produced the first issue of the new comic book in deadly earnest. Cover-dated April–May 1954, the first issue probably hit the stands in February. Shortly after that—on March 9, to be precise—Edward R. Murrow eviscerated McCarthy on CBS television. Suddenly, everyone could see that the crusading senator had no new clothes at all. His entire wardrobe was a fiction, a naked display of demagoguery. McCarthy, Simon realized, was "the lunatic fringe. . . . [He] was unmasked as a hysterical clown."

Feeling uncomfortable and perhaps a little foolish about Fighting American's grimly serious war on communists, Simon and Kirby quickly changed the direction of the comic book. "We relaxed and had fun with the characters," Simon explained. In the second and subsequent issues of the book, Fighting American and Speedboy are plagued by an assortment of villains who look and behave more like graduates of Max Sennett's Keystone Comedies than targets of McCarthy's commie hunt. Just as the senator's fall from power revealed that his fearsome communists lurking in the government were more akin to children's bogeymen than they were threats to national security, so did the commies in *Fighting American* become equally ineffectual bogeymen—or, rather, ludicrous buffoons. Thus, the demon of communism as conjured up by McCarthy was seen as something to laugh at. And with that, *Fighting American* achieved some modest stature as a satire.

But the comic book was not entirely successful as a satirical work. Neither Simon nor Kirby was suited to this kind of effort. They continued to play Fighting American and Speedboy perfectly straight while placing them in situations that were ridiculous in the extreme. In effect, the stories parodied superhero comics rather than communism and commie-bashing. Moreover, the humor was very broad and elementary, laced with juvenile jokes and punning names for villains. And not all of the stories were humorous. Doubtless Simon and Kirby had built up an inventory of stories based upon their initial premise before deciding to abandon that direction; rather than discard work already completed, they simply sandwiched these stories in with the others. Finally, af-

ter seven issues, Simon and Kirby gave up trying to make something of their abortive revival of a super-patriot.

23. Mike Benton, *Superhero Comics of the Golden Age: The Illustrated History* (Dallas: Taylor Publishing, 1992), p. 58.

24. Goulart, *Over 50 Years of American Comic Books*, p. 194.

25. "A Dame Deals Death," *Crime and Punishment*, no. 56 (November 1952): 1, 8. *Crime and Punishment* was Gleason's imitation of its own successful *Crime Does Not Pay*.

26. Goulart, *Over 50 Years of American Comic Books*, p. 217.

27. Ibid.

28. "Jack Kirby," interview by Gary Groth, *Comics Journal*, no. 134 (February 1990): 81.

29. Stan Lee, *Origins of Marvel Comics* (New York: Simon and Schuster, 1974), pp. 17–18.

30. Ibid., pp. 16–17.

31. According to Gil Kane: "The one great thing that Stan Lee, by accident, is responsible for is the fact that when Marvel was turning out all that work, he tried to write it all himself. He couldn't do all that work, so he let Jack Kirby and Steve Ditko make up all the plots on all of the strips that they did, every single one of them, without exception. And what he did was that after it was completely drawn, he would come by and put in the copy" ("Gil Kane on the Evolution of Comics Artists and the State of the Art," *Comics Journal*, no. 75 [September 1982]: 53–54).

A year earlier, Kane had described Lee's method in greater detail: "When Stan would plot in the early days, he would call you, he would plot loosely with you, and we would come back—everybody did in those early days—with a whole story pencilled out. Now, that was all right with Jack because Jack always rose to the level of Stan's expectation. And he drew every one of these things, just like Ditko did on *Spider-Man*. Ditko, in fact, would draw, and in the last two years, he never even spoke to Stan. They didn't speak at all. He would send in the stuff completely done, and Stan put in the copy, and it's just that both [Kirby and Ditko] had such a satisfying sense of narrative and drama that Stan could write for them. They were very good storytelling artists, and Stan was an adept lyricist. In those days, if you gave him something, no matter what, he was adept at placing balloons, he was adept at using dialogue, at heightening the characterizations that the artists gave him. He was able to write one book a night. He wrote one book a night for about ten years. It wasn't possible through any other technique. But I also think that not only was it easy for him, but it was also the best thing that happened to comics because Jack had so much to contribute. Since Stan didn't feel like writing full scripts and since Ditko and Jack were so full of narrative ideas, he was able to channel them to some extent. They did very well, and it seems to me that this is the collaborative effort" ("Forum: Gil Kane and Denny O'Neil on Comics Writing," *Comics Journal*, no. 64 [July 1981]: 73).

32. "Shop Talk with Gil Kane," interview by Will Eisner, *Will Eisner's Spirit Magazine*, no. 28 (April 1981): 21–22.

33. "Gil Kane on the Evolution of Comics Artists and the State of the Art," p. 54.

34. Groth, "Jack Kirby," p. 80.

35. Quoted in Ray Wyman, Jr., *The Art of Jack Kirby* (Orange, Calif.: Blue Rose Press, 1992), p. 106.

In addition to the above, the following works were consulted:

Inge, M. Thomas. "A Chronology of the Development of the American Comic Book." *The Official Overstreet Comic Book Price Guide*, 20th ed., pp. 71–76. Edited by Robert M. Overstreet. New York: House of Collectibles, 1990.

Jack Kirby Treasury. Vol. 2. Forestville, Calif.: Eclipse Books, 1991.

Jacobs, Frank. *The Mad World of William M. Gaines*. Secaucus, N.J.: Lyle Stewart, 1973. Repr. New York: Bantam Books, 1973.

"Shop Talk with Joe Simon." Interview by Will Eisner. *Will Eisner's Spirit Magazine*, no. 37 (October 1982): 20–27, 37–39.

Thompson, Don. "Comics Guide." *Comics Buyer's Guide*, February 9, 1993, pp. 28 and 32.

Yronwode, Catherine (with Denis Kitchen). *The Art of Will Eisner*. Princeton, Wisc.: Kitchen Sink Press, 1992.

CHAPTER 3

1. Quoted in Michael Parkinson and Clyde Jeavons, *A Pictorial History of Westerns* (New York: Hamlyn, 1972), p. 98.

2. Michael Parkinson and Clyde Jeavons, *A Pictorial History of Westerns* (New York: Hamlyn, 1972), p. 98.

3. Ware letter to me.

4. William Harper, *Tom Mix Original Art Catalogue* (N.p.: By the author, 1981), inside back cover.

5. Quoted in Bhob Stewart, "Howard Nostrand Interview," *Graphic Story Magazine*, no. 16 (Summer 1974): 25.

6. Howard Nostrand, "Nostrand by Nostrand," *Graphic Story Magazine*, no. 16 (Summer 1974): 18.

7. Ed Lane, *The Art of Bob Powell* (N.p.: Al Dellinges, 1978), [p. 14].

8. Stewart, "Howard Nostrand Interview," p. 21.

In addition to the above, the following works were consulted:

Savage, William W., Jr. *The Cowboy Hero: His Image in American History and Culture*. Norman: University of Oklahoma Press, 1979.

Smith, Henry Nash. *Virgin Land: The American West as Symbol and Myth*. New York: Vantage Books, 1957.

CHAPTER 4

1. Harvey Kurtzman with Michael Barrier, *From Aargh! to Zap!—Harvey Kurtzman's Visual History of the Comics* (New York: Prentice-Hall, 1991), p. 7.

2. "Forum: Gil Kane and Denny O'Neil on Comics Writing," *Comics Journal*, no. 64 (July 1981): 78.

3. Quoted in Tom Heintjes, "The Real Beginning," *Spirit: The Origin Years*, no. 1 (May 1992): 8.

4. Ibid.

5. Quoted in Tom Heintjes, "Taking a Chance," *Spirit: The Origin Years*, no. 3 (September 1992): 8.

6. Ibid., p. 16.

7. Quoted in Tom Heintjes, "Writing the Rules," *Spirit: The Origin Years*, no. 4 (November 1992): 8.

8. Quoted in Catherine Yronwode (with Denis Kitchen), *The Art of Will Eisner* (Princeton, Wisc.: Kitchen Sink Press, 1982), p. 44.

9. Ibid.

10. Quoted in Heintjes, "Writing the Rules," p. 8.

11. Commentary for the installment of June 9, 1940, "Spirit Bag #1," Collectors' Edition 1972. The "Spirit Bags" are plastic bags that contain several *Spirit* stories reprinted in black and white. On the last page of each story is a typewritten commentary written by Eisner. The publisher is not identified. See also Heintjes, "Taking a Chance," p. 24.

12. Quoted in Heintjes, "Writing the Rules," p. 16.

13. "An Interview with Will Eisner," by Richard Burton and Nick Landau, *Graphixus Magazine*, no. 4 (June–July 1978): 34.

14. Commentary for December 1, 1940, "Spirit Bag #3."

15. Quoted in Dave Schreiner, "The Beginnings of a Roll . . . ," *The Spirit*, no. 20 (June 1986), p. 32.

16. Yronwode, *Art of Will Eisner*, p. 32.

17. "Shop Talk with Milton Caniff," interview by Will Eisner, *Will Eisner's Spirit Magazine*, no. 34 (April 1982): 32.

18. Quoted in Dave Schreiner, "Making Contact with the Reader," *The Spirit*, no. 15 (January 1986), inside front cover.

19. "Shop Talk with Jack Davis," interview by Will Eisner, *Will Eisner's Quarterly*, no. 6 (September 1985): 48.

20. James Steranko, *The Steranko History of Comics*, vol. 2 (Reading, Pa.: Supergraphics, 1972), p. 113.

21. Quoted in Tom Heintjes, "Setting Up Shop," *Spirit: The Origin Years*, no. 2 (July 1992): 32.

22. Steranko, *Steranko History of Comics*, 2:116, 113.

23. Ibid., 2:113.

24. Quoted in Schreiner, "Making Contact with the Reader," inside front cover.

25. Steranko, *Steranko History of Comics*, 2:115.

26. Quoted in Heintjes, "Taking a Chance," p. 32.

27. Quoted in Dave Schreiner, "Cartoonists as Prisoners," *The Spirit*, no. 25 (November 1986), inside front cover.

28. Quoted in Dave Schreiner, "Legends Masked and Unmasked," *The Spirit*, no. 27 (January 1987): 32.

29. Kurtzman, *From Aargh! to Zap!* p. 8.

30. Quoted in Tom Heintjes, "Harried Holidays," *The Spirit*, no. 64 (February 1990): 16.

31. Quoted in Tom Heintjes, "Halloween Spirits," *The Spirit*, no. 63 (January 1990): 16, 32.

32. Michael Barrier, "Comics Master: The Art and Spirit of Will Eisner," *Print* (November–December 1988): 197–98.

33. Quoted in Steranko, *Steranko History of Comics*, p. 115.

In addition to the above, the following works were also consulted:

Benton, Mike. *Masters of the Imagination*. Dallas: Taylor Publishing, 1994.

Goulart, Ron. *Over 50 Years of American Comic Books*. Lincolnwood, Ill.: Mallard Press, 1991.

While I did not consult Will Eisner's *Comics and Sequential Art* (Tamarac, Fla: Poorhouse Press, 1993), it is well recognized as an authoritative commentary on the art of the comics, one that provides through the eyes of a master cartoonist rare insight into his craft.

CHAPTER 5

1. Quoted in Ron Goulart, *Over 50 Years of American Comic Books* (Lincolnwood, Ill.: Mallard Press, 1991), p. 244.

2. "An Interview with Gil Kane," by Gary Groth, *Comics Journal*, no. 38 (February 1977): 43.

3. "Shop Talk with Gil Kane," interview by Will Eisner, *Will Eisner's Spirit Magazine*, no. 28 (April 1981): 24.

4. "Forum: Gil Kane and Denny O'Neil on Comics Writing," *Comics Journal*, no. 164 (July 1981): 73.

5. Quoted in Jerry Robinson, *The Comics: An Illustrated History of Comic Strip Art* (New York: G. P. Putnam's Sons, 1974), p. 18.

6. Eisner, "Shop Talk with Gil Kane," p. 23.

7. Gil Kane, *Blackmark* (New York: Bantam, 1971), last page (pages are unnumbered).

8. Quoted in Ron Goulart, "Star Hawks," *Cartoonist PROfiles*, no. 35 (September 1977): 31.

9. Ibid.

10. "Gil Kane," interview with Burne Hogarth, *Cartoonist PROfiles*, no. 37 (March 1978): 35.

11. "An Interview with Gil Kane," by Gary Groth, *Comics Journal*, no. 38 (February 1977): 41.

12. Eisner, "Shop Talk with Gil Kane," p. 22.

13. Ibid., p. 24.

14. Ibid., p. 23.

15. Ibid., p. 22.

In addition to the above, the following works were consulted:

Levy, Mervyn. *The Human Form in Art*. London: Oldhams Books, 1961.

Steranko, [James]. *Chandler*. New York: Pyramid Books, 1976.

CHAPTER 6

1. "An Interview with the Man behind EC," by Dwight Decker and Gary Groth, *Comics Journal*, no. 81 (May 1983): 56.

2. "Shop Talk with Jack Davis [and Harvey Kurtzman]," interview by Will Eisner, *Will Eisner's Quarterly*, no. 6 (September 1985): 42.

3. EC's bafflingly eccentric numbering system can be explained in purely financial terms. The post office required a publisher to pay $2,000 for a second-class mailing permit whenever a new title was introduced. At first, Gaines sought to avoid the charge by trying to make it seem that every new magazine he concocted was actually just an existing publication with a slightly modified title. Thus, *Moon Girl and the Prince*, a space adventure comic book, became *Moon Girl* (space adventures still), and then *Moon Girl Fights Crime* (crime in space), and then *A Moon, A Girl—Romance* (love stories). As time went on, however, Gaines discarded such semantic niceties and simply renamed his magazines. But he kept the same numbering sequence, hoping the post office would assume the new magazines were merely another manifestation of a continuing publication.

4. "The War Panel," transcript of taped proceedings, *Squa Tront #8* (New York: John Benson, 1978), p. 33.

5. Quoted in *Two-Fisted Tales*, vol. 1 (West Plains, Mo.: Russ Cochran, 1980); the editorial notes and interview by John Benson appear at the end of #23.

6. "Shop Talk with Harvey Kurtzman," interview by Will Eisner, *Will Eisner's The Spirit*, no. 31 (October 1981): 22.

7. "An Interview with the Man Who Brought Truth to the Comics," by Kim Thompson and Gary Groth, *Comics Journal*, no. 67 (October 1981): 80; Harvey Kurtzman with Howard Zimmerman, *My Life as a Cartoonist* (New York: Pocket Books, 1988), p. 64.

8. Eisner, "Shop Talk with Harvey Kurtzman," p. 22.

9. Ibid., p. 27.

10. Harvey Kurtzman with Michael Barrier, *From Aargh! to Zap!—Harvey Kurtzman's Visual History of the Comics* (New York: Prentice-Hall, 1991), p. 22.

11. Thompson and Groth, "An Interview with the Man Who Brought Truth to the Comics," p. 81.

12. Decker and Groth, "An Interview with the Man behind EC," p. 79.

13. Kurtzman, *From Aargh! to Zap!* p. 41.

14. Mark James Estren, *A History of Underground Comics* (San Francisco: Straight Arrow Books, 1974), p. 38.

15. The "What? Me Worry?" kid actually appeared first as one of dozens of tiny illustrations that parodied a page of the Sears catalogue on the cover to *Mad* No. 21 (cover-dated March 1955), but he was scarcely a featured player at that time. But with issue No. 24, he became a focal point on the decorative border of the cover and, hence, gained the chief symbol of the magazine's antic attitude.

16. Adam Gopnik, *New Yorker*, March 29, 1993, p. 75.

17. Quoted in Ron Goulart, *The Encyclopedia of American Comics from 1897 to the Present* (New York: Facts on File, 1990), p. 334.

In addition to the above, the following works were also consulted:

Goulart, Ron. *Over 50 Years of American Comic Books.* Lincolnwood, Ill.: Mallard Press, 1991.

Harvey, R. C. "Cartooning, Comix, Comics, the Classics, and the Kitchen Sink." *Cartoonist PROfiles*, no. 97 (March 1993): 74–81.

Jacobs, Frank. *The Mad World of William C. Gaines.* New York: Bantam, 1973.

Print, November–December 1988, a special issue on comics; see especially, Paul Gravett, "Euro-Comics: A Dazzling Respectability," pp. 74–87, 204, 206; Gary Groth, "Grown-Up Comics: Breakout from the Underground," pp. 98–111; and Arlen Schumer, "The New Superheroes: A Graphic Transformation," pp. 112–31.

CHAPTER 9

1. Charles Perry, *The Haight-Ashbury: A History* (New York: Random House, 1984), p. 245. The description of the Haight to follow is derived from Perry's book. I am also indebted to comics historian Clay Geerdes, who cheerfully checked the factual accuracy of this chapter, as well as the portions of chapter 6 having to do with underground comix and cartoonists. Living in Berkeley, Geerdes began in October 1973 to produce a newsletter about underground comix and related matters. At that time, he also started a journal in which he recorded the day he acquired each new underground comic book. "I know exactly when this or that book came into the Print Mint warehouse in Berkeley or to Last Gasp in San Francisco," he says in "The Dating of Zap Comix," an unpublished manuscript (1994, copyright by Clay Geerdes), from which I will quote with permission from time to time herein. Although Geerdes was not keeping his journal during the formative period covered in these pages, his interest in underground cartooning grew over the years, and he tried to get to know as many of the cartoonists as possible. In conversations with them, he picked up knowledge of the early history of comix. And he dug deeper into the matter as he began seeing erroneous assertions in print in various publications. In the rare instance where I disagree with Geerdes's conclusions, I acknowledge his alternative position.

2. Ibid., p. 252.

3. Mark James Estren, *A History of Underground Comics* (San Francisco: Straight Arrow Books, 1974), p. 50.

4. Perry, *Haight-Ashbury*, p. 112.

5. Robert Crumb, "Introduction," *The Complete Crumb Comics*, vol. 4 (Seattle: Fantagraphics Books, 1989), p. x.

6. Ibid., p. xiv. Crumb's recollection isn't quite accurate: *Zap Comix* No. 1 contains one three-page story that consists entirely of abstractions arranged in irregularly shaped panels. Geerdes states that the magazine was printed on February 24, folded and stapled on the floor of Crumb's apartment that same day, and sold on the streets the next day. The first printing wasn't even trimmed, so after the folding and stapling, the edges of the magazine's pages didn't line up evenly ("Dating of Zap Comix," p. 1; and Geerdes' letter to me, dated De-

cember 10, 1994). The first printing of *Zap Comix* No. 1, incidentally, carries on the back cover the notation "Printed by Charles Plymell." According to Geerdes, the various "printings" of *Zap* No. 1 are virtually meaningless: "Donahue had that [printing] press in the same room where he slept. He could run off a hundred now, a hundred later, a hundred a week later; it wasn't like they went to a regular printer and ordered a specific number of books" (letter to me, dated December 24, 1994).

7. Robert Crumb, "Introduction," *The Complete Crumb Comics*, vol. 5 (Seattle: Fantagraphics Books, 1990), p. viii.

8. Ibid. Robert Williams lived in Los Angeles and did posters for Big Daddy Roth. He became a contributor to *Zap* with the fourth issue; he also produced his share of complete comix books over the next few years. Like Moscoso and Griffin, Williams is a marvelously inventive graphic designer. He is also a fantasist of great imagination, and this combination has produced some of the most fascinating of visual innovations. The character associated with Williams's comix work is a mythical insect, Coochy Cooty. The seventh regular *Zap* contributor was Spain Rodriguez, whose work began appearing with *Zap* No. 6.

9. Ibid., p. vii.

10. Ibid.

11. This is Crumb's own self-analysis, as presented in two installments of "My Troubles with Women" (*Zap Comix*, 1980; *Hup*, 1986; both repr. in *My Troubles with Women* [San Francisco: Last Gasp, 1992]).

12. Quoted in Marty Pahls, "Introduction," *The Complete Crumb Comics*, vol. 1 (Seattle: Fantagraphics Books, 1987), p. xi.

13. Ibid., p. xii.

14. Quoted in Marty Pahls, "Introduction," *The Complete Crumb Comics*, vol. 3 (Seattle: Fantagraphics Books, 1988), p. vii.

15. "The Straight Dope from R. Crumb," interview by Gary Groth, *Comics Journal*, no. 121 (April 1988): 62; see also Pahls, "Introduction," *Complete Crumb Comics*, 3:xi.

16. Crumb, "Introduction," *Complete Crumb Comics*, 4:viii.

17. Groth, "Straight Dope from R. Crumb," pp. 70–71.

18. Crumb, "Introduction," *Complete Crumb Comics*, 4:viii.

19. Crumb, "Introduction," *Complete Crumb Comics*, 5:viii.

20. Quoted in Stanley Wiater and Stephen R. Bissette, eds., *Comic Book Rebels: Conversations with the Creators of the New Comics* (New York: Donald Fine, Inc.), p. 38.

21. Ibid., pp. 35–36.

22. Thomas Albright, "Zap, Snatch and Crumb," *Rolling Stone*, no. 28 (March 1, 1969), p. 25; quoted by Donald M. Fiene, *R. Crumb Checklist of Work and Criticism* (Cambridge, Mass.: Boatner Norton Press, 1981), p. 153; and Claude Chadwick (pseud. of Marty Pahls), "Robert Crumb: King of the Underground Comics," *National Insider* 14, no. 4 (January 26, 1969), p. 13.

23. R. Fiore, "Funnybook Roulette," *Comics Journal*, no. 121 (April 1981): 45–46.

24. Estren, *History of Underground Comics*, pp. 236–37.

25. Geerdes, "Dating of Zap Comix," p. 4.

26. Frank Stack's letter to me, dated January 15, 1995. "Something else about Gilbert," Stack goes on: "He was an active participant in the Austin music scene, jammed on the banjo at Threadgills, wrote country blues songs, and recorded the memorable 'Set Your Chickens Free!' He was also an amateur athlete and semi-professional stock car racer. Modest on one level, supremely cocky and confident-seeming to others—he was extraordinarily good-looking and charismatic. Several beautiful women in Austin and San Francisco were in love with him. He was an amusing and attractive guy—genuinely brilliant, too—still is, though ravages show in his countenance now (well, wouldn't they, twenty-five years later?)."

27. Quoted in Wiater and Bissette, *Comic Book Rebels*, p. 33.

28. Stack's letter to me. Initially, Stack told me the story of the origins of *The Adventures of J* in a telephone conversation on January 3, 1995. The little eight-page (plus cover) opus was produced, he thought, either in the late summer or the fall of 1962, probably after the collapse of Shelton's newsletter (but maybe not). He also told me that he had wanted Shelton to call Wonder Wart-Hog "the Pig of Iron," but Shelton didn't go for it. Stack remembered that it was Bill Helmer, then an editor with *True West* magazine, who photocopied the first issue of the booklet. But when I talked to Helmer a week or so later, he said he wasn't in Austin at the time.

A former editor of the *Texas Ranger* (he succeeded Stack), Helmer was in New York while Stack was there; he returned to Austin in 1963. He lived near Shelton, and Shelton gave him some copies of *The Adventures of J*, which, Helmer believes, had been sitting around in a desk drawer somewhere, uncirculated: the pages Helmer received weren't even stapled together. Helmer took them to his office and ran off a few copies, earning a look askance from his boss, Joe Small, who was a fairly religious fellow.

Geerdes quite rightly points out that these early productions have only been termed *underground comix* in retrospect: "The concept [of underground comix] was unknown in 1962; it became popularized in the mid-1960s through the proliferation of underground newspapers" ("Dating Zap Comics," p. 3).

29. Estren, *History of Underground Comics*, p. 59.

30. "Rip Off Press: The Publishing Company That's a Little like the Weather," interview with Gilbert Shelton, Fred Todd, and Don Baumgart, *Comics Journal*, no. 92 (August 1984): 69.

31. "The Strange World of Snappy Sammy Smoot: An Interview with Skip Williamson," by Grass Green, *Comics Journal*, no. 104 (January 1986): 52.

32. "Destroying Idols: The Role of Satire and the Free Press in Comics," an interview with Jay Lynch by Grass Green, Craig Yoe, and Jackie Lait, *Comics Journal*, no. 114 (February 1987): 86.

33. Dave Schreiner, *Kitchen Sink Press: The First 25 Years* (Northampton, Mass.: Kitchen Sink Press, 1994), pp. 8–15 (quote from p. 13).

34. R. C. Harvey, "Zippy and Griffy," an interview with Bill Griffith, *Cartoonist PROfiles*, no. 101 (March 1994): 37. The rest of Griffith's remarks here are taken from this article.

35. Groth, "Straight Dope from R. Crumb," p. 88.

36. Robert Crumb, "Introduction," *The Complete Crumb Comics*, vol. 6 (Seattle: Fantagraphics Books, 1991), p. viii.

37. Groth, "Straight Dope from R. Crumb," p. 120.

38. Ibid. Crumb's memory is probably a little hazy. Dana was undoubtedly collecting welfare checks, but that could scarcely have been their only income. Crumb had sold cartoons to *Cavalier* magazine throughout 1968, and he had been advanced $2,500 by Viking for a book of Fritz the Cat (which was eventually published by Ballantine in 1969). And Viking presumably paid him for *R. Crumb's Head Comix*, which came out in the summer of 1968. In 1968 he also designed the cover for Janis Joplin's album *Cheap Thrills*. Then in 1969 Ballantine brought out its edition of *Head Comix*, for which Crumb received an advance of $5,000; and he did a second album cover for Joplin. In addition, he contributed artwork to a dozen or more papers or magazines in 1969, and he did stories for over two dozen comix. The pay might not have been lavish, but, given that Crumb was the underground's best-selling cartoonist, it could not have been entirely negligible. Crumb almost certainly didn't pay much attention to money, and he may not have carried much around with him—and Dana doubtless acquired a good bit of what he earned. But they were not poverty-stricken.

39. Crumb, "Introduction," *Complete Crumb Comics*, 5:vii–viii; all of this, as well as the preceding paragraph, is based upon information found in these pages.

40. Fiene says it was the Ballantine advance of $5,000 in 1969 that Dana invested in the Potter Valley property (p. 154). He pegs the Krantz advance at $7,000 in August 1970 (p. 155). The $10,000 payment mentioned here, as well as the amounts of subsequent payments, were supplied by Crumb during his interview with Gary Groth. But the cartoonist's ability to recall facts from the past on the spur of the moment is probably no better than anyone's. According to Fiene, the amounts of the supplemental payments were not very great; but the last payment, reportedly $31,000, wasn't received until after Fiene's book was published.

41. Crumb's account of the Fritz the Cat episode can be found in Groth, "Straight Dope from R. Crumb," pp. 74–75. Bakshi had split with Krantz by the time *Nine Lives* was produced; it was directed by Robert Taylor and released in 1974 (Fiene, *R. Crumb Checklist*, p. 92).

42. Thomas Maremaa, "Who Is This Crumb?" *New York Times Magazine*, October 1, 1972, p. 73.

43. For an account of this period in his life, see Robert Crumb, "Introduction," *The Complete Crumb Comics*, vol. 7 (Seattle: Fantagraphics Books, 1991), pp. vii–viii.

44. Donald M. Fiene, "Crumb Chronology," excerpted in the *Comics Journal*, no. 121 (April 1988): 123. To put Crumb's rate of production in perspective, we can imagine that a full-time comic book cartoonist working on a monthly comic book during the same period probably cranked out about two hundred pages a year. John Byrne may have done as much as 280 pages a year (my estimate) on his *Next Men* series for Dark Horse. Alex Ross, doing full-color paintings for *Marvels*, says he produced all 180 pages in a year, an extraordinary feat (see "Overthinking Things," his afterword in *Marvels*, the trade paperback that reprinted the five issues of the magazine [New York: Marvel Comics, 1994], n.p.). Jack Kirby—whose ability to generate prodigious quantities of top-notch work is one of the wonders of the modern world—averaged 375 pages a year over his half-century career. Incredible though it may seem, in 1962, his most prolific year, he produced 1,158 pages of comic book art (Ray Wyman, Jr., *The Art of Jack Kirby* [Orange, Calif.: Blue Rose Press, 1992], p. xxxiv).

45. Groth, "Straight Dope from R. Crumb," pp. 119–20.

46. Ibid., p. 110.

47. Ibid., p. 118.

48. Dennis O'Neil, "Green Thoughts," introduction to *Green Lantern, Green Arrow: The Collection*, vol. 1 (New York: DC Comics, 1992), n.p.

49. Letter from Steve Gerber, published in "An Interview with Steve Gerber," by Gary Groth, *Comics Journal*, no. 41 (August 1978): 29.

50. "Howard the Duck" entry in Leonard Maltin, *TV Movies and Video Guide: 1992 Edition* (New York: Signet, 1991), p. 554.

51. *The Art of Frank Thorne* (N.p.: Cartoonews, 1978), n.p.

52. Frank Thorne, "Afterword," *Ghita of Alizarr* (San Diego: Blue Dolphin Enterprises, 1983), p. 98.

53. Harvey Pekar, "Stories about Honesty, Money, and Misogyny," interview with Gary Groth, *Comics Journal*, no. 97 (April 1985): 46.

54. Ibid., p. 47.

55. Geerdes, "Dating Zap Comics," p. 9.

56. Pekar, "Stories about Honesty," p. 62.

57. Pahls, "Introduction," *The Complete Crumb Comics*, vol. 2 (Seattle: Fantagraphics Books, 1988), p. x.

58. The work had an earlier incarnation in a different graphic style. Drawn in 1972, this trial version had been published in the second issue of *Comix Book* (January 1975), Denis Kitchen's foray into editing for Marvel Comics. It was also published in *Breakdowns*.

59. The roman numerals in the page citations refer to one or the other of the two volumes of *Maus*. The first volume is called *Maus: A Survivor's Tale* (New York: Pantheon, 1986); the second, *Maus II: Here My Troubles Begin* (New York: Pantheon, 1991).

60. I am grateful to Allan Holtz for mentioning this work to me and for sending me a list of the animals and the nationalities they represented. Even without having seen *The Beast Is Dead*, however, I venture to guess that its deployment of the animal metaphor is much more

conventional than Spiegelman's. And much less debatable.

61. Art Spiegelman and Françoise Mouly, "Jewish Mice, Bubblegum Cards, Comics Art, and Raw Possibilities," interview by Joey Cavalieri, *Comics Journal*, no. 65 (August 1981): 105–6.

62. Quoted in Joel Garrick, "Comic Horror," *How* (March 1987), p. 80.

63. Joseph Witek, *Comic Books as History: The Narrative Art of Jack Jackson, Art Spiegelman, and Harvey Pekar* (Jackson: University Press of Mississippi, 1989), p. 112.

64. Quoted in Garrick, "Comic Horror," p. 82.

65. Scott McCloud, *Understanding Comics* (Northampton, Mass.: Tundra, 1993), p. 152.

66. Ibid., p. 63.

67. Ibid., p. 79.

68. Howard Cruse, *Early Barefootz* (Seattle: Fantagraphics Books, 1990), p. 13.

69. Jim Woodring, *The Book of Jim* (Seattle: Fantagraphics Books, 1993), p. 64.

70. George Dardess, "Instructor's Guide," *Foreign Exchange: A Novel*, (Rochester, N.Y.: Austen Press, 1994), p. 5.

71. "Interview with Frank Miller," *Advance Comics*, no. 71 (November 1994): 67.

72. Dardess, "Author's Foreword," *Foreign Exchange*, p. iv.

73. This happy forecast is entirely dependent upon the continued vitality of the direct sales network of retail stores. As I've indicated, the economic success of the direct sales market is largely responsible for the emergence of comics that are personal works of art rather than corporate money-making mechanisms. But the direct sales market is extremely volatile. Its health is perpetually endangered by the greed or ignorance of the entrepreneurs who work in it at every level. Because the market swings wildly from boom to bust, fluctuating with the mood of acquisitive collectors and speculating investors, the financial viability of the system is precariously balanced between over-supply and fickle demand. This delicate balance is threatened constantly by the raw inexperience of many retail store operators, who are often little more than avid comic book readers, and by the unrealistic aspirations of amateur cartoonists who publish their own comic books, often anticipating overnight success when their product is hopelessly self-indulgent and therefore of negligible appeal to other readers. These two aspects of the market can alone shut down a retail store: the enthusiastic store operator orders a great many comic books from a small publisher, basing his order upon the rave reviews the novice cartoonist/publisher himself supplies; if the books don't sell, the store operator is stuck with inventory and no cash to order next month's Marvel Comics titles. He declares bankruptcy and hires on to clerk in someone else's store.

Hundreds of stores are reported going out of business every other year or so. And every recurrence of the phenomenon drives a few alternative publishers out of business. They survive with orders for small quantities of their comic books only because there are lots of stores, whose small-quantity orders add up. The fewer stores, the fewer orders; and the small publishers are the first to be hurt badly. The major comic book publishers will undoubtedly continue to prosper even as the direct sales network frays and reknits itself and then unravels again. But since the most personal expressions of comic book art depend upon the interest and enthusiasm of small publishers, the artistic future of the medium is always in doubt. Another golden age lies just ahead, but the road to it is not without potholes and pitfalls.

In addition to the above and the numerous comic books mentioned in the text, the following works were consulted:

Pekar, Harvey, and Joyce Brabner. *Our Cancer Year*. New York: Four Walls Eight Windows, 1994.

Barela, Tim. *Domesticity Isn't Pretty*. Minneapolis: Palliard Press, 1993.

CHAPTER 10

1. By this time, Kirby was surely doing most of the creative work for the team. When asked by Gary Groth whether he had written *Boys' Ranch*, Kirby replied, "Yes, I wrote *Boys' Ranch*. I always wrote my strips" (*Comics Journal*, no. 134 [February 1990]: 71). The interview with Groth took place during the time that Kirby was trying to retrieve his original artwork from Marvel, and the adversarial circumstances may have made Kirby more affirmative and unequivocal than he might otherwise have been. But some of what Simon has said supports the notion that Kirby had become the main creative engine by the time *Boys' Ranch* was being produced.

When Will Eisner interviewed Simon, he repeatedly came back to the question of who did what in the partnership. Initially, Simon said that he wrote the stories, doing layouts with rough pencils as well as writing dialogue. Kirby would tighten the pencils—he "interpreted" them, as Simon said later; and then Simon would ink. This was "pure Simon and Kirby," he told Eisner. But he admitted almost at once that "pure Simon and Kirby" was confined almost entirely to the first *Blue Bolts* they did. "There were not too many pure Simon and Kirby," he went on, "because when we did Captain America, we would turn the pencils over to other inkers who outlined the pencils with ink. If there was time, Jack and I then laid in the shading" (*Will Eisner's Spirit Magazine*, no. 34 [October 1982]: 27). He was particularly proud of his unique cross-hatching technique for feathering: "It wasn't the upfront square cross-hatching, the cross-hatching that *we* did was angular—where you'd wind up with a lot of little triangles if you put it under a microscope. The lines would be heavier to get into the dark areas. Our cross-hatching wasn't flat. We tried to achieve varied blending" (p. 23).

Later, as Eisner kept returning to the subject of which of them did what, who influenced whom, Simon responded: "I will say one thing. It was a pastime of mine to sit around and come up with ideas. I'd constantly make up dummies—mock-ups of new comics. The ro-

mance books, *Black Magic*, many of the superheroes—were my ideas. However, I felt that Kirby added so much to them. You know, he would interpret the scripts so well that if somebody else had done them, they might not have been successful" (p. 26).

Shortly after making this comment, though, Simon mentioned that "when we were doing *Boys' Ranch*, we were doing individual strips." This remark comes on the heels of Eisner's saying that he had worked with other people doing backgrounds and the like, "but I never had the kind of team relationship that you and Jack had, and I think that was unique." In this context, Simon's words suggest that he and Kirby were working *individually*.

Taking all this evidence into account, I think I'm safe in assuming that Simon was, in effect, acknowledging that the team was no longer an artistic enterprise, a creative pair. No more "pure Simon and Kirby." By this time, then, the creative product was probably mostly Kirby's, while the business success was attributable to Simon.

At this point, there is probably no longer any way of determining precisely how the duo worked. If confronted in person, each might well claim the major role. And each would feel he is correct. Indeed, they would both be correct, inasmuch as they would be faithfully reporting their memories. The human memory is selective, but neither of them has any resource save their memories; if they report those memories truthfully, they are, perforce, "correct." But the remarks I've quoted above strongly suggest that Kirby was the more prolific creative member of the partnership throughout most of their relationship—certainly by the time *Boys' Ranch* was being produced. And this chapter has been written from that perspective.

INDEX

Indexed here are the names of real persons (last name first), the names of fictional comic book and comic strip characters (first name first), the titles of certain books and comic strips, and the titles of some comic books. Of the latter, only those signficant to the history of the medium or whose history is rehearsed are cited; thus, *Zap Comix* and *Mad* are indexed but *Two-Fisted Tales* No. 31 is not, even though it may be discussed in the text.